PRODUCING WOMEN'S PO.

Producing Women's Poetry is the first speci
English-language poetry by women across th
eighteenth centuries. Gillian Wright explores not only the forms and
topics favoured by women, but also how their verse was enabled and
shaped by their textual and biographical circumstances. She com-
bines traditional literary and bibliographical approaches to address
women's complex use of manuscript and print and their relationships
with the male-generated genres of the traditional literary canon, as
well as the role of agents such as scribes, publishers and editors in
helping to determine how women's poetry was preserved, circulated
and remembered. Wright focuses on key figures in the emerging
canon of early modern women's writing, Anne Bradstreet, Katherine
Philips and Anne Finch, alongside the work of lesser-known poets
Anne Southwell and Mary Monck, to create a new and compelling
account of early modern women's literary history.

GILLIAN WRIGHT is a senior lecturer in English Literature at the
University of Birmingham. She has published extensively on early
modern women's writing and reading, and is especially interested in
women's reception of classical literature and the print–manuscript
nexus in female writing. She has worked with the Perdita Project
on manuscript compilations by sixteenth- and seventeenth-century
women, and her anthology, *Early Modern Women's Manuscript Poetry*
(2005), co-edited with Jill Seal Millman, won the Josephine Roberts
Prize for the Best Edition of 2005, awarded by the Society for the
Study of Early Modern Women. Together with Hugh Adlington and
Tom Lockwood, she is co-editor of the forthcoming *Chaplains in
Early Modern England: Patronage, Literature and Religion*. She has also
published on Samuel Daniel's *The Civil Wars*, editorial theory, and
the cultural influence of Stoic thinking in the early modern period.

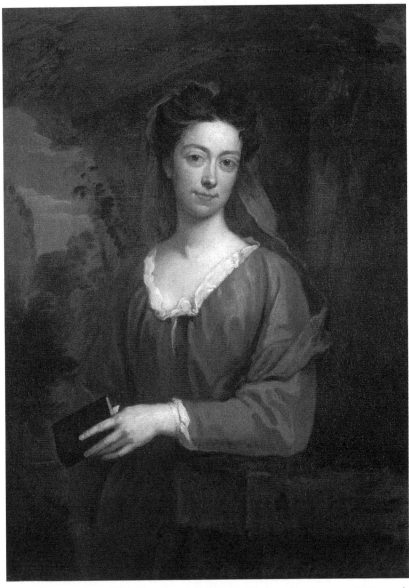

Frontispiece: Portrait of Elizabeth Burnett by Sir Godfrey Kneller, Bt, 1707. © National Portrait Gallery, London.

PRODUCING WOMEN'S POETRY, 1600–1730

Text and Paratext, Manuscript and Print

GILLIAN WRIGHT

University of Birmingham

CAMBRIDGE
UNIVERSITY PRESS

CAMBRIDGE
UNIVERSITY PRESS

University Printing House, Cambridge CB2 8BS, United Kingdom

Cambridge University Press is part of the University of Cambridge.

It furthers the University's mission by disseminating knowledge in the pursuit of education, learning and research at the highest international levels of excellence.

www.cambridge.org
Information on this title: www.cambridge.org/9781107566774

First published 2013
First paperback edition 2015

A catalogue record for this publication is available from the British Library

Library of Congress Cataloguing in Publication data
Wright, Gillian, 1969–
Producing women's poetry, 1600–1730 : text and paratext, manuscript and print / Gillian Wright, University of Birmingham.
pages cm
Includes bibliographical references and index
ISBN 978-1-107-03792-2 (Hardback)
1. English poetry–Early modern, 1500–1700–History and criticism. 2. English poetry–18th century–History and criticism. 3. English poetry–Women authors–History and criticism. 4. Women and literature–England–History–17th century. 5. Women and literature–England–History–18th century. 6. Poetry–Publishing–Great Britain–History–17th century. 7. Poetry–Publishing–Great Britain–History–18th century. I. Title.
PR545.W6W85 2013
821.009′9287–dc23
2012043956

ISBN 978-1-107-03792-2 Hardback
ISBN 978-1-107-56677-4 Paperback

Table of contents

Illustrations

Acknowledgements

This book would not have been possible without the generosity and support of many friends and colleagues. Thanks are due, first, to Elizabeth Clarke who, by appointing me as a postdoctoral researcher on the Perdita Project, helped to initiate my interest in early modern women's writing. I cannot overestimate how much I have learnt both from Elizabeth and from my other Perdita colleagues, Victoria Burke, Marie-Louise Coolahan, Jonathan Gibson and Jill Millman. I hope they will recognise some traces of our many conversations in the pages that follow.

More recently, colleagues at the University of Birmingham have been an invaluable source of advice and support, and have also helped me to develop my research in new directions. I am grateful especially to Valerie Rumbold, who first encouraged me to work on Anne Finch, and to Maureen Bell, whose advice on all aspects of the book trade has enabled me to work more confidently on print as well as manuscript. I have also benefited greatly from discussions facilitated by the Restoration and Eighteenth-Century research cluster and the interdisciplinary Centre for Reformation and Early Modern Studies at Birmingham. Thanks are due in particular to Hugh Adlington, David Griffith, Tom Lockwood, Anne McDermott and Kate Rumbold for their sympathetic and knowledgeable advice. I am also grateful to Richard Cust for advising me on Anne Bradstreet's family background.

Beyond Birmingham, I am indebted to the many colleagues who have stimulated, assisted and informed my work on early modern women's writing and textuality. I have learnt much from conversations with Peter Beal, Danielle Clarke, Elizabeth Hageman, Sue Wiseman and Henry Woudhuysen, all of whom have supported and inspired my research in many ways. Bob Cummings encouraged my early work on Mary Monck, and has been an unfailing source of expert advice and support. Jonathan Gibson, Elizabeth Scott-Baumann and Betsey Taylor-Fitzsimon generously shared unpublished research with me, while Sarah Ross kindly

checked a reference on my behalf. Audiences in Aberystwyth, Keele, London, Montreal, Oxford, Plymouth and Stratford-upon-Avon provided vital advice and feedback on early drafts of each of my chapters. I am also indebted to staff at the Bodleian Library, the British Library, the Folger Shakespeare Library, Lichfield Cathedral Library, the National Library of Wales and the Northamptonshire Record Office for facilitating access to their wonderful collections and for their many acts of practical kindness. I am especially grateful to Charlotte Priddle at the New York University Library and Mariana Oller at the Wellesley College Library for their help and efficiency with images and microfilms.

Research towards this book was supported by the British Academy through its award of a Small Project Grant in 2009–10. I should also like to thank the College of Arts and Law, University of Birmingham, for awarding me two semesters of institutional leave in 2011–12.

I have benefited greatly from the generosity of those colleagues who have read and advised on draft chapters of *Producing Women's Poetry*. I am grateful to Maureen Bell, Elizabeth Clarke, Marie-Louise Coolahan and Clare Hutton, whose wise and knowledgeable suggestions on individual chapters have informed and enhanced the final text. Especial thanks are due to Tom Lockwood and Kathleen Taylor, who heroically read the whole draft – some chapters more than once. Their careful attention to sentences I could no longer bear to read has saved me from many errors, while their enthusiasm for what often felt like an impossible task has helped to ensure that this long-delayed volume has at last reached completion. I have also been much assisted by Kathleen's patient and meticulous help with references.

I am grateful to the Syndicate of Cambridge University Press for approving *Producing Women's Poetry* for publication, and to the Press's anonymous readers, whose generous and constructive advice has shaped and improved the final draft. Linda Bree, Fleur Jones, Maartje Scheltens and the rest of their team at Cambridge University Press have provided exemplary editorial guidance and support. It has been a pleasure, as well as a privilege, to work with them.

Producing Women's Poetry is dedicated to my parents, and to Kathleen.

Textual conventions

Quotations from early modern texts follow original spelling and punctuation. I have regularised the use of i/j and u/v, expanded contractions and lowered superscripts. Italic and block capitals have been regularised to roman and initial capitals in quotations from early modern printed texts.

Early printed texts were published in London unless otherwise stated. Early modern manuscripts are generally cited by name of their modern collection or repository (notwithstanding the anachronism that sometimes results). Quotations from manuscript follow the final version of the text, ignoring corrections, unless these are relevant to the argument. All ellipses are my own unless otherwise stated.

Line references in poetic quotations are cited by number alone. All quotations from online sources were correct as of June 2012.

Abbreviations

ESTC	English Short Title Catalogue estc.bl.uk
HMC Var. Coll.	Historical Manuscripts Commission, *Report on Manuscripts in Various Collections*, vol. VIII (London: His Majesty's Stationery Office, 1913)
IELM	*Index of English Literary Manuscripts*
Klene	Southwell, Anne, *The Southwell-Sibthorpe Commonplace Book: Folger MS V.b.198*, ed. by Jean Klene (Tempe, AZ: Medieval and Renaissance Texts and Studies, 1997)
McGovern and Hinnant	Finch, Anne, *The Anne Finch Wellesley Manuscript Poems*, ed. by Barbara McGovern and Charles H. Hinnant (Athens, GA: University of Georgia Press, 1998)
NRO	Northamptonshire Record Office
ODNB	*Oxford Dictionary of National Biography* www.oxforddnb.com
OED	*Oxford English Dictionary* www.oed.com
POSO	Pope, Alexander, ed., *Poems on Several Occasions* (1717)
Reynolds	Finch, Anne, *The Poems of Anne Countess of Winchilsea*, ed. by Myra Reynolds (Chicago, IL: University of Chicago Press, 1903)
Thomas I	Philips, Katherine, *The Collected Works of Katherine Philips, the Matchless Orinda*, vol. I, ed. by Patrick Thomas (Stump Cross Books, 1990)
Thomas II	Philips, Katherine, *The Collected Works of Katherine Philips, the Matchless Orinda*, vol. II, ed. by Patrick Thomas (Stump Cross Books, 1993)

Introduction

> For it is a perennial puzzle why no woman wrote a word of that extraordinary literature when every other man, it seemed, was capable of song or sonnet.
>
> Virginia Woolf, *A Room of One's Own* (1929)

In 1621, the booksellers John Marriott and John Grismand published a prose romance entitled *The Countesse of Mountgomeries Urania*.[1] A handsome folio some 600 pages in length, *Urania* was the only work by its author, Lady Mary Wroth, to be print-published during her lifetime. Its elaborately decorated title page depicts a complex allegorical landscape, dense with literary allusions and foreshadowing many of the preoccupations subsequently explored in the *Urania* narrative itself. Its title, displayed in cartouche above a mysterious hilltop tower, intimates the author's links with one of the most prominent noble families of the Jacobean age. Both social and literary connections are also foregrounded in the description of the *Urania*'s distinguished author:

Written by the right honorable the Lady Mary Wroath: Daughter to the right Noble Robert Earle of Leicester. And Neece to the ever famous, and renowned Sir Phillips [*sic*] Sidney knight. And to the most exelent Lady Mary Countesse of Pembroke late deceased.

Wroth's 'famous, and renowned' uncle had of course earned his fame not only as a courtier and a soldier but also as one of the most admired poets and patrons of the late sixteenth century. Her aunt, Mary Sidney – mother-in-law to the Countess of Montgomery named in the romance's title – was also known as a poet, translator, editor and literary patron. The *Urania*'s title page, in both words and image, makes powerful claims for Wroth's text to be read both as a continuation of her family's literary projects and as an informed contribution to the genre of prose romance.

[1] Mary Wroth, *The Countesse of Mountgomeries Urania* (1621).

The sheer length of the ensuing narrative also consolidates the message that the *Urania* is the work of a committed and ambitious writer of prose fiction.

But the Wroth of the *Urania* is more than just a prose writer. Pages 2–3 of the volume also include two sonnets, in mildly different formats: one voiced, one discovered, by the eponymous Urania. These sonnets are only the first of numerous poems in different genres – songs, lyrics, meditations, dialogues, verse letters, pastorals and a complaint, as well as sonnets – to be found interspersed within the *Urania* narrative. The volume concludes with a collection of 103 poems – songs and sonnets (including a crown of sonnets) – under the title *Pamphilia to Amphilanthus*. And the print-published *Urania* is by no means the only surviving witness to Wroth's poetic activities. Her own manuscript continuation of the *Urania* narrative, now held at the Newberry Library, Chicago, also includes numerous inset poems.[2] Her pastoral play, *Love's Victory*, extant in two manuscripts, is written in rhymed couplets, interspersed with sonnets, songs and other lyrics.[3] An autograph collection of her poetry, also entitled *Pamphilia to Amphilanthus*, overlaps substantially with the poems in the published *Urania*, including the crown of sonnets.[4]

As even this cursory account makes clear, Wroth took poetry seriously. Her long-standing commitment to verse production is indicated not only by the sheer quantity of her writings in numerous poetic genres but also by the care she took to present, correct, revise and rework her poetry. Her own surviving copy of the printed *Urania* includes numerous handwritten corrections and annotations in both the prose and the poetry sections; evidently, for Wroth, even the apparently definitive forms provided by print-publication did not terminate the creative process.[5] A comparison of the printed *Urania* with the poems in Wroth's autograph manuscript tells a comparable, though more complex, story of authorial revision, rearrangement and redeployment. Of the 117 poems in the autograph manuscript (which probably predates the publication of the *Urania*), 102 were included, in a partially reordered sequence, in the *Pamphilia to Amphilanthus* section

[2] Newberry Library Case MS fY 1565.W 95.
[3] One MS of *Love's Victory* is privately owned; the other is now Huntington Library MS HM 600. The purpose, relationship and history of these manuscripts is discussed by Paul Salzman, *Reading Early Modern Women's Writing* (Oxford University Press, 2006), pp. 77–84.
[4] Folger MS V.a.104.
[5] Wroth's annotated copy of the *Urania* (now in private ownership) is reproduced in *The Early Modern Englishwoman: A Facsimile Library of Essential Works, Part I: Printed Writings 1500–1640*, vol. 10, *Mary Wroth*, ed. by Josephine A. Roberts (Aldershot: Scolar Press, 1996).

of the printed volume, while nine were incorporated into the prose *Urania* narrative and six are extant only in the manuscript itself. Conversely, although all the poems in the printed *Pamphilia to Amphilanthus* are included in the manuscript, the prose section of the *Urania* also incorporates forty-seven poems which are unattested elsewhere and were presumably written expressly for inclusion in the romance narrative. Many of the poems which appear in both volumes have undergone revision – usually minor, occasionally extensive – between manuscript and print. Furthermore, the poetic collections in both the printed *Urania* and the autograph manuscript are carefully subdivided into different – and still puzzling – numbered sequences. Wroth, it is clear, took trouble over her poetry, thought carefully about how it could be used and re-used in different contexts, and was painstakingly attentive to the details of her texts. As much as, if not more than, the family affiliations so proudly asserted on the title page of the *Urania*, this care and attention to text and context in the practice of prestigious genres underpins Wroth's claims to be read within, and accepted into, the highest traditions of English literary history.[6]

Virginia Woolf marvelled, in *A Room of One's Own*, at the 'perennial puzzle' of why 'no woman wrote a word of that extraordinary literature when every other man, it seemed, was capable of song or sonnet'.[7] Strictly speaking, Woolf's 'extraordinary literature' refers to the writings of the late sixteenth century – the reign of Queen Elizabeth, which ended nearly two decades before the publication of Wroth's skilful and highly literary *Urania* in 1621. Yet even within the Elizabethan period, counter-examples to the bleak picture painted by Woolf can be found in writers such as Isabella Whitney, whose poetry was published in two printed collections in 1567 and 1573, Jane Seager, who prepared ten sibylline poems for presentation to Queen Elizabeth in 1589, and Anne Lock, who concludes her translation *Of the Markes of the Children of God* (1590) with the poem 'The necessitie and benefite of affliction'.[8] The most eminent and productive of all Elizabethan female poets was Wroth's aunt, Mary Sidney, who paraphrased 107 of the Psalms in multiple versions (complementing

[6] The standard edition of Wroth's poems – *The Poems of Lady Mary Wroth*, ed. by Josephine A. Roberts (Baton Rouge, LA: Louisiana State University Press, 1983) – is an eclectic version which conflates elements from both the manuscript and printed texts. An electronic parallel-text edition of both manuscript and print versions is now available at http://wroth.latrobe.edu.au; an edition of the Folger manuscript, prepared by Steven W. May and Ilona Bell, is in progress.

[7] Virginia Woolf, *A Room of One's Own and Three Guineas*, ed. by Hermione Lee (London: Vintage, 1996), p. 39.

[8] Seager's autograph manuscript is now British Library Additional MS 10037.

the forty-three previously completed by her brother Philip), as well as translating Petrarch's *Trionfo della morte* and composing an elegy in memory of her brother. If we look beyond Sidney into the seventeenth century – or that portion of the seventeenth century which predates the career of Aphra Behn, identified by Woolf as the founding foremother of women's writing in English – we can find numerous other female poets, as well as Wroth, who challenge Woolf's image of the pre-Behnian literary landscape: Aemilia Lanyer, Anne Bradstreet, Hester Pulter, Katherine Philips and Lucy Hutchinson, to name only the most notable examples. All these women produced substantial corpora of poetry in genres which, collectively, range from the well-established to the innovative. The numerous dedicatory poems in Aemilia Lanyer's *Salve Deus Rex Judaeorum* (1611), for instance, demonstrate her range and facility in encomiastic verse, while her 'Description of Cooke-ham' ranks as one of the first country-house poems in English. The astonishingly versatile Katherine Philips composed songs, elegies, verse letters, encomia and dialogues, as well as poems on love, friendship, retirement, politics, philosophy and religion; she also translated French neoclassical drama into accomplished English couplets. Women poets such as Wroth, Lanyer and Philips did not merely make a few token contributions in marginal genres to the 'extraordinary literature' of the pre-Behnian era. Well-read in anglophone literature – and also, in some cases, in French, Italian and even Latin literature – all were committed, wide-ranging and aspirational writers. All deserve to be taken seriously, both as pioneering figures within English women's literary history and as creative readers of the (mainly male-authored) literary traditions of their day.

Producing Women's Poetry is a study of five women poets – Anne Southwell, Anne Bradstreet, Katherine Philips, Anne Finch and Mary Monck – who flourished between the early seventeenth and early eighteenth centuries, and whose work, like Wroth's, spans the boundary between manuscript and print. Like so much scholarship on early modern women's writing, *Producing Women's Poetry* can be construed as an extended footnote to Virginia Woolf – or, more precisely, as part of an increasingly complex critical response to Woolf's historiography of anglophone women's writing in *A Room of One's Own*. The ideologically and emotionally charged account of English women's writing which forms the centrepiece of *A Room of One's Own* presents a narrative in which women writers, however talented, are repeatedly frustrated by repressive relatives, social conventions or lack of educational opportunities. The many evocative vignettes of seventeenth-century women writers in *Room* include the 'harebrained' Margaret Cavendish, who 'should have been taught to look

at the stars' but remained 'untutored', lost her wits and became 'a bogey to frighten clever girls with'; the 'sensitive' Dorothy Osborne, who 'had the makings of a writer in her' but whose favoured genre, letters, 'did not count'; and Anne Finch, who was capable of 'pure poetry', but whose gifts were frustrated by anger, bitterness and melancholia.[9] Unquestionably the most memorable vignette in *A Room of One's Own* is the haunting word-picture of the gifted but cruelly thwarted Judith Shakespeare, whose ambition to become a playwright like her brother ends in pregnancy, despair and death. In a world where even such able and privileged women as Cavendish, Osborne and Finch (or, indeed, the fictional Judith Shakespeare) were unable to fulfil their literary potential, the failure of early modern women to contribute to the 'extraordinary literature' of the Elizabethan age scarcely requires further explanation; indeed, it may seem all but inevitable.

Yet *A Room of One's Own*, so compelling as polemic, is shaky as history. Over eighty years after it was first published, scholarly understanding of early modern English literature – by men as well as women – has changed considerably, and many of the assumptions, spoken and unspoken, on which Woolf's argument depends now seem at best tendentious, at worst misinformed and misplaced. In recent years, Margaret Ezell's critique of Woolf's 'myth of Judith Shakespeare' has been highly influential in challenging *A Room of One's Own*'s gloomy picture both of the conditions – social, familial, educational – experienced by would-be women writers in the early modern period and also of the extent of their achievements.[10] As Ezell points out, Woolf – writing in the early twentieth century, before the development of modern bibliographical resources and finding aids – simply knew much less about women's writing of the sixteenth and seventeenth centuries than scholars do today. In the decades since *A Room of One's Own* was published, the recovery of many more female writers from the early modern period has made women's literary history, pre-Aphra Behn, look very different than it did for Woolf in 1929. But simple ignorance, in Ezell's view, is only the most obviously problematic aspect of Woolf's literary historiography in *Room*. More insidious and far-reaching is one of the key assumptions underpinning Woolf's polemical argument: namely, her privileging of professionalism and concomitant depreciation of forms of early modern literary production which did not

[9] Woolf, *Room*, esp. at pp. 55–59.
[10] Margaret Ezell, *Writing Women's Literary History* (Baltimore, MD: Johns Hopkins University Press, 1993), esp. Chapter 2.

offer opportunities for financial reward. Woolf's account of seventeenth-century women's writing, for instance, excluded or downplayed manu-script composition and circulation, which would have done little to help women writers to gain either public reputation or financial independence. Similarly devalued in *Room* were non-remunerative genres – such as letters – which did not belong to the traditional literary canon and would have done nothing to help the would-be woman writer achieve the goal regarded by Woolf as crucial to success: earning her living by her pen. Indeed, it is no coincidence that both Aphra Behn and Judith Shakespeare – Woolf's principal examples of realised and unrealised literary potential among early modern women – were both (actual or aspiring) dramatists. Playwriting, sexually compromising for women, was nonetheless the most viable means of earning one's living by imaginative writing in the seven-teenth century. Only when female dramatists could be accepted and succeed in the commercial theatre could women's literary history, on the Woolfian model, properly begin.

Ezell's critique of *A Room of One's Own*, first published in 1993, is in its own way as much a product of its time as is *Room* itself. Its challenge to conventional generic hierarchies is strongly influenced by poststructuralist theory, which deconstructed the traditional distinction between 'literary' and 'non-literary' genres and encouraged the study of 'writing practices' rather than the traditional 'high' literary genres (some of which were, in fact, neither so 'traditional' nor so 'high' as was often supposed). Ezell, drawing on French feminist theorists such as Hélène Cixous and Julia Kristeva, also argued that traditional generic hierarchies were based on unspoken but pervasive androcentric assumptions which mainstream Anglo-American feminism, such as Woolf's, had not merely failed to query but had in fact silently reproduced. Instead of such acquiescence in male-centric norms, Ezell advocated a more historically sensitive scholarly practice which would address the full range of written forms practised by early modern women. Her appeal both complemented and endorsed concurrent moves by critics such as Elaine Hobby and Wendy Wall to bring non-traditional genres, such as prophecies and mothers' legacies, within the purview of academic scholarship on women's writing.[11] In subsequent years, scholarship on 'non-literary' genres of early modern

[11] Elaine Hobby, '"Oh Oxford Thou Art Full of Filth": The Prophetical Writings of Hester Biddle, 1629(?)–1696', in *Feminist Criticism: Theory and Practice*, ed. by Susan Sellers, Linda Hutcheon and Paul Perron (University of Toronto Press, 1991), pp. 157–69, and Wendy Wall, 'Isabella Whitney and the Female Legacy', *English Literary History*, 58.1 (1991), 35–62.

women's writing has continued to flourish; recent examples include studies
by Alison Thorne on petitionary letters and Victoria Burke on arithmetical
manuscripts.[12]

Still more clearly a product of its time was Ezell's insistence – *pace*
Woolf – that writings which did not pass beyond manuscript into print
should not be dismissed as inconsequential and irrelevant for that reason
alone. In arguing for the reappraisal of women's manuscript writings of
the early modern period, Ezell was both responding and contributing to a
full-scale scholarly re-evaluation of the role of early modern manuscript
circulation which began in the 1980s and culminated in a number of
landmark publications in the early 1990s. Research by scholars such as
Peter Beal, Mary Hobbs, Harold Love, Arthur Marotti and H. R.
Woudhuysen, as well as Ezell, persuasively demonstrated the extent and
continuing cultural significance of manuscript transmission as much as 250
years after the introduction of printing into England.[13] Such research was
critical both in reorientating scholarly perceptions of the entire writing
culture of sixteenth- and seventeenth-century England and also in encour-
aging new ways of thinking about early modern textuality. Against this
background, the preference of so many early modern women writers for
manuscript, rather than print, circulation of their works no longer looked
as anomalous as it had to Woolf. When so many eminent male authors of
the same period, whose role in the literary canon was unquestioned, could
be shown also to have favoured manuscript and shunned print, there could
be no defensible grounds for disregarding women writers who had made
similar choices. Ezell's argument that scholarship on early modern
women's writing should take account of manuscript as well as printed
texts was thus consonant with wider trends in literary studies, and has been
highly influential on subsequent research. Essays and articles on early
modern women's manuscript writings have proliferated in recent years,

[12] Alison Thorne, 'Women's Petitionary Letters and Early Seventeenth-Century Treason Trials',
Women's Writing, 13.1 (2006), 23–43, and Victoria E. Burke, '"The art of Numbering well": Late
Seventeenth-Century Arithmetic Manuscripts Compiled by Quaker Girls', in *Material Readings of
Early Modern Culture: Texts and Social Practices, 1580–1730*, ed. by James Daybell and Peter Hinds
(Basingstoke: Palgrave, 2010), pp. 246–65.
[13] Important publications include Peter Beal, 'Notions in Garrison: The Seventeenth-Century
Commonplace Book', in *New Ways of Looking at Old Texts: Papers of the Renaissance English Text
Society, 1985–1991*, ed. by W. Speed Hill (Binghamton, NY: Renaissance English Text Society, 1993),
pp. 131–47; Mary Hobbs, *Early Seventeenth-Century Verse Miscellany Manuscripts* (Aldershot: Scolar
Press, 1992); Harold Love, *Scribal Publication in Seventeenth-Century England* (Oxford: Clarendon
Press, 1993); Arthur Marotti, *Manuscript, Print, and the English Renaissance Lyric* (Ithaca, NY:
Cornell University Press, 1995); and H. R. Woudhuysen, *Sir Philip Sidney and the Circulation of
Manuscripts, 1558–1640* (Oxford: Clarendon Press, 1996).

while the Perdita Project, which catalogues women's manuscript compilations produced between 1500 and 1700, has helped to bring the extent of surviving manuscript material to scholarly notice.[14] Manuscript texts are now routinely addressed even in studies of early modern women's writing which do not assume an explicitly manuscript-related remit. Such work on women's writing in manuscript has also been complemented by a more sharply focused scholarly interest in the involvement of women in print culture, both as print-published authors and as participants in the early modern book trade.[15]

Two decades after the publication of *Writing Women's Literary History*, scholarship on early modern women's writing now looks very different. Ezell's criticisms of *A Room of One's Own*, once iconoclastic, are now as much part of the scholarly landscape as is *Room* itself. My own research on early modern women's writing is firmly post-Ezellian; the present book, as will be apparent, is to a great extent premised on arguments first fully articulated in *Writing Women's Literary History*. Yet there are obvious dangers when any critique of old assumptions becomes the new scholarly orthodoxy, not least that some of the genuine insights of the old assumptions may be overlooked. Amid all the recent interest in early modern women's writing both in manuscript and in a more diverse range of genres, we may be at risk of forgetting that, in some respects at least, Virginia Woolf was right. While her claim that women made *no* contribution to the 'extraordinary literature' of the Elizabethan period is demonstrably incorrect, we should not fail to remember that, relative to men's, women's contribution to early modern literature in English was modest. Even when manuscript as well as print, or a wider range of contemporary genres, is taken into account, it remains the case that comparatively few sixteenth- and seventeenth-century women are known to have produced any kind of writing at all. The qualification 'are known to' is essential, since survival rates for women's writing (especially in manuscript) are likely to have been

[14] The Perdita Project catalogue can be found at http://warwick.ac.uk/english/perdita/html. Essay collections specialising in early modern women's manuscripts include George L. Justice and Nathan Tinker, eds., *Women's Writing and the Circulation of Ideas: Manuscript Publication in England, 1550–1800* (Cambridge University Press, 2002) and Victoria E. Burke and Jonathan Gibson, eds., *Early Modern Women's Manuscript Writing* (Aldershot: Ashgate, 2004).

[15] Pioneering studies of women in the book trade include Maureen Bell, 'Seditious Sisterhood: Women Publishers of Opposition Literature at the Restoration', in *Voicing Women: Gender and Sexuality in Early Modern Writing*, ed. by Kate Chedgzoy, Melanie Hansen and Suzanne Trill (Keele University Press, 1996), pp. 185–95, and Paula McDowell, *The Women of Grub Street: Press, Politics, and Gender in the London Literary Marketplace, 1678–1730* (Oxford: Clarendon Press, 1998). On women and print culture see, for instance, Catharine Gray, *Women Writers and Public Debate in Seventeenth-Century Britain* (Basingstoke: Palgrave, 2007).

lower than for men's, which was in general more highly valued and thus more apt to be preserved either in print or within family or institutional collections.[16] Yet differential survival rates, however significant, are not by themselves enough to explain the disparity between what we know of women's and men's literary activities in the early modern period. Furthermore, scholarly interest in women's exploration of non-literary genres, however valuable both in itself and as a corrective to the preconceptions of *Room*, should not be allowed to obscure the corollary – acknowledged by Ezell as much as Woolf – that of those early modern women who did write, only a relatively small proportion engaged in the literary genres which their own culture held in highest regard.[17] We also need to remember that, of those few early modern women who did attempt to write in recognisably literary forms, even fewer produced a body of work which rivalled in quantity, let alone quality, the writings of their male contemporaries. Much though Woolf may have overstated the contrast between women's and men's literary production in the early modern period, she did not altogether misrepresent it. If we are to understand the full range of women's writing during the early modern period, then the difficulties they faced in their engagement with 'high' literary genres, as well as the opportunities afforded by other, less conventional forms, need to be taken into account.

In other respects, too, the reorientation of scholarship on early modern women's writing since the early 1990s has had unintended and unwanted consequences. One such consequence stems from the emphasis in recent scholarship on the material and paratextual aspects of women's writing. It is now common for studies of texts by early modern women to stress material factors such as the physical construction and organisation of manuscripts and printed books, or the creation of the female author in prefatory, marginal or appended paratexts. This emphasis on productionist and presentational issues is an appropriate and valuable corrective to the tendency in many previous studies to address women's writing in

[16] The exclusion of women from most early modern institutions provides another reason why women's writing survives relatively infrequently in institutional collections. Convents, the one early modern institution fully open to women, were of course outlawed in England after the dissolution of the monasteries. On the preservation of writings by English nuns in continental houses, see Heather Wolfe, 'Reading Bells and Loose Papers: Reading and Writing Practices of the English Benedictine Nuns of Cambrai and Paris', in Burke and Gibson, eds., *Early Modern Women's Manuscript Writing*, pp. 135–56.

[17] For empirical confirmation of this insight, see Patricia Crawford, 'Women's Published Writings, 1600–1700', in *Women in English Society, 1500–1800*, ed. by Mary Prior (London: Methuen, 1985), pp. 211–82, and the Perdita catalogue under 'genres' (for manuscripts).

over-idealised terms, without reference to the material factors which not only helped bring such texts into existence but also made significant contributions to the meanings these texts produced. As the title of the present book suggests, my own approach to women's writing is strongly productionist, and attention to the material aspects of textual construction is foundational to my own attempts to understand and contextualise early modern women's poetry. Yet I also recognise the danger that such attention to the material aspects of women's writing may, under certain circumstances, serve to distract from, rather than illuminate, the writing itself. It is not unknown to find studies of early modern women's writing which devote so much care to describing the physical make-up of a manuscript or printed book that the contents of the text itself are scarcely addressed. It is similarly possible to find studies which focus on reconstructing a woman writer's biography, friendships or textual relationships – those aspects of her life which helped to make her works possible – while saying little about the works themselves. It is arguable that a greater emphasis on material and biographical factors is a necessary first stage in the recovery of many previously unknown texts by early modern women which, unlike the work of their better-known male contemporaries, cannot silently benefit from the accumulated scholarly wisdom of the past four to five hundred years. Even if this is so, however, then – after several decades of intensive primary research – the time has surely now come to move on. This is not to say that material and biographical factors are not (or are no longer) important for understanding early modern women's writing; it is a key premise of this book that they are. My point is rather that research on early modern women's writing has now reached a point of maturity where material and biographical considerations, while still important, need not be emphasised at the expense of other aspects of literary scholarship. Productionist factors are of enormous value in helping to make sense of early modern women's writing, but it is the writing itself which is, or should be, our chief concern. If we are to do justice to early modern women's writing we need to take as much account of form, ideas, imagery and genre – the traditional stuff of literary criticism – as we do of materiality. To do otherwise is to risk yet another unintended consequence: namely, reinforcing old-fashioned stereotypes which see early modern women's writing as valuable only as cultural history, incapable of sustaining formal or substantive analysis. It is hard to imagine any but the most eccentric scholars of early modern women's writing wanting to do this.

My own aim in *Producing Women's Poetry* has been to construct an account of five early modern women poets which, while informed by a

materialist analysis of their texts, situates this analysis within a broader framework of literary investigation.[18] The five women in question – Southwell, Bradstreet, Philips, Finch and Monck – have been chosen for detailed scrutiny precisely because their work can be fruitfully examined in terms both of more traditional literary hermeneutics and of material issues of construction, organisation and presentation. They also, in each case, form instructive examples of women writers who, contrary to Woolf's sweeping claims in *A Room of One's Own*, not only contributed to the extraordinary literature of their age, but did so with determination, persistence and skill. Southwell, Bradstreet, Philips, Finch and Monck, like Mary Wroth, were all substantial, ambitious and accomplished writers who created an extensive body of work in numerous, often challenging, genres. Each did so, moreover, despite choosing to work in a form – poetry – which was among the most prestigious, demanding and (for women) problematic within their culture. As numerous studies have shown, self-authorisation was particularly challenging for early modern women, who were faced (though not uniformly) with the cultural imperative that their sex be chaste, silent and obedient.[19] Ezell's insight that the problem of self-authorisation for women was less an issue of writing than of print-publication – that is, that the cultural pressures which made it difficult for women to enter the world of print did not necessarily inhibit them from the act of writing – needs to be supplemented with the recognition that, even in manuscript, some genres were more accessible to women than others. 'Non-literary' genres such as letters, biographies and memoirs, receipt books, sermon notes and biblical meditations could all variously be justified on grounds either of a woman's duties to her family or of her own spiritual obligations. Thus, for instance, the young Mary Evelyn, in the 1680s, started collecting her devotional meditations into a notebook so that they would be 'more usefull' in furthering her own spiritual reflections and self-scrutiny, while Ann Fanshawe, writing a manuscript memoir of

[18] Both the 'dialogic formalism' advocated by Sasha Roberts, and the 'feminist formalism' modelled by Elizabeth Scott-Baumann, though somewhat different in emphasis from my own approach, respond in part to similar concerns. See Roberts, 'Feminist Criticism and the New Formalism: Early Modern Women and Literary Engagement', in *The Impact of Feminism in English Renaissance Studies*, ed. by Dympna Callaghan (Basingstoke: Palgrave, 2007), pp. 67–92, and Scott-Baumann, *Forms of Engagement: Women, Poetry and Culture 1640–1680* (in press).

[19] The issue of self-authorisation for early modern women is still best addressed in Wendy Wall, *The Imprint of Gender: Authorship and Publication in the English Renaissance* (Ithaca, NY: Cornell University Press, 1993). Wall, however, deals almost exclusively with printed texts, and does not devote much attention to the rather different issues raised by self-authorisation in a manuscript context.

her husband in the 1670s, represented her text as a means of fulfilling her duty to her son, who might otherwise remain ignorant of his father's service to his country, affection for his family and devotion to the Church of England.[20] Although Evelyn and Fanshawe still evidently felt the need to justify their activities as writers, their arguments for doing so were straightforward and assured. Their work in such self-evidently practical genres, as much as their restriction of their texts to manuscript, helps to explain the ease and confidence of their writing.

With literary genres, however, such arguments for usefulness and duty were less easy though not altogether impossible. An instructive example is Katherine Philips's claim, in 'Upon the double Murther of K. Charles I', that her natural feminine modesty has been overcome by her more important obligation, as a loyal subject, to defend the dead Charles against the slanders of his enemies. The cogency of this argument – at least for a royalist readership – can be judged by the fact that when Philips's poetry was published in 1664 and 1667, 'Upon the double Murther' was in each case chosen as the opening poem in the volume.[21] The poem was thus deployed as a mildly deceptive advance justification for a collection which elsewhere includes items – such as Philips's many examinations and celebrations of female friendship – which could not easily be construed as either useful or dutiful. Philips's own admission of her 'incorrigible inclination to that folly of riming' – albeit written in the fraught aftermath of the supposedly unauthorised publication of her 1664 *Poems* – testifies to the care that had to be exercised in defending time and effort spent on poetic production, even so late in the century and in the comparative privacy of manuscript.[22] Even the powerful precedent of the posthumous (and thus more readily defensible) folio of Philips's *Poems* in 1667 did not altogether nullify the problem for later women poets. Anne Finch, preparing a preface for a manuscript volume of her poems and plays in the 1690s, felt it necessary to excuse her 'irresistible impulse' to write poetry, while Robert Molesworth, accounting for the poems and translations of his daughter, Mary Monck, firmly ascribed them to her 'leisure Hours' and assured his dedicatee, Caroline of Ansbach, that Monck had pursued her

[20] British Library Additional MSS 78441 (fol. 1r) and 41161 (fol. 2r; compare fol. 121).
[21] First, that is, in the main (Philips-authored) section of the volume; in each case 'Upon the double Murther' is preceded by a substantial commendatory apparatus.
[22] Katherine Philips, *Poems By the most deservedly Admired Mrs Katherine Philips, The matchless Orinda* (1667), sig. A2v; compare Katherine Philips, *The Collected Works of Katherine Philips, the Matchless Orinda*, vol. II, ed. by Patrick Thomas (Stump Cross Books, 1993) (henceforward Thomas II), p. 130.

linguistic and poetic interests 'without omitting the daily Care due to a large Family'.[23] The cultural pressures which made it difficult for women to print-publish in *any* genre still potentially applied to women's practice of literary genres even in manuscript, though in the latter case they might often remain latent, coming to the surface only when circulation in a more public medium was in question. In such circumstances, it is small wonder that relatively few early modern women should have persisted with poetry long enough to become creatively adept and to produce a varied and substantial body of work. In those cases where they did, both the conditions that enabled them to write and the quality and range of their writings warrant critical attention.

Southwell, Bradstreet, Philips, Finch and Monck are of course not the only early modern women poets whose writings are substantial, ambitious and wide-ranging. One factor, however, which does set them apart from many – though by no means all – of their female contemporaries is that in each case they, or others close to them, were responsible for compiling *collections* of their poetry. The issue of collection is important for women poets in the first instance because it is testament to the seriousness with which their writing was regarded, either by themselves or by their family and friends. The collection of a woman's writing shows that someone – whether the woman herself, or a collaborator of some kind – cared enough about her poetry to gather, organise and transcribe it, either for readership in manuscript or for further circulation in print. Far from anticipating Virginia Woolf's dismissive view of women's literary achievements in the early modern period, these compilers valued their poets' writings, and saw benefit in preserving texts which might otherwise have been scattered and lost. But preservation of materials, important though it is, is by no means the only consequence of the compilation process. By collecting these women's poetry (and also, in some cases, their plays, letters and translations), compilers helped to determine not only *that* each of these poets would be remembered, but also *how* she would be remembered. Poetic collections of the kind studied here are not random or arbitrary, and nor are they necessarily complete. Decisions about exclusion and inclusion, as well as the organisation and presentation of materials, play a vital part in the formation both of poetic canons and poetic reputations. Compilation can highlight or occlude a poet's activity in different genres or topics; it can produce her as more or less radical or conservative, traditional or

[23] Folger MS N.b.3, fol. 8r; Mary Monck, *Marinda: Poems and Translations upon Several Occasions* (1716), sig. b7v.

innovative; or it can create a narrative – accurate or inaccurate – of her poetic career. Uncovering and mapping the compilation practices which underlie the extant collections of these women's poetry is thus essential to an informed understanding both of the shape and extent of their poetic oeuvres, and also of the means by which each was constructed as a poet.

Literary production, as understood in *Producing Women's Poetry*, is a complex process in which women's creative activities are inextricable from the numerous factors – people, institutions, economic and ideological forces – that made those activities both possible and visible. The diverse manifestations and implications of women's literary production are explored and evaluated through attention to three interlinked issues: textuality, agency and genre. 'Textuality', as used here, is an inclusive term which encompasses issues such as the physical construction of documents, the selection, organisation and arrangement of poetic collections, the editing and reshaping of individual poems, and the deployment of paratexts. The term thus subsumes a variety of material and editorial considerations, most of which are potentially relevant to both manuscript and printed texts. This applicability of 'textuality' issues to both manuscript and print is important to the project of *Producing Women's Poetry* since each of the women studied here worked, albeit in different ways, with both forms of textual material. Retrospectively, indeed, each of these poets can be seen to have operated in a characteristically seventeenth- (and early eighteenth-)century intermediate area between the rival modes of manuscript and print transmission. Recent scholarship on the cultures of manuscript and print in the early modern period has increasingly recognised that these two modes, so distinct in theory, might in practice merge or overlap in many possible ways.[24] One example of such boundary-blurring scholarship is Adrian Johns' work on textual instability in the early modern printed book, which challenged the tendency of previous scholarship to construct hard distinctions between the fixity and uniformity associated with print and the uniqueness and malleability associated with manuscripts.[25] The processes through which texts originally intended (or said to have been intended) only for manuscript circulation might, nonetheless, find their way into print have also been widely discussed; distinguished examples include H. R. Woudhuysen's work on Philip Sidney, as well as Arthur Marotti's on

[24] On this phenomenon, see further David McKitterick, *Print, Manuscript, and the Search for Order, 1450–1830* (Cambridge University Press, 2003) and Mark Bland, *A Guide to Early Printed Books and Manuscripts* (Oxford: Wiley-Blackwell, 2010).

[25] Adrian Johns, *The Nature of the Book: Print and Knowledge in the Making* (University of Chicago Press, 1998).

Donne.[26] Still more complex and self-referential processes of interplay
between manuscript and print have been uncovered by Adam Smyth's
work on seventeenth-century printed miscellanies, which shows not only
how such compilations relied on a wide range of manuscript sources, both
for their contents and for their often disingenuous claims to cultural
prestige, but also how individual copies of printed collections might
subsequently be drawn back into the sphere of manuscript through hand-
written annotation.[27] Studies such as these do not wholly dissolve the
boundary between manuscript and print, nor suggest that the two modes
were identical or interchangeable. They do, however, show that, while
early modern manuscript and print each had its own characteristics and
conventions, the two categories were not mutually exclusive. Recognising
the many areas of commonality between manuscript and print, as well as
the more distinctive properties of each mode, is thus essential to any
account of early modern textual practice.

Issues of textuality – and, in particular, the productive interplay between
manuscript and print – are central to *Producing Women's Poetry*. Rather
than focusing on either manuscript or printed texts, the case studies which
follow address material and editorial factors in relation to both of these
modes. As well as examining women's use of the textual resources of their
chosen medium – manuscript, print, or both – I also track the processes of
negotiation, exchange and appropriation between manuscript and print
through which, in different ways, these women's poetry was constructed,
shaped and disseminated. In many of the instances examined in *Producing
Women's Poetry*, this movement between modes is chiefly visible as a
transition from manuscript into print, as a corpus of poetic texts, produced
for and within the manuscript context, found its way into print-published
form. In such instances, I consider how the texts and canon of each
women's poetry were reshaped by and for the print-publication process.
Through comparison between printed texts and manuscript(s) – as with
Katherine Philips and Anne Finch – or through close reading of the
printed texts themselves – as with Anne Bradstreet and Mary Monck –
I analyse how their poetry was reworked for the print medium, whether
through manipulation of the texts themselves, by strategic re-organisation
of materials, or by the use of paratextual material to direct the reader's

[26] Woudhuysen, *Sir Philip Sidney*; Marotti, *Manuscript*, pp. 250–56; see also Margaret Ezell, *Social Authorship and the Advent of Print* (Baltimore, MD: Johns Hopkins University Press, 1999).
[27] Adam Smyth, *'Profit and Delight': Printed Miscellanies in England, 1640–1682* (Detroit, MI: Wayne State University Press, 2004).

perceptions of the author's work. I thus assess the extent to which print
itself was constitutive in fashioning images of these women poets, as well as
considering what interests were served by the image(s) thus created.

But in early modern interactions between manuscript and print the
direction of textual traffic was not merely one-way. Just as early modern
manuscript texts could, in certain circumstances, make the transition into
printed form, so too printed texts, by various means, could be reabsorbed
into the world of manuscript. The handwritten annotation of printed
books, analysed by scholars such as Smyth, is just one way in which the
transition from print into manuscript might occur. Making extracts or
collections from printed books for inclusion in manuscript compilations
was common practice; a somewhat rarer example of such print-to-
manuscript reproduction can be found in Folger MS V.b.231, an exact
full-text transcription of Katherine Philips's *Poems* (1669). Another form of
print-to-manuscript communication, still more relevant to the present
study, is through the creative readership of printed texts. All of the women
studied in *Producing Women's Poetry* were attentive readers of print-
published books, their interests ranging from English poetry to world
history, French, Italian and classical literature (sometimes in translation),
contemporary theology, philosophy and science, and of course – the staple
of women's reading in the early modern period – the Bible. The reason
we know about these interests is because, in each case, they have left
traces – sometimes very substantial traces – in the woman's writings. Anne
Southwell's poetry, for instance, draws inventively on published verse by
John Donne and Henry King, while Anne Bradstreet's *magnum opus* 'The
Foure Monarchies' is a selective poetic reworking of Sir Walter Raleigh's
massive *History of the World*. The different ways in which Southwell,
Bradstreet, Philips and Finch responded to the generic range and cultural
authority of the Bible are not only instructive in terms of each poet's
creative choices and religious priorities, but also help to map the develop-
ment of women's poetry across the seventeenth century; the fact that Mary
Monck's original poems and translations, at least as selected and edited by
her father, scarcely engage with the Bible at all is equally instructive in its
own way. All of these women – who also, of course, read and responded to
texts they encountered in manuscript – were avid consumers of printed
books who used their reading of print-published texts to stimulate and
support their own (originally manuscript) writings. Just as, in my view, we
cannot fully understand the range and ambition of their poetry without
taking into account the material forms in which it was produced, we also
cannot fully appreciate their intellectual scope, ideological motivations and

literary skill without assessing their engagement with print-published texts. My analysis of their poetry thus attends closely to the different ways in which each of these women read, extracted and appropriated material from printed books, as well as to the literary, political and religious priorities revealed by such reworkings of their sources.

Textuality, in all the forms so far outlined, is also inextricable from questions of agency. Another insight of recent research on early modern literature, by men as well as women, is that literary agency in this period is not a singular or uniform category. Recent work on drama, for instance, has disclosed the extent to which an early modern play, rather than being the work of a single autonomous author, often resulted from a collaborative process involving not only multiple playwrights but also members of the wider theatrical company. Agency in the sense of authorship is apt to be especially problematic in manuscript texts, which often dealt in still less absolute forms of literary responsibility than did print-published works. As scholars such as Harold Love and Arthur Marotti have shown, the textually fluid conditions of early modern manuscript composition – and, in particular, the inventive and competitive networks of manuscript transmission which flourished in the early seventeenth century – fostered an approach to textuality which shunned fixity and often showed a casual disregard for the proprietorial claims of the author.[28] Manuscript facilitated mixed-responsibility forms of authorship, such as adaptation, précis, excerption, commentary and paraphrase. The role of scribes, who might alter their copytext, whether under direction or on their own initiative, also complicates questions of authorship in manuscript texts. Still more issues of authorial agency are raised by translation, a form of literary activity often thought to have been especially available to women during the early modern period, and which could involve varying degrees of dependence or independence, fidelity or creativity, on the part of the translator. Tracing the nuances of authorial agency involved in producing these mixed-responsibility forms of writing is a complex but necessary process if texts such as these are to be understood.

But literary agency, of course, does not only mean authorship: not even authorship in the nuanced, attenuated or collaborative forms just described. One corollary of the more diverse models of manuscript and print authorship developed by recent scholarship is that associate figures such as scribes, revisers and editors – often, in the past, either ignored or denounced for interference with the sovereign author's text – are now

[28] Love, *Scribal Publication*; Marotti, *Manuscript*.

more often seen as agents in their own right within the process of textual production. This more diverse understanding of textual agency, however, has challenging implications for the study of women's writing, for the obvious reason that not all of the agents in the textual process are likely to have been women. While some instances of women printers, publishers, scribes or editors facilitating the writing of other women's writing are known, these are noticeably few compared with the many documented instances of men's involvement in preserving and disseminating texts by women.[29] Such involvement might take various forms, from the modest to the momentous, the adulatory to the censorious, the conservative to the creative. In all instances, the intervention of other agents – whether women or men, active or discreet – necessarily complicates the history of a woman's text, helping to shape and determine its subsequent transmission and thus the experience of later readers (including ourselves). The textuality of any early modern woman's writing, in other words, is only very rarely a consequence of the woman's agency alone.

Producing Women's Poetry takes a relatively conventional approach to literary authorship, in the sense that the five women at its centre were all original producers of their own poetic texts. While some also practised mixed-responsibility forms such as translation (Philips, Finch, Monck) or the rewriting of pre-existing texts (Southwell, Bradstreet), all are understandable within the traditional category of the literary author. In each instance, however, other agents – usually men – played an important part in determining how these women's work was selected, organised and (re-) produced for subsequent readership and transmission. In discussing the production of their poetry, therefore, I consider both the creative agency of the women themselves and also the roles of the male agents who variously selected, edited, transcribed and annotated their work for preservation or circulation in print and manuscript. In the case of male scribes, editors and publishers, I consider not only *how* they engaged with these women's poetry, and the effects of this engagement on the poetry itself, but also *why* they did so: that is, what interests and agendas were served by these men's collection and/or transmission of female-authored texts. In evaluating the role of the poets themselves, moreover, I also address the issue of agency at a more basic level: namely, by considering not only what these women

[29] Women who did assist with other women's writing include the printer Anne Maxwell, whose shop was responsible for several of Margaret Cavendish's publications, including her *Blazing World* (1668) and *The Life of William Cavendish* (1667, 1675). A manuscript example of such female co-operation can be found in Folger MS V.a.166, a memoir of Constance, Lady Lucy, written by her daughter-in-law Elizabeth Molesworth and transcribed by the latter's daughter Martha.

wrote but also how they were enabled and empowered to write at all. Agency in the sense of empowerment, as already indicated, was especially problematic for women writers, who faced gender-specific difficulties of self-authorisation, especially in literary genres and in print. In addressing the five women poets at the centre of *Producing Women's Poetry*, I thus consider what factors – familial, educational, social, cultural – helped to make their writing possible. In each of the cases I examine, it is clear that these women enjoyed substantial and often surprising levels of support from fathers, husbands, and other male relatives and friends. Without this support, it is likely that few, if any, of these women would have persisted, still less thrived, as literary writers. Yet enabling factors such as the support of family and friends could be a mixed blessing for women writers, facilitating some kinds of literary endeavours but inhibiting others. Agency in this sense, as in others, is a complex issue, whose effects are neither straightforwardly positive or negative for women writers, and which cannot justly be addressed in isolation from other factors.

A further factor on which agency, in all the senses thus outlined, has an obvious bearing is that of genre. The approval or encouragement of a woman's family might be crucial in enabling her to tackle the more prestigious but less useful literary genres, in inclining her to poetry rather than closet drama or prose romance, or in determining which of the poetic genres were most accessible to her. A woman's practice of biblically rather than classically inspired poetry, for instance, might be more a consequence of familial attitudes and domestic opportunities rather than of her own preferences. Similarly, genre might play a part in the decisions made by scribes and editors in their subsequent collection and transmission of a woman's poetry. Editors of poetic collections might choose to foreground, marginalise or even exclude certain genres to suit their own literary or political agendas, including their own notions of what was proper for women's writing. In issues such as these, genre intersects with and is inextricable from considerations of both agency and textuality; hence, in part, its prominence within *Producing Women's Poetry*.

Genre matters to the project of *Producing Women's Poetry* for other reasons too. One reason why genre is important for the study of early modern women writers is that it offers a means of assessing their gender-inflected relationships with the normative (male-generated) literary canon of their day. There are significant differences, for example, between the cultural meanings produced by female and male sonneteers, or between the use of tropes of retirement by a woman writer, barred by her sex from full engagement in public life, and by a male writer of the same period.

(Comparable differences can be found between the rhetoric used by Aemilia Lanyer and Ben Jonson in their verse epistles to patrons, or between the styles of country house poetry produced by classically educated male poets such as Jonson, Carew and Marvell and by female poets such as Lanyer, Katherine Austin and Marie Burghope.) Reading a woman's poetry for genre also allows us to recognise her willingness and competence to engage in literary forms which may be variously testing, prestigious or hackneyed, innovative, modish or obsolescent. It thus enables us to monitor the extent to which women writers, in their different circumstances, felt equipped to engage with the forms and ideas central to their culture.

Finally, reading for genre offers a means of engaging with women's poetry which is conscious of, but not circumscribed by, considerations of gender. According to circumstance, genre can render gender highly visible, or it can make it disappear. Reading women's poetry for genre allows us to map these points of visibility and invisibility, enabling us to identify both those culturally charged moments where gendered considerations are at their most fraught, and also those other moments where gender, for whatever reason, fades away. It allows us, in other words, to evaluate these writers both as *women* poets and as women *poets*.

Genre, in short, is important to any understanding of women's writing in terms of both materiality and literary hermeneutics. A crucial factor in monitoring issues of textuality and agency, it also offers a framework for evaluating women's writing through attention to more traditionally literary qualities. For all these reasons, reading for genre is key to the remit of *Producing Women's Poetry*.

<div align="center">* * * * *</div>

One figure curiously absent from Virginia Woolf's account of women's literary history in *A Room of One's Own* is the poet Katherine Philips. Philips, unlike some of the other early modern women writers discussed in *Room*, enjoyed a (largely favourable) public reputation in the seventeenth century, and thereafter never altogether faded from the literary-historical view.[30] She was included in the original series of the *Dictionary of National Biography* in 1895, and selections of her poetry were published by John Ramsden Tutin and Louise Guiney in the early twentieth century. Though Woolf undoubtedly knew of Philips's work – she had cited 'the matchless Orinda' alongside Margaret Cavendish and Aphra Behn in a

[30] Philips's reputation in the eighteenth and nineteenth centuries is discussed by Paul Salzman, *Reading Early Modern Women's Writing*, pp. 196–98.

letter published in 1920 – she does not mention her in *Room*.[31] Philips, unlike Margaret Cavendish, did not cultivate a reputation for eccentricity; unlike Dorothy Osborne she wrote in incontrovertibly literary genres; unlike Anne Finch, she wrote little that could be interpreted as angry, bitter, or melancholic.[32] Above all, unlike Aphra Behn, she did not earn her living by her pen. Philips would have been a thoroughly unsuitable inclusion in *A Room of One's Own*, where her voluminous but non-commercial writings would have distracted attention from the pivotal figure of Behn and thus would have compromised the simplicity and power of Woolf's polemic. Her omission from *Room*, though scarcely a surprise, is a clear indication of the historiographical limits and ideological biases of Woolf's feminist narrative.

Philips is, nonetheless, a figure of tremendous importance in women's literary history. Hers were the first literary writings by a woman, in English, to gain widespread respect from both male and female readers. Contemporary admiration for Philips is evinced by the favourable reception of her writings at court, as well as by the posthumous publication of her poems and translations, in folio and with commendatory verse by Orrery, Roscommon, Cowley and other eminent writers. Patronising as some of these male-authored seventeenth-century commendations of Philips may seem to modern readers, there is no reason to doubt that these writers – as well as such diversely prestigious contemporaries as John Dryden, Henry Vaughan, Henry Lawes and Jeremy Taylor – genuinely held her work in high regard, and saw it as at least comparable with male-authored literary works. Philips was also the first English woman writer to be regularly cited, almost always with approval, by other members of her own sex. A poem by a female admirer, Philo-Philippa, was included among the commendatory material to the 1667 *Poems*; originally written in praise of Philips's translation of Corneille's *Pompée*, it hails her as 'Thou glory of our Sex, envy of men', and sees her as an inspirational example for other women writers.[33] Later in the century, women poets such as Jane Barker, Anne Killigrew, Elizabeth Singer and Anne Finch similarly looked to Philips as an important authorising model for their own work. Philips's example showed that it was possible for a woman to be a successful and

[31] Virginia Woolf, *The Diary of Virginia Woolf*, vol. II: 1920–1924, ed. by Anne Olivier Bell and Andrew McNeillie (London: Hogarth Press, 1978), p. 339.
[32] Woolf's emphasis on Finch's anger and bitterness, as Ezell notes, is based on a very narrow selection of her poetry. Her melancholia, though a stronger presence in her writing, still affects a relatively small proportion of her work. See Ezell, *Writing Women's Literary History*, pp. 46–47, 128–29.
[33] Katherine Philips, *Poems* (1667), sig. c2r.

highly regarded writer, even if she lacked the family advantages of a Mary Wroth or a Margaret Cavendish, and notwithstanding the notoriety which attached, for different reasons, both to Cavendish and to Aphra Behn. Indeed, if the testimony of contemporaries – especially women – counts for anything, it is Philips, rather than Behn, who marks the start of a coherent and self-conscious tradition of women's writing in English.

Philips is a central figure within *Producing Women's Poetry*. This centrality is due both to her historic significance within women's writing and to the congruence of her poetry with the issues of textuality, agency and genre at the heart of this book. Philips is textually important as one of the most prolific and well-documented manuscript poets (of either sex) of the seventeenth century. One of her own manuscript collections of her poetry is still extant, as are several other near-contemporary scribal compilations of her verse. There is also a complex story to tell about how her poetry was print-published, as a collection, in 1664 and 1667. This textual complexity, as well as the ample evidence of her reading in English poetry, French drama, theology, and political and religious polemic, clearly situates her writing within and between the rival modes of manuscript and print. But the numerous extant collections of Philips's writings also raise important questions of agency, both on her own part and on others'. Philips's role even in the collections of her writing produced during her own lifetime is still a matter of dispute. Scholars continue to disagree as to whether, as she claimed, the 1664 edition of her poetry was produced without her consent, or to what extent the later, non-autograph manuscripts of her poetry represent her own planned changes to her texts. Generically, as already mentioned, Philips wrote in a wide array of literary forms, and seems to have relished opportunities for poetic experimentation. Her poetry, perhaps more than any in this book, demands to be analysed in terms both of materiality and literary qualities.

My discussion of Philips's poetry (Chapter Three) is preceded by chapters on Anne Southwell and Anne Bradstreet. Southwell, like Philips, worked in a wide array of literary genres, though – unlike Philips – with a marked preference for didactic, biblically inspired verse. Her poetry shows engagement with contemporary debates on literature and religion, and has been linked with the fashion for manuscript miscellanies in the 1620s and 30s. She is thus of interest as both a producer and a consumer of literary texts, as well as providing a fascinating case study of just how freely and confidently an early seventeenth-century woman could engage with that most authoritative and patriarchal of religious texts, the Bible. Textually, Southwell is also of interest – and is unique within *Producing Women's*

Poetry – as an exclusively manuscript-identified poet. There is no evidence that she, or anyone else on her behalf, ever tried to print-publish any of her poetry before the twentieth century. The manuscript production of her poetry was supported, both before and after her death, by her husband and a number of scribes. The two extant manuscripts of her work evince different and informative compositional histories and compilation practices. They thus offer an excellent illustration of what the manuscript mode could offer seventeenth-century women, and of the diverse ways in which one woman, and those around her, could exploit the resources of the form.

The contrasting example of Anne Bradstreet is a useful reminder that, even in the earlier half of the seventeenth century, prior to Katherine Philips, there is no single narrative of women's textual practice or generic preferences. Whereas in the case of Southwell there are two manuscripts and no printed texts, Bradstreet's poetry is extant in a varied, though evidently incomplete, array of material witnesses. Though none of her own autograph collections of her verse is known to have survived, her poetry is attested by two seventeenth-century printed texts and a scribal copy in the hand of her son, Simon.[34] The printed texts also testify to pre-publication circulation of Bradstreet's poetry in manuscript form. Reconstruction of this manuscript circulation is one of the principal concerns of my Bradstreet chapter, which focuses exclusively on the first, more 'English', printed volume of her poetry, *The Tenth Muse*. I address questions raised by the print-publication of the 'Tenth Muse' poetry, including how and why it was printed, and how Bradstreet's poetry was selected and reshaped for this more public medium. I also consider what the poetry tells us about Bradstreet's reading of printed books, especially histories, and how reading her work within generic (in addition to gendered) frameworks may help resolve the difficulties raised by the most challenging and resistant of her poems, 'The Four Monarchies'.

The two remaining single-author chapters in *Producing Women's Poetry* are devoted to Anne Finch and Mary Monck. Finch is the most significant English woman poet of the late seventeenth and early eighteenth centuries. She too, like Bradstreet and Philips, can best be understood as existing – sometimes rather uneasily – between the rival modes of manuscript and print. Her poetry, which includes work in many genres, shows evidence of wide reading in printed literature, and was repeatedly worked and

[34] An autograph manuscript of Bradstreet's prose meditations is extant, and is now held at Harvard (Houghton MS Am 1007.1). This manuscript also includes her own handwritten copy of 'As weary pilgrim' – the only poem by Bradstreet to survive in her own hand.

reworked for use in several different manuscript and print collections. She is exceptional among the poets addressed in *Producing Women's Poetry* in admitting an ambition to see her work in print – though, significantly, this admission was itself confined to manuscript; the 1713 edition of her *Miscellany Poems*, though undoubtedly produced with her approval, is conspicuously reticent about her own involvement in the print-publication process. Though Finch professed anxiety about the censure to which a female poet was liable, her poetic production seems nonetheless to have been remarkably unrestrained and self-directed. In my discussion of her poetry I chart the history of her poetic collections, considering the many factors – familial, political and cultural – which helped to make her poetry possible and to construct her sense of independent agency. I also consider how Finch's strong cultural and political interests were furthered by her generic choices at different stages of her writing life, and evaluate the role of her husband, Heneage, both in enabling and in shaping her extant collections.

In the case of Mary Monck, the final poet addressed at chapter length in *Producing Women's Poetry*, my narrative focus is, by necessity, rather different. The one known collection of Monck's poems and translations, the printed *Marinda*, was published posthumously in 1716, at the instigation of her father, Robert Molesworth. Very little is known of Monck's life and writings outside the *Marinda* volume and there is no reason to suppose that she herself had any role in preparing her work for publication. One of the principal aims of my discussion of *Marinda* is thus to investigate how the volume fits into Robert Molesworth's publishing career, and why it might have been to his advantage to publish his daughter's poems and translations after her death. I analyse the cultural and national politics involved in Molesworth's dedication of *Marinda* to Caroline of Ansbach, and assess how Monck's poems and translations, as selected, organised and edited by her father, helped to promote and complement his own long-standing political priorities. I examine how the *Marinda* volume constructs Monck both as a woman writer and as the central, authoritative figure within a thriving coterie of poets and translators. I also consider how the rather anachronistic poetic interests expressed by the *Marinda* volume can be related to the cultural and political engagements of the wider Molesworth family, as well as how the family's more material interests may have been furthered by the literary genres practised by Monck.

Producing Women's Poetry does not, of course, aim to be an exhaustive survey of English-language verse by women in the period 1600 to 1730. Any reader familiar with seventeenth-century women's poetry will be able

to think at once of other writers whose work might plausibly have been included in the present book. Of these, perhaps the most noteworthy omission is Jane Barker, whose poetry survives in three late seventeenth- and early eighteenth-century collections, one in print and two in manu- script. Barker's compilation practices, however, have been amply discussed by Kathryn King in her *Jane Barker, Exile*, an outstanding scholarly work to which all subsequent research on women's poetry of this period must be indebted.[35] I have nothing to add to King's careful and historically sensitive analysis of Barker's use of manuscript and print at different moments in her writing career. Another omission, Lucy Hutchinson, does not in fact fall within the specific criteria adopted in this book, since all the surviving witnesses to her poetry are of individual texts (in the case of the elegies, a short run of texts). There is no evidence that Hutchinson herself, or any of her contemporaries, attempted to compile a collection of her poetry in different genres; certainly, no such collection seems to have survived to the present day. I do, however, touch on Hutchinson's complex textual practices in my retrospective concluding chapter, which also includes discussion of Aemilia Lanyer, Margaret Cavendish, Aphra Behn and Mary Chudleigh.

I began this introduction by citing the example of Mary Wroth, whose sophisticated and highly self-conscious poetry is such an eloquent counter- argument to *A Room of One's Own*'s dismissive assessment of English women's writing before Aphra Behn. In the *Urania* – though not in her autograph manuscript – Wroth's poetic collection ends with the sonnet 'My Muse now happy lay thy selfe to rest'. Tellingly, the 'happiness' of Wroth's muse, and thus the conclusion of her sequence, results not from the requital of her speaker's 'faithfull love' but from the expression of this love in poetry; she is able to 'leave off' writing only when her verse has sufficiently demonstrated her abilities as a lover.[36] Her reputation secured, Wroth's speaker bids her muse to 'Write ... no more' and to 'Leave the discourse of Venus, and her sonne / To young beginners' (3, 9–10). As an ending to the print-published *Urania*, this is at once a more optimistic and a more self-consciously literary conclusion than is offered in the manu- script collection of Wroth's poetry, where the final lyric, 'I whoe doe feele the highest part of griefe', remains trapped within the familiar sonnet cycle

[35] Kathryn King, *Jane Barker, Exile: A Literary Career, 1675–1725* (Oxford: Clarendon Press, 2000); see also Leigh A. Eicke, 'Jane Barker's Jacobite Writings', in Justice and Tinker, eds., *Women's Writing*, pp. 137–57.
[36] Wroth, *Urania*, sigs. Ffff4r–v (2, 13).

of love and suffering – albeit with a last, teasing, suggestion that the speaker may yet, over time, come to 'care less' for her hard-hearted lover.[37] It is also, however, ironic, since – on the evidence of the manuscript continuation of the *Urania* – Wroth failed to take her own advice. For her, as for surprisingly many women writers of her period, the instruction 'Write … no more' could only be temporarily binding.

Wroth's *Urania*, published to some controversy in 1621, subsequently seems to have passed into near-oblivion. Her work, though cited by Margaret Cavendish, appears to have been little known by later women writers; even Anne Bradstreet, who liked to claim connection with the Sidney family, makes no mention of Mary Wroth. So, while it might be tempting to identify Southwell, Bradstreet, Philips, Finch and Monck with the 'young beginners' to whom Wroth's muse was enjoined to pass on her poetic baton, the connection between Wroth and these five later poets is more analogical than historical.[38] What all these women had in common, however, was a dedication to poetic composition, irrespective of cultural pressures, and whether helped or hindered by friends and family, scribes and editors, publishers and printers. The conditions and processes which made their poetic composition possible, and the kinds of texts that ensued, are my subject in *Producing Women's Poetry*.

[37] Folger MS V.a.104, fol. 65r (34).

[38] Southwell (born 1574) also counts as a 'later' poet than Wroth (born *c.* 1587) on grounds only of textuality, not biography. The Folger manuscript of her poetry was commenced in 1626, five years after the publication of the *Urania*, but includes materials which may have been written several years previously.

CHAPTER I

The resources of manuscript: Anne Southwell, readership and literary property

Until recently, the name of Anne Southwell was comparatively unknown even to specialists in early modern poetry and women's writing. The reason for this scholarly neglect is not difficult to identify: it results primarily from the poet's own choice of medium. Southwell worked exclusively in manuscript, and seems to have had no interest in print-publishing her poetry. Her work reached a wider readership only in 1997, when Jean Klene's diplomatic edition of her two surviving manuscripts was published by the Renaissance English Text Society.[1] Klene's edition – which formed part of the wider recovery of women's manuscript texts in the 1980s and 90s – both contributed to and helped encourage a burgeoning of scholarly interest in Anne Southwell in the late 1990s and early twenty-first century.[2] Thanks to such scholarship, Southwell's status as one of the most intriguing and important female poets of the early seventeenth century now seems assured.

Yet, as critics have also acknowledged, Southwell is a problematic and often contradictory writer.[3] Her forthright vindications of women and her witty gibes at men – especially husbands – coexist in her manuscripts with endorsements of male pre-eminence and female subservience. Her poems advocate the submission of subjects to their monarch and of Christians to a severely Calvinist construction of God. Moreover, the extensive role of her husband, Henry Sibthorpe, in shaping both extant manuscripts of her poetry means that neither can be read as offering straightforward evidence

[1] The two manuscripts are now Folger MS V.b.198 (henceforward 'Folger 198') and British Library Lansdowne MS 740 (henceforward 'Lansdowne 740').

[2] As well as Klene's *Southwell* (Anne Southwell, *The Southwell-Sibthorpe Commonplace Book: Folger MS V.b.198*, ed. by Jean Klene (Tempe, AZ: Medieval and Renaissance Texts and Studies, 1997, henceforward 'Klene'), key 'recovery' publications from the 1980s and 1990s include Josephine Roberts' editions of Mary Wroth's poems and the *Urania*, as well as Sara Jayne Steen's edition of Arbella Stuart's letters (Oxford University Press, 1995).

[3] See, for example, Klene, pp. xxiv–xxviii, and Erica Longfellow, *Women and Religious Writing in Early Modern England* (Cambridge University Press, 2004), p. 92.

for Southwell's own writing or compilation practices. Further textual complications add to the difficulties of accounting for her works within neat critical categories. Not only are both manuscripts unfinished, both are the work of various hands, one – in typical miscellany fashion – includes texts by writers other than Southwell, and neither can be easily dated. Literary scholarship thrives on ambiguity, but the multiple ambiguities of Anne Southwell's manuscripts confront the attentive reader with considerable challenges. Not least among these challenges is that of recognising and grappling with the material complexity of the Southwell manuscripts without allowing such bibliographical concerns to preclude attention to the content of her texts.

My own discussion of Anne Southwell in this chapter begins by assessing the probable facts about her life. As I observed in my introduction, biography can be a risky tool when applied to women's writing, as it can be made either to substitute for or to overdetermine an analysis of the writing itself. Yet establishing what can and cannot be known about Southwell's life is an essential prerequisite for studying her poetry, since her surviving texts are informed and conditioned by her own personal history. Biographical factors can help both to reconstruct the literary and social contexts for Southwell's writing and also to decode the complex textuality of her manuscripts. Furthermore, Southwell's life, like her poetry, is still comparatively obscure, and several of the claims that have been made on her behalf are conjectural and disputed. My discussion reappraises the evidence for these claims and evaluates their significance for the interpretation of Southwell's writings.

Above all, my aim in this chapter is to assess Southwell's significance as a *manuscript* poet. Southwell, like other manuscript-based poets of the early modern period, is a corrective to the anachronistic assumption that a poet who took writing seriously must inevitably aspire to print-publication. The span of her literary career – at least thirty years – and the care she demonstrably took to compile and revise her numerous poems and adaptations clearly identify Southwell as a dedicated, inventive and thoughtful writer. As far as we can tell, both she and Henry Sibthorpe saw manuscript as an appropriate and fully satisfactory means of realising their literary aspirations. This chapter investigates why manuscript was so appropriate for Southwell's – and Sibthorpe's – purposes and how they made use of its varied and distinctive possibilities. For Southwell, as we will see, composition in manuscript created opportunities that print-publication could not feasibly have afforded. The resources it offered were ideal for her circumstances, her ambitions and her needs.

SOUTHWELL'S LIFE

Like many other early modern women, Anne Southwell has left only sparse traces in the historical record. She was born in Devon in 1574, the daughter of Thomas Harris and his wife Elizabeth Pomeroy.[4] Thomas Harris served as serjeant-at-law at the Middle Temple in London, and was also an MP. In 1594 Anne Harris married Thomas Southwell, a Norfolk gentleman, at St Clement Danes church in London. Thomas Southwell was knighted by James I in 1603 and shortly afterwards sent to serve in the Munster plantation in Ireland. Anne appears to have moved to Ireland with her husband, but little is known about their life there. Thomas died in June 1626, and by the end of the same year his widow had married another expatriate Englishman, Henry Sibthorpe, a captain then serving with the English forces in Ireland. Southwell and her new husband returned to England permanently in the late 1620s, settling first in Clerkenwell and moving on to Acton in 1631. Anne Southwell died in October 1636, and was survived by Henry Sibthorpe, as well as by two daughters from her first marriage.

Such are the undisputed facts about Anne Southwell. She was of a good but not especially distinguished family. While her first marriage represented a social step upwards for her, since Thomas Southwell belonged to an eminent family with courtly connections, her second seems to have been perceived as something of a step down.[5] She apparently continued to use her first husband's more prestigious surname even after her marriage to Henry Sibthorpe.[6] In both the Folger and the Lansdowne manuscripts, she is always referred to as 'Anne Southwell', never 'Anne Sibthorpe', even in passages transcribed by Sibthorpe himself. The evidence of the Folger manuscript also suggests that she liked to style herself (and was styled by her second husband) 'Lady Anne Southwell', rather than 'Anne, Lady Southwell', her more correct title. The first page of the manuscript identifies its author as 'the Lady Ann Sothwell', and this is also the title accorded to her in several epitaphs by Sibthorpe at the end of the volume.[7]

[4] Biographical information on Southwell, here and elsewhere in this chapter, follows Klene, supplemented by Marie-Louise Coolahan, *Women, Writing, and Language in Early Modern Ireland* (Oxford University Press, 2010).

[5] Longfellow, *Women and Religious Writing*, p. 100; compare Klene, pp. xiii–xiv.

[6] This would have been accepted practice for a woman who had made a less advantageous second marriage; compare Lois Schwoerer, *Lady Rachel Russell: 'One of the Best of Women'* (Baltimore, MD: Johns Hopkins University Press, 1988), p. xv.

[7] Folger 198, fols. 1r, 73r, 74r, Klene, pp. 1, 113–15. She is also designated as 'Lady Anne Southwell' in the subscription to her letter to Lord Falkland (Folger 198, fol. 4r, Klene, p. 6) as well as in some

In a status-conscious world, Anne Southwell – and her less eminent second spouse – consistently ascribed to her the most impressive designation she could plausibly (if not quite accurately) claim.

Further facts about Anne Southwell's life are more difficult to prove. It has been suggested, for instance, that she may have been the 'Mrs Southwell' who is on record as travelling to Berwick in 1603 to welcome Queen Anne to England, presumably in the hope of gaining a position in the new royal household.[8] Although the ambitious Mrs Southwell's efforts were to be disappointed, she does appear to have had connections at court, and so her ambition to join the queen's household was not altogether unrealistic. There is no conclusive evidence to support the identification of this Mrs Southwell with the poet, though it does seem plausible, in part because of the lack of credible alternatives.[9] If the identification is correct, it places Anne Southwell on the fringes of court society, with enough connections to claim a place in the queen's household, but without enough influence (or enough personal charm) to secure it. Since Thomas Southwell received his knighthood just a few weeks later, it appears that even if his wife was indeed the Mrs Southwell at Berwick, the consequent embarrassment did the couple no immediate political damage.[10] However, the Southwells received no further preferment during the rest of James's reign.

Another claim which has been made on behalf of Anne Southwell is that she is the author of two short prose pieces which were included, with the subscription 'A.S.', in the second edition of *A Wife now The Widdow of Sir Thomas Overbury* (1614).[11] A.S.'s contributions to the *Wife* appear in the concluding section of the volume, entitled 'Newes from Any Whence'. News games, such as those recorded in 'Newes from Any Whence', involved rapid-fire witty exchanges on subjects of topical interest, and were a fashionable activity at the Jacobean court. A.S.'s two short contributions to the volume are both responses: the first answering Overbury's

receipts (Folger 198, fol. 72v, Klene, pp. 112–13), and as 'the Lady A: S:' in the title of her verse epistle to Doctor Adam (Folger 198, fol. 18r, Klene, p. 21).

[8] Klene, pp. xv–xvi, Longfellow, *Women and Religious Writing*, pp. 96–97.

[9] Compare Longfellow, *Women and Religious Writing*, p. 96, n. 16.

[10] The exact date of Mrs Southwell's expulsion from Berwick is not known, but must have occurred in June 1603, while Queen Anne was on her way from Edinburgh to London. Thomas Southwell received his knighthood on 23 July 1603 (Klene, p. xv).

[11] The identification of Anne Southwell with the 'A.S.' of the *Wife* was first made by Louise Schleiner, in *Tudor and Stuart Women Writers* (Bloomington, IN: Indiana University Press, 1994), pp. 107–17. It has since been endorsed by Klene, pp. xxviii–xxxi, Longfellow, *Women and Religious Writing*, pp. 97–98, and (tentatively) Victoria Burke, 'Medium and Meaning in the Manuscripts of Anne, Lady Southwell', in Justice and Tinker, eds., *Women's Writing*, pp. 94–120 (pp. 109–12).

own 'Newes from Court', the second replying to 'Newes from the very Country' by a certain 'I.D.' – possibly John Donne.[12]

This posited identification of 'A.S.' as Anne Southwell is an attractive possibility, since if true it would place her – at the outset of James I's reign – at the fashionable centre of court life, competing on equal terms with the sharpest wits of the age.[13] Recently, however, the credibility of the entire 'Newes from Any Whence' compilation has been questioned by John Considine, who argues that the 'Newes' collection, rather than reproducing genuine coterie documents, is merely an editorial construct, fabricated by the publisher of *A Wife* to enhance the commercial appeal of a second edition.[14] Though Considine's argument – based on print history and manuscript analogues – is speculative and unproven, it is sufficiently plausible that the integrity of the 'Newes' collection cannot be taken for granted. In any case, irrespective of the status of the 'News from Any Whence' *per se*, the case for identifying Anne Southwell as A.S. is weak. The strongest evidence in favour of the identification – the verbal parallels between the two 'Newes' items and passages in the Folger manuscript, cited by Klene – is suggestive but inconclusive.[15] The fact that another participant in the 'Newes from Any Whence' is specified as 'Mistress B' also tends to imply that the untitled 'A.S.' – whether a historical person or an editorial creation – was probably a man.[16] Furthermore, no firm evidence linking Southwell with early Jacobean courtly circles has yet been discovered, despite diligent enquiry, and it is entirely possible that she may have remained in distant Munster throughout this period.

Most critically for our purposes, if Southwell did know and spend time at the Jacobean court, the experience seems to have left remarkably few traces in her own writings. There is little evidence in her manuscripts to suggest that she was in touch with contemporary networks of manuscript transmission, such as flourished in and around the court. Furthermore, although her poetry castigates court vices, it does so in consistently generalised terms, reiterating standard denunciations of the immorality

[12] Sir Thomas Overbury, *A Wife Now the Widdow of Sir Thomas Overbury, second edition* (1614), sigs F4v–G1r and G2v–G3r.

[13] Melanie Faith convincingly attributes the Overbury news games to 'Elizabeth's last and the first few months of James I's reign'. See Faith, 'Correcting the Date of the "conceited *Newes*"', *Notes and Queries*, 53.4 (2006), 505–08 (p. 505).

[14] John Considine, 'The Invention of the Literary Circle of Sir Thomas Overbury', in *Literary Circles and Cultural Communities in Renaissance England*, ed. by Claude J. Summers and Ted-Larry Pebworth (Columbia, MO: University of Missouri Press, 2000), pp. 59–74.

[15] Considine, 'Invention', p. 69.

[16] Compare Burke, 'Medium and Meaning', p. 110.

and corruption of court life rather than disclosing inside knowledge of contemporary abuses or scandals.[17] Southwell's satirical comments on the shortcomings of courtly life are a conventional inclusion within a wide-ranging critique of the manners and mores of her age, and would have required no personal knowledge on her part. The social and intellectual influences on Anne Southwell's poetry owe nothing to the coterie networks of the court in London; their sources are at once less privileged, more idiosyncratic and more diverse.

THE SOUTHWELL MANUSCRIPTS: AGENCY, INTERESTS, COMPILATION

The two surviving manuscripts of Southwell's poetry represent different, though overlapping, textual enterprises. The more substantial of the two, Folger 198, is a miscellaneous compilation of poems and prose texts, both secular and religious. Its contents include love poems, satires, letters, paraphrases of classical texts and meditations on the transience of human life, ending with epitaphs on Southwell by Henry Sibthorpe and the Acton curate, Roger Cox. The most extensive component of the volume consists of poetic paraphrases on seven commandments from the Decalogue.[18]

Both the history and the textual status of Folger 198 are complex.[19] The volume opens with the apparently straightforward heading 'The workes of the Lady Ann Sothwell', and is dated 'December 2 1626'. The obvious implication – that the subsequent contents of the manuscript represent Southwell's own compositions – is in fact only partially correct, as we shall see. Furthermore, despite the emphatic 'Sothwell' in the heading, textual evidence here and elsewhere associates the manuscript closely with Anne Southwell's marriage to Henry Sibthorpe. Receipts transcribed on subsequent leaves, signed by one John Sibthorpe and dating from the 1580s, imply that the manuscript was not new in 1626, but was a long-standing possession of the Sibthorpe family.[20] Since December 1626 is the likely date of the Southwell-Sibthorpe wedding, the volume may have been a

[17] On Southwell's criticisms of court vices, see Burke, 'Medium and Meaning', pp. 108–09.

[18] The omitted commandments are nos 6 ('Thou shalt not kill'), 9 ('Thou shalt not bear false witness against thy neighbour') and 10 ('Thou shalt not covet').

[19] The structure of the Folger manuscript is discussed more fully in Klene, pp. xxxiv–xxxvi, 117–23, Burke, 'Medium and Meaning', pp. 94–96, Longfellow, *Women and Religious Writing*, pp. 102–03, and Jonathan Gibson, 'Synchrony and Process: Editing Manuscript Miscellanies', *Studies in English Literature, 1500–1900*, 52.1 (2012), 85–100.

[20] Folger 198, fols. 5r, 6.

wedding present from Henry Sibthorpe to his wife. However, work on the Southwell compilation, though initiated in 1626, clearly extended well into the 1630s. The inclusion of the epitaphs witnesses to a final transcriptional phase in 1636 or later. Intermediate stages of transcription and compilation are more difficult to date.[21]

Further complications are involved in both the physical construction and the textual composition of Folger 198. Added to the basic folio structure are numerous smaller leaves which have clearly been tipped in at a late stage in the history of the volume. These leaves, which are dispersed across several sections of the manuscript, include Southwell's prose letters to Lady Ridgeway and Lord Falkland and the epitaphs by Sibthorpe and Cox, as well as the Decalogue paraphrases.[22] Textually, the contents of the volume encompass numerous transcriptional states, ranging from fair copies to working drafts, and are the work of multiple hands. Klene's analysis conjecturally identifies seven major scribal hands, including two distinguishable scripts which she attributes to Henry Sibthorpe, as well as an unspecified number of minor contributions by other scribes.[23] In addition, Anne Southwell's own spiky, almost illegible hand occurs on numerous leaves.[24] Southwell's hand is responsible both for drafts in progress and also for numerous corrections – some detailed, some extensive – to the scribal transcriptions. These corrections occur in both the 'original' and the 'tipped-in' portions of the manuscript.

The other extant compilation of Southwell's poetry survives as one section within a composite manuscript, Lansdowne 740. It consists of a dedicatory poem addressed to the king (fol. 142r), followed by paraphrases of the third and fourth commandments (fols. 143r–155r and 156r–167r), here entitled 'Precept 3' and 'Precept 4'. The texts of both poems overlap with, but substantially expand on, the equivalent Decalogue paraphrases in the Folger manuscript, which they probably postdate. The final item in the section is a commendatory poem praising Southwell's virtues and literary accomplishments (fol. 167v). The commendation is unsigned, but is likely to be the work of Henry Sibthorpe.

In Lansdowne 740, as in the Folger manuscript, questions of both textual unity and agency arise. However, although most of the Southwell section of Lansdowne 740 consists of separate leaves, all of its components – the

[21] On the history of additions to the Folger manuscript, see Gibson, 'Synchrony and Process'.
[22] The Decalogue leaves measure *c.* 324 × 206 mm, compared with *c.* 336 mm × 215 mm for the main section of the manuscript.
[23] Klene, pp. 117–23.
[24] See Klene, pp. 166–73, for illustrations of Southwell's hand.

dedicatory poem, the two precepts and the praise poem – can be linked either physically or textually. While the dedicatory leaf is physically separate from the paraphrases, a single stanza from Southwell's first commandment, transcribed on the verso, connects "To the kinges most excellent Majestye' with the Decalogue project. The section also includes one continuous gathering – fols. 151–58 – on which both the end of 'Precept 3' and the start of 'Precept 4' are transcribed, while the last stanzas of the fourth precept are copied on the same leaf as is Sibthorpe's praise poem on Southwell (recto and verso, respectively). Although it is possible that some leaves at the front of the collection may have been lost, the physical connection between the praise poem and 'Precept 4' indicates that the end of the sequence, at least, is textually secure. The leaves can thus safely be read as a single – if not necessarily a complete – poetic compilation.

The Lansdowne copies of Southwell's Decalogue paraphrases are both transcribed in a single hand. The presentation of the poems has clearly been carefully planned: each six-line stanza is numbered and neatly set in from the left margin, with the final couplet indented. Despite such evident care, however, the transcription represents a fair but not a finished copy. The text has been corrected, sometimes quite extensively, both by the scribe himself and by at least one subsequent revising hand. While the principal Lansdowne scribe has not been securely identified, the principal revising hand is likely to be that of Henry Sibthorpe.[25] It is identifiable with one of the scripts attributed to Sibthorpe in Folger 198, and was also responsible for the concluding praise poem in the Lansdowne manuscript. However, in contrast with the Folger manuscript, Lansdowne 740 includes no discernible trace of contributions from Anne Southwell herself. Her distinctively spiky handwriting appears nowhere in the extant document.

The textual complexity of the Southwell manuscripts makes the question of agency especially difficult to assess. There is so much that we do not know about each of these manuscripts. In the case of the Folger manuscript, although Southwell herself was evidently involved to some extent in the drafting and revision of her poems, we do not know how far this involvement extended. We do not know, for instance, whether she was responsible for the order of materials at any point in the extant manuscript. We cannot tell whether the sections which she did not correct were left untouched because she was satisfied with them, or because she did not have time to work on them before she died. While the manuscript includes texts by Southwell which demonstrably date from the 1630s, such as her

[25] Klene, p. xxxiii, Burke, 'Medium and Meaning', p. 103.

epitaphs on Frederick of Bohemia, Gustavus Adolphus and Frances Howard, the terminal date for the poet's personal engagement with the manuscript itself remains uncertain. Nor do we know for sure whether the addition of the Decalogue poems to the original folio structure of the Folger manuscript was at Southwell's own instigation or whether, as recent scholarship has tended to argue, the widowed Henry Sibthorpe was responsible for inserting loose leaves from a separate compositional project into this miscellany collection.[26] Sibthorpe was presumably responsible for the tipping in of his own and Roger Cox's epitaphs on Southwell at the end of the manuscript – an addition which, since Southwell's death date is specified in all three commemorative texts, must have occurred after she died. Though it cannot be proved, it would be consistent to suppose that Sibthorpe's posthumous labours on the manuscript also included the insertion of the Decalogue poems. On this reading, Sibthorpe's completion and reconfiguration of the Folger manuscript was undertaken as a posthumous act of devotion to his late wife, his collection of her poetry at once complementing and illustrating the celebration of her virtues in his own and Cox's epitaphs.

In the case of Lansdowne 740, the key issue of agency to be addressed is the complete absence of Anne Southwell's own hand from the extant manuscript. Despite this absence, there seems no reason to doubt that the extensive reworking and rewriting of these two Decalogue paraphrases for transcription in Lansdowne was Southwell's own work. As we shall see, the additional material in the Lansdowne paraphrases includes much that relates closely to Southwell's own circumstances, experience and theological interests, and for which she is by far the most likely author. However, it is open to question whether the manuscript itself was prepared before or after the poet's death, and thus whether she saw and approved of Henry Sibthorpe's revisions to her text. One possible indication that the manuscript was compiled during Southwell's lifetime is Sibthorpe's praise poem, which refers to Southwell and her writings in the present tense.[27] However, the textual location of the poem, contiguous with the end of 'Precept 4', tends to suggest that transcription into the manuscript did not occur until after Southwell's death. Sibthorpe would scarcely have inserted a commendation of the author after the fourth Decalogue poem if plans to append a further six were still active. It seems likely, therefore, that at least

[26] Burke, 'Medium and Meaning', pp. 112–13, Longfellow, *Women and Religious Writing*, pp. 102–04.
[27] 'Ther's nothing art or nature doth descrye / but shee can draw it through her needles eye' (Lansdowne 740, fol. 167v, Klene, pp. 163, 13–14).

this final stage of work on the manuscript was carried out after Southwell's death, when there was no longer any possibility of her completing revised versions of the remaining commandments. Moreover, even if we suppose that the two extant precepts were transcribed during Southwell's lifetime, this need not mean that she was still alive to witness Sibthorpe's revisions, which may have been added later.

Both the Folger and the Lansdowne manuscripts raise key issues of textuality, agency and genre. In the next section I discuss Southwell's relationship with contemporary print and manuscript culture, as evinced by her treatment of literary materials in the Folger manuscript. Subsequently, I consider the most substantial and audacious of her original literary projects: her free interpretation of the Ten Commandments and the dedication of the Lansdowne manuscript to the king.

FOLGER 198 AND TEXTUAL TRANSMISSION

Southwell's attitude to textuality in the Folger manuscript is proprietorial and assertive. Something of this approach can be glimpsed in the first two leaves of the manuscript, which form a bibliographical unit prior to the first tipped-in addition (see Figure 1).[28] After the heading and date ('The workes of the Lady Ann Sothwell) / December 2 1626'), fol. 1r comprises five short 'sonnetts' (the term here designating short lyric poems rather than fourteen-line poems), the last slightly squeezed in order to fit it on to the opening recto. Fol. 2r consists of a single nine-stanza poem, 'Goe sole the bodies guest' – again, slightly squeezed to fit on to one side of the leaf. The versos of both folios are blank.

As an opening to the manuscript, fol. 1r shows evidence of careful planning. Collectively, the first four sonnets perform an act of withdrawal from earthly contagion and corruption. Sonnet 1 begins with the injunction 'Fly from the world, o fly, thow poore distrest' (1). Its description of the world as the 'betrayer of the mynd' (5) is followed in sonnet 2 by the claim that the 'World first made me rue' (7) and in sonnet 3 by the gloss 'fond World, the onely Schoole of Error' (1). The speaker of sonnet 3 then bids her soul to 'Mount ... unto that Sacred mirror, / That showes menn are but fynite Sommer flyes' (3–4), a sentiment reworked in sonnet 4, where the soul is urged to 'Carry thy selfe upp to that azur'd Sky ... Where Joy and requiem the holy Angles singes' (3, 5). Thus removed from earthly frailties, sonnet 5 then turns to the issue of poetry, addressing the premises

[28] Klene, pp. 1–4.

1. Folger MS V.b.198, fol. 1r. Southwell's 'workes' heading and introductory 'sonnetts'. Reproduced by permission of the Folger Shakespeare Library.

and conditions for Southwell's own writing. Southwell's speaker scorns the option of becoming a 'nedy Debter' to the Muses, distinguishing herself from mere 'Scriveners' who seek (and, by implication, are contented with) earthly fame (2, 5). Before even the first leaf of the manuscript has been turned, these five sonnets have defined the poetic identity claimed by 'the lady Ann Sothwell': pious, moralistic and austerely opposed to the vanities of the world. The contempt for worldly fame stressed in sonnet 5 may also offer an early explanation for this poet's preference for manuscript over print-publication. A writer who really scorned the world to this degree could have no valid interest in bringing her work to its attention.

Ironically, however, Southwell's claims to independence from the world are asserted in part through materials derived from other writers. Of the five sonnets transcribed on fol. 1, three – numbers 1, 2 and 4 – are variant copies of lyrics from contemporary printed songbooks.[29] In each case the sonnet has been excerpted from a longer text, and none is attributed in the manuscript. No sources have been discovered for sonnets 3 and 5, which were probably composed by Southwell herself to complement the three excerpted lyrics. The sequence of texts on fol. 1r thus combines both original and derived material to create a self-authorising narrative for 'the Lady Ann Sothwell'. Once copied into her manuscript, the songbook material is silently absorbed into her own poetic 'workes'.

The possessive absorption of printed material on fol. 1r is consistent with Southwell's practice elsewhere in the Folger manuscript; similarly unacknowledged appropriations include a transcription of Henry King's 'Elegy upon Gustavus Adolphus', drawn from *The Swedish Intelligencer* (1633).[30] A comparable though still more assertive form of textual appropriation can be seen in the poem transcribed on fol. 2r, 'Goe sole the bodies guest' (see Figure 2). 'Goe sole' is a variant copy of one of the most popular poems of the early seventeenth century, Sir Walter Raleigh's 'The Lie'. First printed in 1611, 'The Lie' was also a popular inclusion in manuscript miscellanies – so popular that manuscript rather than print is by far the more likely source for Southwell's text. The poem's currency may be explained in part by its tone of world-weary cynicism, in part by the inherent adaptability of its central conceit.[31] This conceit is initiated in

[29] See Klene, p. 187. Klene also suggests possible manuscript sources for sonnet 1, but these seem less likely than that all three were adapted from printed texts.

[30] Folger 198, fol. 24, Klene, pp. 36–39.

[31] Raleigh's own notoriety, though undoubtedly influential in the poem's popularity, was probably less of a factor than one might expect, since so many copies are unattributed.

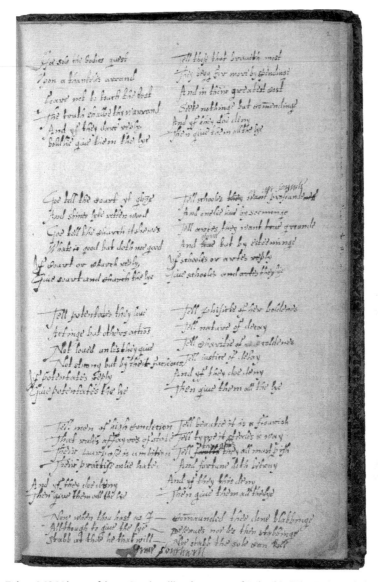

2. Folger MS V.b.198, fol. 2r. Southwell's adaptation of Raleigh's 'The Lie'. Scribal copy subscribed with Southwell's signature. Reproduced by permission of the Folger Shakespeare Library.

stanza 1, where the unnamed speaker sends the soul out into the world
with a confrontational message:

> Goe sole the bodies guest
> Upon a thankeles arrand
> Feare not to touch the best
> The truth shalbe thy warrand
> And yf they dare reply
> boldlie give them the lye
> 'Goe sole', 1–6[32]

Subsequent stanzas expand on this basic premise, instructing the soul to
approach institutions, people and even moral qualities, exposing their
hypocrisy and rejecting their claims to true virtue. Court and church are
the first to be denounced, followed by potentates, men of high condition,
beauty, time, fortune and many other targets; the exact list varies from
copy to copy as different compilers insert their own favourite abuses and
omit others. The poem concludes with the exultant assurance that even
though giving 'the lye' may provoke violence – by implication, a duel – no
mere physical 'stabbinge' can threaten the immortal soul:

> Allthough to give the lye – Deserves noe les then stabbinge
> Stabb at thee he that will – Noe stabb the sole can kill
> 'Goe sole', 50–51[33]

Reading Southwell's copy of 'Goe sole' for textual variants is difficult, since
we do not know which version (or versions) of the poem the poet had
herself received. As far as we can tell, Southwell's treatment of the text,
though incorporating a few unique lines and phrases, is largely typical of
most contemporary compilations, remaining close to the 'core' version at
the beginning and end of the poem, while varying her satirical targets
in the middle stanzas. However, comparison between Southwell's copy
and the core text of 'The Lie' reveals one key difference between them. As
Jonathan Gibson points out, Southwell's version of 'Goe sole' is almost
unique among contemporary copies in representing the text not as a legacy
but as an answer poem.[34] The concluding couplet in Southwell's first
stanza – 'And yf they dare reply / boldlie give them the lye' – constructs
the remaining verses as the third step in a textual exchange initiated by the

[32] Folger 198, fol. 2r, Klene, p. 2; compare *The Poems of Sir Walter Ralegh: A Historical Edition*, ed. by
Michael Rudick (Tempe, AZ: Medieval and Renaissance Text and Studies, 1999), p. 30.

[33] Folger 198, fol. 2r, Klene, p. 4. The line doubling – which occurs only in this stanza – sets off stanza
9 as the conclusion to the poem, and also allows the whole poem to be fitted onto a single page.

[34] Jonathan Gibson, personal communication.

soul itself and perpetuated by its interlocutors' mistaken readiness to reply in their own defence. While Southwell's version of this couplet is shared by only one other known manuscript of the poem, all other copies end stanza 1 with the rather different injunction 'go synce I needs must Dye / and gyve the world the lye', which makes the soul's lie-giving 'arrand' contingent on the speaker's imminent death. Southwell's apparent rejection of death as an authorising premise for her poem is all the more striking since constructing a text as a legacy was a common strategy for female authors in the early seventeenth century.[35] Her own version of the stanza, rather than basing her right to speak on her own demise, depicts the poem as a conversation, which she herself initiates and dominates and in which she awards herself the triumphant last word. Far from ascribing the poem to Raleigh, Southwell explicitly claims it as her own, adding her own distinctive signature at the end of the scribal copy.

Southwell's proprietorial attitude towards received literary material is, of course, far from unusual in her period. Folger 198, produced between 1626 and the late 1630s, is exactly contemporary with the fashion for manuscript compilation and transmission studied by Peter Beal, Mary Hobbs and Arthur Marotti, and its casual approach to literary property has much in common with this so-called 'manuscript system'.[36] Nonetheless, caution must be exercised in relating Folger 198 to contemporary manuscript miscellanies and transmissional networks. Reception of manuscript material, in fact, accounts for relatively few of the texts included in Folger 198. Raleigh's 'Goe sole' is one of only four poems in the manuscript which were probably – in the other three instances, necessarily – derived from unpublished sources. Of the remaining three, the first, 'To thee my soule I rayse', a paraphrase of Psalm 25, is endorsed 'Writen by the ladie Anne daughter to the first Earle of Castle haven'.[37] Another 'sonnet', 'Like to a lampe wherein the light is dead', is an unacknowledged adaptation of a poem by Arthur Gorges.[38] A third poem, here entitled 'An Elegie Writen by Mr Barnard brother to Mrs. Jernegan that dyed at Acton', is a mis-attributed copy of Henry King's elegy on his wife, Anne, known elsewhere as 'The Exequy'.[39] King's elegy, though popular in manuscript, did not

[35] On the use of the 'legacy' strategy by female authors, see Wall, 'Isabella Whitney' and *Imprint*.

[36] Beal, 'Notions in Garrison'; Hobbs, *Early Seventeenth-Century Verse Miscellany Manuscripts*; Marotti, *Manuscript*. The 'manuscript system', though oversimplifying a complex array of contemporary practices, is a useful shorthand.

[37] Folger 198, fol. 7r, Klene, p. 9. The top of fol. 7 has been damaged; 'Anne' and 'daughter' are my own conjectural readings of partially deleted words.

[38] Folger 198, fol. 9v, Klene, pp. 14–15. [39] Folger 198, fol. 21v, Klene, pp. 28–31.

reach print until 1657; Gorges' 'Like to a lampe' remained unpublished until the twentieth century. 'To thee my soule I rayse' is otherwise unknown.

If we compare Folger 198 with the 'typical' literary miscellany of the 1620s and 30s, as described by Beal, Hobbs and Marotti, the differences are striking. Apart from 'Goe sole' and 'An Elegie', Folger 198 includes none of the poems most popular in the manuscript system of the time.[40] Not unexpectedly, it shows no evidence of links with the thriving manuscript communities based in the universities or the Inns of Court – both exclusively male domains. Perhaps more instructively, it also lacks evidence of access to privileged networks associated with the court; if Southwell did spend time at the Stuart court in the early seventeenth century, it has left no obvious trace in her miscellany. The two poems included in the manuscript which do have court origins, 'Goe sole' and 'Like to a lampe', were both by the 1620s relatively old texts, which had had time to circulate widely before reaching Southwell. Comparably, Folger 198 includes nothing by such popular manuscript authors as Donne, Jonson, Carew, Wotton, Strode or Corbett, while the one example of contemporary elite poetry which it does record – King's elegy, composed in 1624 – seems to have reached Southwell via one of her neighbours in Acton (Mr Barnard, or a mutual acquaintance). Neighbourly connections probably also account for the fourth manuscript-sourced poem in the Folger manuscript, 'To thee my soule I rayse', since its likely author, Lady Anne Touchet, would have been contemporary with Southwell within the expatriate English community in Munster. It seems unlikely to be a coincidence that the Barnard and Touchet texts are the only poems in Folger 198 to be attributed to a contemporary author other than Southwell. While printed literature – and less intimately sourced manuscript texts – could be appropriated without scruple or acknowledgement, her neighbours' manuscript poems commanded more respect.

By contrast with her limited reception of manuscript texts, there is ample evidence in Folger 198 of Southwell's reading of – and inventive responses to – printed books. The Folger manuscript, as we have seen, begins with extracts from printed songbooks, which she clearly knew well. A prose letter to Cecily Ridgeway, Countess of Londonderry, in defence of poetry leans heavily (though, as usual, without acknowledgement) on Philip Sidney's *Apology*: Southwell argues, for instance, that poetry 'doth but lay downe a patterne what man should bee' and that notorious

[40] Marotti, *Manuscript*, pp. 126–33.

examples of immoral poems such as *Venus and Adonis* and *Hero and Leander* prove only that poetry has been abused, not that poetry is itself immoral – both Sidneian claims.[41] Two of her poems – 'A Paraphrase uppon Lucius Anneus Seneca on his booke of Providence' and 'An abstract of The lives of the Romaine Empourers ... by Plinie Plutarch; and Suetonius' – draw explicitly on classical sources, which she had probably read in translation.[42] Another poem, entitled 'Written in commendations of Mr Coxe (the Lecturer of Acton) his booke of the birth of Christ', alludes to her local curate's *Hebdomada Sacra*, published in 1630.[43] In her mock-elegy on Cecily Ridgeway, her curiosity as to what Ridgeway's soul may have seen on its ascent into heaven recalls the similar journey of Elizabeth Drury in *The Second Anniversary*, one of the very few of Donne's poems to be published during his lifetime.[44] Prose sections towards the end of the manuscript include extracts from St Augustine's *City of God* and Edward Topsell's *History of Four-Footed Beasts* (1607), as well as apothegms (maxims) derived from published authors such as Henry King.[45] Most influential of all, unsurprisingly, is the Bible: acknowledged inspiration for her Decalogue poems, key source for the apothegms, and a pervasive influence on the contents and compilation of the Folger miscellany.[46]

Recent accounts have portrayed Folger 198 as an instance of scribal publication, whether instigated by Anne Southwell herself, by Henry Sibthorpe after her death, or by both partners in collaboration.[47] On this

[41] Folger 198, fol. 3r–v, Klene, pp. 4–5; and compare Jean Carmel Cavanaugh, 'Lady Southwell's Defense of Poetry', *English Literary Renaissance*, 14.3 (1984), n.p.n. Southwell's use of the unusual word 'turpified' in 'Precept 4', stanza 47.3 (Lansdowne 740, fol. 161r, Klene, p. 151) further suggests she may also have been reading Sidney's *The Lady of May* – the one pre-1620s usage of the term cited by the *Oxford English Dictionary*, www.oed.com (henceforward *OED*).

[42] Folger 198, fols. 8r–v and 30v, Klene, pp. 11–12 and 48. Compare the Southwell-Sibthorpe library catalogue in Folger 198, which includes classical texts such as 'Plinies Naturall History', 'Salust his history', 'Suetonius, of the 12 Caesars' and 'Seneca, his ten Tragedies' (fols. 65r, 66r, Klene, pp. 99–100).

[43] Folger 198, fol. 21r, Klene, p. 28.

[44] Folger 198, fols. 19v–20v, Klene, pp. 24–27 (e.g. 19–20). The catalogue in Folger 198 lists Donne's 1633 *Poems* (Folger 198, fol. 65r, Klene, p. 99; compare Jean Carmel Cavanaugh, 'The Library of Lady Southwell and Captain Sibthorpe', *Studies in Bibliography*, 20 (1967), 243–54, p. 249); however, internal evidence dates the mock-elegy on Ridgeway to shortly before the Countess's death in 1628.

[45] Folger 198, fols. 67r, 68r–69r, Klene, pp. 102–05.

[46] On Southwell's readership of printed books, see also Kathryn DeZur, '"Vaine Books" and Early Modern Women Readers', in *Reading and Literacy in the Middle Ages and Renaissance*, ed. by Ian Moulton (Turnhout, Belgium: Brepols, 2004), pp. 105–25.

[47] E.g. Burke, 'Medium and Meaning', pp. 94, 112 (favouring Sibthorpe), and Longfellow, *Women and Religious Writing*, p. 102 (positing Southwell in collaboration with Sibthorpe). On scribal publication see Love, *Scribal Publication*.

reading, the compilation of the manuscript represents a (perhaps preliminary) move towards using Southwell's writing as a means of 'aiming for some financial or political gain', presumably through presentation to an influential patron.[48] Yet the notion of scribal publication is applicable to Folger 198 only with important restrictions and caveats. There is no reason to doubt that individual texts addressed by Southwell to named acquaintances such as Lord Falkland, Francis Quarles, the Duchess of Lennox, Bernard Adams and Roger Cox were indeed passed on to their intended recipients. But although it is possible to read this transmission of individual texts as 'scribal publication', there is (currently) no evidence that this 'publication' generated any further textual activity. There is no indication either that the texts presented to Falkland, Quarles, Lennox, Adams and Cox achieved any further circulation in manuscript, or that any of Southwell's addressees replied to her literary overtures.[49] Francis Quarles, whose poetic career in the 1620s and 30s is both prolific and well documented, is not known to have made any response to the acrostic Southwell addressed to him. Similarly, despite her commendatory poem on his *Hebdomada Sacra*, Roger Cox's epitaph on Southwell makes no reference to her poetry, while emphasising that her memory will 'give the world perpetuall light'.[50] As for Folger 198 as a whole – messy, inconsistent, sometimes illegible – there is no reason to believe that it was read by anyone at all other than Southwell herself (not necessarily in its current form), her husband and their scribes. And while it is possible that either Sibthorpe alone or Southwell and Sibthorpe, working together, might have prepared a later recension of the Folger poems for presentation to a patron, on current evidence this can be no more than speculation.[51] Had they done so, moreover, it would have been against the existing trends of a collection in which, in its present state, the direction of textual travel is predominantly inwards.

[48] Longfellow, *Women and Religious Writing*, p. 102. Compare Burke's suggestion that Folger 198, in its current state, may be 'an intermediate stage in Sibthorpe's attempts to scribally publish his wife's works' (Burke, 'Medium and Meaning', p. 112).

[49] Coolahan has argued that the Folger miscellany testifies to efforts on Southwell's part to 'establish a network of devotional poets', first in Munster, then in Acton (Coolahan, *Women, Writing, and Language*, p. 185). My own view is that Southwell's appeals to addressees such as Adams and Quarles are merely complimentary pleasantries, while her letter to Cecily Ridgeway constructs the countess as a reader, rather than a writer, of devotional poetry.

[50] Folger 198, fol. 73r, Klene, p. 113.

[51] Burke notes that a further Southwell manuscript, now lost, is recorded in a sale catalogue of 1834 (Burke, 'Medium and Meaning', p. 97). However, the title of this manuscript – 'Lectures on the Commandments and Moral Ethics' – suggests a collection much closer to the Decalogue project of Lansdowne 740 than to the miscellaneity of Folger 198.

The Southwell of the Folger manuscript is more interested in possessing texts for herself than in passing them on to others.[52]

The idea that Folger 198 represents scribal publication on the part of either Southwell or Sibthorpe seems all the more unlikely because so much of the manuscript deals in material either intractably unpopular or of strictly limited interest and appeal. It is hard, for instance, to see how much advantage could have accrued to Southwell or Sibthorpe through the dissemination of either her sympathetic letter to the disgraced Lord Falkland, whose fortunes never recovered after his dismissal as Lord Deputy of Ireland in 1629, or her surprisingly favourable epitaph on Frances Howard, Countess of Somerset, about whom no one else seems to have had anything good to say after her conviction for murder in 1616.[53] Other people claimed in the manuscript as friends and acquaintances – the Countess of Londonderry, the Bishop of Limerick – were marginal figures even at the height of their power and influence, and both the Countess and the Bishop were dead by the late 1620s. Little benefit could reasonably have been expected by Southwell or Sibthorpe from advertising her connections with such figures, or indeed with the living but little-known curate, Roger Cox. The militant Protestantism of the epitaphs on Frederick of Bohemia and Gustavus Adolphus was largely out of fashion amid the Arminian ascendancy of the 1630s. In short, there is no obvious reason why Southwell or Sibthorpe would have wanted to 'publish' any of this material, even in the restricted sense of scribal publication; and the chances of such publication resulting in either financial reward or political advantage seem slim.

Folger 198 presents a complex picture of Southwell's literary connections. Her links with the contemporary manuscript system are few and attenuated. The people whom she celebrates in her manuscript are not the leading nobles and churchmen of her time but rather the heroes of international Protestantism (Gustavus Adolphus, Frederick of Bohemia) and a rather motley array of minor figures whom she seems to have known personally: Ireland-based dignitaries such as Lord Falkland, Cecily Ridgeway and Lady Anne Touchet, and Acton contacts such as

[52] See also Andrea Brady, '"Without welt, gard, or embroidery": A Funeral Elegy for Cicely Ridgeway, Countess of Londonderry (1628)', *Huntington Library Quarterly*, 72.3 (2009), 373–95. The anonymous elegy discussed by Brady shows no knowledge of Southwell's literary correspondence with the Countess.

[53] Similar indifference to contemporary opinion is implied by her retention of a poem attributed to the 'daughter to the first Earle of Castle haven', even after the second earl's conviction for rape and sodomy in 1631.

'Mr Barnard' and Roger Cox. Her otherwise surprising praise of Frances Howard can probably be explained by acquaintance between the two women towards the end of Howard's life.[54] Local connections, whether in Munster or Acton, seem to have been productive influences on Southwell's writing. Meanwhile, her poetic endeavours were supported morally and practically by a scribal community within her own household, and received their chief intellectual stimuli from her readership of printed books – most influentially, the Bible.

In all of this, as I have argued, the direction of textual travel is typically inwards. Southwell draws in material from different sources and puts it to use in her manuscript writings, but seems to give back little in return. Such, at least, is the case with the miscellaneous texts collected in the Folger manuscript. The Lansdowne manuscript, however, is a rather different quantity: aimed at no less a reader than the king himself.

LANSDOWNE 740: WRITING FOR THE KING?

The dedication of Southwell's Decalogue poems in Lansdowne 740 to the king immediately puts this manuscript into a much more public category than Folger 198. Yet Southwell's royal dedication is distinctly problematic. Even such a basic issue as the identity of Southwell's dedicatee is uncertain and contested. Klene makes the case for Charles I, on the grounds that the Lansdowne version of the fourth commandment omits several lines in the Folger copy which refer clearly to his father, James.[55] Longfellow, while agreeing that the manuscript was '[u]ltimately ... most likely intended for Charles', argues that both dedication and meditations may have been originally prepared for presentation to James; following Elizabeth Clarke, she cites the 'rose and thistle' imagery of 'Precept 4,' stanza 74, which seems to allude to James's Scottish origins.[56] Stevenson and Davidson, ostensibly non-committal, imply a marginal preference for James, linking the dedication's allusion

[54] Sarah Ross, 'Women and Religious Verse in English Manuscript Culture, c. 1600–1668' (unpublished doctoral thesis, University of Oxford, 2000), p. 47.

[55] Jean Klene, '"Monument of an Endless affection": Folger MS V.b.198 and Lady Anne Southwell', *English Manuscript Studies 1100–1700*, 9 (2000), 165–86 (pp. 170–71); compare Burke, 'Medium and Meaning', pp. 104, 106.

[56] Longfellow, *Women and Religious Writing*, p. 105, n. 48; Elizabeth Clarke, 'Anne Southwell and the Pamphlet Debate: The Politics of Gender, Class, and Manuscript', in *Debating Gender in Early Modern England, 1500–1700*, ed. by Cristina Malcolmson and Mihoko Suzuki (Basingstoke: Palgrave, 2002), pp. 37–53 (p. 44); Lansdowne 740, fol. 163v, Klene, p. 156.

to the king as 'the nursing father of all pietye' (21) with royal imagery the earlier monarch is known to have favoured.[57]

If nothing else, what this disagreement shows is that there is little definitive evidence either way. 'Brittanes mighty kinge' – Southwell's term for the monarch in her dedicatory poem (2) – sounds more like James, who liked to stress his special status as king of Britain, but logically could also be his heir Charles. It is easier to imagine Charles, rather than James, being credited with a 'blest birth' (5); however, Southwell is surely more likely to have seen the Calvinist James, rather than the Arminian Charles, as 'the mightye champion for the Deitye' (22).[58] Rather than being directed specifically at either James or Charles, the poem reads instead like a potentially transferable address to whoever happens to hold the position of 'Brittanes mighty kinge'. What matters most is not the personal qualities of any particular monarch, but the role which Southwell attributes to her idealised addressee. This portrays the king as God's 'true Epitome' who has 'no pride' (20) and can therefore be trusted to forgive his subject's temerity in approaching him. In a deft conflation, she declares that her addressee has no rival anywhere in the world for 'the vertues of [his] minde' (10), thus neatly combining praise both of his moral qualities and his intellect. Whoever the king is, this is what a king should be.

Another important factor in Southwell's dedicatory poem is her self-construction as a speaker. As might be expected, she uses the modesty topos, wondering at her own audacity in presenting her poetry to the king (1–2), and depicting herself as approaching her 'dread Soveraigne ... on the knees of hope' (16). But this is an ungendered modesty, which does not noticeably inhibit the speaker from assessing either the monarch's personal qualities or his role as God's 'Epitome'. Similarly, though she alludes to her poems as 'poore endeavors' (26), she makes no attempt to justify her own right to paraphrase the word of God. Indeed, when she describes herself as 'your majestyes most humble and faythfull subject', the implication is not only that she is loyal to the king, but also that she holds to – and can speak for – the true faith. The inclusion of her name at the end of the leaf apparently does nothing to undermine the spiritual authority consistently assumed in the dedication.

[57] Jane Stevenson and Peter Davidson, eds., *Early Modern Women Poets, 1520–1700* (Oxford University Press, 2001), pp. 119–20.
[58] My lineation. Klene's slightly different lineation includes several lines cancelled in MS.

As described above, the Lansdowne manuscript of Southwell's poems is a fair but not a finished copy, which appears to have been completed – probably by Henry Sibthorpe – after Southwell's death. Why – or indeed whether – Southwell chose to prioritise the third and fourth commandments rather than beginning with the first is a matter for conjecture. Since the beginning of the Lansdowne manuscript is textually insecure, it is possible that the original compilation did include copies of the first and second commandments, which have since been lost. However, the stray stanza from the first commandment transcribed on the verso of the dedication leaf in Lansdowne shows few differences from the equivalent passage in the Folger manuscript, thus suggesting that revision of this poem was still at an early stage when the dedicatory poem was transcribed. With all ten commandments potentially within her remit, Southwell apparently chose to prioritise respect for God's name and for the Sabbath day.

Southwell's dedicatory poem – which refers to the Decalogue paraphrases only in the broadest of terms – provides no explanation for her privileging of the third and fourth commandments. However, there may be a clue in the opening stanza of 'Precept 3', where the speaker identifies failure to honour God's name as a particularly serious form of corruption – all the more widespread and insidious because it is not subject to secular penalties:

> Heere is our hartes corruption most exprest
> and spreds it self more then in any other
> those faultes that are by temporall lawes deprest
> even for afliction sake wee seeke to smother.
> but to blaspheme or take gods name in vayne,
> is held a sport, because tis freed from payne.
> 'Precept 3', stanza 1[59]

Similarly, Southwell's introduction to 'Precept 4' is careful to explain why Sabbath-breaking, apparently so harmless, is such a shameful offence:

> In this day rest from all thy worldly paynes
> take out the harrow from the plowmans handes
> refresh his faynting limmes and tired braynes
> and from thy oxen take theyr yoaked bandes
> tis six to one, then having soe much oddes,
> twere badly done to steale that day that's gods.
> 'Precept 4', stanza 4[60]

[59] Lansdowne 740, fol. 143r, Klene, p. 125. [60] Lansdowne 740, fol. 156v, Klene, p. 144.

Southwell seems to have been particularly exercised by – and keen to explicate – those sins whose inherent wickedness or harmful consequences were least apparent. In the Folger manuscript, which includes equivalent explanations in its versions of commandments 3 and 4, no such justification is thought necessary in the case of the remaining five (on respect for God, idolatry, respect for one's parents, adultery and theft). Such concerns with swearing and sabbatarianism, typical of puritan preoccupations in any period, would have been especially topical during the 1620s and 30s. Puritans were outraged by King James's Declaration of Sports (1618), which approved the practice of traditional sports and recreations on Sundays, and still more by its republication in 1633, at the behest of Charles I and Archbishop Laud. The prioritising of these sins in a manuscript addressed to the king can surely not have been coincidental.

The passages just quoted from the early stanzas of precepts 3 and 4 are relatively little altered from the equivalent versions in the Folger manuscript. Southwell seems to have been more or less satisfied with the openings to her versions of commandments 3 and 4: in each case the Lansdowne manuscript follows Folger (albeit with a few alterations) for the first few stanzas.[61] Thereafter, however, the two versions diverge substantially, though 'Precept 3' and the Folger third commandment reconverge at the very end, when both conclude with Southwell's characteristic 'Jehovah's school' refrain.[62] Broadly speaking, as Southwell revised and expanded her versions of each commandment, she allowed herself greater and greater licence to depart from the letter of the biblical text. On her own admission, she saw her task in teasing out the implications of her source text as potentially endless:

> I have confined my penne to, to few lines
> they cannott limitt out this precepts boundes,
> in these exorbitant and wicked times
> 'Precept 3', stanza 6.1–3[63]

Southwell's assumption of spiritual authority in stanzas such as this is consistent with the attitude expressed in her dedicatory poem. If her

[61] Compare Klene, pp. 125 and 57, 143–44 and 60–61. (The biggest single change is the addition of an extra stanza (2) in 'Precept 3'.) By contrast, the stray stanza from commandment 1 preserved in the Lansdowne manuscript derives from a slightly later stage of the poem (stanza 9), when – by analogy with Southwell's treatment of commandments 3 and 4 – divergence between the original and the revised versions should have been expected.

[62] Thus 'Precept 3': 'Then goe and learne in great Jehovaes schoole / who takes gods name in vayne is but a foole', stanza 101.5–6 (Lansdowne 740, fol. 155r, Klene, p. 143; compare Folger 198, fol. 37r (119–20), Klene, p. 60).

[63] Lansdowne 740, fol. 143v, Klene, p. 126.

paraphrase of the third commandment fails to 'limitt out this precepts boundes', it is not because of her own lack of spiritual insight, but rather because of the vast extent of human sinfulness. As in the dedicatory poem, she recognises no disqualification on grounds of her sex. When she appeals a few stanzas later for poetic inspiration ('Precept 3', stanza 16), she does so not because of any gender-based weakness, but because, like all humans, she is afflicted by 'this stupid lethargie of sense' (stanza 16.2).[64] A later passage attributes her writerly confidence both to her extensive reading, through which she has equipped herself with knowledge of the world, and to the support of God himself:

> For I by booke have travelld all the world
> to find out the religions of all landes
> ech where I see how ignorance hath hurld
> her foggye mantle uppon all theyr strandes
> I will not dare to judge theyr misteryes
> yett I will ever fly theyr villanyes.

> My witt and Judgment is as poore and light
> my lines are on the oceans brow a buble
> yett the poore widdowe did present her mite
> hee helpes the building that doth bring but stuble
> God filles ech soule and polisheth all braynes
> Then none but atheists will flout my paynes
> 'Precept 3', stanzas 72–73[65]

Southwell's citation of the 'poore widdowe' (stanza 73.3) – at first sight an unexpectedly gendered image for limited but valuable ability – is balanced by the equivalent 'hee' of the following line; both, of course, are biblical allusions.[66] Her use of the modesty topos ('I will not dare to judge …') is belied by her own practice elsewhere in the precept, where she does not hesitate to judge the religious condition of both England and Ireland. In an earlier stanza in 'Precept 3' she condemns people who presume to comment on religious subjects but who 'speake not to instruct, nor read to learne' (stanza 27.1).[67] Southwell's own self-construction in the Decalogue poems is as the opposite of this sorry condition. The evidence of her reading pervades each precept, and instruction is the *raison d'être* of her writing.

[64] Lansdowne 740, fol. 144v, Klene, p. 128.
[65] Lansdowne 740, fols. 151v–52r, Klene, pp. 137–38.
[66] Mark 12:42/Luke 21:2, Exodus 5:12. [67] Lansdowne 740, fol. 146r, Klene, p. 130.

Southwell's ready assumption of authority is a consistent strand in both the precepts in the Lansdowne manuscript. This aside, however, one of the most striking aspects of these two poems is their (sometimes disconcerting) miscellaneity. Southwell's copious expansion on the biblical texts in these two paraphrases sometimes takes her very far indeed from their avowed subjects. The 109 stanzas of 'Precept 4', for instance, include sections which deride writing 'for pence' (stanza 47.3), debate the merits of rhyme (49–50), and engage at some length in the *querelle des femmes*, condemning both 'witty wantons' and those men who unjustly disparage women (stanzas 63–86).[68] Other sections, such as the depiction of Jesus in imagery drawn from the Song of Songs (stanzas 52, 57), are linked only very tenuously to the issue of the Sabbath day.[69] Much of 'Precept 4' reads like free-association, with Southwell ranging into several areas – such as men's mockery of women writers – which are not only of doubtful relevance to the fourth commandment but in which it is difficult to see the king (*either* king) taking very much interest. Indeed, the *querelle des femmes* stanzas are directly addressed not to the king but to women themselves, to whom she offers detailed advice on how to defend themselves against male slanders (stanzas 65, 67–68, 71).

Such shifts and digressions are even more pronounced in 'Precept 3'. No less free in her expansion on the third commandment than on the fourth, Southwell even includes in the former poem an apparently autobiographical section where she addresses 'You litle brattes that hange about my knees' (stanza 19.1) – presumably her daughters.[70] Southwell bids the children to 'keepe gods precepts ever in your harte' (stanza 20.2), and offers to help by lending them 'these poore fruites of my studye' (stanza 21.1).[71] She also holds the children responsible for the fact that her poems are not more erudite, claiming that she has been too busy taking part in their 'gamballs' (stanza 21.5) to have had time to write any more than 'forced lines' (stanza 23.6).[72] Further stanzas complain about Irish Catholicism, in terms which imply that Southwell was still in Ireland when they were written. Her scornful comment 'Rome holdes not upp more fopperyes then this land' (stanza 34.5) might conceivably be a Calvinist's

[68] Lansdowne 740, fols. 161r, 162v–65r, Klene, pp. 151, 152, 154–58.
[69] Lansdowne 740, fols. 161v, 162r, Klene, pp. 152, 153.
[70] Lansdowne 740, fol. 145r, Klene, p. 128.
[71] Lansdowne 740, fol. 145r, 145v, Klene, pp. 128, 129.
[72] Lansdowne 740, fol. 145v, Klene, p. 129.

disdainful verdict on the England of the 1620s or 30s, but in context more probably refers to Ireland, her home until 1629.[73] Stanza 41 speculates on how the 'poore wretched' Irish, whom 'the Pope doth cozen ... of wealth and wittes', will mourn her death, 'Yt in Hibernia god will have mee dye' (stanza 41.5, 6, 1).[74] A later stanza also seems to imply that she is writing from outside England:

> For mee, I have of all but litle reason
> to flatter gaynst my harte that happy land
> where I was borne, who like fruit out of season
> hath layd on mee an envious stepdames hand
> yett doe I pray all Catelines may perish
> and our Augustus happily may florish.
>
> 'Precept 3', stanza 69[75]

The reference to Augustus in stanza 69.6 is one of the clearest pieces of evidence that the Lansdowne versions of commandments 3 and 4 were originally intended for dedication to James, who liked to compare himself to the first Roman emperor. Composition for James is also consistent with the Irish setting implied by stanzas 34, 41 and 69, given that Southwell did not return from Ireland until 1629, three years after James's death. But there are also passages in each precept which appear to suggest other, more domestic or personal origins for the Lansdowne paraphrases. Southwell claims, for instance, in 'Precept 4', stanza 48.1, that 'I write but to my self and mee', while stanzas 19–23 of 'Precept 3', addressed to her daughters, strongly imply that the Decalogue paraphrases were originally intended as moral guidance for them.[76] The reference to Southwell's daughters as 'litle brattes' ('Precept 3', stanza 19.1) also suggests a comparatively early date for at least this section of the poem, perhaps the first decade of the seventeenth century.[77]

The obvious conclusion to be drawn from all this unevenness and inconsistency is that the surviving state of Southwell's precepts in Lansdowne 740 is even further than might have been imagined (on the textual evidence alone) from being finished copy. 'Precept 3', especially, reads as if it has been patched together out of at least two previous texts: one a domestic document, written for the instruction of Southwell's daughters,

[73] Lansdowne 740, fol. 147r, Klene, p. 131. Southwell's residence in Ireland is discussed by Coolahan, *Women, Writing, and Language*, pp. 181–95.

[74] Lansdowne 740, fol. 148r, Klene, p. 132. [75] Lansdowne 740, fol. 151v, Klene, p. 137.

[76] Lansdowne 740, fols. 161r, 145r–v, Klene, pp. 151, 128–29.

[77] The dates of birth of Southwell's daughters are not known; however, since Thomas and Anne Southwell were married in 1594, it is likely that their daughters were born in the 1590s, or perhaps the early 1600s.

the other genuinely intended for presentation to the king.[78] The stanzas on men and women in 'Precept 4' may similarly, on this reading, derive from a text written for the Southwell daughters, while forthrightly Calvinist stanzas such as 'Precept 3', stanza 13 (where Southwell denies that Christ died for 'those that wilfully rebell') or 'Precept 4', stanza 33 (where she writes eloquently on the helplessness of the human soul) may have been intended either to instruct her own family in true theology, or to point the Stuart monarch in the right direction.[79] Yet although both these possible predecessor texts are advice documents, the difference between them provides a useful reminder of just how audacious Southwell's royal dedication really was. While it would have been entirely proper for an early modern mother to expound the Ten Commandments for the sake of her own children, especially daughters, it would have been both unusual and controversial for a woman to presume to interpret such a key biblical text to the king. Manuscript is the only medium in which such an enterprise could possibly have been feasible.[80]

With unfinished draft poems, such as the Lansdowne paraphrases, it is often difficult to reach tidy conclusions. It seems likely – albeit on the slight basis of the Augustus allusion and the imagery of the dedicatory poem – that Southwell did indeed originally plan to present her Decalogue paraphrases to James, who would have been much more sympathetic than his son to the Calvinistic tenor of her theology. However, it seems equally unlikely that the poems *in their current state* represent what James might have received had the manuscript been completed. The one inescapable conclusion from this analysis of Lansdowne 740 is that Southwell's precepts could not plausibly have been presented to the king – any king – without a painstaking and probably lengthy process of rethinking and rewriting.

Another difficult question concerns the role of Henry Sibthorpe in the creation of the current Lansdowne copy of Southwell's poems. The textual evidence suggests that his is the revising hand responsible for such substantial and considered changes as the alteration of 'gallant' to 'gazeling' and then to 'wizzard' ('Precept 4', stanza 24.1) and for the editorial decision inscribed below 'Precept 4', stanza 90: 'These verses and those that follow

[78] On the legacy aspects of Southwell's precepts, see Jennifer Heller, *The Mother's Legacy in Early Modern England* (Farnham: Ashgate, 2011), pp. 118–31.

[79] Lansdowne 740, fols. 144v, 159v, Klene, pp. 127, 149.

[80] The case of Eleanor Davies, who did presume to advise Charles I in print, makes a salutary comparison; she was widely deemed to be mad.

though crossed out are fitt to stand'.[81] He is also the most likely person to
have composed the commendatory poem on Southwell transcribed at the
end of the manuscript. Given that Southwell and Sibthorpe did not marry
until 1626, a year after the death of King James, his involvement must
indicate a post-Jacobean stage of revisions to the Decalogue poems, though
whether there was any thought of repackaging the poems for presentation
to Charles I is another question.

How far Sibthorpe's responsibility for the current state of the Lans-
downe manuscript extended is, on current evidence, impossible to tell.
However it seems likely that Sibthorpe, who seems to have encouraged
and cherished his wife's poetry, may have instigated this fair transcrip-
tion of precepts 3 and 4, during her lifetime, as a basis for further
revision. Although Southwell's handwriting cannot be detected at any
point in the extant manuscript, it is possible that some of the single-line
cancellations in the document may have been hers. Who but Southwell
herself is likely to have deleted the stanzas which Sibthorpe describes as
'crossed out' but 'fitt to stand'?[82] If this is the case, then it may also have
been Southwell who deleted the original lines 5–6 and 9–10 of the
dedicatory poem to the king; perhaps, if she was indeed planning to
rework the poems for presentation to Charles, she may have balked at
describing him as 'The only touchstone of great natures storye', or his
'sacred lippes' as 'the Heralds of all grace and wonder'.[83] But Southwell's
death before even precepts 3 and 4, let alone the other eight command-
ments, were fully recast seems to have put a stop to creative work on
this project. Sibthorpe's role in revising Southwell's poetry presumably
did not extend to the substantial labours that completing work even on
these two commandments would have required. It seems likely that
following his wife's death he made a last few adjustments to the
manuscript – transcribing his encomiastic poem on Southwell on the
free space at the end of 'Precept 4' and inserting her dedicatory poem to
the king in front of 'Precept 3' – and then stopped work, leaving the

[81] Lansdowne 740, fols. 158v, 165r, Klene, pp. 147, 159. The gallant-gazeling-wizzard revision
transforms Southwell's target from a man of fashion, to an ogling idiot ('gazeling' is a variant of
'gosling', but plays on the notion of the male gaze), to a sage or occultist: in each case, a carefully
thought-out and significant change.

[82] The method used for deleting these sections – giant crosses cancelling whole stanzas – is also the
same as is used in sections of the Folger manuscript believed to have been corrected by Southwell:
e.g. fols. 35v–36r and 54r–v.

[83] Lansdowne 740, fol. 142r, Klene, p. 124.

unfinished copy to bear witness both to his wife's poetic talents and to the aspirations which now would never be realised.

MANUSCRIPT, READERSHIP AND LITERARY CONFIDENCE

Southwell's writing is characterised by confidence. The miscellaneous poems preserved in the Folger manuscript show her, *inter alia*, pronouncing on the moral value of poetry, speculating on the Christian afterlife, and reinterpreting the biblical story of Adam and Eve to Eve's advantage.[84] Her epitaph on Frances Howard steadfastly disregards the opprobrium which had attached to Howard's name for nearly two decades, while her précis of Seneca's *De Providentia* condenses the six dense chapters of Thomas Lodge's translation into fifty lines which retain the structure of Seneca's argument – and the predestinarian logic so compatible with Southwell's Calvinism – but omit the Roman's advocacy of suicide.[85] The Howard epitaph also provides a rare – though characteristically self-assured – example of Southwell weaving together literary influences from both printed and manuscript sources, with echoes from Donne's *Anniversaries* merging into a reworking of Gorges' 'Like as a lampe'.[86] While Southwell does seem to have drawn more substantially on printed rather than manuscript sources in her poetry, it is likely that this was less a matter of preference than of access to materials. If manuscript sources were suitable and available, she would draw on them as readily and as confidently as on printed books.

Paradoxically, Southwell's writerly confidence is most conspicuous in her free reinterpretation of the most famous and influential book of all, the Bible. Rather than being intimidated by this uniquely foundational text, Southwell seems to have borrowed from its status to authorise her own writings. Hers is a different degree of adaptation from that which occurs, for instance, in Mary or Philip Sidney's psalm paraphrases. In the Sidney psalter, despite the virtuosity displayed by both translators, the psalm itself never slips out of view. Southwell, by contrast, uses the premise of the

[84] In the letter to Cecily Ridgeway, her mock-elegy on Ridgeway, and the poems 'All.maried.men' and 'Sir give mee leave to plead my Grandams cause' (Folger 198, fol. 3, Klene, pp. 4–5; Folger 198, fols. 19v–20v, Klene, pp. 24–27; Folger 198, fol. 16r, Klene, p. 20; Folger 198, fol. 26v, Klene, p. 42). Southwell's fascinating reworkings of the Adam and Eve story are discussed by Longfellow (*Women and Religious Writing*, pp. 107–21).

[85] Folger 198, fol. 23r, Klene, pp. 34–35; Folger 198, fol. 8, Klene, pp. 11–12. Southwell presumably read Seneca in Lodge's translation (1614), since there is no evidence that she knew Latin.

[86] Lines 3–4 and 4–16 respectively.

commandments to range far and wide, producing texts in which her own self-assuredly didactic voice becomes the only consistent presence. More remarkably still, Southwell manipulates her own appropriation of biblical authority in order to be visibly female only when she wants to be. In passages directly addressed to female readers she will admit to being one of their much-maligned sex, and thus having all the requisite knowledge to address their circumstances.[87] Elsewhere, however, her poetic voice eschews the marks of femininity, producing an apparently ungendered, biblically charged idiom which enhances the moral authority of her didactic pronouncements.

As Arthur Marotti reminds us, James I's reign was a bleak period for published poetry. It was only in the 1630s, with such landmark publications as Donne's *Poems*, Herbert's *The Temple* and Cowley's *Poetical Blossomes* (all 1633) that print-publication of lyric poetry started to become anything like common practice, for either living or dead authors.[88] Southwell, who spent so many years in Ireland and who died in 1636, was probably in the wrong time and the wrong place to gain access either to the manuscript networks of the 1620s and 30s or the new print-publishing possibilities which started to become available in the last few years of her life. It scarcely seems to have mattered to her. Manuscript production within the household enabled Southwell to write with remarkable freedom and assurance on a wide array of topics and occasions: commemorating her friends and political heroes, appropriating secular literature, and even enlarging on the Bible. It gave her as much scope as she liked to revise and rework her poems, whether in Ireland or Acton, independently or in collaboration with her supportive second husband. It also gave her the opportunity to offer advice, forthrightly but discreetly, to the king – the one reader, outside her own family, she seems to have seriously considered. Compared with print-publication, or even manuscript dissemination, it offered increased control and diminished anxiety. For Southwell – intellectually ambitious but theologically unfashionable, lacking prestigious connections but supported by a sympathetic husband – no medium could have been better.

[87] In her rebuke to vain women, for instance, she claims that she has as much reason to boast of beauty as anyone (Lansdowne 740, fol. 162v, stanza 64, Klene, p. 154).

[88] Marotti, *Manuscript*, pp. 246–47.

CHAPTER 2

The material muse: Anne Bradstreet in manuscript and print

Anne Bradstreet, it seems, is an embarrassing poet. Over the past 350 years a sizeable number of her readers, including many who otherwise admired her, appear to have felt that aspects of her work required extenuation, or even apology. Apology has been thought especially necessary in the case of her first published volume of poetry, *The Tenth Muse*, which was printed in London in 1650. American readers have tended to disparage *The Tenth Muse* as being insufficiently American, regrettably failing to shake off the culture and preoccupations of the Old World which Bradstreet and her family had left in 1630.[1] Similarly, feminist scholars have disparaged *The Tenth Muse* for being unduly concerned with male-dominated public events and a masculinist literary history, and giving little expression to distinctively female interests and experiences. Both Americanists and feminists have typically preferred the second publication associated with Bradstreet, *Several Poems* (1678), which not only had the merit of being published in Boston but also included several more personal poems, testifying both to Bradstreet's experience as a wife and mother and to her life in seventeenth-century Massachusetts.[2] It is on these more personal poems that Bradstreet's reputation within both American and women's literary history chiefly

[1] The *locus classicus* for this evaluation of *The Tenth Muse* is Adrienne Rich's preface to *The Works of Anne Bradstreet*, ed. by Jeannine Hensley (Cambridge, MA: The Belknap Press of Harvard University Press, 1967), pp. ix–xx. Critiques of Rich's ideological preconceptions have become frequent in recent Bradstreet scholarship: see, for instance, Patricia Pender, 'Disciplining the Imperial Mother: Anne Bradstreet's "A Dialogue Between Old England and New"', in *Women Writing 1550–1750*, ed. by Paul Salzman and Jo Wallwork (Bundoora, Australia: Meridian, 2001), pp. 115–31 (pp. 125–27); Susan Wiseman, *Conspiracy and Virtue: Women, Writing and Politics in Seventeenth-Century England* (Oxford University Press, 2006), pp. 182–84; and Mihoko Suzuki, 'What's Political in Seventeenth-Century Women's Political Writing?', *Literature Compass*, 6.4 (2009), 927–41 (pp. 930–31).

[2] The best brief guide to Bradstreet's life and works is Neil Keeble, 'Bradstreet, Anne', *Oxford Dictionary of National Biography*, www.oxforddnb.com (henceforward *ODNB*).

rests: hence Adrienne Rich's commendation of 'the later poems which have kept her alive for us'.[3]

There have been other reasons, too, why *The Tenth Muse* has seemed to warrant apology. The emphatic assertion in the prefatory matter to the volume that Bradstreet herself was in no way involved in its publication has clearly been regretted by many readers, and has sometimes been questioned.[4] Also deprecated is the tenor of many of the male-authored poems prefixed to *The Tenth Muse*, which praise Bradstreet at the expense of other women: depicting her as, unusually amongst her sex, poetically competent, morally solid, and both witty and wise.[5] Most damning of all, however, has been the view that *The Tenth Muse* is, quite simply, dull. Here particular criticism has attached to the series of 'quaternions' and the long historical poem 'The Foure Monarchies', which dominate the volume but which seem not to appeal to post-Romantic poetic tastes.[6] 'The Foure Monarchies' has been deemed especially unsatisfactory; routinely dismissed as metrically tedious and narratologically repetitive, it has also long been known to rely on standard seventeenth-century printed sources for its historical information.[7] 'The Foure Monarchies' thus stands condemned by many scholars not only as dull but also as derivative and intellectually limited.

Some of this embarrassment is reflected in the ways Bradstreet's poetry has been represented to a modern readership. In different ways, the two most important editions of Bradstreet's poetry produced in the late twentieth century both attempted to reconstruct her oeuvre by means of exclusions. The most commonly read edition of Bradstreet's poetry, Jeannine Hensley's Belknap Press volume (1967), is prefaced by Rich's

[3] Bradstreet, *Works*, ed. Hensley, p. xv. On the American feminist view of Bradstreet, see further Patricia Caldwell, 'Why Our First Poet Was a Woman: Bradstreet and the Birth of an American Poetic Voice', *Prospects*, 13 (1988), 1–35.

[4] E.g. Rosamond Rosenmeier, *Anne Bradstreet Revisited* (Boston, MA: Twayne, 1991), pp. 10, 131 (speculatively); Pender, 'Disciplining the Imperial Mother', p. 115 (by implication); Kathrynn Engberg, *The Right to Write: The Literary Politics of Anne Bradstreet and Phillis Wheatley* (Lanham, MD: University Press of America, 2010), pp. 1–3, 10–13.

[5] Thus, for instance, N. Ward: 'It half revives my chil frost-bitten blood, / To see a woman once do, ought, that's good' (*The Tenth Muse*, sig. A4r). See Kathryn Derounian-Stodola, '"The Excellency of the Inferior Sex": The Commendatory Writings on Anne Bradstreet', *Studies in Puritan American Spirituality*, 1 (1990), 129–47 (p. 130).

[6] The word 'quaternions' is not used in *The Tenth Muse*, but provides a useful means of distinguishing Bradstreet's first four 'fours' poems (on the four elements, the four constitutions (or humours) of the human body, the four ages of man, and the four seasons) from 'The Foure Monarchies', which evidently represented a distinct intellectual project.

[7] See, for instance, *The Works of Anne Bradstreet in Prose and Verse*, ed. by John Harvard Ellis (Charlestown, MA: A. E. Cutter, 1867), pp. xliii–l.

influential essay, which forthrightly disparages the poems of *The Tenth Muse* as 'long, rather listless pieces', disastrously eschewing personal history in favour of 'nostalgia for English culture'.[8] Readers of the Hensley edition are thus effectively invited to discount more than half of its contents, in an act of erasure implicitly presented as essential to securing Bradstreet's status within the feminist and American literary canons. By contrast, the standard scholarly edition, the *Complete Works*, edited by Joseph McElrath and Allan Robb, firmly resists such partisan readings of Bradstreet's poetry, adopting a much more cautious approach to the editorial process.[9] Operating in the Greg-Bowers era of editorial theory, McElrath and Robb sought to recover Bradstreet's own intentions as far as possible, distinguishing them from the interventions of later hands. Accordingly, they relegated to the back of the volume all the prefatory material from *The Tenth Muse* and *Several Poems*, giving spatial priority to Bradstreet's own works rather than the commendations of her editor and early readers. In doing so, they elided the bibliographical codes and displaced the paratexts through which Bradstreet's poetry was originally mediated for a print readership. That said, the McElrath and Robb edition deserves to be recognised as one of the most important pieces of recent Bradstreet scholarship. It is especially valuable for its rigorous efforts to separate fact from myth in the reception of Bradstreet's poetry and for its willingness to give serious attention to the poems of *The Tenth Muse*. Its influence on my own thinking about Bradstreet is extensive and profound.

My discussion of *The Tenth Muse* seeks to explore not only its paradoxical relationships with Old and New England but also the complex textual processes through which the collection was formed. Although no pre-publication manuscripts of Bradstreet's *Tenth Muse* poems are known to survive, careful reading of the volume itself – both Bradstreet's own poetry and its prefatory paratexts – yields important insights into how her writing was generated, circulated and received, in America and England, in manuscript and in print. Attending to Bradstreet's comments on her own writing, her creative responses to manuscript and printed texts, and her politicised use of literary genre is crucial to understanding not only how her complex, intellectually ambitious poetry was first produced, but also how and why it was refashioned for print publication. Similarly, reading the textuality of *The Tenth Muse* – its paratexts, its internal organisation,

[8] Bradstreet, *Works*, ed. Hensley, pp. xiv, xv.
[9] *The Complete Works of Anne Bradstreet*, ed. by Joseph R. McElrath Jr. and Allan P. Robb (Boston, MA: Twayne, 1981).

its generic selectivity – is essential to appreciating what Bradstreet's earliest readers, in both Old and New England, valued in her poetry, and why they felt they could use it to their own advantage.

As a printed collection, *The Tenth Muse* is not merely an essential early witness to Anne Bradstreet's poetic skills, political interests and generic preferences. Its textual construction also played an active role both in fashioning Bradstreet's own literary reputation and in shaping her miscellaneous poetry into a single, topical collection. In the next sections of this chapter, I examine two of the key components in this textual construction of Bradstreet and her poetry: the title page and the dedicatory matter to *The Tenth Muse*.

PRESENTING THE MUSE

The Tenth Muse was published in London, in July 1650, under the imprint of one Stephen Bowtell. Primarily a publisher of political and religious works, Bowtell favoured moderately puritan writers. Pope's Head Alley, where his shop was situated, was at the centre of radical and nonconformist publishing in London during the 1640s and 50s, and was also associated with publications from New England.[10] Among Bowtell's first publications, in 1643, was the Elizabethan John Udall's antiprelatical tract *A new discovery of old pontificall practises*, and his bestselling authors included the godly minister Stephen Marshall and the Presbyterian Roger Drake. He had also published several books by Bradstreet's New England acquaintance Nathaniel Ward, including the hugely successful *The Simple Cobler of Aggawam* (1647).[11] This existing connection between Ward and Bowtell probably accounts for the otherwise rather odd choice of the latter as publisher of *The Tenth Muse*. In a career lasting at least thirteen years, Bowtell published no other literary verse, though he did produce editions of William Barton's metrical psalms in 1645, as well as *The Lamentations of Jeremiah, in meter* in 1652. The selection of Bowtell as Bradstreet's publisher may reflect her New England circle's lack of connections with, or indeed interest in, the literary end of the London book trade. Its effect was to associate her

[10] Maureen Bell, 'Hannah Allen and the Development of a Puritan Publishing Business, 1646–51', *Publishing History*, 26 (1989), 5–66.

[11] On Marshall, Drake and Ward, see *ODNB*. Bowtell himself has no entry in *ODNB*; my information on his publication record derives from the English Short Title Catalogue http://estc.bl.uk (henceforward ESTC).

poetry not with contemporary literary verse but with the religio-political preoccupations of Bowtell's regular clients.[12]

The fact that Bowtell was not a literary publisher may also help to account for the unusual make-up of *The Tenth Muse*'s title page. The title pages in most volumes of printed poetry in the 1640s and 50s follow a briefly informative but largely standard structure, with the title at the top of the leaf (sometimes followed by a subtitle), then the name of the author, sometimes with a few descriptive details, perhaps an epigraph, and finally the publisher's imprint.[13] The title page for *The Tenth Muse*, however, follows quite a different format, resembling instead the much more crowded title leaves provided by Bowtell for publications such as Ward's *The Simple Cobler*, Drake's *Sacred Chronologie* (1648) and Giles Firmin's *A Serious Question Stated* (1651). Bowtell's practice, though not uniform, was to capitalise on the title page's potential as advertising copy, laying it out with extensive information about the contents and arguments of the book itself. The title page of *The Tenth Muse* is similarly constructed in order both to summarise and to promote the contents of the ensuing volume (see Figure 3).

Several points are worth noticing about this highly strategic title page. The first concerns authorship. Anne Bradstreet's name is conspicuously absent from the title page of *The Tenth Muse*, which reserves until almost the end even the periphrasis 'By a Gentlewoman in those parts'.[14] This elision of the author is not typical of most of Bowtell's title pages, which more often include the author's name, emphasised by rules, approximately halfway down the leaf.[15] A partial comparison may be drawn with Bradstreet's acquaintance, Nathaniel Ward, who published his best-known work, *The Simple Cobler of Aggawam*, under a pseudonym. In the case of both *The Tenth Muse* and *The Simple Cobler*, the effect is to collapse the unnamed author into her/his eponymous title. The person of the author is displaced in favour of the functionality the title implies: in Ward's case, the simple cobbler's desire to 'help mend his native Country, lamentably tattered'; in Bradstreet's, the divine inspiration of the Muse.

[12] The one other London publisher with whom any member of her immediate circle is known to have had dealings – Edmund Paxton, who had published Benjamin Woodbridge's *Church Members Set in Joynt* in 1648 – also favoured religious publications, and did not have even Bowtell's limited experience of dealing with verse texts.

[13] Title pages in poetry collections by Thomas Randolph (1638), Thomas Carew (1640), John Milton (1645), John Suckling (1646), Abraham Cowley (1647) and William Cartwright (1651) broadly follow this structure.

[14] All quotations from *The Tenth Muse* follow the original 1650 publication and by necessity lack line numbers. The Hensley edition, which does provide line numbers, follows the 1678 *Several Poems*, while the McElrath and Robb edition, which follows *The Tenth Muse*, does not provide line numbers, and is now difficult to obtain. A new critical edition of Bradstreet's poetry is much needed.

[15] Thus, for instance, his title pages for Giles Firmin's *Separation Examined* (1652) and Stephen Marshall's *A Defence of Infant-Baptism* (1646).

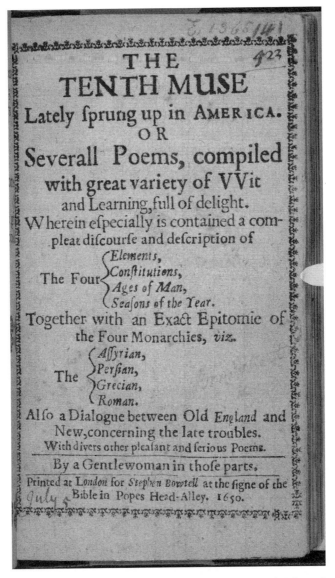

3. *The Tenth Muse*, title leaf. British Library E.1365.(4). © British Library Board.

Yet although the title page of *The Tenth Muse* is anonymous, there is no attempt to conceal the sex of the author. The implication of female agency in the title is confirmed by the information at the foot of the title page: 'By a Gentlewoman in those parts'. Bradstreet herself is named in full five times in the prefatory material to the volume (sigs A7r and A8r–v, p. 2), which in any case focuses repeatedly on the perceived incongruity between Bradstreet's sex and her poetic gifts. However, as many critics have noted, the very notion of designating a female poet as 'the Tenth Muse' indicates some discomfort with the notion of female poetic agency.[16] In invocations of the Muse in male-authored early modern poetry, the goddess herself is typically represented not as a poet but rather as the source of inspiration for an eloquent male supplicant. Ironically, then, the conflation of roles represented by *The Tenth Muse*, though undoubtedly devised to compliment Bradstreet's abilities and elevate her claims as a poet, instead testifies to its compilers' difficulty in trying to imagine poetry as a female activity. Rather than a cleverly conceived tribute to Bradstreet's powers, the 'tenth muse' conceit is a well-meant but awkward attempt to invoke a suitably impressive female precedent for her writing, its implications as redolent of anxiety as praise.[17]

Further ironies – this time more straightforwardly complimentary – are evident in the description of Bradstreet not merely as 'The Tenth Muse' but as 'The Tenth Muse Lately sprung up in America'. The allusion to the traditional nine muses of Greek mythology locates Bradstreet and her poems firmly within a European, classical frame of reference, which is then immediately complicated by the translocation of the tenth muse to the New World. The title thus depicts its author as the complement to – or culmination of – a distinctively European tradition of imagining poetic composition, while also hinting that her strange and exotic location in America has made possible this unprecedented development in European convention. European civilisation had, after all, managed

[16] E.g. Tamara Harvey, '"My goods are true": Tenth Muses in the New World Market', in *Feminist Interventions in Early American Studies*, ed. by Mary C. Carruth (Tuscaloosa, AL: Alabama University Press, 2006), pp. 13–26, and Kate Chedgzoy, *Women's Writing in the British Atlantic World: Memory, Place and History, 1550–1700* (Cambridge University Press, 2007), pp. 133–34; compare Timothy Sweet, 'Gender, Genre, and Subjectivity in Anne Bradstreet's Early Elegies', *Early American Literature*, 23.2 (1988), 152–74 (p. 166).

[17] Both the difficulty of imagining the woman poet and the use of the 'tenth muse' conceit have a long history. Plato is said to have used the term to refer to Sappho, while Anne King and Lady Harflete were among other seventeenth-century Englishwomen thus honoured. See W. R. Paton, trans., *The Greek Anthology*, III (London: Heinemann, 1916), p. 281, Larminie, 'King, Anne', *ODNB*, and Marotti, *Manuscript*, pp. 53–54.

for centuries with the paltry total of nine muses. Now, within a few decades of the first English settlements in the New World, a tenth muse has 'sprung up'.[18]

The detailed description of the contents of *The Tenth Muse* that follows the expanded title raises several further points of interest. One such is the claim that the Tenth Muse's poetry has been 'compiled with great variety of Wit and Learning, full of delight'. These references to 'Wit' and 'delight' are strongly though disconcertingly reminiscent of the many printed poetry miscellanies which were published during the 1640s and 50s: collections bearing titles such as *Wits Recreations* (1640), *Musarum Deliciae* (1655) and *Wit and Drollery* (1656). These miscellanies, typically pro-royalist and anti-puritan, typically celebrated conviviality and sexual excess, and were often unashamedly misogynistic.[19] While the references to 'Wit' and 'delight' on Bowtell's title page risk associating *The Tenth Muse* with such popular volumes – as against elite verse collections such as Milton's *Poems* (1645) or Cowley's *The Mistress* (1647) – the juxtaposition of these terms with the rather more unexpected 'Learning' places Bradstreet's work squarely in the traditions of humanist poetry.[20] Indeed, the collocation 'Wit and Learning, full of delight' almost exactly restates Philip Sidney's dictum in *The Defence of Poesy* that the purpose of poetry is to teach and delight. Given that Bradstreet explicitly celebrates Sidney in the text of *The Tenth Muse*, this is likely not to be coincidental.

The connotations of 'Wit' and 'Learning' are complicated still further by their deployment as persuasive advertising for a *woman's* poetry. Wit and learning were not by any means qualities stereotypically associated with English women's writing in the mid-seventeenth century. When women writers during this period received commendation from others it was more typically on account of their virtue or their piety. Many writers of the period, indeed, deplored learning in women, seeing it as a worldly preoccupation all too likely to distract them from the spiritual and domestic concerns more appropriate to a woman's place

[18] On the association between the Tenth Muse and the New World by English-, French- and Spanish-language writers, see Stephanie Merrim, *Early Modern Women's Writing and Sor Juana Inés de la Cruz* (Liverpool University Press, 1999), and Tamara Harvey, '"My goods are true"'.

[19] For a complete list of mid-century miscellanies, and a searching critique of their cultural, political and sexual presuppositions, see Smyth, 'Profit and Delight'.

[20] Of the forty-one miscellanies identified by Smyth, only one – *The Harmony of the Muses* (1654) – cites both wit and learning in its (full) title; it is said to be 'full of various, pure, and transcendent wit' and to be 'written by ... unimitable masters of learning and invention'. See ESTC.

in life.[21] This attitude, frequent in Old England, is often thought to have been even more prevalent in New England; witness Governor Winthrop's well-known comments on Anne Hopkins, whose loss of 'understanding and reason' he attributed to 'her giving herself wholly to reading and writing' and her husband's over-indulgent failure to restrict her to 'such things as belong to women'.[22] But so far is *The Tenth Muse*'s title page from disparaging female learning that virtually all the specified contents of the volume testify to Bradstreet's intellectual interests. Readers are told of her poems on the elements, the constitutions, the ages of man and the seasons, as well as on the four monarchies. They are also alerted to her 'Dialogue between Old England and New, concerning the late troubles'. Not only is the 'Dialogue' another instance of Bradstreet's transatlanticism, but it also flags up, without hesitation or apology, this gentlewoman poet's willingness to comment on public affairs. Bowtell's credentials as a puritan publisher notwithstanding, we should also note that, in the immediate aftermath of the English Civil War, 'the late troubles' is a conveniently neutral euphemism, provoking curiosity while remaining prudently silent about which side in the troubles this gentlewoman poet had favoured.

As a preliminary signpost to Bradstreet's work, Bowtell's title page performs an admirably concise feat of cultural positioning. It capitalises on the exotic potential of *The Tenth Muse*, emphasising the author's doubly unusual status both as a woman and as a resident of America. It also conspicuously eschews the two categories most often associated with women's writing in the early modern period: religious material and translation. The contents outlined in the title page of *The Tenth Muse* are predominantly secular, with only the 'Exact Epitomie of the Four Monarchies' (and perhaps the 'Dialogue') so much as hinting at religious preoccupations.[23] Instead, perhaps surprisingly, the emphasis is on the creativity of a gentlewoman who is at once poet and muse: the self-generating source of her own inspiration. The aspiration of the volume to reconcile 'Wit', 'Learning' and 'delight' harks back to somewhat

[21] For the striking example of Elizabeth Joscelin, see Sylvia Brown, *Women's Writing in Stuart England: The Mothers' Legacies of Dorothy Leigh, Elizabeth Joscelin, and Elizabeth Richardson* (Stroud: Sutton, 1999), p. 107.

[22] Ivy Schweitzer, *The Work of Self-Representation: Lyric Poetry in Colonial New England* (Chapel Hill, NC: University of North Carolina Press, 1991), p. 128.

[23] On the relative secularity of *The Tenth Muse*, see Wendy Martin, *An American Triptych: Anne Bradstreet, Emily Dickinson, Adrienne Rich* (Chapel Hill, NC: University of North Carolina Press, 1984), p. 37, and Wiseman, *Conspiracy and Virtue*, pp. 207–08.

old-fashioned Tudor ideals about the cultural role of poetry, while the reference to Bradstreet's 'Dialogue between Old England and New' – the last item specified on the title page, though not the last poem in the volume – provides a late, tantalising glimpse of more topical concerns.

The final irony in the title page of *The Tenth Muse* is the disparity between its author's location and her perspective. While both the allusions to the poet herself on this title page stress her residence in New England ('The Tenth Muse Lately sprung up in America'; 'a Gentlewoman in those parts'), the outline of the volume itself shows an ongoing preoccupation with the affairs of the Old World – from the invocation of the classical muses to the references to the four monarchies and the recent English Civil Wars. The Tenth Muse is thus produced by America, but preoccupied with England. From her location in the New World, she is authorised to comment on the Old.

MEDIATING THE MUSE

Bowtell's title page is not the only paratextual means by which the structure of *The Tenth Muse* mediates Bradstreet's poetry to a public readership. The volume proper begins with twelve pages of prefatory matter: an unsigned prose epistle, followed by commendatory poems by N. Ward, I.W., C.B., R.Q., N.H. and H.S.[24] One other short prefatory poem is unsigned in *The Tenth Muse*, but is subscribed with the initials 'B.W.' in *Several Poems*.

There is general agreement among Bradstreet scholars that the publication of *The Tenth Muse* was initiated and organised by her brother-in-law, John Woodbridge. Woodbridge, who had married Bradstreet's sister, Mercy, in 1639, had briefly served as a minister in Massachusetts before returning to England in 1647.[25] He was appointed chaplain to the parliamentary leaders who negotiated with Charles I in 1648, and in 1650 became rector of Barford St Martin, Wiltshire, where he served until ejected in 1662. John Woodbridge was thus in England at the right time to have organised the publication of Bradstreet's poems in London. He is assumed to be the author both of the unsigned prose letter which

[24] The prefatory material to *The Tenth Muse* is discussed in Derounian-Stodola, '"The Excellency of the Inferior Sex"'; see also Elizabeth Wade White, *Anne Bradstreet: The Tenth Muse* (New York: Oxford University Press, 1971), pp. 253–66, and Phillip Round, *By Nature and by Custom Cursed: Transatlantic Civil Discourse and New England Cultural Production, 1620–1660* (Hanover: Tufts University, published by University Press of New England, 1999), pp. 192–200.

[25] On Woodbridge's life, see Paul Lim, 'Woodbridge, Benjamin', *ODNB*.

opens *The Tenth Muse* and of the commendatory poem ascribed to I./J.W.; the latter identifies himself as Bradstreet's brother and admits responsibility for arranging the publication of his sister's poems without her knowledge. 'B.W.', presumed contributor of the third commendatory poem on Bradstreet in *The Tenth Muse*, is thought to have been a younger Woodbridge brother, Benjamin. The remaining semi-anonymous poets who commended Anne Bradstreet's poetry to the world in 1650 have not been conclusively identified, though they are likely to have been contacts either of the extended Bradstreet-Dudley-Woodbridge family in Massachusetts or of John Woodbridge in England.[26]

Despite its celebratory purposes, the prefatory material to *The Tenth Muse* is in many ways deeply misogynistic. Woodbridge and his all-male team of collaborators are obsessed with Bradstreet's status as a woman poet, and while most of them are keen to celebrate her literary prowess, they are also anxious to deny that her abilities represent any threat to the conventional gender hierarchy.[27] In his prefatory letter, Woodbridge makes somewhat uneasy use of the modesty topos, dwelling on the obviously incongruous discrepancy between his own lack of eloquence and the superior abilities manifested by this (as yet unnamed) female poet. Yet his praise of Bradstreet's writing trades on misogynistic stereotypes, even as it insists on Bradstreet's difference from the feminine norm:

I feare'twil be a shame for a man that can speak so little, to be seene in the title page of this Womans Book, lest by comparing the one with the other, the Reader should passe his sentence, that it is the gift of women, not only to speak most, but to speake best; I shall leave therefore to commend that, which with any ingenious Reader will too much commend the Author, unlesse men turne more peevish then women, to envie the excellency of the inferiour Sex. I doubt not but the Reader will quickly finde more then I can say, and the worst effect of his reading will be unbeleif, which will make him question whether it be a womans Work, and aske, Is it possible?[28]

While endorsing the age-old cliché of women as the garrulous sex, Woodbridge speculates that the merits of *The Tenth Muse* may give cause to

[26] Attempts to identify authors of the remaining commendatory poems include White, *Anne Bradstreet*, pp. 260–65, Derounian-Stodola, '"The Excellency of the Inferior Sex"', pp. 135–36 and Wiseman, *Conspiracy and Virtue*, pp. 204–05.

[27] R.Q., the one exception, does not directly comment on Bradstreet's abilities. His contribution to *The Tenth Muse* is in many respects anomalous, and it seems significant that his was the only one of *The Tenth Muse*'s commendatory poems not to be reprinted in *Several Poems*. Although the identities of R.Q. and several of the other commendatory poets are unknown, all clearly write from a male subject position.

[28] *The Tenth Muse*, sig. A3r.

question the frequently assumed corollary that women's speech is worth less than men's. But far from pursuing the dangerously destabilising implications of this possibility, Woodbridge immediately retreats into exceptionalist assumptions, labelling women 'the inferiour sex', and positing that the sceptical reader may think *The Tenth Muse* too good to be genuinely a woman's writing. On this point, however, Woodbridge is categorical. The poet of *The Tenth Muse* is not only a woman, but in every way the right sort of woman:

> It is the Work of a Woman, honoured, and esteemed where she lives, for her gracious demeanour, her eminent parts, her pious conversation, her courteous disposition, her exact diligence in her place, and discreet mannaging of her family occasions; and more then so, these Poems are the fruit but of some few houres, curtailed from her sleep, and other refreshments.[29]

The claim that a woman has produced such impressive poetry without in any way neglecting her family touches on a long-running anxiety about women's writing; as late as 1716, Robert Molesworth felt obliged to make a similar claim on behalf of his daughter, Mary Monck.[30] But the other factors cited by Woodbridge in his vindication of Bradstreet are also instructive. First he stresses that Bradstreet is a respected member of her community; unusual though she may be, she is neither socially disruptive nor an isolated misfit. The rider 'honoured, and esteemed where she lives', reminding the alert reader of the distant location ascribed to the poet on the title page, ensures that the ideal of womanhood constructed by Woodbridge in this sentence redounds to the credit not only of Bradstreet herself but also of the colonial settlements in New England.[31] One such settlement has not only produced this exemplary female, but has given her outstanding qualities the honour they deserve. More instructive still are the terms deployed by Woodbridge in praise of this female poet. Bradstreet is commended not only for such predictable virtues as her piety, her 'exact diligence' in the sphere allotted to her and her skills in household management, but also for her 'eminent parts'.[32] This emphasis on Bradstreet's intellectual abilities echoes an allusion in Woodbridge's opening sentence to 'the Authors wit'; together they reiterate the 'Wit and Learning' claimed

[29] *The Tenth Muse*, sig. A3r–v.
[30] See also the prefatory matter to *Poems on Various Subjects, Religious and Moral* (1773), by the African-American writer Phillis Wheatley, which provides assurances not only that Wheatley 'had no Intention ever to have published' her poems (p. iv) but also that they were genuinely her own work.
[31] Round, *By Nature and by Custom Cursed*, p. 191.
[32] *OED* defines this sense of 'part' as 'A personal quality or attribute, *esp. of an intellectual kind*; an ability, gift, or talent' (sense 15, first citation 1561; my emphasis).

for Bradstreet on the title page. While Woodbridge does not privilege Bradstreet's learning, embedding his allusion to her 'eminent parts' within a list of more conventionally feminine attributes, he is unembarrassed about crediting her with intellectual skills.

Recent scholarship on *The Tenth Muse* has, understandably, tended to emphasise the sexist logic in Woodbridge's defence of Bradstreet.[33] There is a danger, however, that over-emphasising Woodbridge's sexism may in fact obscure the complexity of his attitudes both in the prose epistle and his commendatory poem. As I have stressed, despite his many equivocations, Woodbridge does not shrink from praising Bradstreet's intellectual abilities. Although his prose epistle depicts her as a rarity, a woman whose talents are so unusual as to cast doubt on her sex, the ideal of womanhood which the letter constructs – combining social, intellectual, religious and domestic virtues – is one that is potentially available to all women. When he reverts to the gender issue in his commendatory poem, he again uses exceptionalist arguments, this time comparing Bradstreet's 'Works' directly with those of other women. While the comparison, unsurprisingly, works entirely to Bradstreet's advantage, Woodbridge uses the excellence of her writing as a somewhat unexpected argument for the inherent abilities of the female sex. Bradstreet's outstanding example suffices to prove that the weakness of other women's writing must be due to individual deficiency, not the inherent limitations of all women:

> If women, I with women, may compare,
> Your Works are solid, others weake as aire;
> Some books of Women I have heard of late,
> Perused some, so witlesse, intricate,
> So void of sence, and truth, as if to erre
> Were only wisht (acting above their sphear) …
> Their vanity make this to be inquired,
> If women are with wit, and sence inspired:
> Yet when your Works shall come to publick view,
> 'Twill be affirm'd, 'twill be confirm'd by you:
> And I, when seriously I had revolved
> What you had done, I presently resolved,
> Theirs was the Persons, not the Sexes failing …
> 'To my deare Sister'[34]

Woodbridge's discussion of Bradstreet's writing in this passage, though still generalised, provides important clarification of what he finds so

[33] E.g. Derounian-Stodola, '"The Excellency of the Inferior Sex"' and Sweet, 'Gender, Genre, and Subjectivity', pp. 166–67; however, compare Round, *By Nature and by Custom Cursed*, pp. 197–200.

[34] *The Tenth Muse*, sigs A4v–5r.

praiseworthy in Bradstreet's writing. In the prose letter, despite praising 'this Womans Book' as at least possible evidence that women may 'speake best', Woodbridge never quite explains what the outstanding merits he ascribes to *The Tenth Muse* actually amount to. In the commendatory poem, however, addressing Bradstreet herself, he is rather more specific as to what he values in her writing, albeit by contrast with others'. Writings by other, inferior women are robustly condemned as 'witlesse', 'intricate' (i.e. obscure) and 'void of sence, and truth'. Bradstreet's poetry, by implication, manifests the 'wit, and sence' which those less able women, in Woodbridge's view, so damagingly lack. Her linguistic skill and intellectual substance, touched on in the prose letter, are here represented as foundational to the excellence of her writing. By (implicitly) praising her 'sence, and truth', Woodbridge makes the further discreet insinuation that the judgements and analyses in Bradstreet's poetry are, broadly speaking, correct. Not only are her poems worthy of admiration, the views they express are fit to be trusted.

The 'books of Women' derided in Woodbridge's commendatory poem, though not precisely specified, may well have been the numerous ecstatic and visionary writings published by women prophets during the 1640s. If a particular culprit is intended, it may have been Elizabeth Avery, an aunt of the Woodbridge brothers, whose *Scripture Prophecies Opened, Which are to be Accomplished in these Last Times* had been published in 1647.[35] To a university-trained puritan such as Woodbridge, the unstructured writings of female prophets would undoubtedly appear 'void of sence, and truth, as if to erre / Were only wisht', and such women's claims to have received direct revelation from God would unquestionably look like 'acting above their sphear'. However, despite clearly identifying Bradstreet as a very different sort of woman writer, and praising her accordingly, Woodbridge does not attempt to back up his claims with examples from her writing. His commendatory poem, like his prose letter, operates at a highly abstract level, and rarely engages with the contents of Bradstreet's verse. The only one of Bradstreet's poems to which he specifically refers, in either epistle or poem, is 'Elizas ditty': that is, her elegy on Queen Elizabeth, which he mentions in passing as a vindication of women.[36] The detail to substantiate

[35] Sue Wiseman reads the Woodbridges' promotion of *The Tenth Muse* as a response to the perceived threat represented by Avery. See Wiseman, *Conspiracy and Virtue*, pp. 199–209.

[36] *The Tenth Muse*, sig. A5r. On the protofeminist implications of Bradstreet's elegy on Elizabeth, see Lisa Gim, 'Representing the "Phoenix Queen": Elizabeth I in Writings by Anna Maria van Schurman and Anne Bradstreet', in *Resurrecting Elizabeth I in Seventeenth-Century England*, ed.

Woodbridge's claims on Bradstreet's behalf comes, in the first instance, not from Woodbridge himself but from the title page of *The Tenth Muse*, which, as we have seen, summarises the contents of the volume at some length. Bowtell's title page supplies the preliminary evidence to ground Woodbridge's claims for Bradstreet's intellectual merits. Conversely, Woodbridge's polemical epistle and poem gloss and vindicate the gendered authorship boldly asserted on the title leaf.

The remaining commendatory poems in *The Tenth Muse* typically adopt a middle position between these two extremes: none making detailed reference to the substance of her poems, but several alluding to one or more distinctive features of her writing. Nathaniel Ward, for instance, stresses her poetic debt to the sixteenth-century French poet Guillaume Du Bartas; so too does the first of the two anagrammatists who pun on her name in the concluding commendatory page.[37] R.Q., N.H. and H.S., meanwhile, all mention her writings on the subject of monarchy – the latter two alluding in clear though non-specific terms to her long poem 'The Foure Monarchies'.[38] N.H. also claims that her poetry elucidates 'Natures darke secret Mysteries': presumably a reference to 'The Foure Elements' and 'The foure Humours' (or 'Constitutions').[39] Apart from R.Q., whose clumsy attempts at humour seem sorely out of place amid the general spirit of compliment, all of these writers concur with Woodbridge in seeing the intellectual ambition of Bradstreet's poems as a matter for praise. In Ward's poem, Mercury and Minerva compare Bradstreet's work with Du Bartas', describing her approvingly as 'a right Du Bartas Girle', whose success in emulating the French poet, though unusual for a woman, is clearly not seen as inappropriate.[40] H.S., while similarly marvelling that a woman poet can aim so high, encourages her to continue in the same vein of historiographical poetry. Gender is apparently no hindrance to his concluding wish that she be honoured like the Roman poets of old:

> I've read your Poem (Lady) and admire,
> Your Sex, to such a pitch should e're aspire;
> Goe on to write, continue to relate,
> New Histories, of Monarchy and State:
> And what the Romans to their Poets gave,
> Be sure such honour, and esteeme you'l have.
> 'Another to Mistress Anne Bradstreete'[41]

by Elizabeth Hageman and Katherine Conway (Madison, NJ: Fairleigh Dickinson University Press, 2007), pp. 168–84.
[37] *The Tenth Muse*, sigs A4r and A8v. [38] *The Tenth Muse*, sigs A6v, A7v and A8r.
[39] *The Tenth Muse*, sig. A7v. [40] *The Tenth Muse*, sig. A4r. [41] *The Tenth Muse*, sig. A8r.

If anything, H.S.'s poem encourages Bradstreet to be more ambitious
rather than less; his suggestion that her future poetry should tackle 'New
Histories, of Monarchy and State' hints at controversially up-to-date
subject matter. There is certainly no suggestion, either in his or
in any of the other commendatory writers' work, that any topics or
genres are off-limits for a woman poet. What Woodbridge, however,
does see as potentially improper is the notion that Bradstreet herself
might have had any role in, or knowledge of, the publication of *The
Tenth Muse*. The latter part of his epistle and much of his commen-
datory poem are devoted to insisting, rather, that responsibility for
bringing Bradstreet's poems to 'publick view' is wholly his own.
Bradstreet, indeed, will be displeased and disconcerted when she finds
out what he has done:

> I feare the displeasure of no person in the publishing of these Poems but the
> Authors, without whose knowledge, and contrary to her expectation, I have
> presumed to bring to publick view what she resolved should never in such a
> manner see the Sun; but I found that divers had gotten some scattered papers,
> affected them wel, were likely to have sent forth broken peices to the Authors
> prejudice, which I thought to prevent, as well as to pleasure those that earnestly
> desired the view of the whole.[42]

In his commendatory poem, Woodbridge further suggests that Bradstreet
will feel shamed by his action. He also admits that, due to his premature
intervention, Bradstreet's poems have reached print in a less than fully
revised form:

> 'Tis true, it doth not now so neatly stand,
> As ift 'twere pollisht with your owne sweet hand;
> 'To my deare Sister'[43]

It is, of course, open to question whether Woodbridge's disclaimers on
Bradstreet's behalf should be taken at face value. However, as I will argue
in the next section of this chapter, such evidence as can be inferred from
the make-up of *The Tenth Muse* tends to indicate that Woodbridge was
correct and that Bradstreet indeed took no part in preparing her poems
for print-publication. If this is so, the question then arises as to why

[42] *The Tenth Muse*, sig. A3v.
[43] *The Tenth Muse*, sig. A5v. Woodbridge's use of the word 'neatly' anticipates the two
anagrammatists, whose otherwise different transpositions of Bradstreet's name both include the
word 'neat': 'Deer Neat An Bartas' and 'Artes bred neat An' (*The Tenth Muse*, sig. A8v). I stress this
privileging of 'neatness' by Woodbridge and his collaborators as a salutary reminder of the misogyny
their writings undoubtedly do display.

Woodbridge (and perhaps sympathisers such as Ward) took the initiative in arranging publication of *The Tenth Muse*.[44] Why did they go to so much trouble to bring Bradstreet's poetry to an English readership? Whose interests did it serve, and how?

To begin to answer these questions, we need to look more carefully at *The Tenth Muse* itself, and try to reconstruct something of the prepublication history of its constituent texts. What can we tell about these poems in their pre-print condition(s)? How were they produced and transmitted in manuscript, and how did the conventions within which Bradstreet was working shape her writing? What can we tell about the process through which Bradstreet's poems passed in their transition from manuscript to print? What happened to them when they were refashioned into printed form? Indeed, to what extent, in reading *The Tenth Muse*, are we reading what Bradstreet herself originally wrote?

MANUSCRIPT INTO PRINT

The prefatory material to *The Tenth Muse* represents appreciation of Bradstreet's poetry as a predominantly male activity. The only female figures who are allowed to share in the admiration are members of the classical pantheon. Thus Nathaniel Ward pictures Minerva presenting Apollo with a copy of Bradstreet's poems (to compare with Du Bartas', as presented by Mercury) and John Woodbridge speculates that the original nine muses may 'vouchsafe' to accept Bradstreet as a tenth.[45] The reception of Bradstreet's poetry by human female readers appears, however, to have been less highly valued. There is some circumstantial evidence that Mercy Dudley – Woodbridge's wife – may have written a commendatory poem on her sister's work.[46] If so, it was not included in the prefatory material to *The Tenth Muse*, and has since been lost. The reader addressed in Woodbridge's prose epistle and implied in his commendatory poem is consistently male; in the latter, for instance, he imagines the 'longing Reader' complaining because Woodbridge's interventions in the volume 'Hind[er] his minds content, his sweet

[44] Woodbridge himself was not in the habit of publication. The first print-publication with which his name is linked, apart from *The Tenth Muse*, is *Severals Relating to the Fund* (1682), a work on banking.

[45] *The Tenth Muse*, sigs A4r and A5r.

[46] Harold Jantz, *The First Century of New England Verse* (Worcester, MA: Proceedings of the American Antiquarian Society, 1944), p. 284.

repose, / Which your delightfull Poems doe disclose'.[47] That the pronouns
applied to this hypothetical reader are specifically male rather than the
generic masculine is confirmed by Woodbridge's assertion (in the prose
epistle) that the 'ingenious Reader' will be sure to appreciate Bradstreet's
work 'unlesse men turne more peevish then women, to envie the excel-
lency of the inferiour Sex'.[48] Though the gendering of Bradstreet's future
readership is not especially emphasised, it is consistently expressed. Evi-
dently, far from aiming Bradstreet's poetry (derisorily or otherwise) at
women readers, Woodbridge is careful to construct it as worthy of male
approval.

The introductory material to *The Tenth Muse* projects this male reader-
ship of Bradstreet's poems both into the future and into the past. The men
whom Woodbridge expects to read and appreciate Bradstreet's published
poetry will be following the example of Woodbridge himself and the other
commendatory writers who have read and admired Bradstreet's poetry
prior to publication. But *The Tenth Muse* also represents Bradstreet's
own poetry as being itself generated by and within a male-dominated
context of textual exchange. The first of Bradstreet's poems included
in the volume bears the title 'To her most Honoured Father Thomas
Dudley Esq; these humbly presented'.[49] Bradstreet's 'these' are her
quaternions, which her dedicatory poem not only presents to her father
but also construes as 'homage' to an earlier poem written by Dudley
himself:

Deare Sir, of late delighted with the sight,	TD on the
Of your *four sisters, deckt in black and white	four parts
Of fairer Dames, the sun near saw the face,	of the
(though made a pedestall for Adams Race)	world
Their worth so shines, in those rich lines you show.	
Their paralells to find I scarcely know,	
To climbe their Climes, I have nor strength, nor skill,	
To mount so high, requires an Eagles quill:	
Yet view thereof, did cause my thoughts to soare,	
My lowly pen, might wait upon those four,	
I bring my four; and four, now meanly clad,	

[47] *The Tenth Muse*, sig. A5r. [48] *The Tenth Muse*, sig. A3r.

[49] Male reception is also indicated by another poem included in *Several Poems* though not in *The Tenth Muse*, 'To her Father with some verses' (*Several Poems*, p. 244). Thomas Dudley and Simon Bradstreet are the only living individuals to whom Bradstreet is known to have addressed poems (the latter in *Several Poems*); poems with female subjects, such as her mother Dorothy and daughter-in-law Mercy, are invariably elegies.

To do their homage unto yours most glad.
Who for their age, their worth, and quality,
Might seem of yours to claime precedency;
But by my humble hand thus rudely pen'd
They are your bounden handmaids to attend.

'To her most Honoured Father'[50]

'To her most Honoured Father' locates the production of Bradstreet's poetry amid a productive but somewhat problematic sequence of reception acts. In the first instance, Bradstreet constructs her own verses as answer poems, inspired by her own reading of a poem by her father 'on the four parts of the world'. Although Dudley's poem is not known to survive, Bradstreet's allusions in 'To her most Honoured Father' strongly suggest that its figures and premises exercised extensive influence over her own writing. Dudley's trope of the 'four sisters' to represent the four continents – Europe, America, Asia and Africa – evidently lies behind his daughter's use both of the quaternion structure and of female family relationships in her own answer poems: her poem on the four elements represents the elements as sisters, while the eponymous four humours are each daughter to their own respective elements.[51] The familial trope may also have influenced her representation of Old and New England as mother and daughter in her 'Dialogue' poem on the Civil Wars, where Old England extends the metaphor to describe her northern neighbour as 'Sister Scotland'.[52] The competitive premises of Dudley's 'four sisters' poem – 'Yours did contest, for Wealth, for Arts, for Age' – may also have provided precedent not just for the contestative structure of Bradstreet's 'Elements' and 'Humours' poems, but more generally for the overall mood of *The Tenth Muse*, which critics have read as pervasively preoccupied with the theme of conflict.[53]

'To her most Honoured Father' represents Bradstreet's reception of her father's poetry, as well as Dudley's anticipated reception of his daughter's verses, in somewhat paradoxical terms. Bradstreet, on this evidence, was working within domestic circumstances which facilitated, stimulated and authorised, but also to some extent predefined, her own poetic activities.

[50] *The Tenth Muse*, p. 1.

[51] Phillip Round assumes that Bradstreet herself – rather than Dudley – was responsible for designating her father's verses as 'sisters', seeing this as a means of levelling 'the unequal power relations that formerly obtained between father and daughter' (Round, *By Nature and By Custom Cursed*, p. 175). This possibility cannot be excluded, but the contestative structure that Bradstreet attributes to Dudley's poem strongly implies that it, too, was constituted as a debate between sisters.

[52] *The Tenth Muse*, p. 183.

[53] *The Tenth Muse*, p. 2. Compare Martin, *An American Triptych*, p. 38.

Dudley's 'four sisters' poem made possible and legitimated *a certain kind of poem* in response. Also, while Bradstreet's application of her father's trope of familial competition within the quaternions was evidently acceptable – indeed, complimentary – 'To her most Honoured Father' also provides a brief but tantalising glimpse of another context in which pursuing such ideas would have been much less tolerable. Bradstreet's remark that the subjects of her own poems might seem to 'claime precedency' over her father's on grounds of 'age', 'worth' and 'quality' momentarily hints at a competitive instinct which would not have been out of place in the masculinist manuscript coteries of the universities or the Inns of Court, but would have been thoroughly unacceptable within a father–daughter relationship premised on an unchallengeable hierarchy of age and sexual difference.[54] Though Bradstreet immediately retreats into the modesty topos, disparaging her own poems as fit only to be her father's 'bounden handmaids', her moment of self-promotion offers a useful reminder that there were certain kinds of poem she could not permissibly write within these gendered conditions of manuscript exchange. A truly competitive poem which refused the role of 'bounden handmaid' would have been out of the question as a gift from Anne Bradstreet to Thomas Dudley, and would have been a most unlikely inclusion in any print collection overseen by John Woodbridge.[55]

It is sometimes assumed that Bradstreet wrote 'To her most Honoured Father' to accompany all four of the quaternions. In fact, however, as Elizabeth Wade White points out, all the references in this dedicatory poem relate specifically to the first two quaternion poems, 'The Foure Elements' and 'Of the foure Humours in Mans Constitution', making no mention of the latter two, 'The Four Ages of Man' and 'The four Seasons of the Yeare'.[56] The competitive structure which Bradstreet attributes to

[54] Compare Round, *By Nature and By Custom Cursed*, p. 175; Gray, *Women Writers and Public Debate*, pp. 165–66.

[55] Bradstreet's construction of her poems as filial homage to her father may also help to account for her otherwise rather puzzling denial, in 'To her most Honoured Father', that the 'Elements' and 'Humours' poems are indebted to Du Bartas (*The Tenth Muse*, p. 2). The link with Du Bartas, though not as strong as is sometimes suggested, clearly exists, and was recognised by Ward and the anonymous anagrammatists. Within the textual context which produced the 'Elements' and the 'Humours', however, there seems to be room for only one male influence on Bradstreet's poems – Dudley's. Borrowing from Du Bartas (had it occurred) is depicted as theft, for which Dudley – a long-serving judge in the Massachusetts colony – would have been expected to mete out due 'reward'.

[56] White, *Anne Bradstreet*, pp. 179, 181.

her 'fours' poems is a feature only of the first two quaternions, and her paraphrase on the content of the poems –

> My first do shew, their good, and then their rage,
> My other four, do intermixed tell
> Each others faults, and where themselves excell
> 'To her most Honoured Father'

– not only relates specifically to the subject matter of the 'Elements' and 'Humours' poems but also implies ('My other four') that at the time of writing only two quaternions were in existence.[57] This detail matters in part because it helps to establish that Bradstreet's dedication of the quaternions to Dudley was not a one-off event but formed part of an extended textual exchange between father and daughter. The fourth quaternion, 'The four Seasons of the Yeare', concludes with an eight-line dedicatory envoy signed 'Your dutifull Daughter'.[58] The likely implication is that the latter two sequences – the 'Ages' and the 'Seasons' – were also written for presentation to Dudley, presumably after favourable reception of the first two.[59] A continuing process of composition, dedication, approval and renewed composition is thus implied.

The original application of 'To her most Honoured Father' only to the first two quaternions is also significant, however, because it lends extra credibility to the claim that Bradstreet herself was not involved in the publication of *The Tenth Muse*. 'To her most Honoured Father', read closely, relates specifically to the *manuscript* transmission of Bradstreet's quaternions, rather than to their further circulation in print. Alluding only to the 'Elements' and 'Humours' poems, it does not actually perform the function implied by its location within the print volume: namely, introducing the entire sequence of quaternions. Had Bradstreet herself had a role in the print-publication of *The Tenth Muse*, she would surely have either written a new dedicatory poem, relevant to all four quaternions, or made suitable revisions to 'To her most Honoured Father'. The clumsy use of 'To her most Honoured Father' to perform a function for which it is not properly fitted suggests instead that *The Tenth Muse* was prepared for

[57] *The Tenth Muse*, p. 2. She also glosses the poems as depicting 'the hot, the cold, the moist, the dry, / That sinke, that swim, that fill, that upwards flye' (p. 1) – again alluding only to the elements and humours poems.

[58] *The Tenth Muse*, p. 64.

[59] The envoy, like 'To her most Honoured Father', also seems to have been written to accompany only two of the four quaternions: presumably in this case 'The first' ('The Four Ages of Man') and 'The last' ('The four Seasons of the Yeare'), though see below.

publication by persons other than the author, who might presume to tweak but not rewrite sections of Bradstreet's poetry.[60]

Though most scholars have accepted John Woodbridge's claim that he, not Bradstreet, was responsible for the print-publication of *The Tenth Muse*, the textual extent and implications of his role within the volume have not, to date, been completely explored. Since we lack any prepublication manuscripts of Bradstreet's *Tenth Muse* poems, we can only speculate about what Woodbridge – perhaps working with Nathaniel Ward, or his own younger brother, Benjamin – may have done to edit them for print. There are, however, a few suggestive pieces of evidence to be gleaned from the shape, structure and consistency of the *Tenth Muse* volume itself. As even a cursory examination of its contents will reveal, *The Tenth Muse* shows signs of careful organisation.[61] The preliminary paratexts, as we have seen, perform a diverse array of mediatory functions: flagging up Bradstreet's sex and her exotic location, emphasising both her modesty and her learning, and alerting the reader to some of the key contents of the volume. Following the dedicatory verses, the main body of poetry in *The Tenth Muse* consists of the four quaternions, the 'Foure Monarchies', the 'Dialogue between Old England and New', elegies on Sir Philip Sidney, Du Bartas and Queen Elizabeth and a paraphrase of David's lament for Saul and Jonathan, and a final poem in the spirit of Ecclesiastes, 'Of the vanity of all worldly creatures'. The shape of the volume thus manifests a clear pattern, beginning with the philosophical poems (the first two quaternions) which establish Bradstreet's poetic and intellectual competence, addressing more overtly political concerns in the later quaternions and the 'Foure Monarchies', rising to a height of public engagement in the 'Dialogue between Old England and New' and the elegies, and then withdrawing into disengagement from earthly concerns in 'Of the vanity of all worldly creatures'. The location of the two biblically inspired poems, 'David's Lamentation' and 'Of the vanity of all worldly creatures', also

[60] Evidence of 'tweaking' can be inferred from lines 11–12 of 'To her most Honoured Father', which in *The Tenth Muse* read: 'I bring my four; and four, now meanly clad, / To do their homage unto yours most glad'. Probably Bradstreet's original manuscript version of line 11 read 'I bring my four and four, now meanly clad' [i.e. the 'Elements' and the 'Humours'], and was repunctuated in *The Tenth Muse* to make each incidence of 'four' seem applicable to the whole quaternion sequence. Significantly, in the 1678 *Several Poems*, which may incorporate revisions by Bradstreet herself, line 11 is changed to 'I bring my four times four', which clearly does refer to all four quaternions. The discrepancy in the 1650 version of line 11 is noted by McElrath and Robb (*Complete Works*, pp. xxxiii–xxxiv), who make this one of only two exceptions to their strict policy of using *The Tenth Muse* as copy text wherever possible.

[61] On this point, see also Wiseman, *Conspiracy and Virtue*, p. 208.

ensures that a volume which does not otherwise foreground devotional material nonetheless culminates with a solidly religious conclusion.

Although not all of the poems in *The Tenth Muse* are explicitly on public themes, all – even 'To her most Honoured Father' – can plausibly be described as outward-facing. The absence of personal material, such as the poems to her husband and elegies on her grandchildren included in *Several Poems*, is well known and, as already noted, is key to the low regard in which *The Tenth Muse* has often been held. However, what has often passed unnoticed in Bradstreet scholarship is that at least some of her more personal poetry does in fact predate the publication of *The Tenth Muse* in 1650. Among the items first published in *Several Poems*, for instance, are an epitaph on Bradstreet's mother, who had died in 1643, as well as a poem on an illness undergone by Bradstreet herself in 1632. 'Before the Birth of one of her Children' is also likely to be an earlier poem, since all but one of Bradstreet's eight children were born before 1650, and it is also possible that such undatable poems as the 'Contemplations', the letters to her husband, and 'To her Father with some verses' may date from the 1630s or 40s. When these anomalies are borne in mind, it becomes apparent that the much remarked-on dichotomy between public and private poems in Bradstreet's oeuvre does not, after all, reflect a division between her early poetry – public, didactic, and still obsessed with Europe – and the later, more American poems of her maturity, but is instead a construct of print-publication. In short, the reason why there are no personal poems in *The Tenth Muse* is not because Bradstreet had not yet started to write them, but rather because personal materials have been consistently excluded from the volume.

Recognising *The Tenth Muse* as a selected rather than a collected volume of Bradstreet's early poetry casts Woodbridge's prose preface back under the spotlight. Attempting to explain how Bradstreet's poems have come to be printed, contrary to her wishes, Woodbridge claims that the present volume is intended to forestall the efforts of 'divers' who might have 'sent forth broken peices to the Authors prejudice ... as well as to pleasure those that earnestly desired the view of the whole'.[62] Clearly 'the whole' is not quite what *The Tenth Muse* provides, though whether Woodbridge himself was aware of the discrepancy is impossible to say. It is possible that Woodbridge did not enjoy access to the full range of his sister-in-law's poems and that some other agent – perhaps Thomas Dudley, Simon Bradstreet, or even Anne Bradstreet herself – was responsible for excluding

[62] *The Tenth Muse*, sig. 3v.

personal items from that portion of her oeuvre released for manuscript circulation. However, given the close family relationships between the Woodbridges, Dudleys and Bradstreets, and the likelihood that John and Mercy Woodbridge continued to receive poetry by Bradstreet even after their removal to England, it seems more probable than not that John Woodbridge did have access to his sister-in-law's private as well as public poems, and that the decision to exclude the former from *The Tenth Muse* was his.[63] This would also be consistent with the evidence *The Tenth Muse* otherwise provides of Woodbridge's concern to manipulate both the texts and paratexts of the volume: shaping readers' expectations, forestalling objections, fashioning the complex print identity of Bradstreet as the Tenth Muse.

Some of the more obviously unfinished or discrepant aspects of *The Tenth Muse* make rather more sense if we see the compilation and organisation of the volume not as the carefully planned work of the poet herself, or even of a meticulous and textually scrupulous editor, but as a much more broadly conceived enterprise, the execution of which is often surprisingly careless or makeshift. I have already noted the not-quite-appropriate use of 'To her most Honoured Father' as an introduction to the whole series of quaternions, but the envoy to the sequence has a still less precise and accurate relationship with the poems it is supposed to accompany ('The Four Ages of Man' and 'The four Seasons of the Yeare'). The envoy's depreciation of the 'Ages' and 'Seasons' – 'My Subjects bare, my Brains are bad'; 'The last, though bad, I could not mend' – goes beyond the conventional deployment of the modesty topos into sheer inaccuracy, since there is nothing obviously bare about the ages of man or the seasons of the year as poetic subjects, and nothing obviously inadequate about the execution of the final quaternion.[64] What *is* obviously inadequate is the envoy itself, which is a surprisingly amateurish piece of verse in comparison with 'To her most Honoured Father', and reads as if it has been inserted in the volume merely on account of its strategic function, with little regard to its poetic merits. Similarly, the gloss on the four monarchies incorporated towards the end of Bradstreet's third monarchy – comparing the Assyrian, Persian, Greek and Roman monarchies at some length both to the four kingdoms of Daniel 2 and the four

[63] On the likely transatlantic transmission of 'David's Lamentation', see White, *Anne Bradstreet*, pp. 246–48.

[64] *The Tenth Muse*, p. 64. One might suspect 'bare' of being a punning reference to the final season described before the envoy – winter – but in fact Bradstreet's 'Winter' poem ends with the return of the 'golden Sun', heralding the return of spring.

beasts of Daniel 7 – seems oddly out of place, and would have made much better sense as part of a conclusion to the 'Monarchies' sequence as a whole.[65] If, as seems likely, the Daniel references are indeed misplaced in the printed version of 'The Foure Monarchies', their current location must be due to an editor who, for reasons of his own, did not want to include them in their natural position, at the end of the Roman monarchy.

Perhaps the most puzzling discrepancy in the organisation of *The Tenth Muse* – and one of the most intriguing clues to the prepublication circulation of Bradstreet's poetry – is her short poem 'The Prologue'. 'The Prologue' is now best known for its apparently protofeminist defence of Bradstreet's poetic activities against 'each carping tongue, / Who says, my hand a needle better fits'.[66] As such it does perform an important 'prologue' function: a point worth stressing, since Woodbridge's editorial interventions in the volume might plausibly have included the provision of titles for poems. Less clear, however, is which of Bradstreet's poems it was originally intended to introduce. Although located immediately before 'The Foure Elements' in *The Tenth Muse*, the poem makes no direct reference to the topics of the four quaternions, though its second stanza does pay a graceful tribute to Du Bartas, whose poetic influence on Bradstreet is most apparent in 'The Foure Elements' and 'The foure Humours'. The fact that its opening stanza explicitly disclaims any ambition to 'sing of Wars, of Captaines, and of Kings, / Of Cities founded, Common-wealths begun' has led some critics to argue that 'The Prologue' is, in fact, an ironic introduction to 'The Foure Monarchies', which addresses almost exactly the range of subjects this formulation disavows.[67] My own view is that Bradstreet's disclaimer is too absolute to be plausibly ironic, and if 'The Prologue' is indeed connected with any specific poems within *The Tenth Muse*, it is likely to be the quaternions, if only on grounds of the Du Bartas link. The connection, however, is far from certain, and it is equally possible that 'The Prologue' was written as a more general vindication of Bradstreet's poetic practice, without an intended application to any specific poems. Either way, 'The Prologue' unquestionably reads oddly in a volume which

[65] *The Tenth Muse*, pp. 173–74. The discrepant lines run from 'Thus Kings, and Kingdoms, have their times, and dates' to 'All trembling stand, before that powerfull Lambe'. Compare McElrath and Robb in Bradstreet, *Complete Works*, p. xxx.

[66] *The Tenth Muse*, p. 4.

[67] *The Tenth Muse*, p. 3; Jane Donahue Eberwein, '"No rhet'ric we expect": Argumentation in Bradstreet's "The Prologue"', *Early American Literature*, 16.1 (1981), 19–26 (pp. 19–20); compare Gray, *Women Writers and Public Debate*, p. 173.

also incorporates 'The Foure Monarchies', and its inclusion in *The Tenth Muse* – its position implying a function which its content does not clearly fulfil – reads best as yet another instance of imprecise practice by a compiler whose chief editorial priorities lay elsewhere.

Another inconsistency in 'The Prologue' is its allusion to a 'carping' audience clearly at odds with the supportive familial readership described in 'To her most Honoured Father'. The audience constructed by 'The Prologue' perceives Bradstreet solely in terms of her sex, and rejects out of hand her ability to write good poetry:

> A Poets Pen, all scorne, I should thus wrong;
> For such despight they cast on female wits:
> If what I doe prove well, it wo'nt advance,
> They'l say its stolne, or else, it was by chance.
> 'The Prologue'[68]

If the disparaging audience Bradstreet adduces in these lines refers to genuine contemporary readers and is not just a rhetorical construct, then the obvious implication is that 'The Prologue' stems from an intermediate stage in the circulation of Bradstreet's poetry, when it had passed beyond the encouraging and approving milieu of her own immediate family into a more extensive network of manuscript transmission. This more dispersed readership appears to have taken a much less positive view of female capabilities; its disfavour, as paraphrased in 'The Prologue', is premised on the assumption that Bradstreet's sex automatically precludes her from writing well. This is likely to be much the same stage in the manuscript transmission of Bradstreet's poetry as is adumbrated by Woodbridge in his prose epistle; and although the poet's own account of a 'carping' readership diverges obviously from Woodbridge's claim that prepublication readers of Bradstreet's poems had 'affected them wel', there are interesting convergences between her own self-construction in 'The Prologue' and the description of poet and poetry promulgated by Woodbridge in the paratexts to *The Tenth Muse*. The acknowledgement of Du Bartas as a poetic role model is one point of similarity, despite the differing views of Bradstreet and her commenders as to how well they think she follows the Frenchman's example. Bradstreet's skilful use of rhetoric and adept deployment of classical references, furthermore, amply fulfil the prefacewriters' claims about her as a learned poet; 'The Prologue' shows her to be fully at ease in comparing herself – modestly, of course – to 'that fluent sweet-tongu'd Greek', Demosthenes, and debating the Greeks' attitude to

[68] *The Tenth Muse*, p. 4.

poetry. Her culminating plea to the 'high flown quills, that soare the skies' to grant her a 'wholsome Parsley wreath' in place of the traditional 'Bayes' also recalls Woodbridge's insistence that Bradstreet's poetic and intellectual activities have not in any way compromised her diligence in managing her household.

Like so much else in the arrangement of *The Tenth Muse*, the positioning of 'The Prologue' is locally anomalous but strategically adroit. While its precise introductory role within Bradstreet's oeuvre is unclear, the poem nonetheless serves several key functions within the *Tenth Muse* volume. Originally written to vindicate Bradstreet's poetic practice against the aspersions of some of her manuscript readers, it is equally effective in anticipating and refuting misogynistic responses from a print readership. By consolidating the image of the poet posited by Woodbridge in his prefatory pretexts, it also confirms her authority to express informed and well-reasoned views on literary, cultural and political issues. The unspoken corollary is that these views – though ostensibly those of an obscure and modest American poetess – carry the implicit endorsement of the New England community that has produced both her and *The Tenth Muse* itself. The assorted men who so ostentatiously usher Bradstreet's writings into print not only explicitly legitimise her as a woman poet, but also implicitly endorse the views expressed in her texts.

BRADSTREET, READERSHIP AND VERSE HISTORY

Family and coterie networks were not the only influences which shaped Bradstreet's writing. Bradstreet is a visibly bookish writer whose poetry draws variously on sources ranging from poets such as Du Bartas, Sidney, Spenser and Sylvester, to contemporary science writers such as the physiologist Helkiah Crooke, and ancient and modern historians such as Plutarch, Raleigh, Pemble and Ussher. The Bible, unsurprisingly, was a powerful influence on her work, its effects only most obvious in overtly scripture-based poems such as 'David's Lamentation', and 'Of the vanity of all worldly creatures'. Bradstreet's immersion in Old World, male-authored literature, though not always treated kindly by modern criticism, would undoubtedly have helped to recommend her poetry to its earliest audiences, and studies of her reading are likely to form a key area in future scholarship on her work.

Bradstreet's most ambitious exercise in the transformation of printed sources was her lengthy historical poem 'The Foure Monarchies'. As already noted, however, 'The Foure Monarchies' has long been regarded

as the least successful of Bradstreet's poems. Many critics dismiss the entire project of the poem as misconceived, and even those who take a more charitable view of its intellectual remit tend to take a dim view of its poetic execution. Elizabeth Wade White describes 'The Foure Monarchies' as 'a barren exercise in rhetorical ingenuity, unreadable by present-day standards', and even Sue Wiseman, otherwise one of the poem's most sympathetic critics, feels obliged to admit to its 'intermittently dull metre'.[69] The most interesting recent attempt to account for the unpopularity of 'The Foure Monarchies' comes from Jane Eberwein, another largely sympathetic witness who nonetheless seems to share the widespread critical dissatisfaction with Bradstreet's longest poem. Eberwein's assessment attributes the failure of 'The Foure Monarchies' to one crucial factor – the impersonality of its narrative voice:

What 'Monarchies' has been universally condemned as lacking – in contrast to 'Contemplations', the marriage poems, the domestic elegies, and even the quaternions – is evidence of the author's presence. Bradstreet has proven herself over the centuries a personable and admirable woman. Readers study her poems for witness to the tensions and conflicts this articulate Puritan woman experienced on the early Massachusetts frontier. Yet we fail to hear the poet's own voice in her verse history, and we miss the energy imparted to other *Tenth Muse* poems ... by explicit presentation of contending interests. In comparison with Bradstreet's most popular poems, 'Monarchies' seems pallid despite its sensational subject matter and disappointing in its impersonal attempts at objectivity.[70]

Eberwein's analysis, plausible in many ways, is problematic in others. Her discussion is premised on long-standing attitudes to women's writing which privilege the personal, the spontaneous and the autobiographical in preference to the public, the considered or the intellectual. Such attitudes are still common in scholarship in women's writing and, while sometimes tacit or unconsidered, can also be adopted as a matter of feminist principle. Yet they are troubling in many ways, not least because they collude, often inadvertently, with older conceptions of women as less intellectually adept than men. If the critical disfavour suffered by 'The Foure Monarchies' is indeed due in part to preconceptions such as these, then there is all the more reason why the poem should now be reappraised. Twenty-first-century readers should be no less willing than their

[69] White, *Anne Bradstreet*, p. 236; Wiseman, *Conspiracy and Virtue*, p. 189.
[70] Jane Donahue Eberwein, 'Civil War and Bradstreet's "Monarchies"', *Early American Literature*, 26.2 (1991), 119–44 (p. 120).

seventeenth-century predecessors to appreciate the breadth of Bradstreet's reading and the intellectual ambition of her writing.

However, another issue – which critics who read Bradstreet's poetry primarily from a 'women's writing' perspective may be apt to overlook – concerns the genre of 'The Foure Monarchies'. Verse history, popular in England during the early modern period, subsequently fell out of fashion, and has never fully returned to critical favour. Other practitioners of the form besides Bradstreet have had their works ignored, or dismissed as misconceived efforts in an impossibly hybrid genre. Thus Samuel Daniel, whose verse history *The Civil Wars* (1595–1609) is a close generic analogue of 'The Foure Monarchies', was scorned even in his own time as 'too much historian in verse', and has subsequently earned (in Arthur Freeman's words) 'the questionable honor of being considered either as the most historical of English poets or the most poetical of English historians (a fact which has done little to enhance his reputation as either a poet or a historian)'.[71] To do Bradstreet justice, we need to recognise that the reputation of 'The Foure Monarchies' has suffered not only on gendered but also on generic grounds. It is not just that verse history has been regarded as an unsuitable genre for a woman poet, but also that it has often been regarded as an inherently unstable and unsatisfactory genre which wise poets of both sexes should have known to avoid.

It may be too late to restore either verse history or 'The Foure Monarchies' to critical popularity, but if we are to appreciate what is at stake in Bradstreet's most ambitious poem, then reading her text through the lens of genre is an essential prerequisite. 'The Foure Monarchies' can best be understood not merely as a verse history, but as a rare belated example of a subgenre which began to emerge at the end of the sixteenth century, now known as 'politic history'. Politic history was defined by Fritz Levy, who popularised the term, as 'a new form of history writing whose usual characteristics were a laconic and epigrammatic style, a radical condensation of subject matter, and, most important, an insistence that the purpose of writing history was to teach men political wisdom'.[72] Levy describes the intellectual fashion for politic history as being 'of brief duration[:] Sir John Hayward's *Henrie IIII*, of 1599, was the first such book in English; before 1640 decline had set in badly, and ... the vogue

[71] Arthur Freeman, 'The Historical Thought of Samuel Daniel: A Study in Renaissance Ambivalence', *Journal of the History of Ideas*, 32.2 (1971), 185–202 (p. 185). The contemporary verdict is Michael Drayton's (cited Joan Rees, *Samuel Daniel: A Critical and Biographical Study* (Liverpool University Press, 1964), p. 134).

[72] F. J. Levy, *Tudor Historical Thought* (San Marino, CA: Huntington Library, 1967), p. 237.

may be said to have ended there'.[73] Bradstreet's experiment in a form which, when she began the poem in the 1640s, was already obsolescent may be attributed to her remote location in New England, but can more plausibly be read as another aspect of the cultural nostalgia which also led her to elegise Philip Sidney, Du Bartas and Queen Elizabeth. It is a deliberate harking back to the intellectual, political and moral values associated with an earlier, pre-Stuart period in English history.

A comparison between 'The Foure Monarchies' and 'politic history', following Levy's definition, throws up some interesting results. One aspect of politic history clearly adopted in 'The Foure Monarchies' is its 'radical condensation of subject matter'. Although readers of 'The Foure Monarchies' frequently complain about its length, the *c.* 3,500 lines of Bradstreet's poem are small change compared with the many hundreds of closely printed folio pages included in its principal source text, Raleigh's *The History of the World*.[74] Whereas Raleigh's vast text, as its title implies, aims to survey nothing less than the history of human civilisation, Bradstreet's reworking of his material is highly and very carefully selective. Rather than simply following copy, Bradstreet has meticulously extracted from Raleigh's history only those elements relevant to her chosen subject: the story of the Assyrian, Persian, Greek and Roman monarchies. Given that Raleigh's history does not itself separate out 'the four monarchies' as a distinct narrative unit, this process would have required Bradstreet herself to reconstruct the course of monarchical history at several key moments in her story; a case in point is the transition from Ninias to Sardanapalus, where source materials for two reigns, consecutive in 'The Foure Monarchies', have been drawn from widely disparate sections of *The History of the World*.[75] The unity and focus of Bradstreet's subject matter – the key characteristics which identify her poem as a politic history – are by no means 'found' qualities, pre-existing in her source: they have been constructed by the poet herself.

Reading 'The Foure Monarchies' as politic history casts new light on many of the 'faults' which generations of Bradstreet critics have detected in the poem. Take, for example, the issue of 'impersonality' raised by Eberwein. Clarifying her claim that 'the author's presence' is missing from the poem, Eberwein explains:

[73] Levy, *Tudor Historical Thought*, p. 252.
[74] Noted also by Eberwein, 'Civil War and Bradstreet's "Monarchies"', p. 129.
[75] *The Tenth Muse*, pp. 80–81 [*sic*, for 70–71]; Raleigh, *The History of the World* (1614), sigs X3r–4r, and Bbb5r.

It is not as though 'Monarchies' lacks a narrator's first-person voice, just that the speaker cannot be recognized as Bradstreet. When she second-guesses her sources with parenthetical asides ... she can be quite charming until the reader discovers that almost all these statements of supposedly independent judgement actually paraphrase her principal source, Sir Walter Ralegh's *History of the World*.[76]

One such parenthetical aside occurs towards the end of Bradstreet's account of King Nebuchadnezzar of Babylon. After tracing Nebuchadnezzar's recovery from seven years of madness, Bradstreet concludes that the king:

> The time expir'd, remains a Beast no more,
> Resumes his Government, as heretofore,
> In splender, and in Majesty, he sits,
> Contemplating those times he lost his wits;
> And if by words, we may guesse at the heart,
> This King among the righteous had a part ...
> 'The Foure Monarchies'[77]

The equivalent passage in Raleigh reads as follows:

Seven years expired, it pleased God to restore Nabuchodonosor, both to his understanding, and his estate, for which hee acknowledged and praised God all the rest of his life, confessing his power and everlasting being; that he was the Lord of heaven and earth, and wrought without resistance what he pleased in both; that his works were all truth, and his waies righteous. Which gave argument to many of the Fathers, and others, not to doubt of his salvation ...

Raleigh, *History*, sigs Bbbb5r–v

The point to be made here is not merely that Bradstreet's rendering of Nebuchadnezzar's latter days implies a personal judgement ('if by words, we may guesse ...') where there is none in Raleigh. Eberwein admits of exceptions to her claim ('almost all'), and there are many other occasions in 'The Foure Monarchies' where apparently personal asides do indeed largely reproduce precedents in *The History of the World*. More significant is the question of exactly what role personal judgement should properly play in a text such as 'The Foure Monarchies'. Much as some readers may regret her absence, the biographical Bradstreet would have been a wholly unsuitable presence within a politic history. This is not simply because historiography was assumed to be a masculine pursuit in early modern England (although it was – Levy's classic study of the genre does not

[76] Eberwein, 'Civil War and Bradstreet's "Monarchies"', p. 121.
[77] *The Tenth Muse*, p. 83.

include a single female writer).[78] More importantly, it is because the
'I' narrator typical of politic history is rarely a biographically individuated
figure, outside paratextual matter such as prefaces and title pages. What
matters in the 'I' of politic history is not the biographical baggage which he
or she (overtly at least) brings to the task, but rather the qualities of
discrimination, political judgement and apt expression which are manifest
in the narrative. The very invisibility of Bradstreet within 'The Foure
Monarchies' – the difficulty of distinguishing her own self-generated
parenthetical asides from those others which are recastings of Raleigh –
contributes to the success of the poem as politic history. Her succinct,
epigrammatic judgement on Nebuchadnezzar may not show the personal
touch that some modern readers would like to see, but the wit and
analytical discernment it displays are entirely appropriate to her chosen
genre.

 Why does it matter whether we read 'The Foure Monarchies' as politic
history? It matters because of the final rider in Levy's definition: his claim
that the 'most important' characteristic of this form of historiography was
'an insistence that the purpose of writing history was to teach men political
wisdom'. But what lessons in political wisdom might the Bradstreet of 'The
Foure Monarchies' have wanted to teach? One possible clue is provided by
the overall shape of the poem: specifically, the selection and definition of its
beginning and end.[79] From all the voluminous materials available in *The
History of the World*, Bradstreet has chosen to begin her poem with
Nimrod: proverbial in the seventeenth century as the first tyrant in human
history. Her opening lines stress that Nimrod's reign sees the end of the
'Golden Age' and the onset of a period when 'striv[ing] for Soveraignty' is
the expected norm.[80] At the other extreme, the poem ends with the fall of
the Roman monarchy – described, significantly, as 'the fourth and last'.[81]
Bradstreet's account of the Roman kings, one of the hastiest sequences in
'The Foure Monarchies', comes to an abrupt conclusion after the suicide of
Lucretia, when Collatine, her widower, and Junius Brutus intervene to
force Tarquin and his family into exile:

> The Tarquins they from Rome with speed expell,
> In banishment perpetuall, to dwell;

[78] It does, however, include discussion of *The History of ... Edward II*, here ascribed to Edward Cary
but now generally attributed to Elizabeth Cary (Levy, *Tudor Historical Thought*, pp. 270–71).

[79] On the political significance of the shaping of 'The Foure Monarchies', see also Wiseman,
Conspiracy and Virtue, pp. 190–95 and Suzuki, 'What's Political', pp. 931–36.

[80] *The Tenth Muse*, p. 65. [81] *The Tenth Muse*, p. 179.

The Government they change, a new one bring,
And people sweare, ne're to accept of King.
'The Foure Monarchies'[82]

Succinct as it is, this passage puts its own subtly different gloss on events as described by Raleigh:

Junius Brutus by the helpe of Collatine, having expelled Tarquine, and freed his countrey from that heavie yoake of bondage, inforced the people by solemne oath, never to admit any government by Kings amongst them: whereupon they ransacked their Kings goods, consecrated their fields to Mars, and conferred the government of the State upon Brutus and Collatine.

Raleigh, *History*, sig. Bbbbb3r

Bradstreet's version strips out all extraneous details: perhaps surprisingly, Raleigh's reference to the 'heavie yoake of bondage' suffered by the Romans under Tarquin's rule; more instructively, his account of the looting and profiteering that follows Tarquin's fall. By comparison, Bradstreet's version is clean and clinical, with nothing permitted to distract from the central fact of the deposition or to compromise the protagonists' motives. Also worth noting are her revisions to Raleigh's account of the oath sworn by the people to mark the change in government. Whereas in Raleigh the people are 'inforced' to swear by Brutus and Collatine, who are clearly the moving spirits in the revolution, Bradstreet represents a rather differently balanced situation, where the aristocracy are undoubtedly in the vanguard of change, but are politically at one with and enthusiastically supported by the people at large. This unity of purpose between the aristocracy and the population as a whole, resisting the excesses of the royal prerogative, has obvious analogies in seventeenth-century England; it is very much how classically minded supporters of the parliamentary side in the Civil Wars liked to conceptualise their own position.[83]

A full-scale comparison between 'The Foure Monarchies' and *The History of the World* would be an enormous task, and is considerably beyond the scope of this chapter. However, a comparative analysis of two key passages provides useful insights into Bradstreet's politically tendentious rewriting of Raleigh. Both passages concern the Persian king Darius Hystaspes, who, it should be noted, is one of the more favourably represented of Bradstreet's kings. Darius's accession to the throne is

[82] *The Tenth Muse*, p. 179.
[83] Zera Fink, *The Classical Republicans* (Evanston, IL: Northwestern University Press, 1945), esp. pp. 23–24, 45–46.

controversial, and Bradstreet's account of his early reign focuses on the
various means through which he seeks to secure his grip on power:

> Darius by election made a King,
> His title to make strong omits no thing;
> He two of Cyrus Daughters now doth wed,
> Two of his Neeces takes to nuptiall bed;
> By which he cuts their hopes (for future times)
> That by such steps to Kingdoms often climbs.
> And now a King, by marriage, choyce, and bloud,
> Three strings to's bow, the least of which is good;
> Yet more the peoples hearts firmly to binde,
> Made wholsome gentle Laws, which pleas'd each mind.
> 'The Foure Monarchies'[84]

A comparison with *The History of the World* reveals that Bradstreet, though
drawing her principal facts from Raleigh, has substantially developed his
political analysis, in a manner typical of politic history:

… by strong hand he obtained the Empire, which he the more assured to himselfe
by taking two of Cyrus Daughters, and as many of his Neeces for his wives …

Darius devised equall lawes whereby all his subjects might bee governed, the same
being formerly promised by Cyrus.

> Raleigh, *History*, sig. Dddd6v

Bradstreet has not only clarified how Darius's marriages strengthen his grip
on power, but has also introduced a markedly *realpolitik* explanation of the
new king's legal reforms. In Raleigh, Darius's 'equall lawes' are represented
in comparatively innocent terms as the fulfilment of a promise by a
previous king. Bradstreet's reworking of events, however, emphasises the
political advantage to Darius in enacting these new laws, which she depicts
as a means of winning popularity and gaining the love of the people. The
apparent fair-mindedness of even a good king, on Bradstreet's account,
cannot be taken at face value. When possession of the kingdom is at stake,
justice itself can be a mask for royal self-interest.[85]

Even more revealing than Darius's efforts to consolidate his grip on
power, however, is Bradstreet's description of how that power was origin-
ally gained. Darius Hystaspes makes his first appearance in 'The Foure
Monarchies' at a point where the former king, Cambyses, has died without
leaving an obvious heir to the throne. Darius is one of seven princes who

[84] *The Tenth Muse*, p. 94.

[85] Bradstreet's 'politic' account of Darius's accession may have been influenced by Daniel's *The Civil
Wars*, which makes a similarly cynical assessment of Henry IV's attempts to secure his possession of
the throne. See Samuel Daniel, *The Civil Wars* (1609), Book 3, stanzas 2–3, 10.

meet during the 'inter-regnum' to deliberate the future government of the empire. Initially, their discussions focus not on the narrow question of who should replace Cambyses as king, but on the broader issue of what form of government the Persian state should now adopt:

> All things in peace, and Rebells throughly quell'd,
> A Consultation by the States was held.
> What forme of Government now to erect,
> The old, or new, which best, in what respect,
> The greater part, declin'd a Monarchy.
> So late crusht by their Princes Tyranny;
> And thought the people, would more happy be,
> If governed by an Aristocracy.
> But others thought (none of the dullest braine,)
> But better one then many Tyrants reigne.
> What arguments they us'd, I know not well,
> Too politicke (tis like) for me to tell,
> But in conclusion they all agree,
> That of the seven a Monarch chosen be;
> All envie to avoyd, this was thought on,
> Upon a Green to meet, by rising Sun;
> And he whose Horse before the rest should neigh,
> Of all the Peers should have precedency.
> They all attend on the appointed houre,
> Praying to Fortune, for a Kingly power;
> Then mounting on their snorting coursers proud,
> Darius lusty stallion neighed full loud;
> The Nobles all alight, their King to greet,
> And after Persian manner, kisse his feet.
> His happy wishes now doth no man spare,
> But acclamations ecchoes in the aire;
> A thousand times, God save the King, they cry,
> Let tyranny now with Cambyses dye.
> They then attend him, to his royall roome,
> Thanks for all this to's crafty Stable-groome.
> 'The Foure Monarchies'[86]

Bradstreet's version of events represents a highly selective reworking of the equivalent passage in *The History of the World*, which occupies most of a chapter. One immediately obvious difference between the two versions is that Raleigh is distinctly less coy than Bradstreet in outlining the part played by Darius's stable-groom in ensuring his master's accession to the throne. Raleigh explains:

[86] *The Tenth Muse*, pp. 93–94.

[I]t is said that Darius consulted with the Master of his horse Ocharus, who in the Suburbs of the Citie when the election was resolved of, caused the same Horse, whereon in the morning Darius was mounted, to cover a Mare, who as soone as he came into the same place was the first horse that brayed.

<div align="right">Raleigh, History sig. Dddd6r</div>

Sex is the secret reason for Darius's success; his horse 'bray[s]' because Ocharus has primed him to associate the scene of this crucial political drama with the recent pleasures of 'cover[ing] a Mare'.[87] The contrast between Raleigh's candour and Bradstreet's discretion is scarcely surprising: one would not expect a modest puritan matron of the seventeenth century to provide explicit detail on such a racy subject. The point to be emphasised, however, is that despite her lack of detail, Bradstreet nonetheless clearly specifies that a deception has been practised ('Thanks for all this to's crafty Stable-groome'). The origins of even this relatively virtuous king are premised on fraud and dishonesty.

But the most critical area of comparison between these two passages concerns the arguments for and against choosing a new king. Here, as so often, Bradstreet's treatment of events is a radically selective version of the much more substantial account provided by Raleigh. Raleigh devotes four paragraphs of the *History* to expounding the arguments of three strategically contrasting interlocutors: Otanes, who 'did not fancie any election of Kings, but that the Nobilitie and Cities should confederate, and by just lawes defend their libertie'; Megabyzus, who argues that 'the tyrannie of a multitude was thrice more intolerable, than that of one', and thus 'thought it safest to make election of a few, and those of the best, wisest, and most vertuous'; and Darius himself, who 'perswaded the creation of a King', to prevent 'the discord of many Rulers'. Bradstreet's version in 'The Foure Monarchies', however, reduces this debate to just six pentameter lines ('The greater part ... many Tyrants reigne'), and distils Raleigh's not always clearly contrasting political options into just two: rule by an 'Aristocracy' or by a single person. The very brevity of her account throws into sharp relief the issue which her narrative construes as central to the argument – tyranny. It is because the Persians have been 'crusht' by the tyranny of the previous ruler, Cambyses, that they are now prepared to contemplate unconventional options for the future government of their country. But Bradstreet, selectively combining the arguments of Raleigh's Megabyzus and Darius, is clearly unconvinced that any system can be

[87] The ultimate source for this scurrilous anecdote is Herodotus's *Histories*; see *Herodotus*, trans. by A. D. Godley, vol. 2 (Cambridge, MA: Harvard University Press, 1982), pp. 113–15.

devised to guarantee the people's liberties. In her version, the dilemma facing the Persian princes – described in such lengthy detail by Raleigh – resolves into a stark choice between one tyrant or many. In describing the princes' eventual decision in favour of monarchy, she also omits Raleigh's gloss on this form of rule as 'Imperiall governement by God established, and made prosperous'. By contrast, however, her allusion to the 'acclamations' with which Darius's accession is greeted – 'A thousand times, God save the King, they cry, / Let tyranny now with Cambyses dye' – has no equivalent in Raleigh. This is Bradstreet's own addition, reminding her readers of the traditional, baleful association between monarchy and tyranny, in the very act of hoping that the new king, Darius, will bring this unhappy association to an end. As the remaining saga of 'The Foure Monarchies' grimly shows, this is a false hope.

THE MATERIAL MUSE

When we try to account for Anne Bradstreet's poetry in *The Tenth Muse*, at least two scenes of production need to be considered. The first is Bradstreet's home environment in colonial New England: the scene of her own poetic composition and early manuscript circulation. This is an environment which, as I have argued, not only cherished and stimulated Bradstreet's writing, but was also decisive in determining the poetic possibilities open to her. Bradstreet's 'politic' rewriting of Raleigh's *History of the World* in 'The Foure Monarchies' demonstrates beyond doubt that she was a politically astute reader, keenly attuned to the long-standing debates about government, monarchy, tyranny and liberty explored in Raleigh's text. There can also be little question as to the role of Bradstreet's family environment both in helping to construct the political ideology of 'The Foure Monarchies' and in ensuring its favourable reception and early circulation. The envoy to the third monarchy, enjoining 'What e're is found amisse, take in best part, / As faults proceeding from my head, not heart', implies that 'The Foure Monarchies', like the quaternions, was written for presentation to a reader – probably Thomas Dudley – whose authority to judge the political merits of Bradstreet's historical analysis is taken for granted.[88] We can safely assume that if Dudley and other members of Bradstreet's immediate circle had disapproved of its ideological tenor, further circulation of 'The Foure Monarchies' would have been quietly prevented. We can also, however, safely assume that, given the

[88] *The Tenth Muse*, p. 174.

compositional practice underlying 'The Foure Monarchies', family approval of its politics would have been more or less assured from the start. A poem based on Raleigh's *The History of the World* – a reputedly anti-monarchical work by a notoriously anti-Stuart writer – would never have been likely to present a favourable view of kingship or the royal prerogative. Bradstreet's sceptical redaction of the *History*'s political emphases is to some extent a matter of accentuating what, for those seventeenth-century readers familiar with Raleigh's reputation, was already present in her source. If we assume that Bradstreet obtained her copy of *The History of the World* through family agency, the role of the Dudley-Bradstreet circle in shaping the politics of 'The Foure Monarchies' becomes clearer still.

While in England, Thomas Dudley served as steward to the Earl of Lincoln, and was closely involved in the latter's resistance to Charles I's forced loan.[89] Dissatisfaction with the absolutist tendencies of Stuart government is the likely reason for his transatlantic emigration with his family – the move which enabled his daughter's later emergence as the 'Tenth Muse ... sprung up in America'. It is within this context of principled opposition to Stuart absolutism that Bradstreet's own poetic production was instigated and encouraged, and against which texts such as the nostalgic neo-Elizabethan elegies on Sidney, Du Bartas and Queen Elizabeth herself, the anti-tyrannical 'Foure Monarchies', and the pro-parliamentarian 'Dialogue between Old England and New' need to be read.[90]

Rather different considerations, however, apply in the second scene of production relevant to *The Tenth Muse*: the compilation and publication of the volume in London in 1650. Here the key figure to be considered is John Woodbridge, who was, like his father-in-law Thomas Dudley, involved in opposition to Charles I's policies, but whose reactions to the unexpected outcome of this opposition – the trial and execution of the king – are rather more difficult to trace. The best clue to Woodbridge's intentions in arranging the publication of Bradstreet's poetry is of course the volume itself, but the evidence provided by *The Tenth Muse* is, overall,

[89] See White, *Anne Bradstreet*, pp. 87–88, and Richard Cust, *The Forced Loan and English Politics, 1626–1628* (Oxford: Clarendon Press, 1987), p. 171. Cust notes that some of Charles I's opponents in the 1620s took comfort from Raleigh's 'The Prerogative of Parliaments' (pp. 155–56). Given the political awareness and personal history of many in Bradstreet's immediate circle, I am unconvinced by Eberwein's claim that it 'seems unlikely that Bradstreet recognized the subversive impact of her model [i.e. Raleigh]' (Eberwein, 'Civil War and Bradstreet's "Monarchies"', p. 141).

[90] To this list should also be added 'The Four Ages of Man', which inveighs against cavalier excesses ('Youth') and the anti-puritan policies of James I's and Charles I's governments ('Old Age'). The neo-Elizabethanism of *The Tenth Muse* is best surveyed in Gray, *Women Writers and Public Debate*, pp. 143–81.

surprisingly mixed. While personal motives – the desire to honour Brad-
street, their family and their New England community – undoubtedly
played a part in Woodbridge's decision to publish, the political objectives
underlying his very publicly orientated collection of his sister-in-law's
poems are much less clear. Although *The Tenth Muse* questions Stuart
government and royal absolutism, it is rather short on precise political
prescriptions for the future. 'The Foure Monarchies', which so assiduously
charts the inadequacies of kingly government, stops at the very moment
when the last Roman king is expelled; the foundation of the Roman
republic is neither explicitly mentioned nor held up as a political ideal.
The poem most directly concerned with the English crisis – the 'Dialogue
between Old England and New' – is ascribed to 1642 and advocates a
solution to 'the present troubles' – the reconciliation of Charles and his
'brave Nobles', and their joint implementation of a more godly form of
government – which by 1650 would have been all too obviously inapplic-
able. *The Tenth Muse* – clear in its critique of monarchical excesses – seems
somewhat at a loss in a world where monarchy is no more.

The Tenth Muse, in fact, refuses to offer either apocalyptic or political
solutions to the dilemmas confronting a post-monarchical nation. I have
already argued that the text of 'The Foure Monarchies' shows signs of
editorial rearrangement, with the biblical gloss on the four ancient king-
doms and the anticipated rule of 'that powerfull Lambe' displaced from its
obvious location at the end of the 'Monarchies' sequence as a whole and
instead embedded towards the end of the Greek monarchy. As a result,
'The Foure Monarchies' ends not with the apocalyptic denouement which
its title seems to anticipate – and which seems likely to have been
Bradstreet's own plan for the poem – but with the abrupt and directionless
termination of the Roman monarchy. This strategic rearrangement –
probably effected by Woodbridge – is followed by a sequence of poems
in which political solutions to the English political crisis are repeatedly
found wanting. The 'Dialogue' and the elegies for Sidney, Du Bartas and
Queen Elizabeth all speak to historic situations which, by 1650, no longer
apply. The penultimate poem in *The Tenth Muse*, 'David's Lamentation
for Saul, and Jonathan', also refuses to yield up a straightforward political
solution, though its emotional impact testifies strongly to the conflicted
loyalties which afflicted so many erstwhile critics of the English monarchy
in the late 1640s and beyond. Bradstreet's 'Lamentation' has sometimes been
read as a covert elegy for Charles I, and while the poem itself studiously
avoids contemporary references, it is hard to see how an early print readership
could have avoided drawing comparisons between the fallen Saul and the

executed Charles.[91] Yet while the application of 'David's Lamentation' to Charles undoubtedly suggests that Bradstreet – and Woodbridge – wanted to register sorrow at the execution, it by no means points towards a desired political outcome; neither condemnation of the execution itself nor approbation of the subsequent parliamentary regime is necessarily implied.

Insofar as *The Tenth Muse* does reach a resolution, it is not an otherworldly, apocalyptic resolution, following the Book of Daniel, or a this-worldly political conclusion, either endorsing parliamentary government or aspiring towards a reformed, less absolutist monarchy. Instead, the volume ends with the Christian consolation of another biblically inspired poem, 'Of the vanity of all worldly creatures'. Loosely following Ecclesiastes, Bradstreet rejects the supposed attractions of honour, riches, pleasure, beauty and wisdom, insisting that true comfort is to be found only through recourse to Christ, 'that living Christall fount'.[92] While this conclusion, on one level, undoubtedly marks a retreat from the political preoccupations which characterise so much of *The Tenth Muse*, eschewing resolution in the public sphere in favour of personal salvation in the individual soul, it is also significant that Bradstreet's salvific imagery is construed in strongly political terms:

> This pearl of price, this tree of life, this spring,
> Who is possessed of, shall reign a King.
> Nor change of state, nor cares shall ever see,
> But wear his Crown unto eternitie.[93]

Unlike the political solutions offered by previous poems in *The Tenth Muse*, which are variously found wanting, the individualised – and politicised – salvation adumbrated in 'Of the vanity of all worldly creatures' is allowed to stand unchallenged. Bradstreet, as I have noted, is a less consistently religious poet than many women writers of her period; Anne Southwell, with her much-revised Decalogue paraphrases, is a pertinent comparison. But Woodbridge was, after all, a clergyman. His selection of Bradstreet's poems, ironically, excludes personal – in the sense of biographically specific – material, but produces a narrative of juxtaposition which queries all political options but culminates in a vision of personal salvation. The Tenth Muse his volume creates is, as the paratexts promise, witty, learned and politically aware. She is also – finally – a Protestant poet.

[91] White, *Anne Bradstreet*, p. 250. Bradstreet's paraphrase of the 'Lamentation' (2 Samuel 1.19–27) – unlike Southwell's Decalogue poems – is a close rendering of her biblical source.
[92] *The Tenth Muse*, p. 207. [93] *The Tenth Muse*, p. 207.

The extraordinary Katherine Philips

Katherine Philips – poet, translator, letter-writer, critic – is one of the most significant figures in English women's literary history. Before Philips, even the most prolific and ambitious of English women writers had achieved, at most, only a temporary, limited or counterproductive form of public recognition. Mary Wroth's *Urania*, for instance, despite its brief period as a *succès de scandale*, soon faded from the contemporary cultural memory, and Wroth herself was largely forgotten by the 1630s. Her example seems to have played little part in inspiring women of later generations: only one seventeenth-century woman writer, Margaret Cavendish, is known to have been familiar with her work, and even Cavendish may have known less about the work itself than about the controversy it so briefly generated.[1] Cavendish's own writing, though well known, was subject to widespread derision, and received some of its harshest criticisms from female contemporaries such as Dorothy Osborne and Mary Evelyn.[2] Even Bradstreet's *The Tenth Muse*, despite the ambitions evident in its introductory apparatus, seems to have gained little recognition in its author's home country; Bathsua Makin's brief acknowledgement of Bradstreet's 'excellent' poetry in *An Essay to Revive the Ancient Education of Gentlewomen* (1673) is the first and only known response to the latter's verse by a seventeenth-century Englishwoman.[3] Furthermore, Wroth, Cavendish and Bradstreet, dissimilar though they were, had at least this much in common: all were socially well-connected women from moneyed families in which literary writing was valued and practised. To women who lacked such social eminence and

[1] On Cavendish and Wroth, see Margaret Hannay, *Mary Sidney, Lady Wroth* (Farnham: Ashgate, 2010), p. 307.

[2] Katie Whitaker, *Mad Madge: Margaret Cavendish, Duchess of Newcastle, Royalist, Writer and Romantic* (London: Chatto and Windus, 2002), p. 316; for a more favourable view, see Bathsua Makin, *An essay to revive the antient education of gentlewomen in religion, manners, arts and tongues* (1673), p. 10.

[3] Makin, *An essay*, p. 20.

familial support, all three would probably have looked like exceptional, thus inimitable, figures. None would have offered a model of female authorship to which most subsequent women could easily aspire.

Philips was different. Her *Poems* (1667), printed three years after her death, represented the most varied and ambitious single-volume female-authored publication yet produced, and elicited unprecedented acclaim from both male and female readers. Male writers as diverse as John Dryden and Richard Baxter praised her work, and she was cited as an influence by all the major women writers of the later seventeenth century, including Aphra Behn, Jane Barker and Anne Finch.[4] The generic variety of her writings, which encompass songs, elegies, dialogues, odes, verse epistles, panegyrics, epithalamia, and poetic and dramatic translations, gave ample scope for later writers with a wide range of interests to find inspiration in her work. Yet although, in literary terms, Philips's example was key to opening up opportunities for later women writers, in political terms the precedent she created may have had quite the opposite effect, contributing towards a narrowing of possibilities for later seventeenth- and early eighteenth-century women. Whereas the Civil Wars and interregnum had seen a proliferation of radical pamphleteering by women, the publication of Philips's self-consciously royalist *Poems* established a near-identification between female-authored literary writing and pro-Stuart conservatism. Her example helped to consolidate the cultural conditions in which it was more thinkable for a royalist or Tory woman than for her anti-Stuart or Whig counterpart to publish literary works. Katherine Philips was thus critical not only in making literary writing by women possible and respectable but also in determining its political direction for the half-century after her death.[5] Her influence on English-language women's literary history, unrivalled in the late seventeenth and early eighteenth centuries, is all the more remarkable because of the absence of obvious cultural resources in her personal and familial circumstances.

[4] On Dryden, Baxter, and other male admirers, see Katherine Philips, *The Collected Works of Katherine Philips, the Matchless Orinda*, vol. 1, ed. by Patrick Thomas (Stump Cross Books, 1990) (henceforward Thomas 1), pp. 23–26; on Behn and Finch, see Thomas 1, pp. 28 and 33–34. Barker is compared to Philips (under her sobriquet Orinda) in the introductory apparatus to her *Poetical Recreations* (1688), sig. A5r; her own tributes to Philips occur in *Love Intrigues* (1713), pp. 14–15, *A Patch-Work Screen for the Ladies* (1723), pp. 64 and 71, and *The Lining of the Patch-Work Screen* (1726), pp. 174 and 176.

[5] The prevalence of royalism – and later, Toryism or Jacobitism – among seventeenth- and early eighteenth-century writers has been much discussed. See Carol Barash, *English Women's Poetry, 1649–1714: Politics, Community, and Linguistic Authority* (Oxford University Press, 1996), Catherine Gallagher, 'Embracing the Absolute: The Politics of the Female Subject in Seventeenth-Century England', *Genders*, 1 (1988), 24–39, and McDowell, *The Women of Grub Street*.

Neither her birth nor her marital family seems to have been especially interested in poetry, and the many literary connections evident in her writing appear to have been created exclusively through her own actions and agency. Her success and influence represent an extraordinary personal achievement.

Poems (1667) and its subsequent reprints were crucial in creating Philips's reputation.[6] A folio volume, this posthumous edition was also furnished with an elaborate introductory apparatus, vindicating Philips's feminine modesty (which the publication of a previous edition of her poetry, in 1664, had given cause to question) and testifying to the praise her works had elicited from such well-regarded men of letters as Orrery, Roscommon and Cowley. Its publisher, Henry Herringman, was one of the most eminent literary booksellers of the period, who also published works by Cowley, Crashaw, Denham, Donne, Suckling and Waller. *Poems* (1667) thus treated Philips's writing with a dignity and honour never previously accorded to any English woman writer. Yet the 1667 edition was not, of course, the first attempt to produce a collection of Philips's poetry. In addition to the printed *Poems* of 1664, four seventeenth-century manuscript compilations of Philips's poetry are known to survive.[7] Of these, one – now known as the Tutin manuscript – is an autograph manuscript of Philips's poetry, dating from the late 1650s.[8] Two others, the Clarke and Dering manuscripts, were probably produced between June 1662 and July 1663, while Philips was in Ireland; each partially overlaps with a printed volume, *Poems, by Several Persons*, published in Dublin in 1663.[9] A fourth compilation, the Rosania manuscript, closely postdates Philips's death in July 1664.[10] No doubt there were once

[6] Philips's poetry was reprinted in 1669, 1678 and 1710. The 1710 edition was published by Jacob Tonson.

[7] Other seventeenth-century manuscript collections survive, but most – e.g. Folger MS V.b.231 – are clearly copied from printed sources. A further manuscript, now Cardiff Central Library MS 2.1073, apparently predates print-publication, but includes only fourteen of Philips's poems and lies outside the scope of this chapter. See *Index of English Literary Manuscripts* (henceforward *IELM*), vol. II, part 2, p. 130.

[8] The Tutin manuscript – named for the early twentieth-century bookseller, John Ramsden Tutin, who first brought it to public attention – is now National Library of Wales MS 775B. For full descriptions of Tutin and the other Philips manuscripts discussed in this chapter, see *IELM*, pp. 128–30.

[9] Clarke and Dering are now, respectively, Worcester College Oxford MS 6.13 and University of Texas at Austin Pre-1700 MS 151.

[10] The Rosania manuscript is now National Library of Wales MS 776B. All four of these manuscripts, as well as other early witnesses to her work, have been published on microfilm: Katherine Philips, *Orinda: The Literary Manuscripts of Katherine Philips (1632–1664)*, 4 microform reels (Marlborough: Adam Matthews, 1995).

others – autograph collections of the later poetry; scribal manuscripts produced for friends and admirers – which are now either lost or unrecognised. Both Philips herself and members of her literary circle were clearly interested in collecting her work, long before there was any question of a printed edition. She has been described as 'the foremost woman writer of the seventeenth century to flourish in the context of a manuscript culture'.[11]

Philips's short life – born in 1632, she died from smallpox aged just 32 – nonetheless included a surprisingly lengthy writing career. Several of her attested poems date from the early 1650s, when she was in her late teens, and two other lyrics, more speculatively attributed to her, date from 1648 or earlier.[12] Though many of her poems are undated, the four manuscripts and two early printed editions of her poetry make it possible to document in some detail several distinct phases within her writing life. Attending to these phases is important to understanding the shape of Philips's literary career, allowing us not only to monitor the kinds of poems she wrote at different points in her life, but also to trace the timetable of her responses to literary and intellectual influences and political events, and to examine how her sense of herself as a poet developed through the 1650s and early 1660s. Her autograph manuscript provides important evidence as to how she herself regarded her own writing, at least during one key period within her writing career, while the three scribal manuscripts offer equally valuable insights into how her poetry was received and appreciated within her own literary coterie, and perhaps beyond. Comparing the manuscripts with the printed volumes of 1664 and 1667 also allows us to see how, in the published editions, Philips's poetry was reshaped and manipulated to meet the demands of the Restoration literary marketplace and to suit the ideological biases of her editors. Taking account of these reconstructive strategies is of particular scholarly importance since it is this post-Restoration image of Philips which continues – to an often unrealised extent – to determine how her writing is read and perceived, even in the twenty-first century.[13]

[11] Peter Beal, *In Praise of Scribes* (Oxford University Press, 1998), p. 147.

[12] On the 1640s poems, see *IELM*, pp. 134–35, and Elizabeth Hageman and Andrea Sununu, '"More Copies of it abroad than I could have imagin'd": Further Manuscript Texts of Katherine Philips, The Matchless Orinda', *English Manuscript Studies 1100–1700*, 5 (1995), 127–169 (p. 135).

[13] Most critical discussions of Philips's poetry, except those specifically focused on textual issues, follow either the 1667 *Poems* (or its derivatives) or Patrick Thomas's *Collected Works*, volume 1. Although Thomas's textual policy prioritises manuscript evidence where possible, his order of materials (for understandable reasons) follows 1667. This reliance on 1667 silently introduces many print-based and Restoration assumptions into the version of Philips's poetry presented to readers.

A more textually and historically secure understanding of Philips's poetry can also help to shed light on some of the most complex and controversial critical debates surrounding her work. In recent years, criticism on Philips has grappled with several difficult issues, including her relationship with royalism, the role of homoeroticism in her friendship poetry, and the question of whether the 1664 *Poems* was really, as she claimed, unauthorised. While much of the best Philips criticism on these and other issues does take account of the textual evidence in discussing her work, some otherwise excellent studies do not, thus limiting the force of their arguments. Moreover, even those accounts of Philips's writing which do attend to the textuality of her writing rarely attempt to survey all six of the major extant witnesses.[14] Yet comparing these six collections of her writing – reading them for genre, history and material organisation – has critical as well as textual consequences. Reading Philips's poetry as she collected it herself, and as it was received by others within and shortly after her own lifetime, makes it possible, for instance, to distinguish between her pre- and post-Restoration verse, and thus to discern the role played by external events and a more public readership in influencing the genres she practised and the opinions she voiced. While a textually focused reading of Philips's poetry cannot provide definitive answers to the many critical questions raised by her work, it forms an essential part of any informed appreciation of her literary interests and priorities. At the most basic level, it helps to guard against the problem which beset so much early criticism of Philips, namely anachronistic interpretations of her writing.[15] It also helps to clarify the degree to which surviving texts of Philips's poetry inscribe her own agency, and to what extent that agency can justly be described as 'her own'.

My discussion of Katherine Philips's poetry in this chapter combines these chronological, textual and generic imperatives. Beginning with her early autograph collection, the Tutin manuscript, I examine each of the

[14] Philips was a widely disseminated writer, and even these six collections represent only a portion of her textual distribution in both manuscript and print. On the circulation (and adaptation) of individual poems by Philips, see *IELM*, and also Beal, *In Praise of Scribes*, Gray, *Women Writers and Public Debate*, Elizabeth Hageman, 'Treacherous Accidents and the Abominable Printing of Katherine Philips's 1664 *Poems*', in *New Ways of Looking at Old Texts*, vol. III, ed. by W. Speed Hill (Tempe, AZ: Arizona Center for Medieval and Renaissance Studies in conjunction with Renaissance English Text Society, 2004), pp. 85–95, and Hageman and Sununu, 'New Manuscript Texts of Katherine Philips, The "Matchless Orinda"', *English Manuscript Studies 1100–1700*, 4 (1993), 174–219, and '"More Copies"'.

[15] See, for example, Maren-Sofie Røstvig, *The Happy Man: Studies in the Metamorphoses of a Classical Ideal*, vol. I, 1600–1700, second edition (Oslo: Norwegian Universities Press, 1962), pp. 252–62 – an important early study which attributes Philips's retirement poems to the Restoration and thus misunderstands their significance.

early witnesses to her poetry, tracking Philips's writing as it developed through the interregnum and the early 1660s, and as it responded both to the opportunities offered by the post-Restoration English and Irish courts and to the crisis generated by the 1664 *Poems*. My discussion focuses on Philips's original poetry, excluding the letters and translations except insofar as they impinge on the original verse. Important and accomplished as Philips's letters and translations are, she viewed herself – and has been viewed by posterity – principally as a poet. Her transformational role within English women's literary history is due above all to her original poetry, to which the first significant witness is the Tutin manuscript.

PHILIPS BY HERSELF: THE POETRY OF THE TUTIN MANUSCRIPT

Katherine Philips's autograph collection of her own poetry is an unassuming quarto notebook, now consisting of 222 pages.[16] Like many seventeenth-century manuscripts, it has been written in at each end; and both sections – excluding additions by later owners – are transcribed in a single italic hand. The texts are fair copies, produced with clear attention to the *mise-en-page*, with titles underlined and centred and stanzas separated and indented. The relatively few corrections include running, marginal and supralinear revisions. Texts are generally copied on rectos only (as viewed from the direction of transcription), though with a few exceptions. As currently constituted, the manuscript consists of fifty-five poems (some incomplete), and two titles.[17] Of the incomplete poems, one – 'On the death of my first and dearest childe' – was left unfinished by Philips herself, while others (such as 'To the Right Honourable Alice Countess of Carbery' and 'La Grandeur d'esprit') are now defective due to later damage.[18] The last datable item in the manuscript, 'Parting with Lucasia', is ascribed to 13 January 1657/8.

[16] On the Tutin manuscript, see also *IELM*, pp. 128–29, and Hageman, 'Treacherous Accidents', pp. 89–94.

[17] For the order of materials in Tutin, see Philips, *Orinda*, or Thomas 1, pp. 65–68, column IV. The Tutin manuscript also includes numerous additions by later hands; see Marie-Louise Coolahan, '"We live by chance, and slip into Events": Occasionality and the Manuscript Verse of Katherine Philips', *Eighteenth-Century Ireland*, 18 (2003), 9–23 (p. 13). These are ignored in my subsequent discussions.

[18] 'On the death of my first and dearest childe' survives in Tutin as two quatrains and two further stanza numbers; in *Poems* (1667), titled 'Orinda upon little Hector Philips', it comprises five quatrains. Citing Philips's poems is problematic, as many of her titles are long and/or minimally different from one another, and sometimes vary substantially from witness to witness. My own practice in this chapter is not to standardise titles but to quote according to the manuscript/printed edition under discussion, supplying cross-references where necessary. Abbreviated titles are used where possible.

The Tutin manuscript is clearly an important witness to Philips's poetry, and offers unique evidence as to how she understood her work not only as individual texts but as a collection. Reading this evidence, however, is a complex task. How, for instance, can we account for the organisation of materials in Tutin? Which, if either, of the two transcriptional sequences in the manuscript should take priority, and how much significance should be attached to the order of items in each section? How, furthermore, should we understand Tutin's omission of other poems – such as 'Upon the double Murther of King Charles' and 'On the 1. of January 1657' – which almost certainly predate 'Parting with Lucasia'? And why did Philips abandon work on the manuscript in the late 1650s, leaving two of the most personal items in the collection – her epitaph on her son Hector, and 'To my dearest friend, on her greatest loss' – so poignantly unfinished? (Both Hector Philips and John Owen, first husband of Philips's closest friend, Anne Owen, died in 1655, so these poems are unlikely to have been works-in-progress in 1657/8.) Simple as these questions may seem – and unanswerable though some of them may be – it is important that they be asked if the textuality of the Tutin manuscript is to be understood but not fetishised.

The two transcriptional sequences in the Tutin manuscript are differentiated by subject. One end of the volume comprises seventeen poems on philosophical topics, the other thirty-eight poems (and two titles) on more personal matters, chiefly people and events within Philips's family and friendship circles. Although many critics have assumed the priority of the personal poems in Tutin, there is in fact no clear designation of either end of the manuscript as the 'front' or the 'back': neither section, for instance, has a title page or a table of contents.[19] For this reason, I will refer to the two sections within Tutin as 'the personal sequence' and 'the philosophical sequence'.

Another complicating factor is excision from the manuscript. Hageman and Sununu have shown that a manuscript fragment now held at the University of Kentucky – two quarto leaves, comprising 'A Sea-Voyage from Tenby to Bristoll' in Philips's hand – once formed part of the Tutin volume.[20] The remnants of these leaves in Tutin itself – identifiable

[19] Hageman, 'Treacherous Accidents', pp. 89–90; compare Salzman, *Reading Early Modern Women's Writing*, p. 184. By contrast with more recent readers, John Ramsden Tutin seems to have identified the 'philosophical' section of the manuscript as the 'front', attaching his bookplate at this end.

[20] Hageman and Sununu, 'New Manuscript Texts', pp. 175–80; compare *IELM*, p. 162 (PsK 326). It is not clear when this or any of the other excisions from Tutin may have occurred, but all are likely to postdate Philips's involvement with the manuscript.

between 'Content, to my dearest Lucasia' and 'To my deare Sister Mrs. C. P.' in the personal sequence – are just two of twenty-eight stubs contained in the surviving manuscript.[21] While some of these stubs apparently represent mid-transcriptional excisions by Philips herself, others are clearly post-transcriptional: thus, for instance, a stub midway through 'To the truly noble Sir Edward Dering' (pp. 63, 65) does not interrupt the run of the text, whereas a page now missing between pp. 68 and 69 must once have supplied the now-missing final stanza of 'To the Right Honourable Alice Countess of Carberry'.[22] The fact that the Tutin order of materials is partially preserved in two of the other early witnesses to Philips's poetry, most nearly in the Clarke manuscript, has also led Hageman to suggest that five further poems – 'A Dialogue of Absence 'twixt Orinda and Lucasia', 'To Mrs M. A. at Parting', 'To Antenor on a paper of mine', 'Upon the double Murther of King Charles' and 'A Countrey Life' – were originally also included in the autograph manuscript: stubs in Tutin exactly correspond to the positions in Clarke where these five poems are copied.[23]

Given the close connections between the Clarke and Dering manuscripts and Tutin (to be described more fully in the next section), it is plausible that three further poems transcribed in these early 1660s manuscripts – 'For Regina', 'To the Queen of inconstancie, Regina, in Antwerp' and 'The Enquiry' – were also once included in Tutin. The Regina poems are closely associated with three other poems extant in Tutin ('Engraved on Mr John Collyers Tombstone', 'On Little Regina Collyer' and 'To J. J. Esq. upon his melancholly for Regina') and, although undated, seem likely to have originated in the same period, the late 1640s and early 1650s.[24] 'The Enquiry' – the only one of Philips's philosophical poems not extant in Tutin – seems likely to stem from the same compositional period as 'The World', 'The Soule' and 'A Friend', with which it has much in common; a stub between 'The Soule' and 'L'accord du bien' in the philosophical sequence in Tutin may mark its excision.[25]

[21] Hageman, 'Treacherous Accidents', p. 90.
[22] The third stanza is provided in all other early manuscripts and printed texts of the poem, including the autograph presentation copy preserved among the Egerton papers. See Hageman and Sununu, 'New Manuscript Texts', pp. 180–83.
[23] Hageman 'Treacherous Accidents', pp. 91–92.
[24] On the dating of the Collyer poems, see Thomas I, pp. 349, 351 and 359–60.
[25] On Philips's 'Ode on Retirement', first extant in *Poems, by Several Persons* (Dublin, 1663) and the Dering manuscript, and arguably another extra-Tutin philosophical poem, see further below. Hageman, albeit tentatively, ascribes 'The Enquiry' to the early 1660s (Hageman, 'Treacherous Accidents', p. 91).

By contrast, while poems such as 'On the 1. of January 1657' and 'Epitaph on Hector Philips at St. Sith's Church' (another epitaph on Philips's son) are also attributable to the 1650s in terms of subject, their absence from Clarke and Dering means that there is no textual reason to suppose they were ever included in Tutin. It is likely, therefore, that Philips's autograph manuscript always represented a selective, rather than an exhaustive, collection of her work.

Organisationally, Tutin is uneven. Although the key distinction between the personal and philosophical sections of the manuscript is clear, reasons for the order of materials within each sequence are not always easy to determine. While the philosophical sequence begins with a series of six religious poems ('Out of Mr More's Cupid's Conflict', 'On Controversies in Religion', 'Happyness', 'Death', 'The World', 'The Soule'), the remaining eleven poems in this section follow no clear thematic or generic order.[26] The subsequent four poems, for instance ('L'accord du bien', 'Invitation to the Countrey', 'In memory of Mrs E. Hering' and 'On the 3rd September 1651'), comprise a philosophical discussion of friendship, a retirement lyric, an elegy and a political meditation.[27] The other two elegiac or consolatory poems in this section – 'To Mrs Wogan' and 'In memory of ... Mrs Owen' – are separated both from 'Mrs E. Hering' and from each other; 'A Friend' and 'Friendship' are transcribed several leaves apart; and two further religious poems ('Submission' and 'God was in Christ reconciling the world to himself') are added towards (but not at) the end of the section, separate from the introductory run of religious texts but not presented as a conclusion to the sequence.[28] There is also no reason to suppose that the texts were copied in order of composition: while only a few of the poems in this section are datable, 'God was in Christ', ascribed to 8 April 1653, is transcribed prior to 'In memory of ... Mrs Owen', probably written shortly after Owen's death in February of the same year. Comparably, 'A Countrey Life', probably once the antepenultimate poem in this section, is dated to 1650 in the Rosania manuscript.

In the personal sequence, by comparison, some evidence of purposeful arrangement is apparent. While no consistent ordering principles apply

[26] Tutin MS, pp. 222–190. 'Out of Mr More's Cupid's Conflict' is my own supplied title, based on (corrected) comparison with Clarke and *Poems* (1664). The title is defective in Tutin; due to damage to the leaf, only 'Out of Mr More's' survives. The poem is known as 'God' in Dering and 'A Prayer' in *Poems* (1667); see *IELM*, p. 148 (PsK 115, 117).

[27] Tutin MS, pp. 188–166, rectos only.

[28] Tutin MS, pp. 146–44 (Wogan), 136–132 (Owen), 172–170 (Hering); pp. 164–158 ('A Friend') and 130–126 ('Friendship'); and pp. 156–148 ('Submission' and 'God was in Christ'); all rectos only.

across the sequence as a whole, some elements of organisation by person, date and topic can be inferred. While the poems on Rosania – Philips's coterie name for her friend Mary Aubrey – do not follow a precise chronological order ('L'amitié', dated 6 April 1651, is transcribed prior to 'To Mrs M. A. upon absence', dated 12 December 1650), all the Rosania poems are grouped together, and the distinction between those poems that precede and those that follow Rosania's marriage is consistently observed.[29] Similarly, though the more numerous poems on Lucasia – Anne Owen – are broken into several groupings, the early poems ('To the truly noble, and obleiging Mrs. Anne Owen', 'To the excellent Mrs A. O.') are transcribed at the beginning and the latest items ('To my dearest friend, on her greatest loss', dated 27 December 1655, and 'Parting with Lucasia, 13th January 1657/8') towards the end.[30] As Hageman has noted, the irregular transcription of 'To my Lucasia, in defence of declared friendship' on versos alongside 'To my Lucasia' strongly implies that Philips saw these two poems as belonging together, and was prepared to disrupt the orderly presentation of the manuscript so that 'declared friendship' could be inserted in its appropriate position in the sequence.[31] Other Lucasia poems, however, either transgress chronology ('To My excellent Lucasia' apparently predates 'To the excellent Mrs A. O.' but is transcribed later in the manuscript) or seem to be grouped almost arbitrarily, with poems on Lucasia's personal virtues (such as 'Lucasia') irregularly interspersed with others which treat her as guarantor of Philips's philosophy of friendship ('Friendships Mysterys') and still others which address her much more incidentally '('Content').[32] No obvious rationale underlies the location of poems to other addressees, such as Henry Vaughan, Ardelia, Edward Dering, Cicely Philips or Henry Lawes, while Philips's two poems to Francis Finch (both of which allude to his treatise on friendship) are transcribed in quite different parts of the personal sequence, again for no very clear reason.[33] It also seems likely that, over time, even the inconsistently subject-based organisation of the earlier parts of the sequence gave way to a more pragmatic practice of adding new poems more or less as they

[29] 'L'amitié', p. 15, 'To Mrs M. A. upon absence', p. 17. 'Invitation to the Countrey', though addressed to Rosania, is primarily a retirement lyric and is included in the philosophical sequence.

[30] 'To the truly noble, and obleiging Mrs. Anne Owen' (subtitled 'on my first approaches'), p. 39, 'To the excellent Mrs A. O.' (dated 29 December 1651), p. 41, 'To my dearest friend, on her greatest loss', p. 113, and 'Parting with Lucasia', pp. 125, 127.

[31] Hageman, 'Treacherous Accidents', pp. 89–90.

[32] 'To My excellent Lucasia', p. 49, 'To the excellent Mrs A. O.', p. 41, 'Lucasia', pp. 73, 75, 77, 'Friendships Mysterys', pp. 79, 81, 'Content', pp. 83, 85, 87.

[33] 'On Mr Francis Finch', pp. 9, 11, 13, 'To the Noble Palaemon', pp. 95, 97.

were written. The last seven poems in the personal sequence include five which date from between 1655 and 1658, and the remaining two may also be late work. None of the other Tutin poems can be firmly dated to 1655 or later.

Given these inconsistencies, any attempt to read Tutin – whether the manuscript as a whole, or either or both of the sequences – as a coherent narrative is very problematic. 'Evidence' from location or inclusion in the manuscript can easily be read in different ways. Carol Barash, for instance, interprets the use of 'To my dearest Antenor on his Parting' as the opening poem in the personal sequence as a means of excluding Philips's parliamentarian husband (Antenor) from the rest of the manuscript, 'leav[ing] the speaker imaginatively free to construct an alternate community, one which does not overtly include him again'.[34] While this is possible, one might just as plausibly argue that the priority accorded within Tutin to 'To my dearest Antenor' – an affectionate poem premised on a Donnean image of exchanged hearts – ascribes a position of prime importance to James Philips.[35] Furthermore, if Hageman's argument for the excision of 'To Antenor on a paper of mine' from Tutin is correct, Philips's original version of her autograph manuscript would also have included a second poem 'overtly' addressed to her husband, as well as two others – the epitaph on young Hector and the epithalamion on James's sister Cicely – in which his existence is tacitly implied. To account for 'To my dearest Antenor' we need also to note that Philips seems to have relished the literary possibilities of separation: Tutin includes 'Philoclea's parting' and 'Parting with Lucasia' and probably once also incorporated 'To Mrs M. A. at Parting'; later 'parting' poems include 'To the Queen-mother's Majesty' (on Henrietta Maria's departure from England in 1661), 'Lucasia, Rosania, and Orinda parting at a Fountain', 'Orinda to Lucasia parting', 'Lucasia and Orinda parting with Pastora and Phillis', and 'Parting with a Friend'.[36] Philips's address to her husband of a poem on this subject – especially one that shares imagery with the 'Mrs. M. A.' lyric – thus tends to imply congruence, rather than opposition, between the marital and the friendship poems.[37] That said, it is undeniable that James Philips, both in

[34] Barash, *English Women's Poetry*, p. 69.
[35] On Philips's use of Donnean imagery in 'To my dearest Antenor', see Paula Loscocco, 'Inventing the English Sappho: Katherine Philips's Donnean Poetry', *Journal of English and Germanic Philology* 102.1 (2003), 59–87 (pp. 66–71).
[36] 'Philoclea's' is corrected from 'Phioclea's' (an apparent mistranscription) in Tutin.
[37] On the similarities between the Antenor and Aubrey poems, see Loscocco, 'Inventing the English Sappho', p. 68.

Tutin and in the later collections, seems to have been a relatively unpro-
ductive subject for his wife's poetry. The three poems addressed to him
(a third, 'To my Antenor, March 16. 1661/2', appears first in the 1667 *Poems*)
compare modestly with the many more addressed to Rosania and Lucasia.
(Rosania, the less frequently cited of the two friends, is mentioned in seven
poems in Tutin and six more in later collections; she is also likely to be the
object of Philips's displeasure in a further Tutin poem, 'Injuria amici'.)[38]
The evidence of the Antenor texts is that James Philips, rather than acting
as a regular inspiration for his wife's poetry, appears only on occasions of
overlap with her pre-existing poetic preoccupations or at moments of
crisis; the three poems are stimulated respectively by the topic of parting,
the attack on James Philips by 'J. Jones' (an attempt by a political rival to
use Katherine's 'Upon the double Murther of King Charles' against her
husband) and the threats to James's political prospects – and even his life –
after 1660. It is thus not so much that James Philips is excluded from the
Tutin manuscript as that opportunities to include him scarcely arise.

As this discussion indicates, it is impossible to make sense of Philips's
manuscripts – or, indeed, of the early printed editions of her work –
without recourse to biographical considerations. In the case of Tutin, both
the manuscript as a whole and its constituent poems need to be read
alongside what we know of Philips's life up to and including the late 1650s.
She was born in London in 1632, the daughter of John Fowler, a cloth
merchant, and his wife Katherine Oxenbridge.[39] In the era of High
Church Laudianism, her family favoured the Puritan wing of the Church
of England, and several of her relatives subsequently served on the parlia-
mentary side during the Civil Wars. Little is certain about the young
Katherine Fowler's early life, but she is known to have attended boarding
school in Hackney from the age of eight onwards; there she met friends
such as Mary Harvey (who later married Sir Edward Dering) and Mary
Aubrey, and may have begun her studies in French. Her father died in
1642, and some four or five years later her mother married Sir Richard
Phillips of Pembrokeshire and moved with him to Wales. In 1648, the
sixteen-year-old Katherine married her stepfather's kinsman, James Philips,
a Cardiganshire landowner and leading parliamentarian. Though it
was formerly thought that James Philips was 54 at the time of their

[38] The figure of seven for Tutin assumes the original inclusion of 'To Mrs M. A. at Parting'.
[39] My account of Philips's life, here and elsewhere in this chapter, follows Chernaik, 'Philips, Katherine', *ODNB*, supplemented by Philip Souers, *The Matchless Orinda* (Cambridge, MA: Harvard University Press, 1931).

marriage, it is now believed that he was in fact 24, though already a widower. From 1648 until the early 1660s, the Philipses lived mainly at Cardigan Priory but made frequent visits to London; James served several terms as MP for Cardigan or Pembroke and was also appointed to the High Court of Justice in 1651. The couple had two children: Hector, born in 1655 but dead just a few weeks later, and his sister Katherine, born in 1656 (and never mentioned in her mother's poetry). The family also included Frances, the daughter of James Philips and his first wife, born in 1647.

On the evidence of the Tutin manuscript, the earliest poems which the adult Katherine Philips chose to preserve in her personal collection date from 1649–50, when she was about eighteen years old. The extant manuscript includes 'To Mrs M. A. upon absence', dated 12 December 1650, and 'Philoclea's parting', dated 25 February 1650, while Hageman's list of five poems probably excised from Tutin includes two – 'To Mrs M. A. at Parting' and 'A Countrey Life' – ascribed to that year in the Rosania manuscript.[40] The Collyer epitaphs also seem likely to belong to this period: the young Regina Collyer was buried in September 1649, her father the following January.[41] The technical range of these six poems, which encompass three different stanzaic forms as well as both tetrameter and pentameter couplets, suggests that even by this early stage in her life Philips was a confident and practised poet. However, the question of when Philips began copying her poetry into the Tutin manuscript is by no means clear. As already noted, the poems are not consistently transcribed in the order of composition, and though the early items in the personal sequence do include the Collyer epitaphs, they also include 'On Mr Francis Finch', which alludes to Finch's *Friendship* treatise, published in 1654.[42] The compilation of Tutin may thus have begun at any time between 1649/50 and 1655 (the point at which a more consistent practice of chronological additions to the personal sequence seems to have started), and cannot have ended before January 1657/8, the date ascribed to 'Parting with Lucasia'. Additions to the manuscript may have extended into 1659 and even 1660, but are unlikely to postdate spring 1660, when Philips embarked on the new tranche of writing first extant in Clarke and Dering.

[40] Tutin MS, pp. 17 and 37; Rosania MS, pp. 314, 267.

[41] Thomas I, p. 360.

[42] The dedicatory letter to Finch's privately published treatise is dated 30 March, 1654 (sig A3r). It is possible, however, that Philips had seen a manuscript copy. The Collyer and Finch items comprise the second, third and fifth items in the personal sequence.

What kind of poet is the Philips of the Tutin manuscript? For a start, she is a poet who engaged seriously with both topical and long-standing issues in philosophy and theology. The seventeen poems extant in the philosophical sequence of Tutin, though outnumbered by the thirty-eight personal poems, represent a sustained attempt to address such questions as how to live a good life, the reconciliation of the soul to God, the benefits of retirement, and the nature of friendship. As Andrea Brady has noted, much scholarship on Philips has tended to ignore this strand in her work, and has often regarded her neoplatonic writings on friendship as a proxy for less readily admissible yearnings – 'a nervous sublimation of lesbian desire'.[43] On Brady's reading, however, Philips's neoplatonising poems, though not highly original, are both 'philosophically nuanced' and based on a sound knowledge of contemporary thought.[44] 'Out of Mr More's Cupid's Conflict', as the title indicates, responds directly to a poem by the Cambridge Platonist Henry More (first published in 1646), and in Tutin is headed by an excerpt from More's text. A comparison of Tutin with later witnesses, however, clearly indicates that this philosophical phase in Philips's career was largely confined to the 1650s. Of the twenty-seven neoplatonising poems discussed by Brady, twenty-four are extant in Tutin and only one – 'To the Queen-mother's Majesty' – clearly postdates the Restoration. (Of the remaining two, 'On the 1. of January 1657' is a Tutin-era poem, and 'The Enquiry', in my view, is also likely to date from this decade.) She seems never to have written an original religious poem after the 1650s (though she later translated an excerpt from Corneille's *De l'imitation de Jésus-Christ*), and her only post-1660 retirement poem, 'An ode upon retirement', differs significantly from her 1650s poems on the same topic. Her theoretical discussions of friendship, similarly, seem to fade away in the early 1660s; their reappearance – again in a slightly different guise – in 1664 seems likely to result from the embarrassment caused to Philips and her friends by the unauthorised *Poems* of that year. While Philips seems to have retained her interest in philosophical issues into the 1660s – her correspondence with Sir Charles Cotterell in 1662 includes discussion of Roman stoicism[45] – her creative engagement with such concerns seems effectively to have ended with the close of her work on the Tutin manuscript in the late 1650s.

[43] Andrea Brady, 'The Platonic Poems of Katherine Philips', *The Seventeenth Century*, 25.2 (2010), 300–22 (p. 302). See also Mark Llewellyn, 'Katherine Philips: Friendship, Poetry and Neo-Platonic Thought in Seventeenth Century England', *Philological Quarterly*, 81.4 (2002), 441–68.
[44] Brady, 'Platonic Poems', pp. 318, 317, 302–03.
[45] Katherine Philips, *Letters from Orinda to Poliarchus* (1705), pp. 63–64.

Reading Philips's retirement poetry against the textual/historical evidence of Tutin and the later witnesses discloses a curious paradox. Following Maren-Sofie Røstvig's classic study of seventeenth-century retirement poetry, *The Happy Man*, it is generally accepted that this genre – at least as practised by royalists – peaked during the late 1640s and 50s, as erstwhile supporters of the king, largely excluded from the national government, tried to make the best of their powerless situation.[46] Philips, despite the parliamentarianism both of her birth family and of her husband, was associated with literary royalism as early as 1651, when her elegy on William Cartwright was published amid the solidly royalist preliminaries to his posthumous works.[47] Ironically, though, while Philips's Tutin-era interest in retirement poetry is consonant with contemporary developments within royalist writing, it is inconsistent with her own biographical experience. As the wife of a leading parliamentary supporter and MP who was also active in Welsh local politics, Philips was by no means out of touch with public life during the 1650s. By contrast, the event which heralded her husband's withdrawal from local and national government – the Restoration – seems also to have coincided almost exactly with the point in her career when she stopped writing retirement poetry. One answer to this paradox is that after the Restoration Philips became more directly engaged with public events on her own account. Her many poems on events surrounding the coronation of Charles II would have sat uneasily alongside lyrics arguing for the superiority of country retirement over the vanity and corruption of city and courtly life. Another still more straightforward answer is that Philips's emotional identification with royalism took precedence, at least within her poetry, over mere biographical fact – complicated in any case, since her 1650s involvement in public life, through her husband, would have been only at one remove. However, the position is still further complicated by the many fissures and contradictions within Philips's pre-Restoration royalism. Far from testifying unequivocally to the strength and steadfastness of her pro-Stuart loyalties, the Tutin manuscript instead witnesses to two apparently anomalous aspects of Philips's writing: on the one hand, the relatively slight attention devoted to politics in her pre-Restoration poetry; and on the other, the complexity of attitudes her political allusions of this period reveal.

[46] Røstvig, *The Happy Man*, esp. p. 48.

[47] On Philips's inclusion in the Cartwright volume, see Gray, *Women Writers and Public Debate*, pp. 108–16; on Cartwright's influence on Philips, see *The Plays and Poems of William Cartwright*, ed. by G. Blakemore Evans (Madison, WI: University of Wisconsin Press, 1951), pp. 50–53.

Compared with Philips's post-Restoration poetry, surprisingly few of the poems in the Tutin manuscript are overtly concerned with contemporary politics. The only poem in the extant volume to be directly focused on a political topic is 'On the 3rd September 1651', a meditation on the Battle of Worcester. Given the evidence cited by Hageman, it is likely that 'Upon the double Murther of King Charles' – the only other directly political poem by Philips to predate the Restoration – was also once included in Tutin. However, the fact that these two poems were copied at different ends of the manuscript – 'On the 3rd September' within the philosophical sequence, 'Upon the double Murther' among the personal poems – gives cause to question just how important the issue of politics was to Philips during the pre-Restoration period. Put bluntly, she did not write enough on this topic to make a political sequence within Tutin worthwhile. It should also be noted, on a point of practical textuality, that the separation of 'On the 3rd September' and 'Upon the double Murther' is just one of several anomalies within Tutin which speak to the limitations of its double-ended structure: further inconsistencies include the treatment of elegies (most transcribed in the personal sequence but a few located among the philosophical poems), as well as the discrepant transcription of the retirement poem 'Content, to my dearest Lucasia' in the personal sequence and the very similar 'Invitation to the Countrey', addressed to Rosania, at the philosophical end.

In the case of 'On the 3rd September' and 'Upon the double Murther', however, the likely reasons for the assignation of these two poems to different sections are particularly telling. 'Upon the double Murther' belongs among the personal poems because it responds to a denunciation of the late king by the Welsh puritan Vavasour Powell, and in turn led to two further poems addressed to James Philips and Anne Owen, 'To Antenor on a paper of mine' and 'To (the truly competent Judge of Honour) Lucasia upon a scandalous Libell made by J. Jones'. Philips's inclusion of 'Upon the double Murther' in the personal sequence, rather than foregrounding her royalism, embeds the poem within a localised Welsh context of manuscript exchange in which Philips read Powell, Jones read Philips, and Philips read Jones. 'On the 3rd September', contrastingly, belongs among the philosophical poems because of the world-denying resignation with which Philips brings her meditation on the ill-fated Battle of Worcester to a close. Though Philips's sympathies as she reflects on the battle are clearly with 'Gasping English Royalty' (11) rather than its enemies, the emphasis in her conclusion is not on the wrongs suffered by the monarchy but rather on the vanity of trusting too much in human authority:

Who'd trust to Greatness now, whose food is ayre
Whose ruine sudden, and whose end despaire?
Who would presume upon his Glorious birth?
Or quarrell for a spacious share of earth
That see's such diadems become thus cheap
And Hero's tumble in the common heap?
 O! give me vertue then which summ's up all
And firmely stands when Crowns and Scepters fall.
 'On the 3rd September', 27–34[48]

A comparison between 'Upon the double Murther of King Charles' and 'On the 3rd September' provides a good indication of the scope and contradictions of Philips's pre-Restoration royalism. 'Upon the double Murther' sees Philips defending Charles against Vavasour Powell's claim that he had broken all the commandments; she alludes to the late king's execution as 'Treason' (23) and describes Powell's attack on his reputation as the 'height of Horror' (33).[49] Her sense of shock at Powell's 'libellous rime' becomes the vindication for the 'breach of Natures lawes' (6) involved in her own poem: unnatural as it is for a woman to speak out on a public event, it can be justified in response to the still greater crime of libelling a monarch. Yet compared with the forthright royalism of Philips's post-Restoration poems, the approach to monarchy in 'Upon the double Murther' is relatively indirect, with Philips's arguments focused less on the outrage represented by the execution than on the relatively minor (though symbolic) assault on Charles's memory by the libeller Powell.[50] Meanwhile, 'On the 3rd September', despite its obvious emotional commitment to royalism, ends by viewing monarchical 'Greatness' as transitory and without true foundation, less solid and dependable than personal 'vertue' (33).[51] The impression it conveys is of a poet who, rather than suffering

[48] Tutin MS, pp. 168, 166, Thomas I, pp. 82–83.

[49] Quoted from Clarke MS, pp. 48–49; Thomas I, pp. 69–70. Powell's poem is reproduced in Hageman and Sununu, '"More Copies"', p. 129.

[50] See also my discussion in 'Textuality, Privacy and Politics: Katherine Philips's *Poems* in Manuscript and Print', in *Material Readings of Early Modern Culture: Texts and Social Practices, 1580–1730*, ed. by James Daybell and Peter Hinds (Basingstoke: Palgrave, 2010), pp. 163–82 (p. 168).

[51] The ambiguous royalism of 'On the 3rd September' is also noted by Ellen Moody, 'Orinda, Lucasia, Rosania *et aliae*: Towards a New Edition of the Works of Katherine Philips', *Philological Quarterly* 66.3 (1987), 325–54 (pp. 328–29), Robert C. Evans, 'Paradox in Poetry and Politics: Katherine Philips in the Interregnum', in *The English Civil Wars in the Literary Imagination*, ed. by Claude Summers and Ted-Larry Pebworth (Columbia, MO: University of Missouri Press, 1999), pp. 174–85 (pp. 182–85), and Andrew Shifflett, '"Subdu'd by You": States of Friendship and Friends of the State in Katherine Philips's Poetry", in *Write or be Written: Early Modern Women Poets and Cultural Constraints*, ed. by Ursula Appelt and Barbara Smith (Aldershot: Ashgate, 2001), pp. 177–95 (pp. 179–82).

deep distress at the demise of the English monarchy, is preparing, none too painfully, to live without it.

Other political references in the Tutin manuscript present a similarly mixed picture. The poems in the personal section of Tutin include several addressed to cultural figures of known royalist sympathies – Francis Finch, Henry Vaughan, John Berkenhead and Henry Lawes – as well as her epitaph on William Cartwright. Yet she also addressed one of her most encomiastic poems to Alice Countess of Carbery ('on her enriching Wales with her presence'), whose husband was well known to have compromised with the Cromwellians in the later 1640s.[52] While the allusions to kings and monarchy in many of the Tutin poems do imply a habitually royalist cast of mind, the implications of these allusions are not always straightforward. The comparison of 'our king' to God in 'God was in Christ' –

> O what a desperate Lump of sins had we
> When God must plot, for our felicity! ...
> And what still are we, when our King in vain
> Beg's his lost Rebells to be friends again!
> 'God was in Christ', 11–12, 15–16

– is an unusually unambiguous expression of Philips's loyalties, all the more overt since the king in question (given the dating of the poem to April 1653) must be the exiled Charles II.[53] Elsewhere, however, Philips's royalist references are often complicated by the same privileging of personal virtue over worldly grandeur glimpsed already in 'On the 3rd September'. Her elegy on Mary Lloyd (Anne Owen's grandmother), for instance, counts it as one of the sorrows of Lloyd's life that she had seen 'Crowns revers'd, Temples to ruine hurl'd' (88). Yet Lloyd's response to these upheavals – 'She in Retirement chose to shine and burne / As Ancient Lamps in some Egiptian Urne' (89–90) – suggests resignation rather than heartfelt grief, and Philips's conclusion to the elegy verges on the antiroyalist in its doubled preference for Lloyd's virtue over the more questionable benefits conferred by regal origins:

> A Royall Birth, had less advantage been
> 'Tis more to dy a Saint, then Live a Queen.
> 'In memory of ... Mrs Mary Lloyd', 105–106[54]

[52] Ronald Hutton, 'Vaughan, Richard, second earl of Carbery', *ODNB*.
[53] Tutin MS, p. 150, Thomas I, p. 181. Compare her use of 'Roundhead' as a term of abuse in 'For Regina' (19), possibly once included in Tutin (Thomas I, p. 125).
[54] Tutin MS, p. 125, Thomas I, p. 114.

Similarly, her elegy on Anne Owen's step-grandmother, Dorothy, speaks of the latter's quiet acceptance of 'the angry Fate / Which tore a church and overthrew a State', explaining that Owen herself, 'Humble and high, full of calme Majesty / ... kept true 'State within' ('In memory of ... Mrs Owen', 33–34, 38–39).[55] Just as Philips's elegies on Lloyd and Owen are transcribed, respectively, in the personal and philosophical sequences within Tutin, other allusions privileging individual virtue over the claims of royalty can be found in both sections of the manuscript. In the philosophical sequence, 'The Soule' and 'L'accord du bien' both assert that self-control is better than monarchy (77–78; 97–100), while 'La Grandeur d'esprit' draws a contrast between 'Kings / And conquerours' who are 'tumbled to their graves in one rude heap / Like common dust' and 'the greate immortall man' who can '[b]e virtuous' (23–24, 25–26, 96).[56] Comparably, in the personal sequence, while Rosania in 'Rosania shaddow'd' is likened to a palace (31–36), she is also described as 'beyond a Throne' (58); the friendship of Orinda and Lucasia in 'Friendships Mysterys' is said to be '[t]hen Thrones more great and innocent' (17); and 'Content' includes the insistence that true contentment 'ne're dwelt about a Throne' (8).[57] Even 'To the Noble Palaemon on his incomparable discourse of Friendship', though figuring Francis Finch's vindication of friendship as the restoration of an injured queen, concludes from Finch's 'august ... action' that ''Tis greater to support then be a Prince' (19–20); the irony is all the stronger given the obvious royalism of Finch's *Friendship* treatise.[58] In another era, many of these comments would have been unremarkable literary commonplaces. In the sensitive political context of the 1650s, however, such an innocent interpretation of these high-minded sentiments becomes impossible.

As evidence for Philips's politics during the 1650s, the poetry of the Tutin manuscript points in different directions. The royalist sympathies which she seems to have shared with many of her friends are problematised by the tendency of so much of her philosophical poetry to favour stasis over struggle and personal integrity over any form of worldly greatness.

[55] Tutin MS, p. 134, Thomas i, p. 164.

[56] Tutin MS, p. 190, Thomas i, p. 188; Tutin MS, p. 180, Thomas i, p. 173; Tutin MS, p. 140, Clarke MS, p. 23, Thomas i, pp. 157, 159. (The final line of 'La Grandeur d'esprit' is quoted from Clarke because of damage to Tutin.) The indiscriminate conflation of kings and conquerors is also significant.

[57] Tutin MS, p. 21, Thomas i, pp. 118–19; Tutin MS, p. 79, Thomas i, p. 90; Tutin MS, p. 83, Thomas i, p. 91.

[58] Tutin MS, p. 95, Thomas i, p. 84. On Finch's royalism see his *Friendship* [1654], pp. 7 and 28, and Hero Chalmers, *Royalist Women Writers, 1650–1689* (Oxford University Press, 2004), pp. 64–65.

While her friendship poems sometimes testify to shared political loyalties (as in her appeal to Lucasia to defend her honour against J. Jones), others manifest the same conflicting priorities as does the rest of the Tutin collection, while one, 'A retir'd frendship', advocates an Indifference to worldly concerns which more committed royalists of the period might have found distinctly offensive.[59]

Contradictory priorities also apply in the case of poems addressed to figures outside her immediate friendship circle. As the array of address-ees in the Tutin poems clearly shows, Philips's access to the world of public poetry and culture in the 1650s was mediated through con-nections with staunchly royalist men. As well as 'In memory of Mr Cartwright', Tutin also includes a copy of 'To the truly noble Mr Henry Lawes', a version of which was published among the dedica-tory matter to the composer's *Second Book of Ayres and Dialogues* in 1655. Lawes was an erstwhile member of the Chapel Royal who had also written music for secular court entertainments. Given such connections (probably initiated through her friend Edward Dering, poems by whom are also included in the Cartwright and Lawes volumes), Philips's expression of forthrightly royalist views, while no doubt sincere, also involves a significant element of self-interest.[60] Self-interest similarly helps to account for her politically anomalous praise of the Countess of Carbery, since the latter's husband was an important landowner in south-west Wales – a position which, indeed, his willingness to compromise with parliament had enabled him to sustain. Royalists such as Lawes and Francis Finch could assist Philips's cultural prospects in London; the Earl and Countess of Carbery were potential patrons closer to home.[61]

Catharine Gray has aptly described Philips's elegy on William Cartwright as 'post-courtly' verse which, though witnessing to royalist allegiances, was paradoxically enabled as a print-publication by the absence of the court and its supporting structures.[62] Philips's post-courtliness, though premised on royalist nostalgia, is less inclined to dwell on

[59] See Wright, 'Textuality', pp. 171–74.

[60] On the inclusion of Dering in the Cartwright and Lawes volumes, see Gray, *Women Writers and Public Debate*, p. 117.

[61] Philips and the Countess had a mutual acquaintance in Henry Lawes, who had been the latter's music teacher (Chalmers, *Royalist Women Writers*, p. 19); however, 'To the Right Honourable Alice, Countess of Carbery' makes no claim that the two women were themselves acquainted.

[62] Catharine Gray, 'Katherine Philips and the Post-Courtly Coterie', *English Literary Renaissance*, 32.3 (2002), 426–51 (esp. pp. 427 and 435).

past wrongs than to investigate ways of living virtuously in the present. This is apparent even in her praise of the steadfastly royalist Henry Lawes, to whose music she attributes the power to heal and renew the country: 'Be it thy care our age to new-create: / What built a world may sure repayre a state' (39–40).[63] It is also, though more subtly, apparent in the several religious poems Philips wrote during the Tutin period. Typically, Philips's religious poems yearn towards a condition of peace and stasis in which the soul, no longer afflicted by earthly travails, moves towards closer union with God.[64] In 'On Controversies on Religion', for instance, the soul

> ... resting here hath yet activity
> To grow more like unto the Deity.
> Good, Universall, wise and Just as he
> (the same in kind though differing in degree)
> Till at the last 'tis swallow'd up and grown
> With god, and with the whole Creation One.
> 'On Controversies in Religion', 61–66[65]

Similarly, in 'Out of Mr More's Cupid's Conflict', she prays 'To the still voice above my Soule advance, / My light, and Joy, fix'd in Gods Countenance' (53–54).[66] This privileging of stillness in Philips's religious poems, together with the measured, uncomplicated tone of their arguments, may help to account for their relative unpopularity with twenty-first-century readers: these texts offer no equivalent to the anguished spirituality of Donne or Herbert and read like considered statements of preformed opinions, rather than spiritual self-dialogue in action. (The opening of 'Submission' – ''Tis so; and humbly I my will resign, / Nor dare dispute with Providence divine' (1–2) – describes a position which in a Donne or Herbert poem might be the end, not the beginning, of the argument.)[67] When read against the denominational strife of the 1640s and 50s, however, Philips's emphasis on stillness takes on a rather different resonance. Her assertion in 'On Controversies in Religion' that ''tis injustice and the minds disease / To think of gaining truth by loosing Peace' (23–24) clearly sets her apart from the sectarian divisions of the Civil War and interregnum, as does her reference to church disruption as among the chief troubles of Dorothy Owen's life

[63] Tutin MS, p. 93, Thomas I, p. 88; compare Gray, *Women Writers and Public Debate*, p. 118.
[64] See further Brady, 'Platonic Poems', pp. 311–15. [65] Tutin MS, p. 214, Thomas I, p. 131.
[66] Tutin MS, p. 219, Thomas I, p. 140. [67] Tutin MS, p. 156, Thomas I, p. 178.

('In memory of ... Mrs Owen', 34).[68] Yet there is nothing in the poetry of the Tutin manuscript which indicates a deep attachment to the forms and traditions of Church of England worship: no mention is made of liturgy, Eucharistic theology, vestments, church windows or Episcopalian government. Significantly, when Philips envisages spiritual enlightenment, she imagines it occurring not through external structures or processes but through direct communication between God and the soul. In 'Out of Mr More's Cupid's Conflict', she asks 'When shall those cloggs of sence, and fancy break / That I may heare the God within me speak?' (49–50), while in 'On Controversies in Religion', she declares that truth cannot be found 'in a Thunder, or a Noise / But in soft whispers and the stiller voice' (29–30, citing 1 Kings 19:11–12).[69] The religious poetry of the Tutin manuscript, in other words, neither harks back to the Laudian Church of England with which Charles I had been so closely associated nor includes any forms of religious devotion which would have been difficult to practise in the 1650s. Rather than aligning Philips, like so many royalists in this decade, with regret for the institutional Church of England, it implies a willingness to accommodate her own spiritual beliefs, peaceably, within the new circumstances of the 1650s.

Overall, the Philips of the Tutin manuscript is a diverse creature. As well as the friendship poetry for which she is now best known, the manuscript also includes serious discussions of philosophy, religion and politics, pursued with more depth and complexity than she is often given credit for. It bears witness to Philips's role as a family and social poet, commemorating deaths and marriages within her own household and the local community. Her poems on public figures indicate her ambition and hint at an interest – mostly latent at this stage in her career – in the print-publication of her own works. Her confident use of a wide range of metres and verse forms speaks both to her technical skill and to her ability to match form to subject. She is at ease in using the choric 'we' to authoritative effect, not only in her friendship lyrics but also in religious poems such as 'Death' and 'The World'. However, while she frequently invokes the notion – favoured in so much male-authored early modern poetry – of the immortalising powers of art, she is conspicuously cautious about claiming

[68] Tutin MS, p. 218, Thomas I, p. 130; Tutin MS, p. 134, Thomas I, p. 164. 'On Controversies in Religion', unusually among Philips's religious poetry, does recall Donne – significantly, however, the more analytical Donne of 'Satire 3' rather than the tortured speaker of the Holy Sonnets.

[69] Tutin MS, p. 219, Thomas I, p. 140; Tutin MS, p. 218, Thomas I, p. 130.

any such powers for her own poetry. While Sir Edward Dering is saluted for conferring 'eternity' on Philips (through ventriloquising her 'Orinda' persona in one of his poems), allusions elsewhere in the Tutin poems typically disavow any such claims on her own account: immortalising powers are attributed confidently to Lucasia ('Wiston-Vault', 15–18; 'To my Lucasia', 29–36), friendship ('Friendship in Emblem', 61–64), surviving friends and relatives ('In memory of Mrs E. Hering', 45–48) and even 'an abiding faithfull Stone' ('Epitaph on Mr John Lloyd', 12), but only rarely and convolutedly to Philips herself – as when she assures Anne Owen that 'tell[ing] the world I was subdu'd by you' is the only way she can secure her own posthumous reputation ('To the truly noble, and obleiging Mrs. Anne Owen', 16).[70] Much though Philips – it seems – would like to claim these immortalising powers on her own account, the imperatives of feminine modesty trump the expression of such poetic ambitions.

Philips's description of herself as 'born and bred in so rude and dark a Retreat' implies, as John Kerrigan and Sarah Prescott have argued, that she liked to associate her emergence as a poet with her move to Wales; the terms of this self-description do not readily apply to her actual birthplace, London.[71] The evidence of her own autograph collection, which includes no poems firmly datable before autumn 1649, bears out this association, and suggests further that Philips's marriage in August 1648 may have helped make it possible for her writing to flourish. Why she abandoned work on the Tutin manuscript in the late 1650s or early 1660 may never be known for certain, but is likely to be due to two interconnected factors: the limitations inherent in Tutin's binary structure, and the new, more public, poetic genres she began to explore after the Restoration, which could not have been readily categorisable as either 'philosophical' or 'personal'. It seems fitting that among the final items to be added to Tutin – and unquestionably the last addition to the personal sequence – is the title (though not the text) of 'To the Right Honourable the Lady E. C.'.[72] Philips's verse epistle to the Lady Elizabeth Carr, daughter to the first Earl

[70] Tutin MS, p. 63, Thomas I, p. 86; Tutin MS, p. 99, Thomas I, p. 106; Tutin MS, p. 109, Thomas I, p. 129; Tutin MS, p. 105, Thomas I, p. 108; Tutin MS, p. 170, Thomas I, p. 176; Tutin MS, p. 133, Thomas I, p. 248; Tutin MS, p. 39, Thomas I, p. 103. Many of Philips's disclaimers, on closer examination, prove mildly disingenuous.

[71] Katherine Philips, *Letters*, p. 201; John Kerrigan, *Archipelagic English: Literature, History, and Politics 1603–1707* (Oxford University Press, 2008), p. 213; Sarah Prescott, '"That private shade, wherein my Muse was bred": Katherine Philips and the Poetic Spaces of Welsh Retirement', *Philological Quarterly* 88.4 (2009), 345–64 (p. 352).

[72] Tutin MS, p. 135; compare *IELM*, p. 129.

of Ancram, marks a new direction in her poetry, as she started to look beyond her immediate familial, friendship and geographical networks and to cultivate a wider and more public readership. The initial stages of this new phase in her career are documented in the next two manuscript collections of her poetry, the Clarke and Dering manuscripts, as well as in a printed volume, *Poems, by Several Persons*, published in Dublin in 1663.

POET OF THE RESTORATION: CLARKE, DERING, AND *POEMS, BY SEVERAL PERSONS*

Clarke, Dering, and *Poems, by Several Persons* are linked by a complex network of textual connections. The Clarke manuscript, whose scribe is unknown, includes seventy-three poems by Katherine Philips, transcribed in a single unidirectional sequence. The sequence is preceded by a complimentary ode on Philips by Abraham Cowley, while the final poem, 'On the Honourable Lady E. C.', is followed by another complimentary poem, beginning 'Madam the praises of your freind shall live'.[73] All but three of the poems extant by text or title in Tutin are also present in Clarke; the three exceptions are the incomplete epitaph on Hector Philips, 'To my dearest friend, on her greatest loss', included in Tutin as title-only, and 'Epitaph on Mr John Lloyd', voiced in the person of Lloyd's widow, Cicely.[74] Philips's verse epistle to Elizabeth Carr, the other title-only inclusion in Tutin, is fully transcribed in Clarke. Also included in Clarke are the nine poems identified above as certain or probable excisions from Tutin, as well as ten further poems dating between March 1660 and May 1662: an elegy on Philips's step-daughter, Frances, who died in May 1660, and nine complimentary on Charles II's accession and on other leading members of the royal family. Following the Cowley ode, the collection begins with the third poem in the Tutin philosophical sequence ('Happiness'), then continues with the remaining philosophical poems, in Tutin order but including the excised poems, followed by the personal-sequence poems as far as 'To my Lucasia' and 'To my Lucasia in defence of declared freindship', also in Tutin order but including excisions.[75] At this point, where Tutin continues with the two unfinished poems (the Hector

[73] On the Clarke MS, see further *IELM*, pp. 130 and 174 (PsK 500).

[74] On the contents and order of the Clarke manuscript, see Philips, *Orinda*, and Hageman, 'Treacherous Accidents', pp. 91–92.

[75] This is a simplified description which does not fully account for the difficulties of fitting the two non-Tutin Collyer poems and 'The Enquiry' into the Clarke sequence.

Philips epitaph and 'To my dearest friend, on her greatest loss'), Clarke adds 'The Enquiry', the nine royal poems and the elegy on Frances Philips. It then continues with the next three personal-sequence Tutin poems (the Mary Lloyd elegy, 'Parting with Lucasia' and 'Against Pleasure'), inserts the first two poems from the Tutin philosophical sequence ('Out of Mr More's Cop. Conf.' and 'On Controversies in Religion'), and concludes with 'On the Honourable Lady E. C.'. Clarke's copies of poems also extant in the Tutin manuscript show little evidence of purposeful variation from the Tutin texts; differences between the two manuscripts in this respect are more probably due to the Clarke scribe's lack of technical skill.[76]

The Dering manuscript, transcribed by Philips's friend Sir Edward Dering, includes seventy-four poems by Philips, plus the titles of two more, all transcribed in a single sequence. Of these, seventy-two of the completed poems are also extant in Clarke. Dering omits 'On Controversies in Religion', and adds two further poems not found in Clarke: 'To the Lady Mary Butler at her marriage with the Lord Cavendish' and 'An ode upon retirement made upon occasion of Mr Cowleys on that subject'. The two titles – 'The Irish greyhound' and the song 'How prodigious is my fate' – are also new. The order of materials in the Dering manuscript again follows the Tutin manuscript, though less closely than Clarke and in a different arrangement.[77] The manuscript begins with the personal-sequence poems, transcribed in approximate Tutin order, as far as 'To my Lucasia' and 'To Lucasia. in defence of declared freindship'. It then continues with 'The Enquiry' and eight of the nine new royal poems, transcribed in an order slightly different from Clarke's, and also incorporating the Frances Philips elegy. This is followed by two series of poems corresponding to Clarke sequences (the philosophical poems from 'Happynesse' to 'Friendship' and the personal poems from the Mary Lloyd elegy to 'Against pleasure'), the More poem, and two blank pages presumably once intended for the transcription of 'On Controversies in Religion'. The last six items in the collection are the verse epistle to Elizabeth Carr, 'To the Queene on her arrivall at Portsmouth', the two title-only inclusions, 'To the Lady Mary Butler', and 'An ode upon retirement'. Dering's copies of poems also extant in Tutin include numerous (though generally minor) textual variations, in both substantives and accidentals.[78]

[76] Hageman, 'Treacherous Accidents', pp. 93–95.
[77] See Philips, *Orinda*, and Thomas 1, pp. 65–68.
[78] Germaine Greer, *Slip-Shod Sibyls: Recognition, Rejection and the Woman Poet* (London: Penguin, 1996), p. 149; Hageman, 'Treacherous Accidents', p. 94.

To complete the picture, *Poems, by Several Persons* includes Cowley's ode on Philips (as in Clarke), as well as Philips's own 'Ode. On Retirement' and 'To the Right Honourable, the Lady Mary Butler' (as in Dering). It also includes both a full text of 'The Irish Greyhound' and a poem by the Earl of Orrery praising Philips's translation of an excerpt from Corneille's *Pompée*. Clarke and Dering further resemble the Dublin-published *Poems* in that both appear to have Irish links. The Clarke manuscript, preserved among the papers of the politician and architect George Clarke, was probably bequeathed to him by his father, William, who had business in Ireland in the early 1660s.[79] Sir Edward Dering was also based in Ireland between 1662 and 1669–70.[80] The likelihood is that both manuscripts were compiled during Philips's visit to Ireland in 1662–63, and were produced with her approval and support.[81]

The Restoration of the monarchy in 1660 brought significant personal changes for both Katherine Philips and her husband James. Though James was re-elected to parliament in 1661, he was soon afterwards put on trial, accused of responsibility for a capital conviction in the interregnum High Court of Justice. Though he was acquitted of this charge (with Sir William Clarke giving evidence on his behalf), in the following year his election to parliament was overturned on a technicality and he was excluded from the House of Commons, his involvement in national government effectively over. Philips's poem 'To my Antenor, March 16. 1661/2', which aims to dissuade her husband from 'talk[ing] of graves' (2), implies that James's despair at these misfortunes brought him close to suicide.[82]

For Philips herself, however, the Restoration opened up important new opportunities. She became acquainted with Sir Charles Cotterell, formerly steward to Elizabeth of Bohemia and adviser to Henry Duke of Gloucester, and now Master of Ceremonies to Charles II. As well as politics, Philips and Cotterell had literary interests in common: Sir Charles was an accomplished linguist and published translator, and it is clear from Philips's surviving letters to him – the *Letters from Orinda to Poliarchus*, dating from December 1661 to May 1664 – that he not only supplied her with books in French and Italian but also advised her on technical aspects of

[79] Beal, *In Praise of Scribes*, p. 163.
[80] Paul Seaward, 'Dering, Sir Edward, second baronet', *ODNB*.
[81] Greer argues, based on watermark evidence, that the Dering manuscript may have been transcribed later (Greer, *Slip-Shod Sibyls*, p. 149). If this is the case, the manuscript nonetheless preserves an early 1660s collection, including very few of Philips's Irish poems and none which postdate her departure from Ireland in 1663.
[82] *Poems* (1667), p. 145; Thomas I, p. 217.

translation. Philips tried to encourage a match between Cotterell and her friend Anne Owen, but the attempt failed, and Owen married Marcus Trevor, Viscount Dungannon, in May 1662. Despite her disapproval of this marriage, Philips accompanied Trevor and Owen when they travelled to Ireland shortly afterwards, hoping also to sue for recovery of some of her father's investments in the Irish courts. During her year in Dublin she made the acquaintance of many leading members of the Irish nobility, including the Duke of Ormond, the Countess of Cork and her daughters, and the Earl and Countess of Roscommon. She also met the Earl of Orrery – politician, playwright and romance-writer – who encouraged her to complete her translation of Corneille's *Pompée* and helped arrange its successful public performance at the Smock Alley theatre. After seeing her court cases to a partially satisfactory conclusion, she returned to Wales in July 1663.

Though both Clarke and Dering, through the verses shared with *Poems, by Several Persons*, have clear textual links with Philips's sojourn in Dublin, both consist largely of work predating her departure for Ireland. The fact that both collections, despite their differences, include substantial sections closely based on the Tutin order of materials, forms an interesting coda to the mixed organisational evidence offered by Tutin itself. Inadequate though the organisation of Philips's autograph collection had turned out to be, Clarke and Dering provide only partial and conjectural evidence that the poet herself had attempted to revise it. While the material arrangements of the Clarke and Dering manuscripts plainly differ, the structural similarities in how they divide up the two Tutin sequences and insert the post-1660s material strongly suggests that the bulk of materials in each derives ultimately from the same source – possibly a revised autograph collection by Philips herself, now lost. If so, while Philips herself may have taken the key structural decisions on how to revise her collection (including the decision to merge the two sequences into one), she did nothing to rearrange the order of materials at a poem-by-poem level. Perhaps Philips was broadly content with the micro-organisation of her Tutin poems, despite its apparent shortcomings. Perhaps, at this stage of her career, she no longer saw such details as important.

The new material common to both Clarke and Dering clearly indicates what Philips did consider important in the early 1660s. 'In memory of FP', one of the longest and most affecting of her epitaphs, shows her continuing role as an elegist and verse-chronicler for her family. Yet missing from Clarke and Dering are two other family-based poems by Philips which can also be linked with the early 1660s: 'To my Antenor, March 16. 1661/2' and

'Epitaph on my truly honoured Publius Scipio'. Both poems witness to Philips's familial links with leading parliamentarians – her mother's third husband, Philip Skippon, who died in 1660, had served under Essex and Fairfax and had been honoured by Cromwell – and 'To my Antenor' also discloses more about James Philips's mental health than a concerned wife may have cared to make public. Both poems are also missing from the next two collections of Philips's poetry (*Poems* (1664) and the Rosania manuscript), and are collected for the first time in the posthumous *Poems* (1667). The most likely explanation is that while Philips was happy for non-familial readers to see her elegy on Frances, which brought only credit on herself and her family, she preferred to restrict the circulation of the potentially more embarrassing Antenor and Scipio poems. Neither would have kept easy company with the main body of new material in Clarke and Dering, the nine poems on the Restoration and the royal family.

The new royal poems in Clarke and Dering comprise three on the accession and coronation of Charles II, as well as six occasional poems on other members of the royal family: complimentary verses addressed to Henrietta Maria, Catherine of Braganza and the Duchess of York, and elegies on the Princess Royal, Prince Henry of Gloucester, and Elizabeth of Bohemia. Unsurprisingly, the royalism of these post-Restoration panegyrics is enthusiastic and unambiguous, while the treatment of individuals is typically formal and conventional. The poems clearly struggle to devise a mode for addressing public figures with whom, unlike almost all the subjects and addressees of the Tutin manuscript, Philips had no personal acquaintance. It is no coincidence either that the Tutin poem which most nearly resembles these stilted verses is 'To the Right Honourable Alice Countess of Carberry', or that the two royal poems which come closest to reinventing the ease, detail and intimacy of the Tutin lyrics are her elegies on Prince Henry and the Queen of Bohemia – both personally known to her friend, Charles Cotterell, though not to Philips herself.[83]

The awkward style of Philips's royal poems is indicated by the biblical allusions deployed in each of her poems on the coronation. While these allusions, which link Charles II successively with Joseph, Solomon and Moses, are elegant and ingenious, they each seem to have been less than fully thought through. In 'On the Numerous Accesse of the English to waite upon the King in Flanders', the analogy between Joseph (restored to his father Jacob) and Charles (restored to his people, England) is graceful in itself but depends on the reader choosing not to recall that the new

[83] Compare Thomas I, pp. 327–29.

king's true father was not England but Charles I – who, unlike Philips's England, never had the opportunity to 'grow ... old with woes' (19).[84] Comparably, her implicit identification of Charles II with Jesus in 'Arion to a Dolphin' (10) pushes decorum to the limit, while her likening of the symbolic interlude of sunshine at Charles's coronation to the Israelites' crossing of the Red Sea ('On the faire weather', 15–18) is rather too contrived to be persuasive.[85] (Her praise of Charles as a devoted husband and as a bulwark against Catholicism now carries heavy ironies, and underscores how little she, like so many of her countrymen, really knew about their restored monarch.)[86] As well as asserting Philips's royalism, emphatically and unsubtly, several of the poems also serve her familial interests by insisting on Charles's clemency to his enemies: 'Arion to a Dolphin' compares him to 'a God [who] doth rescue those / Who did themselves and him oppose' (57–58), while her identification of Charles with Joseph, who forgave his would-be murderous brothers, carries similar implications. For the royalist wife of a parliamentarian husband, the practical advantages of asserting loyalty while advocating mercy are obvious.[87]

While the new material common to Clarke and Dering speaks clearly to Philips's personal and political situation in 1660–61, the (different) poems shared by each with *Poems, by Several Persons* foreshadow many of the key developments in her writing during and after her triumphant year in Ireland. Abraham Cowley's commendatory verses on Philips (in Clarke) provide solid evidence her poetry had been noticed at the highest level of contemporary literary readership, while her own 'An ode upon retirement', subtitled 'made upon occasion of Mr Cowleys on that subject' (in Dering) shows her not only responding to Cowley but doing so in his own most characteristic genre, the pindaric ode. Its divergence from Philips's pre-Restoration retirement poems, none of which cites a public figure, is also shown in its construction of solitude rather than friendship as the ideal state of retirement.[88] Her poems on the Irish greyhound (probably a specific allusion to an animal owned by the Earl of Orrery) and Lady Mary Butler (also in Dering), mark her first attempts to gain favour with

[84] Clarke MS, p. 66, Thomas I, p. 70.
[85] Clarke MS, p. 68, Thomas I, p. 71; Clarke MS, p. 72, Thomas I, p. 73. The 'Arion' allusion plays on Jesus' self-comparison to Jonah and Solomon (Matthew 12:41–42). Line numeration of 'On the faire weather' follows Dering and other copies; Clarke omits line 12.
[86] 'To the Queene on her arrival at Portsmouth', 21–22, 37–44, 'Arion on a Dolphin', 71–72.
[87] Compare Souers, *The Matchless Orinda*, pp. 104–05; Chalmers, *Royalist Women Writers*, pp. 82–85.
[88] One pre-Restoration retirement poem ('A Countrey Life') also privileges solitude.

the Irish nobility, while Orrery's compliments on her *Pompey* translation
(in *Poems, by Several Persons* and later reproduced in the 1667 *Poems*)
initiate one of the most sympathetic and productive patronage relation-
ships she was ever to enjoy.[89]

The Philips of the Clarke and Dering manuscripts (and also *Poems, by
Several Persons*) is a poet whose prospects are expanding rapidly. She is
experimenting with new forms of public poetry, and though she has not
yet perfected a mode of address to the restored royal family, she has gained
the respectful attention of one of the most acclaimed poets in England
(Cowley) and one of the most influential nobles and men of letters in
Ireland (Orrery). Furthermore, despite the shortcomings of her royal
poetry, both collections provide early evidence of its favourable reception
at court: her poem to the Duchess of York is endorsed 'on her Command-
ing me to send her some things that I had written'.[90] As (apparently)
approved scribal copies, both manuscripts also indicate Philips's willing-
ness to permit circulation of a selected range of her poetry, even if only to a
limited degree amongst friends and allies. Moreover, while she does not
seem to have been directly responsible for the inclusion of her work in
Poems, by Several Persons, she evidently saw her role in the volume as
flattering rather than offensive, enclosing a copy with a letter to Cotterell
(albeit with a modest disclaimer).[91] The Philips of the early 1660s, though
still primarily a manuscript-based poet, is edging ever closer to the world
of print. The next collection of her poetry, *Poems, by the incomparable
Mrs. K. P.*, marks the point at which the ambiguous boundary between
print and manuscript was definitively crossed. Its publication, in January
1664, is still the most controversial episode in Philips's career.

PHILIPS IN PRINT: *POEMS* (1664)

On returning from Ireland in July 1663, Philips rejoined her husband in
Wales. She was apparently alerted to the publication of *Poems* by letters
from her friends Charles Cotterell and John Jeffreys, just a few days after it
was advertised for sale in London. Though Philips professed horror on
hearing of the volume and emphatically denied any responsibility for it,
claiming that she had 'never writ any line in my life with an intention to

[89] On Orrery and the greyhound, see Thomas I, p. 374.
[90] Clarke MS, p. 72; compare Thomas I, p. 80. The duchess's favourable reception of Philips's work is
also recorded in the letters to Poliarchus (Philips, *Letters*, p. 38).
[91] Philips, *Letters*, p. 146; compare Greer, *Slip-Shod Sibyls*, p. 154.

have it printed', many later readers have suspected her of protesting too much.[92] The fullest and most persuasive case for Philips's involvement with *Poems* (1664) is made by Germaine Greer, who argues that publication may have been motivated by the 'severe financial difficulty' faced by James Philips in the 1660s, as he was obliged to surrender the sequestered properties and crown lands he had acquired over the previous two decades.[93] Although, on balance, this explanation seems unlikely – as Beal points out, the likely financial rewards from publication would have been minimal, social embarrassment certain – Greer's bibliographical reasons for doubting the 'unauthorised' status of *Poems* (1664) compel attention.[94] Greer notes not only that Richard Marriott, the publisher of *Poems*, was an experienced and well-regarded literary bookseller, but also that *Poems*, unlike most pirated volumes, includes only texts by the named author, all in largely uncorrupted states.[95] Though Hageman questions some aspects of Greer's argument, the counterexamples she cites do not seriously undermine the latter's key bibliographical claims.[96] While the copytext underlying *Poems* (1664) was evidently problematic in some respects, it clearly derived from a source close to Philips, if not from Philips herself.

Poems (1664) is an octavo volume containing seventy-five poems by Katherine Philips. Compared with Bradstreet's *The Tenth Muse*, with its wealth of male-authored commendatory material, and Margaret Cavendish's *Poems and Fancies* (1653), prefaced by five letters and three poems by Cavendish herself (as well as one commendatory letter by a former maid), its introductory apparatus is relatively modest: just two poems, albeit one by Abraham Cowley (a lightly revised version of the 'Ode' from *Poems, by Several Persons*), as well as a second by an unidentified 'H.A.'. The preliminaries to the volume also include a table of contents.

Like the Clarke and Dering volumes, *Poems* (1664) has a close but complex textual relationship with preceding collections of Philips's poetry. Its seventy-five poems include only one which had not previously appeared in either Clarke or Dering, 'On the Queen's Majesty, on her late Sickness and Recovery'. While it includes her 'Ode on retirement' (here entitled

[92] *Poems* (1667), sig. A1v. [93] Greer, *Slip-Shod Sibyls*, p. 163. [94] Beal, *In Praise of Scribes*, p. 163.
[95] Greer, *Slip-Shod Sibyls*, pp. 160–62; see also Nathan Tinker, 'John Grismond: Printer of the Unauthorized Edition of Katherine Philips's *Poems* (1664)', *English Language Notes*, 34.1 (1996), 30–35, on the equally reputable printer of the 1664 *Poems*. On the ideological congruity of Philips's *Poems* within Marriott's career, see Jonquil Bevan, 'Isaac Walton and his Publisher', *The Library*, 32.4 (1977), 344–59.
[96] Hageman, 'Treacherous Accidents', pp. 87–88.

'Upon Mr. Abraham Cowley's Retirement'), extant in Dering though not Clarke, it omits 'The Irish Greyhound', the song 'How prodigious is my fate' and 'To the Lady Mary Butler', all in Dering (the first two as title-only). In terms of order, the most obvious innovation in *Poems* is its foregrounding of Philips's poems on the royal family. The volume begins by gathering the eleven royally connected poems extant in Tutin, Clarke and Dering: 'Upon the double Murther of King Charles I', the nine poems on Charles II and his family, and 'On the 3. of September, 1651'. It then continues with Philips's friendship poems, in a sequence close to but not identical with the order followed in Clarke and Dering.[97] Also included in this section are the elegies on Frances Philips (here misidentified as 'T. P.'), 'On Controversies in Religion' and 'Out of Mr. More's Cop. Conf.'. The collection then continues with seventeen philosophical poems, again in a slightly shuffled order, and including 'To my Lucasia, in defence of declared Friendship' (apparently here reclassified as a philosophical poem on grounds of its abstract discussion of friendship). It culminates with a curious double conclusion: 'To the Queen's Majesty, on her late Sickness and Recovery', the last poem listed in the table of contents, is followed by 'Finis', an errata list and a blank leaf, before the addition of 'Upon Mr. Abraham Cowley's Retirement'. Presumably the Cowley poem was a late inclusion in the volume.[98]

As a representation of Katherine Philips's writing up to autumn 1663 (when the volume would have been in press), *Poems* (1664) is both carefully planned and oddly naïve. It is also demonstrably out of date. The collection is based on a copytext similar to Clarke and Dering, which evidently included neither Philips's uncollected poems from earlier periods (such as 'On the 1. of January 1657' or 'Epitaph on my truly honoured Publius Scipio') nor the poems and translations produced during her latter months in Ireland (later collected in the Rosania manuscript and the 1667 *Poems*). The use of the eleven royal poems to commence the volume is a clear and deliberate attempt to identify the print-published Philips as a royalist poet: no previous witness had grouped these pre- and post-Restoration poems as a single sequence or placed them at the head of the collection. *Poems* (1664) further accentuates Philips's royalism by

[97] On the relationship between *Poems* (1664) and Dering, see further Thomas 1, pp. 65–68.

[98] I discuss the structure and politics of the 1664 *Poems* more fully in Wright, 'Textuality'. See also Ellen Moody's discussion of the structure of the 1667 *Poems* (Moody, 'Orinda, Lucasia, Rosania *et aliae*', pp. 327–30), since many of the characteristics she observes in the later volume ultimately derive from *Poems* (1664).

reordering the post-Restoration royal poems into a finely judged hierarchical series (beginning with Charles II, his wife and his mother, and concluding with 'To her Royal Highness the Duchess of York' and 'On the Death of the Queen of Bohemia'), while using 'To the Queen's Majesty, on her late Sickness and Recovery' – the only royal poem by Philips to postdate Clarke and Dering – as a late recapitulation of the poet's monarchist credentials.

However, this privileging of royalist materials is only one of several respects in which the compilation of *Poems* (1664), so strategic in terms of broad patterns and structures, looks mechanical and even crude at the level of detailed textuality. The solid and long-standing royalism implied by the structure of the 1664 volume, though fully endorsed by the royal poems of the 1660s, is partially undermined for the attentive reader by the contradictions inherent in both 'Upon the double Murther' and 'On the 3. of September'.[99] To this anomaly should be added the bibliographical problems noted by Hageman (the poor quality of some of the texts, the failure to differentiate Philips's text from More's in 'Out of Mr. More's Cop. Conf.'), as well as the gross error of tact involved in the inconsistent use of coterie names for Philips's friends.[100] As Greer observes, the use of both coterie and proper names for the poet's friends Rosania/Mary Aubrey and Lucasia/Anne Owen in the 1664 *Poems* commits a flagrant breach of privacy through disclosing the apparently passionate and troubled course of Philips's relationships with these two women to the outside world, while the titles of other poems decode the identities of male correspondents in a manner that some, at least, might have found embarrassing.[101] Considerations of friendship and courtesy seem to have been largely ignored in a compilation which foregrounds public at the expense of private and is surprisingly unsophisticated in its translation of manuscript conventions into print.

Embarrassment alone, in my view, sufficiently accounts for Philips's well-documented distress at the publication of the 1664 *Poems*.[102] As well as the mortification inflicted on her two closest friends, print-publication risked compromising her discreet but determined campaign to bring her royal poems – in manuscript, through Cotterell – to the attention of the

[99] Compare Moody, 'Orinda, Lucasia, Rosania *et aliae*', pp. 328–29.
[100] Hageman, 'Treacherous Accidents', pp. 87–88. Some of the textual problems in 1664 are likely to result from the nature of its copytext, rather than the inadequacies of the print editor; see Hageman, 'Treacherous Accidents', pp. 94–95.
[101] Greer, *Slip-Shod Sibyls*, pp. 163–64.
[102] Beal, *In Praise of Scribes*, pp. 163–65; Hageman, 'Treacherous Accidents', p. 87.

Duchess of York and even the king himself.[103] Her own likely connivance
in the manuscript transmission of her poetry, as well as her flattered
response to inclusion in the prestigious *Poems, by Several Persons*, no doubt
made it all the more important for her to express horror at the ill-judged
publication of *Poems* (1664). There also seems no good reason why, had
she herself been involved in the publication, she would not have added
some more recent material to the rather outdated collection represented by
the 1664 volume; obvious candidates include the songs for *Pompey*, which
she had described in a letter to Cotterell as 'not inferior to any thing I ever
writ'.[104] But while Philips's disavowal of responsibility for *Poems* (1664)
seems likely to be genuine, she also appears to have realised that its
unauthorised appearance had irretrievably recast her as a print-published
writer. Her assurance to Cotterell that 'provided the World will believe me
wholly innocent of the least Knowledge, much more of any Connivance at
this Publication, I will willingly compound never to trouble them with the
true Copies, which nevertheless you advise me to do', unerringly identifies
the two most persuasive justifications for a future 'authorised' edition of
her works: the concern to replace inaccurate texts of her work with 'true
Copies' and the encouragement of friends such as Cotterell.[105] Though
Philips did not live to see a revised version of her poems in print, there is
evidence that she used the few months between the publication of the 1664
Poems and her death the following June to begin preparing for a new
edition. This evidence is preserved in the two remaining collections of
Philips's poetry, the Rosania manuscript and *Poems* (1667).

THE POSTHUMOUS POET: THE ROSANIA MANUSCRIPT AND *POEMS* (1667)

The Rosania manuscript is at once the most fully explained and the most
mysterious collection of Philips's writings. A quarto manuscript 404 pages
in length, it begins with a dedicatory letter addressed to Rosania (Mary
Aubrey) and signed by one Polexander, apparently an otherwise unknown
member of Philips's coterie and the principal scribe of the subsequent
texts. Polexander's transcription begins with a text of *Pompey*, five poetic
translations from French and Italian, and an unfinished copy of *Horace*
(a second dramatic translation from Corneille which Philips had been

[103] On the presentation of *Pompey* to the king, see Philips, *Letters*, pp. 122 and 145–46.
[104] Philips, *Letters*, p. 110. [105] Philips, *Letters*, pp. 232–33, compare *Poems* (1667), sig. A2r.

working on when she died). None of this material had appeared in any previous collection of Philips's writings. The remainder of the volume comprises ninety-one original poems, fourteen previously uncollected in either manuscript or print. All the poems included in the 1664 printed volume reappear in Rosania, apart from 'To Mrs M. A. upon Absence'. Another poem, 'Rosania's private Marriage', is not in Polexander's hand and seems likely to be a later addition from a printed source. Rosania also includes three poems previously collected only in the Dering manuscript: 'To the Right Honourable the Lady Mary Boteler', 'The Irish Greyhound', and the song 'How prodigious is my Fate' (the last two title-only in Dering). The order of materials in the poetry section of the manuscript has been radically revised, and retains few traces of the Tutin/Clarke/ Dering patterns of organisation.[106] The texts of numerous poems also incorporate substantial and apparently purposeful revisions, with the omission of whole couplets or quatrains as well as alterations to individual words and phrases.[107] The manuscript is presented as a mourning volume: it is bound in black morocco, and ends with the poems 'Submission', 'Happiness' and 'Death'. Polexander's introductory letter both compliments Rosania on risking her life to care for her friend in her last illness and presents the latter's texts as a means of surviving her own death: 'Orinda, though withdrawn, is not from you; In lines so full of Spirit, sure she lives'.[108] The immortalising power which Philips had so fastidiously declined to claim for her own poetry is now unhesitatingly attributed to her by Polexander.

The still unresolved identity of Polexander is just one of many unanswered questions about the Rosania manuscript. We do not know, for instance, exactly when the manuscript was compiled, though it clearly postdates Philips's death while predating the publication of *Poems* (1667); Polexander, stressing 'To appear in Print, how un-inclined she was', adds 'I confess, an Edition, now, would gratify her admirers'.[109] We also do not know whether the revisions to either the texts or the order of Philips's poems in the Rosania manuscript are attributable to the author herself. The subtle poetic judgement evinced by many of the textual revisions in the manuscript makes authorial responsibility for these changes a plausible (though currently unprovable) possibility. However, if the order of materials in Rosania is also due to Philips, it must derive from an

[106] See Philips, *Orinda*, and Thomas I, pp. 65–68. Clarke is not collated in Thomas.
[107] On the textual variants in the Rosania manuscript, see Greer, *Slip-Shod Sibyls*, pp. 165–67.
[108] Rosania MS, p. 5. [109] Rosania MS, p. 6.

incomplete authorial manuscript of her poems, since it omits several poems subsequently published in the 1667 printed volume. Though these poems include some, like the epitaph on Philip Skippon, that Philips is likely to have withheld from public circulation, they also include others, such as 'To my Lady M. Cavendish' and 'To my Lord and Lady Dungannon on their Marriage', which seem to have been expressly written with public readership in mind. Furthermore, with a few obvious exceptions, it is difficult to discern any rationale underlying much of the organisation of the Rosania manuscript. The grouping of Philips's translations at the start of the collection is clearly purposive, as is the movement towards consolation at the end, while the royal poems of 1660 to 1662 and all but one of the Collyer poems are presented in chronological order.[110] Elsewhere, however, philosophical and friendship poems are interspersed, apparently at random, and the Rosania and Lucasia poems are separated and reordered without regard for chronology or narrative.[111] While the Rosania manuscript represents by far the most comprehensive collection of Philips's literary works thus far produced, it is by no means complete, and its textual authority remains uncertain.

The fourteen original poems gathered for the first time in the Rosania manuscript span a wide range of periods and genres. They include Philips's 'Epitaph on Hector Philips at St. Sith's Church', which presumably dates from 1655, two verse epistles addressed to Irish noblewomen ('To my Lady Elizabeth Boyle, singing' and 'To my Lady Ann Boyle's saying I look'd angrily upon her') which derive from her year in Dublin, and at least three poems produced during the last few months of her life: 'On the Death of my Lord Rich' must postdate its subject's death in May 1664, while 'To the Countess of Thanet, upon her Marriage' celebrates the former Elizabeth Boyle's wedding in April of the same year, and 'To my Lord Arch-Bishop of Canterbury his Grace' responds to the 1664 *Poems*, comparing its unauthorised publication to the rape of the biblical Tamar. Collectively, these fourteen poems encompass both established categories and new directions within Philips's work, as well as the re-emergence of one genre – friendship poetry – for the first time in any extant compilation since the Tutin manuscript. Her epitaphs on Hector Philips and her 'honour'd

[110] 'To her Royall Highness yᵉ Dutchess of York', which is arguably out of sequence among the royal poems, may have been difficult to date.

[111] On the treatment of the Rosania and Lucasia poems, see also Coolahan, '"We live by chance"', pp. 16–17.

Mother in Law' continue her role as a family poet, while her poems on the Boyle sisters and their nephew, Lord Rich, testify to the same determined cultivation of the Irish nobility first evident in the Dering manuscript and *Poems, by Several Persons*.[112] By contrast, 'On the Welch Language' manifests an interest in Welsh culture not previously apparent in her work, while her epistle to the Archbishop of Canterbury, Gilbert Sheldon, includes an overtly partisan commitment to the Church of England (described as 'the best Church of all the World' and opposed to 'the sullen Scismatick', 16, 45) which is sharply at odds with the quietism of her 1650s religious poetry.[113] Philips's unprecedented identification with establishment Anglicanism in 'To my Lord Arch-Bishop of Canterbury' – a religious counterpart to her newly unequivocal post-Restoration enthusiasm for the English monarchy – represents a plainly self-interested attempt to secure the goodwill of an influential patron, whom she begs to cast over her 'the same wing' (15) which already protects the Church.[114] But the very fact that Sheldon was a public figure, unconnected with any of her known friendship networks, provides possible if conjectural evidence that Philips's creative response to the 1664 *Poems* extended not only to denouncing and dissociating herself from Marriott's volume but also to beginning preparations for a revised and authorised edition. The poem to Sheldon is not only premised on but appears to anticipate a public readership for Philips's poetry, and seems obviously designed to vindicate the poet's reputation in a print-published volume. It was to be deployed to exactly this effect in *Poems* (1667).

Another element in the Rosania manuscript which seems likely to anticipate an authorised print edition is the reappearance of poems on Lucasia and Rosania. No new poems on either woman had been included in any previous 1660s collection of Philips's poetry, while even in Tutin Philips's poems to her closest women friends are concentrated in the earliest phase represented by the manuscript: the Rosania poems apparently terminate with 'To Rosania (now Mrs. Mountague)' in September 1652, while most (though not all) of the Lucasia poems also date from the early 1650s. The Rosania manuscript, however, adds three new friendship poems: 'A Dialogue betwixt Lucasia and Rosania', 'Lucasia, Rosania, and Orinda, parting at a Fountain. July 1663' and 'A Farwell to Rosania'. It is

[112] On Philips and the Irish nobility, see Coolahan, *Women, Writing, and Language*, pp. 200–12.
[113] Rosania MS, pp. 347, 348, Thomas I, pp. 239, 240. On Philips and Welshness, see Prescott, "'That private shade'".
[114] Rosania MS, p. 347, Thomas I, p. 239.

possible, as some critics have suggested, that the inclusion of these three poems in the Rosania manuscript is due to its intended recipient, Mary Aubrey, who may have held copies of all poems addressed to her.[115] However, it is also possible that these poems were specifically intended to counteract the most damaging impression produced by the 1664 *Poems*: namely, that Philips and Aubrey had quarrelled and that the latter had been replaced in the poet's affections by Anne Owen. The warmth expressed in 'A Farwell to Rosania' – another 'parting' poem, which looks eagerly towards Rosania's 'quick return' (6) – re-establishes the friendly relations which 'To Rosania (now Mrs. Mountague)' had given cause to question, while the 'Dialogue' and 'Lucasia, Rosania, and Orinda, parting at a Fountain' are the first poems in any collection which bring Lucasia and Rosania together.[116] 'Lucasia, Rosania, and Orinda' portrays all three women as equally grieved by their impending separation, while 'A Dialogue' insists specifically on the mutual affection between Rosania and Lucasia:

> ROS: Better't had been, I thee had never seen,
> Then that content to loose.
> LUC: Such are thy charms; I'de dwell within thy arms,
> Could I my station choose.
> 'A Dialogue betwixt Lucasia and Rosania', 17–20[117]

While 'A Farwell' and 'A Dialogue' are undated, and may have been written at any time, 'Lucasia, Rosania, and Orinda, parting at a Fountain' is attributed to July 1663. As Thomas points out, the alleged occasion of 'Lucasia, Rosania, and Orinda' has to be fictitious, since there is no point during July 1663 at which all three women – then dispersed across Ireland, England and Wales – can have been physically together.[118] I suspect that Philips composed 'Lucasia, Rosania, and Orinda' – and possibly also 'A Farwell to Rosania' and 'A Dialogue betwixt Lucasia and Rosania' – in direct response to *Poems* (1664); aware that the inappropriately personal poems in the unauthorised volume could not be thoroughly suppressed, she embarked on a new phase of friendship poetry in order to clarify – as seems to have been biographically the case – that all three women were on friendly terms.[119] (The backdating of 'Lucasia,

[115] Adapting Greer, *Slip-Shod Sibyls*, p. 166. [116] Rosania MS, p. 340, Thomas I, p. 201.
[117] Rosania MS, p. 282, Thomas I, p. 197. [118] Thomas I, p. 376.
[119] Philips's letters to Cotterell between 1662 and 1664 refer frequently and affectionately to Rosania, while the inclusion of her most effusive poems to Lucasia in the Rosania manuscript (the first of which precedes any of the Rosania poems) implies an amicable coexistence between the two friendships.

Rosania, and Orinda' prior to the publication of the 1664 *Poems* may thus have been a bluff.) To this phase of friendship poetry should also be attributed the two other extant poems that bring Rosania and Lucasia together in person and on friendly terms – 'Rosania to Lucasia on her Letters', in *Poems* (1667), and 'To Rosania and Lucasia Articles of Friendship', uncollected – which also appear, on bibliographical evidence, to be late work.[120] As with 'To my Lord Arch-Bishop', the friendship poems of the Rosania manuscript and later are carefully judged to vindicate Philips's reputation in precisely the areas most injured by the 1664 *Poems*. Their anticipated readership is one without knowledge of Philips's biographical circumstances: most likely, a print readership.

The short interval – just five months – between the publication of the Marriott *Poems* and her death the following June meant that Philips herself had little time to begin preparing a revised print edition of her works. At least one of her friends, however, cared enough about her poetry and reputation to compile an expanded edition of her literary works after her death. *Poems* (1667), published by Henry Herringman, includes not only a larger canon of Philips's poetry than had appeared in any previous collection but also a much more substantial introductory apparatus. This apparatus includes an engraving of Philips herself, a prose preface by the editor, and commendatory poems by Orrery, Roscommon, Cowley, 'Philo-Philippa', James Tyrrell and Thomas Flatman. Within the main body of the volume, Philips's original poems are followed by her five poetic translations and her two plays, *Pompey* and *Horace*. Herringman's careful presentation of Philips's work is indicated by his complex use of internal titles: 'Poems' is used both as the initial heading (p. 1) and as the running title for the original and translated poems (pp. 2–198); the translations are demarcated from the original poems by their own title page ('Translations. By K. Philips', p. 169), and *Pompey* and *Horace* are each given a separate title page with full publisher's imprint.[121] The volume – the longest

[120] On the likely late date of 'Rosania to Lucasia', see also Hageman and Sununu, 'New Manuscript Texts', p. 185; this poem also survives in an undated autograph manuscript (*IELM*, p. 162, PsK 319). I follow Beal (against Thomas) in regarding Philips's authorship of 'To Rosania and Lucasia' as probable (*IELM*, p. 135, Thomas I, p. 398).

[121] The organisation of *Poems* (1667) is typical of Herringman's treatment of complex literary editions; comparable patterns can be detected in his editions of Cowley's *Works* (1668) and Thomas Killigrew's *Comedies and Tragedies* (1664).

collection of Philips's poetry thus far produced – includes all items from the Rosania manuscript except 'To the Right Honourable the Lady Mary Boteler'. It also includes twenty-three previously uncollected poems, as well as providing full texts of two poems – 'To my dearest friend Mrs. A. Owen upon her greatest loss' and 'Orinda upon little Hector Philips' – otherwise extant only, incomplete, in Tutin. The editor of *Poems* (1667) is often assumed to be Sir Charles Cotterell; however, this identification rests only on the inclusion of a letter from Philips to Poliarchus ('a Friend of that incomparable Ladys') in the prose preface, and although possible is unproven.[122]

As already noted, one of the key preoccupations of the 1667 *Poems* is the defence of Philips's reputation. The editor's prose preface begins by describing the 1664 volume as 'the false Edition of these Poems' and stressing that Philips herself had not only been 'averse ... to be in print' but also, 'being then in Wales above 150 miles from this Town', had known nothing of the Marriott publication until alerted by Poliarchus.[123] Philips's own letter to Poliarchus offers similar assurances, and had indeed, as the 1705 *Letters* reveals, been expressly written 'to the end that you may, if you please, shew it to any body that suspects my Ignorance and Innocence'.[124] The importance attached to vindicating Philips is also shown in the use of her poem to the Archbishop of Canterbury to end the original section of the volume. Whereas the 1664 *Poems* – at least before the late addition of 'Upon Mr Abraham Cowley's Retirement' – had closed by recalling Philips's royalism through 'On the Queen's Majesty, on her late Sickness and Recovery', its successor concludes the poet's original work by recalling her authorial modesty and Anglicanism in 'To his Grace Gilbert Lord Arch-Bishop of Canterbury'. For the 1667 *Poems*, this insistence on Philips's feminine modesty is even more important than her royalism in constructing her literary identity.[125]

Given this evident concern for Philips's reputation, *Poems* (1667) is in several other respects surprisingly careless in its treatment of the poet and her work. Even the commendatory poems, on close examination, are a

[122] *Poems* (1667), sig. A1r. Cotterell's role as the editor of 1667 is assumed by Moody, 'Orinda, Lucasia, Rosania *et aliae*', but treated as uncertain by Beal, Thomas and Hageman (*IELM*), p. 134, Thomas II, pp. 193–94; Elizabeth Hageman, 'Making a Good Impression: Early Texts of Poems and Letters by Katherine Philips, the "Matchless Orinda"', *South Central Review*, II.2 (1994), 39–65 (pp. 43, 62).

[123] *Poems* (1667), sig. A1r. [124] Philips, *Letters*, p. 221.

[125] The importance of the Sheldon poem is also noted in Moody, 'Orinda, Lucasia, Rosania *et aliae*', pp. 329–30.

somewhat makeshift assemblage rather than the unequivocal posthumous tribute they may at first appear. Of the seven commendatory poems, only three – those by James Tyrrell and Thomas Flatman and the second contribution by Abraham Cowley – postdate Philips's death and can be construed as responding to her complete poetic achievement. The other four – by Orrery, Roscommon, Cowley and Philo-Philippa – had evidently been written at much earlier stages of Philips's life, and at least two respond specifically to single texts: Orrery's to her partial translation from Act 3 of *Pompée*, Philo-Philippa's to the production of the full *Pompey* translation. Their compliments on Philips's writing, though often graceful – Orrery assures Philips that 'The French to learn our Language now will seek, / To hear their greatest Wit more nobly speak', while Philo-Philippa claims that Corneille himself would prefer her 'inlightned' translation to his own French original – thus seem oddly partial and out of date, with Orrery's appeal to Philips to finish her translation of *Pompey* an especially anomalous inclusion in a volume which includes the completed play.[126] By contrast, while both Tyrrell and Flatman are warmly complimentary about Philips, neither appears to know her work in detail: Tyrrell praises her 'gen'rous wit' but makes no reference to the content of her writings, while Flatman represents her, rather oddly, as a war poet – presumably a reference to *Pompey*.[127] Cowley, comparably, though firm in his praise of Philips's achievements, shows little knowledge of specific poems or genres in her canon – he mentions only her friendship poetry, described broadly as 'A new, and more surprising story / Of fair Lucasia and Orinda's glory' – and often seems at least as interested in Philips's physical beauty as in the literary qualities of her work.[128] Furthermore, the competitive language in which he constructs Philips's superiority over male poets (including himself), though presumably intended as a tribute to her powers, sometimes edges disconcertingly close to self-pity: he says that Philips would 'my Envy raise, / If to be prais'd I lov'd more than to praise' and claims that her poems 'will long my praise of them survive, / Though long perhaps too that may live'.[129] All told, many of these poems read as if amassed rather than critically edited: that is, as though the 1667 editor had

[126] *Poems* (1667), sigs b1v, d1v–d2r. On Philo-Philippa's praise of Philips, see further Coolahan, *Women, Writing, and Language*, pp. 212–17.

[127] *Poems* (1667), sigs e1v, f1r–v (stanzas 4 and 5). *Pompey* is specifically mentioned in stanza 5.

[128] *Poems* (1667), sig. g1r. On Cowley's ambivalence towards Philips in his commendatory poems, see further Hageman, 'Katherine Philips, *Poems*', in *A Companion to Early Modern Women's Writing*, ed. by Anita Pacheco (Oxford: Blackwell, 2002), pp. 189–202 (pp. 192–93).

[129] *Poems* (1667), sigs c1r, f2v.

simply gathered his commendatory texts with more regard to the eminence of their authors than to the detail of their commendations. The one apparent exception is Philo-Philippa, who, given her pseudonymous status, must presumably have earned her inclusion in the volume through the quality and quantity of her praise of *Pompey.*[130]

But the surprising aspects of the 1667 *Poems* do not end with its commendatory apparatus. Stranger still, given the clear concern of the 1667 editor to distinguish his own collection from *Poems* (1664), is his near-exact reproduction of the 1664 order of materials in his own volume. Of the first seventy-six original Philips poems in 1667, seventy-two follow the order of 1664; the four exceptions include two Lucasia poems which are moved to a slightly earlier point amid the personal sequence, as well as two extra poems on women friends, not in 1664, which are anomalously included among the philosophical poems.[131] The most likely explanations are either that the 1667 editor simply followed 1664 mechanically, or that he judged the political advantages of privileging Philips's royalism to outweigh the potential dangers of reproducing the 1664 order. The second explanation receives some support from the evident care taken to deploy 'To his Grace Gilbert' in 1667 (which indicates sensitivity to the shaping of the collection), but does not account for the persistence of the 1664 order beyond the initial block of royal poems. The first explanation, however, not only makes sense of this continuing reliance on 1664, but is also consistent with the solidly source-linked ordering of the non-1664 original poems. Following the last two items from 1664 ('To the Queen's Majesty, on her late Sickness and Recovery' and 'Upon Mr. Abraham Cowley's Retirement'), the remainder of the original section consists of continuous blocks of poems first gathered in different collections of Philips's poetry: two from Dering, twelve from Rosania, and twenty-two previously uncollected. ('Upon Mr. Abraham Cowley's Retirement', which immediately precedes the two Dering poems, had also been first collected in that manuscript.) The only interruptions or anomalies in this source-linked ordering involve the two extra poems from Tutin – 'On my dearest friend Mrs. A. Owen', inserted between the Rosania texts and the previously uncollected poems, and 'Orinda upon little Hector Philips', included

[130] This apparent anomaly might dissolve if we knew the identity of Philo-Philippa – as the 1667 editor may conceivably have done.

[131] The rearranged and inserted poems are, respectively, 'To the Excellent Mrs. Anne Owen' and 'To the truly Noble Mrs. Anne Owen', pp. 32–34; and 'On Rosania's Apostacy, and Lucasia's friendship' (previously uncollected) and 'To my Lady Elizabeth Boyle, Singing' (in Rosania), pp. 106–07.

midway through the uncollected section – and 'To his Grace Gilbert'. While the Tutin poems (as 'dropped' items previously collected only in unfinished form) were in any case obviously anomalous within the textual history of Philips's poetry, the unique location of the Sheldon poem outside the 'Rosania section' of 1667 re-emphasises its strategically vindicatory role within the 1667 volume.

A comparison between the Rosania manuscript and *Poems* (1667) also reveals that the order of materials in the Rosania section of the latter, though not identical to the order in Rosania itself, is closely related to it: if the order of the fourteen previously uncollected poems in Rosania is expressed alphabetically A to N, the equivalent poems in 1667 are included in the order C-BADEGFHIJKMN-L (where L represents 'To his Grace Gilbert' and dashes represent breaks in the physical juxtaposition of the Rosania poems).[132] Among the previously uncollected poems in 1667, it is difficult to detect planned order of any kind: there is no attempt either to group categories or genres, such as the Lucasia poems or the verse epistles, or to arrange materials by date. Overall, careful reading of the 1667 order suggests that – apart from the Sheldon poem – the organisation of the original section represents source-linked agglomeration rather than purposeful compilation. The exceptional use of the Sheldon poem to enhance Philips's reputation contrasts with the indifference to exploiting organisational possibilities elsewhere in the collection.

Perhaps the most startling example of disregard for Philips's reputation in *Poems* (1667) is its treatment of her friendship poetry. If it is true that disclosing personal information about her friends was the real reason why *Poems* (1664) caused such embarrassment for Philips, then it must seem strange that virtually all this personal information is also preserved in *Poems* (1667). Mary Aubrey and Anne Owen are still identified as Rosania and Lucasia, while coterie names such as Silvander, Palaemon and Cratander are decoded exactly as before. Indeed, the most acutely embarrassing aspect of *Poems* (1664) – the implied rivalry between Rosania and Lucasia – is exacerbated still further by one of the new poems in 1667, the previously uncollected 'On Rosania's Apostacy, and Lucasia's friendship'. This poem – its contents all too accurately summed up in its provocative title – makes explicit the disillusionment and transfer of affections implied in Tutin texts such as 'To Rosania (now Mrs. Mountague)', 'Injuria amici'

[132] In statistical terms, the correlation coefficient between the two sequences is 0.96 (where 1 would represent exact equivalence). The chances of such a close correlation occurring by accident are low. I am indebted to Kathleen Taylor for calculating the correlation and advising me on its significance.

and the early Lucasia poems, and presumably dates from the same period. Its exclusion from all previous collections of Philips's work, including Tutin, suggests strongly that the poet herself had wanted to omit it from the manuscript canon of her works. Its inclusion in 1667 indicates, by contrast, that Philips's posthumous editor cared less about tact or decorum than about assembling the fullest possible collection of the poet's works. It thus bears out his claim, in the preface, to have included all texts that could be compellingly attributed to her: 'though some of her Pieces may perhaps be lost, and others in hands that have not produc'd them; yet none that upon good grounds could be known to be hers, are left out'.[133] Unimaginative though his treatment of Philips's texts may have been, the 1667 editor was evidently thorough and diligent as a collector of her work. Of the eleven poems in Patrick Thomas's edition which are not included in the 1667 *Poems* (nos. 123–33), only two are extant in authoritative manuscripts ('Epitaph on Mr John Lloyd', in Tutin, and 'To the Lady Mary Butler', in Dering and Rosania), and the attribution of many of the others is doubtful.[134] Conversely, of the twenty-three previously uncollected poems included in 1667, only two are otherwise extant, both in autograph copies.[135] Philips scholarship owes this unnamed editor a considerable debt of gratitude.

How does the new material in *Poems* (1667) extend our understanding of Katherine Philips? Of the twenty-three new poems in 1667, many fall into categories already familiar from earlier collections of her work. There are ten poems on or addressed to Lucasia; these include three which also involve Rosania ('On Rosania's Apostacy, and Lucasia's friendship', 'Rosania to Lucasia on her Letters', and 'Parting with a Friend'), as well as the much more formal 'To my Lord and Lady Dungannon on their Marriage', which does not use the latter's coterie name. The topic of parting is reworked not only in 'Parting with a Friend' but also in 'Orinda to Lucasia parting', 'A Triton to Lucasia going to Sea', and 'Lucasia and Orinda parting with Pastora and Phillis', while the nature of friendship is debated by Orinda and Musiphilus in 'A Dialogue of Friendship multiplyed'. (Orinda's insistence that friendship is weakened by a 'third partner' (26) reads ironically in relation to the following poem in the collection,

[133] *Poems* (1667), sig. a1v.
[134] If the 1667 editor had access to Tutin – an unverifiable assumption – he may simply not have realised that the Lloyd poem, composed 'in the person' of his widow, Cicely Philips, was actually the work of Cicely's sister-in-law, Katherine.
[135] The autograph poems are 'Rosania to Lucasia on some letters' and 'To my Lord Duke of Ormond' (*IELM*, pp. 162 and 170, PsK 319 and 437).

'Rosania to Lucasia on her Letters' – another indication that the 1667 order of materials does not represent a planned sequence.)[136] Philips's assiduous cultivation of Irish noblewomen, already evident in Dering and Rosania, re-emerges in poems addressed to Lady Mary Cavendish (the former Lady Mary Butler), Elizabeth Boyle, and the Countess of Roscommon (born Frances Boyle); the use of coterie names for Cavendish and Elizabeth Boyle (Policrite and Celimena respectively) indicates how much care she devoted to consolidating her relationships with these women. However, another poem from her Irish period, 'To my Lord Duke of Ormond, upon the late Plot', shows her moving beyond familiar territory to engage with the most important man in Ireland on a matter of national significance.[137] (In doing so, she would also have been building on pre-established connections with the Irish nobility, as Ormond was Mary Cavendish's father.) 'Against Love' and 'An Answer to another perswading a Lady to Marriage' witness to her interest in reworking conventional literary forms, while 'To my Antenor, March 16 1661/2', 'On the death of the truly honourable Sir Walter Lloid' and 'Epitaph on my truly honoured Publius Scipio' recall one of her oldest and most cherished literary roles, that of poet and elegist for her family and friends. By contrast, 'On the 1. of January 1657', a meditation by Philips on her own birthday, represents an innovative combination of old and new, readdressing some of the familiar preoccupations of her Tutin-era poetry – the vanity of earthly things, the pointlessness of political violence – within a previously unattempted generic form. Philips, however, seems to have found this overtly autobiographical mode poetically unproductive; the meditation is apparently unfinished, which may explain its omission from Tutin and subsequent collections. As far as we know, she never attempted such a straightforwardly autobiographical poem again.

As a guide to Philips's own literary activities, the new poems in the 1667 volume offer only fragmentary evidence. Apparently assembled from diverse textual sources, they do not represent a single period within Philips's poetic career, but include texts from as early as 1657 ('On the 1. of January') and as late as the summer of 1663 (when the plot against Ormond was detected); the undatable poems may, of course, include work from still earlier or later periods. In a few instances, reasons for noncirculation prior to 1667 can be easily surmised: non-completion in the case of 'On the 1. of January', prudent restriction of potentially

[136] *Poems* (1667), p. 144, Thomas I, p. 216.
[137] On the plot, see Thomas I, p. 384, and Alan Marshall, 'Blood, Thomas', *ODNB*.

compromising material in the case of 'On Rosania's Apostacy, and Lucasia's friendship', 'To my Antenor' and the epitaph on Philip Skippon. In other instances, non-circulation is much more puzzling: in terms of content, there is no obvious reason why 'On the death of the truly honourable Sir Walter Lloid' (a Welsh royalist) or 'To my Lord and Lady Dungannon' should not have been included in earlier collections, such as the Rosania manuscript. The most likely reason for the previous omission of such poems – that compilers such as Polexander did not have access to them – merely reformulates the issue; it is not clear why these texts should have been less accessible than others of the same or later periods. The fact that poems demonstrably later than any of the datable new texts in the 1667 volume, such as 'On the death of my Lord Rich' and 'To my Lord Arch-Bishop of Canterbury his Grace', were nonetheless included in the Rosania manuscript deepens the mystery still further.

Whoever compiled the original section of *Poems* (1667) evidently enjoyed privileged access to a wide range of texts by Katherine Philips. We should not assume that his textual exemplar(s) actually included any of the manuscripts discussed in this chapter, though use of *Poems* (1664) is unquestionable. He is unlikely, for instance, to have worked directly with either Dering and Rosania: each includes patterns of textual variation not reproduced in *Poems* (1667), which instead generally follows the textual tradition associated with Tutin, Clarke and *Poems* (1664).[138] The relatively few but often complex textual revisions incorporated into *Poems* (1667), as compared with *Poems* (1664), seem unlikely to be the work of the 1667 compiler, given the lack of literary sophistication apparent elsewhere in his work, and more probably follow an already revised source text or texts.[139] It is even possible that these textual revisions derive from Philips herself and represent another strand in her response to *Poems* (1664). The replacement of an extravagant tribute to the late Mary Lloyd –

> She lost all sense of wrong, glad to believe
> That it was in her power to Forgive.

– with the more temperate

[138] The omission of 'To the Right Honourable the Lady Mary Boteller', extant in the Rosania manuscript, from *Poems* (1667) provides further evidence that Rosania itself was not used by the compiler of *Poems* (1667).

[139] A full discussion of the textual revisions in *Poems* (1667) is outside the scope of this chapter. For a preliminary account, see Greer, *Slip-Shod Sibyls*, pp. 168–71.

> She grew to love those wrongs she did receive
> For giving her the power to Forgive.
> 'In memory of ... Mrs Mary Lloyd', 51–52

might plausibly result from Philips's corrective reading of her own work (though the ugly internal echo, 'giving ... Forgive', is an unfortunate touch).[140] Philips herself might also have chosen to omit one of her more excessive compliments to Mary Aubrey – 'And should her whole Sex to dissembling fall, / Her own Integrity redeems them all' – from a revised version of 'Rosania shadowed' (43–44).[141] Though Philips's responsibility for the 1667 revisions cannot be proved, their inclusion alongside previously restricted texts such as 'On Rosania's Apostacy, and Lucasia's friendship' makes her involvement a tenable and intriguing hypothesis.

The limitations of the 1667 editor are chiefly evident in his unimaginative compilation both of the commendatory items and of Philips's own poetry. Of the many sophisticated elements in the presentation of *Poems* (1667), almost all are attributable not to the editor himself but to his publisher, Henry Herringman. Furthermore, the editor, as I have noted, did not shrink either from admitting the full, complex range of Philips's literary and political affiliations or from risking embarrassment to surviving friends and family such as Mary Aubrey, Anne Owen or even James Philips. Given these factors, the traditional identification of the 1667 editor as Sir Charles Cotterell seems unlikely, since Cotterell was not only a skilled writer with over twenty years' experience of literary publishing but had also already demonstrated his concern for Philips's reputation through his role in suppressing *Poems* (1664).[142] Greer, moreover, argues that, as a former suitor for Anne Owen, Cotterell would have had a special interest in protecting her reputation as well as Philips's.[143] While the exact identity of the 1667 editor may seem like a side issue, it has important potential consequences for Philips scholarship, since the assumption of Cotterell's responsibility has undoubtedly helped to shape perceptions of the volume's scope and significance. If scholarly understanding of *Poems* (1667) is to make progress, the claims of other candidates to have compiled the most

[140] *Poems* (1664), p. 84, *Poems* (1667), p. 43; compare Thomas I, pp. 113, 277.

[141] *Poems* (1664), p. 97, *Poems* (1667), p. 49; compare Thomas I, pp. 118–19, 279. Lines 45–46, which would have made no sense without 43–44, are also omitted.

[142] On Cotterell's own literary activities, see Thomas II, pp. 172–73, 176–77, and Philip Major, '"A credible omen of a more glorious event": Sir Charles Cotterell's *Cassandra*', *The Review of English Studies*, 60.245 (2009), 406–30. Thomas argues that Cotterell may simply have been too busy in the mid-1660s to have compiled *Poems* (1667); see Thomas II, pp. 193–94.

[143] Greer, *Slip-Shod Sibyls*, p. 164; it is equally possible that Cotterell's failure to woo Anne Owen resulted in a much less chivalrous attitude.

influential collection of Katherine Philips's work deserve serious consideration. An obvious possibility is James Philips himself, whose involvement – could it be proved – would compel reassessment not just of *Poems* (1667) but of his wife's entire writing career.

Poems (1667) was foundational not only in the construction of Katherine Philips's literary reputation but also in the history of women's writing in English. It was *Poems* (1667) – or a subsequent reprint – which was read by John Dryden, Edward Philips, Richard Baxter and George Farquhar, and which helped to inspire later women such as Jane Barker, Anne Finch and Mary Chudleigh to present themselves as literary writers. Conversely, the association established by both *Poems* (1664) and *Poems* (1667) between women's writing and literary royalism may have helped to persuade more radical or Whiggish women such as Lucy Hutchinson, Anne Wharton and Octavia Walsh (and their posthumous editors) to confine their own poetry to manuscript.[144] Whatever its shortcomings, *Poems* (1667) produced a version of Philips which did justice to her poetic invention, her energy, and her willingness to experiment with an astonishing range of literary forms. It is not, of course, the version that the poet herself would have produced had she lived, but it may be closer than has often been supposed.

PHILIPS AND LITERARY HISTORY

Katherine Philips's writing life marks a crucial moment in English literary history: a moment when a young woman with little formal education and no conspicuously literary relatives could engage competently, creatively and assertively with the most stubbornly masculine poetic genres in the English language. For almost the first time in English, a woman had found a means of appropriating the conventions of both love lyric and patronage poetry, reinventing them in the light of her own, gendered, experience. While Philips seems to have had little interest in overtly confessional or self-analytical poetry, the vast majority of her poems are semi-autobiographical, reimagining traditional literary topics and genres in the light of her own personal relationships, preoccupations and circumstances. This, in my view, is the key reason why friendship forms so large and heterosexual relationships so small a part of her surviving poems: it is not

[144] Excerpts from the writings of each of these women were published during or shortly after their lifetimes, but there were no known attempts to print-publish collections of their works. Philips's influence on women's poetry in the long eighteenth century is surveyed by Paula Backscheider in *Eighteenth-Century Women Poets and their Poetry: Inventing Agency, Inventing Genre* (Baltimore, MD: Johns Hopkins University Press, 2005), pp. 5–8.

so much that the historical Philips cared more for Mary Aubrey and Anne Owen than for her husband (though this may also have been the case), as that, given her biographical situation, friendship rather than marital love offered more feasible opportunities for rewriting literary convention. By 1649/50, when she started writing the mature lyrics collected in Tutin, Katherine Philips was long past the stage of premarital courtship, and happy marriages have rarely supplied a productive subject for poetry. Friendship, by contrast, provided a means of engaging with mainstream literary tradition which not only offered scope for originality but did so without prejudice to her (socially essential) reputation for chastity. The respectable Mrs Philips did not enjoy the dangerous freedom of an Aphra Behn.

The Katherine Philips of the Tutin manuscript is a resourceful and able young writer with a distinctive range of literary interests and an impressively sure understanding of form, convention and genre. Tracking her development from Tutin, through Clarke and Dering, *Poems* (1664) and the Rosania manuscript, to the posthumous *Poems* (1667) enables us to see how – over just six highly productive years – she built on these early achievements, developing her sense of poetic agency and responding creatively to the challenges variously offered by the Restoration, her year in Ireland, and the traumatic publication of *Poems* (1664). 'To my Lord Arch-Bishop of Canterbury his Grace' shows her still, in the last few months of her life, seeking new audiences and alliances, trying to turn a potentially disastrous event to her own advantage. Philips's pivotal role within English women's literary history is due to many factors: to the scribes, editors and publishers who secured her an audience beyond her own friends and family; to good luck and good timing; above all, of course, to her own skills as a reader and a writer. It is also due to her perseverance and her unquenchable ambition.

The anxieties of agency: compilation, publicity and judgement in Anne Finch's poetry

Influential and respected though it was, Katherine Philips's *Poems* (1667) did not immediately transform either the writing practices of English women poets or the conventions within which they worked. It was not the case that, after *Poems*, print-publication became the inevitable medium for women's poetic collections, or that manuscript compilations of women's poetry ceased to be produced. In the years after *Poems*, many gentlewomen writers continued to treat print-publication with caution, finding manuscript a safer and more satisfactory repository for their works. Nonetheless, in the decades after Philips, the balance between print and manuscript, even for the most conservative of writers, did begin to shift. How difficult, contradictory and, sometimes, pleasurable this transition might be is best illustrated by the leading woman poet of the next generation, Anne Finch (1661–1720).

Finch is unusual among seventeenth- and early eighteenth-century women writers in using both manuscript and print to collect her own poetry.[1] Four collections of her poems – three in manuscript, one in print – are known to survive.[2] Finch herself was involved, to differing extents, in the production of at least three of these collections, and may also have had a role, albeit more problematically, in the production of the fourth. In each case, these collections, far from representing random or casual records of her work, are carefully planned and structured compilations. Even the earliest manuscript collection of Finch's poetry – the octavo manuscript

[1] Jane Barker compiled two autograph manuscripts of her own poetry (British Library Additional MS 21621 and Magdalen College MS 343), but was probably not directly responsible for the print-publication of her *Poetical Recreations* (1688). See King, *Jane Barker*, pp. 34–38.

[2] The most comprehensive work to date on the various Finch collections is W. J. Cameron's 'Anne, Countess of Winchilsea: Materials for the Future Biographer' (unpublished doctoral thesis, Victoria University of Wellington, New Zealand, 1951). Cameron's thesis surveys Finch's writing life through a detailed and insightful examination of the numerous print and manuscript witnesses to her poetry. An outstanding work of scholarship, it has formed the foundation for all subsequent work on Finch.

now held at the Northamptonshire Record Office, produced in 1690–91 – shows careful attention to organisation and presentation.³ The two subsequent collections completed during her lifetime – the folio manuscript now held at the Folger Shakespeare Library (compiled *c.* 1691–1701) and the printed *Miscellany Poems* of 1713 – both result from and witness to a detailed process of textual revision, continuing over more than two decades.⁴ Such revision includes both the textual alteration of individual works and also the repackaging and re-presentation of Finch's writings for different audiences and different historical moments. Each collection, moreover, shows Finch engaging creatively but critically with the resources of her chosen medium: making use extensively of the possibilities afforded by manuscript, more selectively of the possibilities afforded by print.

Finch did not work alone. Her husband, Heneage, acted as her scribe – and, to some extent, editor – on the Northamptonshire and Folger manuscripts, and seems to have had principal responsibility for the Wellesley manuscript, much (possibly all) of which postdates Finch's death. The publication of *Miscellany Poems* in 1713 involved collaboration between the Finches and her printer-publisher, John Barber, who wrote the commendatory letter from 'The Bookseller to the Reader', and divulged the identity of the author in at least three of the variant issues of the volume.⁵ At other points in her writing career, Finch's poetry was promoted by such influential poets, editors and publishers as Nahum Tate, Charles Gildon, Jacob Tonson and Alexander Pope. Nonetheless, one of the most remarkable aspects of Finch's poetry is the overwhelming impression it conveys of the poet's own creative agency. This sense of agency is pervasively and diversely apparent in Finch's writing: most evidently in her careful self-presentation within many of her texts and paratexts, but also in the self-confidence with which she manipulated generic and material forms, deployed literary conventions and allusions, and expressed her views on politics. Although, in her various manuscript and print collections, she always wrote for an audience, there is never any suggestion – unlike with Katherine Philips – that her writing was motivated by expedience or the desire for self-promotion. Though her work was encouraged and, in part,

³ The octavo manuscript (henceforward 'Northamptonshire manuscript' or 'NRO') is now Northamptonshire Record Office MS Finch Hatton 283.
⁴ The folio manuscript (henceforward 'Folger manuscript') is now Folger MS N.b.3.
⁵ A letter from Heneage Finch to a clergyman friend, Thomas Brett (28 October 1714), insists that his wife had denied permission for her name to be included on the title page of her poems, and blames the bookseller for adding it on his own initiative to some copies (Bodleian MS Eng. th. c. 25, fol. 99r).

made possible by supportive male relatives such as Heneage and his nephew Charles (who gave the Finches a home for several years after the Revolution of 1688 exiled them from court), their role appears to have been genuinely a matter of supporting and facilitating her writing, rather than – as with Anne Bradstreet's male relatives – dictating the terms within which her poetry could be produced and distributed. While it would be much too simple (as well as unprovable) to claim that Finch wrote the poetry she wanted to write and circulated it as and when she chose, such notions of unfettered independence apply more readily to her than to many of the other women poets discussed in this book. Even Aphra Behn, self-inventive as she can often appear, was constrained by financial necessity to please her patrons and create a marketable product. Impoverished and indebted as she was for much of her life, Finch did not write or publish for money; indeed, she professed to believe that producing a book such as hers would be financially ruinous for her unlucky printer.[6]

In this chapter, I examine the 'agency' constructed by the four major witnesses to Finch's writing. In the first section I consider the premises and circumstances which made her poetry possible. What were the enabling sources and conditions for Finch's writing, and to what extent did they influence the forms and subjects attempted in her poetry? In subsequent sections I analyse Finch's agency through attention both to her textual practices and to the many self-reflexive poems and paratexts in which she discusses her position as a writer. Tracing Finch's use of, and attitudes towards, her own poetry in these four compilations helps us to see how her literary agency was both asserted through and complicated by her sense of audience, her generic choices and her political loyalties. For Finch, as we will see, literary agency was intimately connected with gender insecurity, political disappointment and fears about hostile readership. How such anxieties shaped, defined and stimulated her writing is the subject of this chapter.

CONSTRUCTING AGENCY: THE CONDITIONS FOR FINCH'S WRITING

Finch's husband, Heneage, was not the first member of her close family to influence her writing practice. Finch's father, William Kingsmill, was also a poet, though his role in stimulating his daughter's poetry has rarely been

[6] 'Mercury and the Elephant', 47–50 (Anne Finch, *Miscellany Poems On Several Occasions* (1713), p. 4; Anne Finch, *The Poems of Anne Countess of Winchilsea*, ed. by Myra Reynolds (Chicago, IL: University of Chicago Press, 1903) (henceforward Reynolds), p. 4).

examined in Finch scholarship. Kingsmill was a royalist who wrote all his known poetry during the Civil War and interregnum; his death in 1661 postdated the birth of his younger daughter by just five months.[7] His poetry now survives in a unique manuscript which was almost certainly not known directly by Finch, as it has a documented history outside their family from at least the early 1670s and probably the mid-1650s.[8] However, given the many areas of similarity between the two writers, it seems highly probable that Finch was familiar with another copy of her father's poetry, since lost. There is obvious common ground, for instance, between Kingsmill's description of his manuscript as 'A Miscellany of his Melancholy'[9] and the emotional preoccupations of so much of his daughter's writing, witnessed by such poems as 'The Spleen' and 'Ardelia to Melancholy'. (In the preface to the Folger manuscript Finch also cites the relief of melancholy as one of her principal motivations in writing her two closet dramas.)[10] Also common to both father and daughter is their preoccupation with censure. The several dedicatory poems in Kingsmill's manuscript include one entitled 'For his Criticall friends and theyr Censures' and another 'Of his Censurers'. Finch, comparably, expresses fears about censure in the prefatory apparatus to each of the collections of her poetry produced during her lifetime, and engages with issues of slander and correct judgement in many of her poems.[11]

More significant still, however, is the close similarity between the poetic genres favoured by the two poets. The poetry in Kingsmill's manuscript includes love poems, religious meditations, translations, country house poems and retirement lyrics, satires, elegies and poems about poetry. All these genres are strongly represented within Finch's poetry; even satire,

[7] On Kingsmill's life, see Ronald Fritze, 'Kingsmill family', *ODNB*. Kingsmill's poetry has been edited by John Eames, in 'The Poems of Sir William Kingsmill: A Critical Edition' (unpublished doctoral thesis, University of Birmingham, 1981), and is discussed by him in 'Sir William Kingsmill (1613–1661) and His Poetry', *English Studies*, 67.2 (1986), 126–56.

[8] The Kingsmill manuscript was probably presented to its dedicatee, the Marquess of Hertford (later the Duke of Somerset) some time in the mid-1650s (the last dated items in the manuscript are ascribed to 1653). Inventoried in the Duchess of Somerset's possession in 1671, it was part of the Duchess's bequest to Lichfield Cathedral Library two years later. It is now Lichfield Cathedral MS 2. The Kingsmill manuscript may testify to a long-standing relationship between Heneage and Anne's respective birth families, since the Marquess of Hertford, Kingsmill's patron, was Heneage Finch's maternal grandfather.

[9] Lichfield MS, p. iir.

[10] Folger MS, fol. 9v, Reynolds, p. 12. On the foliation/pagination of the Folger manuscript, see *IELM* (vol. III (1700–1800), part 4, ed. by Alexander Lindsay), pp. 537–38. Citations in this chapter follow the *IELM* conventions.

[11] For a complementary discussion of Finch and contemporary literary criticism, see Michael Gavin, 'Critics and Criticism in the Poetry of Anne Finch', *English Literary History*, 78.3 (2011), 633–55.

which she is sometimes thought to have eschewed, finds expression in many of her fables as well as in mocking lyrics such as 'Sir Plausible' and the more explicitly satirical 'Ardelia's answer to Ephelia'.[12] Of the two poetic kinds favoured by Finch but not by Kingsmill, one – songs – can be explained by contemporary circumstances: songs were among the most popular literary genres in the 1670s and early 80s, when Finch began writing.[13] The remaining genre, the fable – practised by Finch throughout her career and the dominant genre in *Miscellany Poems* – can similarly be explained to some degree by literary fashion. Fables were newly modish in the 1690s and early eighteenth century, with recent publications including Barlow's *Aesop's Fables* (1687), Dryden's *The Hind and the Panther* (1687) and *Fables Ancient and Modern* (1700), and L'Estrange's *Fables of Aesop* (1692). The pro-Stuart affiliations of Aphra Behn (who contributed the English texts to Barlow's fables), L'Estrange and Dryden, and the political uses each was able to make of the fabular form, may also have played a part in attracting Finch to the genre.[14] But Finch, whose first extant fables probably predate both Behn's and Dryden's, may even in this instance have found some early inspiration in her father's example. Although Kingsmill wrote no poems explicitly described as fables, he included an extended fabular allusion (using the Aesopian figures of the Fox and the Lion) in his satire 15, 'On the votes for generall pardon'.[15] It seems likely that Finch, like several other early modern and eighteenth-century women writers, was attracted to – or found more accessible – those genres in which there was a role model among her own immediate family.[16] (The classic instance of this pattern is Mary Wroth, who seems to have worked exclusively in genres previously favoured by her uncle, Philip Sidney.)

[12] In the preface to the Folger manuscript, Finch claims only to have eschewed 'Lampoons, and all sorts of abusive Verses' (fol. 8v, Reynolds, p. 10) – the satirist's standard self-defensive ploy – but admits that 'Ardelia's answer' nonetheless 'tends towards this' (fol. 9r, Reynolds, p. 11).

[13] Compare Paul Hammond, *The Making of Restoration Poetry* (Woodbridge: Boydell and Brewer, 2006), pp. 153–54.

[14] On the Jacobitism of L'Estrange's and Dryden's fables, see Annabel Patterson, *Fables of Power: Aesopian Writing and Political History* (Durham, NC: Duke University Press, 1991).

[15] There was also a family connection between Finch and fables, as John Ogilby's edition of Aesop had been jointly dedicated to Heneage Finch's father and his brother-in-law William Seymour, son of the Marquess of Hertford. See Ogilby, *The Fables of Aesop Paraphras'd in Verse* (1651), sigs A2r–A3v.

[16] Both father and daughter also wrote poems on pet birds (Kingsmill, 'On her Bullfinch learning to sing'; Finch, 'To the Lord March upon the death of his sparrow'), as well as 'fragments'. A late section of the Kingsmill MS is entitled 'Certaine other fragments' and concludes 'Finis Fragminis'; Finch's *Miscellany Poems* includes a 'Fragment at Tunbridge-Wells' (pp. 229–30) as well as a 'Fragment' (pp. 280–82); the Wellesley manuscript includes 'Mary Magdalen at our Saviour's Tomb. A Fragment' (p. 104). A pronounced hostility to the political pretensions of the lower classes is also common to both.

Kingsmill was a considerably less able poet than his daughter, and may not have shared her commitment to poetry as a lifelong vocation.[17] Nonetheless, it seems probable that his example played an important part in creating the enabling conditions for Anne Finch's writing. Another, more directly practical, respect in which Kingsmill helped to make his daughter's writing possible is that his will, unusually for the period, made explicit financial provision to support his two daughters' education as well as his son's.[18] Exactly what Anne Finch's education consisted of is not known, but it evidently included instruction in French (though not in Latin or Italian) and probably some study of English poetry and history, classical literature in translation, and the Bible and devotional literature.[19] Whatever the precise details of its content, it is clear that Finch's education played a crucial role in equipping her with the intellectual resources necessary for her to engage knowledgeably and confidently in the literary culture of late-seventeenth-century England. Finch's poetry cites an extraordinarily wide range of literary references, ranging from contemporary poetry and drama to older writers such as Spenser, Shakespeare, Jonson and Milton, and including French, Italian and Latin literature (the latter two in translation), as well as the Bible. This extensive knowledge of the literary canon is among the many factors underpinning the ready assumption of agency in Finch's writing: manifest not only in her explicit citations of other writers but also, more subtly, in her skilful manipulation of so many well-established poetic genres and even in her willingness to mock, albeit gently, such a highly-regarded (and notoriously prickly) poet as Pope.[20] Essential to her self-assurance and resourcefulness as a writer, Finch's easy familiarity with the canon has its origins in the education secured for her by William Kingsmill.

For Finch, however, formal education, important as it was, was only the beginning. While her knowledge of the canon undoubtedly owes much of its depth and confidence to its origins in childhood instruction, her literary

[17] All Kingsmill's known poetry dates from the period 1643–53. It is also possible that manuscripts of poetry written in the last eight years of his life have simply been lost.

[18] Barbara McGovern, *Anne Finch and Her Poetry: A Critical Biography* (Athens, GA: University of Georgia Press, 1992), p. 10.

[19] On the likely scope of Finch's education, see McGovern, *Anne Finch*, pp. 17–19. Finch's use of French intermediaries for her Tasso translations implies a lack of confidence with written Italian, though she may have acquired some spoken Italian during her years as maid of honour to Mary of Modena.

[20] Alexander Pope, ed., *Poems on Several Occasions* (1717) (*POSO*), pp. 111–13, Wellesley MS, pp. 97–98; Anne Finch, *The Anne Finch Wellesley Manuscript Poems*, ed. by Barbara McGovern and Charles H. Hinnant (Athens, GA: University of Georgia Press, 1998) (McGovern and Hinnant), pp. 69–70.

education clearly did not stop when she left the schoolroom. Finch's entire writing career witnesses to an ongoing process both of reading and responding to new literature and of continuing to revisit, reappraise and reappropriate the work of writers she had admired since her youth. Even the Northamptonshire manuscript, her earliest known poetry collection, compiled when she was about thirty years old, encompasses a range of old and new literary sources. Paraphrases of the Bible, religious meditations and even adaptations of French poems by De Bussy and La Fontaine draw, often inventively, on texts she is likely to have read in childhood. Her translations of Tasso, however, probably stem from literary interests initiated during her years as maid of honour to Mary of Modena (1682–84), while the Earl of Roscommon's 'Silenus', cited in a marginal note to her 'Pastoral between Menalcus and Damon', was first published only in 1684 and may have been brought to her notice by Heneage Finch, then a member of Roscommon's literary academy.[21] The final collection of her poetry, the Wellesley manuscript, encompasses a similar range of old and new, ranging from further reworkings of the Bible to a playful citation of Eusden, a more respectful reference to Prior, and the reproduction of her poetic correspondence with Pope. This self-assured, creative engagement with both well-established and emerging literary resources is a consistent feature across the nearly forty years of Finch's poetic career.

Awareness of tradition, of course, had the potential to inhibit, as much as to inspire, the well-read late-seventeenth-century woman writer. Finch herself was sensitive to the paradoxical implications of literary heritage, especially for women. In the preface to the Folger manuscript, probably compiled about 1696, she wrote that 'Poetry has been of late so explain'd, the laws of itt being putt into familiar languages, that even those of my sex, (if they will be so presumptuous as to write) are very accountable for their transgressions against them'.[22] The translation of classical literature into modern languages in this period is usually assumed to have been empowering for women writers: given the foundational status of the classics in relation to European vernacular literature and the exclusion of most women from education in either Latin or Greek, translation gave many women access for the first time to privileged literary sources which had previously – for the most part – been the preserve of school- and

[21] On the publication of 'Silenus', see Carl Niemeyer, 'A Roscommon Canon', *Studies in Philology*, 36.4 (1939), 622–36 (p. 629). On Roscommon's academy, see Stuart Gillespie, 'Dillon, Wentworth, fourth earl of Roscommon', *ODNB*.

[22] Folger MS, fol. 8r, Reynolds, p. 9.

university-educated men. Finch's analysis inverts this assumption, seeing the translation of the classical precepts of literary decorum into 'familiar languages' (for her, English and French) as adding to the burden of responsibility on women writers, who could now no longer plead linguistic ignorance as an excuse for not keeping the rules.[23] This graceful deployment of the modesty topos is somewhat disingenuous on Finch's part, glossing over the fact that few women even in her own social class would have had the advantages she takes for granted; by no means all women would have counted French among their 'familiar languages' or been intellectually or culturally equipped to follow the advice laid down by the translators she names (Rapin, Despreaux, Dacier, Roscommon, Dryden). Finch's own success as a poet was not by any means the result of mechanically or slavishly following the literary prescriptions of male neoclassical critics, but her evident ease in citing their ideas is a clear if ironic indication of just how culturally at home she was in their world.

Many other factors underpin the assumption of agency in Finch's writing. Paradoxically, these factors include both obvious advantages and apparent disadvantages. Chief among the advantages are two already mentioned: the years she spent as maid of honour to Mary of Modena and her marriage to Heneage Finch. Anne Finch seems to have experienced her comparatively brief period of attendance on the young Italian Duchess and her subsequent four-year residence with Heneage in Westminster Palace as a time of extraordinary cultural variety and stimulation. Her attraction to Tasso – by then a somewhat outmoded writer, his influence superseded by French neoclassicals such as Boileau – is only the most obvious legacy of a period when she would have been exposed to the latest poetry, plays and music, as well as encountering, perhaps for the first time, the classic literary texts of Mary of Modena's native language. Her references in 'Ardelia's answer to Ephelia' to Etherege, Lee, Wycherley and Otway probably draw on her experience of attending the theatre during these years, while James Winn's suggestion – unproven but tenable – that she may have been the librettist for John Blow's opera *Venus and Adonis* (c. 1683) is a salutary reminder that Finch's time at the late Stuart court coincided with one of the most innovative periods in English musical history.[24] Even in the last few years of her life, Finch still seems to have

[23] On the paradoxical consequences of classical translation for women's writing, see also my discussion in 'Women Reading Epictetus', *Women's Writing*, 14.2 (2007), 321–37.

[24] Folger MS, p. 8, Reynolds, pp. 41, 420; James Winn, '"A Versifying Maid of Honour": Anne Finch and the Libretto for *Venus and Adonis*', *The Review of English Studies*, 59.238 (2008), 67–85.

enjoyed, and been creatively encouraged by, recollections of late Stuart
court culture. In a late poem, 'To the Right Honourable Frances Countess
of Hartford' (c. 1717), she digresses from her ostensible subject (playful
reproach of the Countess's practice as a patron) to express pride in the
recent commendation of her own poetry by John Sheffield, Duke of
Buckingham. Praise from Sheffield is construed as especially valuable both
because of his acute poetic judgement (which Finch distinguishes from the
'Pedantry' (155) of other critics) and because his own poetry had been
exceptional even among the many talents of the court of Charles II:

> Not Sheaffield so condemns who lately prais'd
> My untaught rhimes and as from death has rais'd
> For none like Sheaffield can the muse support
> Who still composes as in Charles's Court
> Where high he stood amidst the tunefull choire
> 'To the Right Honourable Frances', 159–63[25]

Important though her six years at court clearly were for Finch, however,
they represent a relatively small proportion of her writing life. By contrast,
the most sustained and material encouragement Finch is known to have
enjoyed came from rather closer to home and lasted for nearly four
decades. Anne Finch's poetry is almost unimaginable without the support
it received – even beyond her own death – from her husband, Heneage.
Finch's earliest poetic collection, the Northamptonshire manuscript, seems
to have been begun in 1690, at a time when Heneage Finch had been
arrested and imprisoned in the Tower of London for Jacobite activities.
Initial poems in the manuscript are transcribed in her own 'formal or
"best" hand', and the collection was probably intended either as a gift for
Heneage or as a means of self-consolation during his imprisonment (or
indeed both).[26] After Heneage's release, however, he assumed a role he was
to maintain for the next thirty years: chief amanuensis and editor of
his wife's poetry. Heneage transcribed the final nineteen poems in the
Northamptonshire manuscript, compiled the table of contents, and later
made some corrections to both his own and Anne's transcriptions.[27]

[25] Wellesley MS, p. 75, McGovern and Hinnant, p. 35. Finch's reference to Sheffield's Stuart poetry is
presumably to his *Essay on Poetry* (1682). Quotations from the Wellesley MS are by permission of
Wellesley College Library, Special Collections.

[26] *IELM*, p. 536. In identifying Anne Finch as the scribe of NRO, pp. 1–87, I follow Cameron ('Anne,
Countess of Winchilsea', vol. 1, pp. 72–73) and Lindsay (*IELM*, p. 536). McGovern's view that the
first hand in the Northamptonshire manuscript is 'definitely not Anne Finch's' (McGovern, *Anne
Finch*, p. 68) does not take account of the 'best hand' hypothesis.

[27] On Heneage's corrections, which include the deletion of two poems, see *IELM*, p. 537.

He subsequently took responsibility – though evidently in conjunction with Anne – for the compilation of the second manuscript collection of his wife's poems (now the Folger manuscript). Heneage was the principal scribe of this much more substantial and ambitious collection, which comprises 107 poems and 2 plays, as compared with the 53 poems of the Northamptonshire manuscript, and includes 2 commendatory poems on Anne Finch (by William Shippen and an otherwise unknown 'Mrs Randolph'), as well as a prose preface by Finch herself. Heneage may also have influenced the decision to include Finch's poem 'A Letter to Dafnis' among the first poems in the Folger manuscript. 'A Letter to Dafnis [i.e. Heneage]' is often cited as evidence for the Finches' unfashionably devoted marriage – Finch describes Heneage as 'the Crown and blessing of my life' and declares 'They err, who say that husbands can't be lovers' – but its location at such a significantly early stage within the Folger collection also emphasises its role among Finch's strategies of authorial self-vindication. Crucially, in the 'Letter', the justification for Finch's poetry is made to depend solely on the approval and good judgement of Daphnis:

> Ev'n I, for Daphnis, and my promise sake,
> What I in women censure, undertake.
> But this from love, not vanity proceeds;
> You know who writes; and I who 'tis that reads.
> Judge not my passion, by my want of skill,
> Many love well, though they express itt ill;
> And I your censure cou'd with pleasure bear,
> Wou'd you but soon return, and speak itt here.
> 'A Letter to Dafnis', 10–17[28]

The 'Letter' emphasises Heneage's role as his wife's ideal reader and construes her love for him as at once motivation and authorisation for her poetry. The fear of censure which Finch expresses so often elsewhere throws into relief both her reliance on 'Daphnis, and my promise sake' to justify her transgressing her own strictures on women's writing and the 'pleasure' with which she promises to 'bear' any censure spoken by the just and loving Daphnis. All of the poems transcribed in the Folger manuscript – indeed, all the Finch poems extant in any authorised source – are, by implication, those that have survived the critical scrutiny of Heneage Finch.

[28] Folger MS, p. 4, Reynolds, p. 20. 'A Letter to Dafnis' is dated 2 April 1685 – less than a year after the Finches' marriage. It is also transcribed in Anne's portion of the Northamptonshire manuscript (pp. 35–36), where it is the first in a section of more secular poems following an introductory devotional sequence. The spellings 'Dafnis' and 'Daphnis' are used interchangeably and often inconsistently in the Finch manuscripts.

Heneage's role in producing the Finch corpus that has lasted to the present day is pervasive. It seems likely, for instance, that the scholarly notes appended to several poems in both the Northamptonshire and the Folger manuscripts, which typically clarify matters of historical or literary reference, were drafted by Heneage; they begin in his section of the Northamptonshire manuscript and seem to reflect his antiquarian and genealogical interests.[29] Later, he oversaw the compilation of the last substantial witness to Finch's poetry, the Wellesley manuscript, which was probably begun about the time of Finch's death in 1720. Heneage's work on Wellesley included both the transcription of the last eleven poems (pp. 123–46) and the correction of the forty-two poems copied by another, as yet unidentified, amanuensis (pp. 49–122).[30] He is also likely to have determined the role and scope of the manuscript as a repository for those of Finch's poems which had not been collected elsewhere. With one exception, the Wellesley manuscript excludes all poems preserved in the Northamptonshire and Folger manuscripts, *Miscellany Poems* and Pope's edited collection, *Poems on Several Occasions* (1717).[31] The exception – Finch's 'To Mr. Pope', previously published in *Poems on Several Occasions* – may have been included in Wellesley either because of the prestige represented by the correspondence with Pope or because Heneage wanted to clarify its status as an answer poem. (The poem by Pope to which Finch responds is transcribed immediately prior to Finch's reply in Wellesley; it is not included in *Poems on Several Occasions*.)[32] Furthermore, although the poems in Wellesley are less obviously a shaped compilation than either the Northamptonshire or Folger manuscripts (in part because the collection lacks front matter), there is evidence of at least some degree of planning in the ordering of materials in the volume.[33] Short sequences of ordered poems occur at several points in the manuscript – for example, the series of poems on dogs ('The puggs', 'A Letter from Sir A. F. to Ardelia',

[29] The first extended note in NRO, for instance, glosses line 17 of 'From the Muses, at Parnassus' (NRO, p. 122, Reynolds, pp. 32–33, 419). Anne's claim that the muses will 'trace [Charles Finch's] blood, until itt mix with Kings' (16) is explained with reference to the young Earl's descent, through the Marquess of Hertford, from Charles Brandon and Mary Tudor.

[30] On the dating of the Wellesley manuscript, see *IELM*, p. 539.

[31] Another partial exception is 'On Absence', an adaptation from De Bussy. This poem exists in a one-stanza version in the Folger manuscript (p. 38) and a four-stanza version in Wellesley (p. 100).

[32] Wellesley MS, pp. 96–98, McGovern and Hinnant, pp. 68–70; *POSO*, pp. 111–13. Wellesley shows a consistent interest in preserving answer poems in their original context: poems by 'Sir A. F.' and Catherine Fleming are transcribed in the manuscript in order to account for the poems written in reply by Finch (pp. 54–65).

[33] The first forty-eight pages of the Wellesley manuscript are blank, and may have been reserved for a later round of transcription which never occurred.

'The agreeable'), pp. 50–57, and the sequence of 'picture' poems (on
Sir George Rooke, John Dryden, Marshall Turenne and Major
Pownoll), pp. 103–4 – and the final nine poems in the manuscript form
a devotional conclusion, ending with the eschatological 'A Contemplation'
(pp. 143–46).[34] For better or worse, the Wellesley manuscript – often read
as a straightforward guide to what Anne Finch was writing in the final
years of her life – is Heneage Finch's creation. It is entirely possible,
indeed, that Heneage may have excluded poems which, for whatever
reason, he did not see fit to incorporate into the Wellesley manuscript.
There is some evidence that he did.[35]

Anne and Heneage Finch worked together so closely that in many areas
of their lives it can sometimes be difficult to distinguish one spouse's
activities from the other's. This is the case in the final – somewhat
paradoxical – enabling condition for Finch's poetry that we need to
consider: namely, her political circumstances. The deposition of James II
in 1688 was, in both political and personal terms, the pivotal event of Anne
and Heneage Finch's adult lives. Both Anne and Heneage had close
personal ties to the ousted king and his household: Anne through her
service to Mary of Modena, Heneage as a Gentleman of the Bedchamber
to James himself. The Finches' unequivocal support for the deposed James
had highly adverse consequences which were to set them at material
disadvantage for the rest of their lives. Heneage, caught trying to join
James in France in 1690, was lucky to suffer only a short imprisonment in
the Tower, but his refusal to take the oaths of loyalty to the new regime
necessarily meant the loss of all his appointments at court, as well as
debarring him from any prospect of holding public office under William
and Mary or any of their successors. This tenacious loyalty to James II
contrasts with the more pragmatic attitudes of his father and nephew who,

[34] In identifying these principles of order in Wellesley, I differ both from Finch's editors, McGovern and Hinnant, who see 'no order of any sort with regard to subject matter or genre, suggesting that the texts were gathered haphazardly' (p. xliv) and also from Ellen Moody ('A Review of *The Anne Finch Wellesley Manuscript Poems*' http://jimandellen.org/finch/review.mcgovern.html), who speaks of the 'disarray' of the manuscript.

[35] At least one late poem, probably by Finch, survives in Heneage's hand but is not included in Wellesley (*IELM*, p. 539). Cameron argues that Heneage found the poem after transcription had finished on the Wellesley manuscript (vol. 1, p. 123); however, given the many blank leaves in the Wellesley manuscript, the validity of this explanation cannot be assumed. Several other poems by Finch, uncollected in NRO, Folger, *Miscellany Poems* or Wellesley, are known to survive; see *IELM*, pp. 540–41. See also my discussion of Finch's 'The Nightingale, and the Cuckoo' in 'The Birds and the Poet: Fable, Self-Representation and the Early Editing of Anne Finch's Poetry', *The Review of English Studies* (in press).

despite Jacobite sympathies, managed to accommodate themselves to the new regime, and it seems likely that at least part of the difference was due to Anne and Heneage's mutually reinforcing political and personal allegiances.[36] Anne, who had resigned her place in Mary of Modena's household on her marriage, was less well placed to make public attestations of loyalty to the former monarchs, but her poetry – both in manuscript and in print – is unwavering, over the subsequent thirty years of her life, in its devotion and fidelity towards them. She risked publishing (albeit anonymously) an elegy in memory of James in 1701, and the Wellesley manuscript includes a notably affectionate elegy on Mary of Modena, who died in 1718. Though *Miscellany Poems* – whose authorship seems to have been an open secret – is a less openly Jacobite collection than Finch's manuscript writings, its political loyalties would have been plain to even a minimally attentive reader.[37]

Anne and Heneage Finch's uncompromising Jacobitism did not merely banish them from court society and ruin Heneage's career in public life. It also left them both financially vulnerable and homeless. Though the issue of homelessness was soon resolved when Charles Finch invited them to live at the family property, Eastwell in Kent, this solution necessarily removed them from the city and courtly literary society which had already begun to have such a shaping effect on Finch's writing. Ironically, however, the dispossession – both political and material – which Finch suffered following the upheavals of 1688 seems to have provided a still more potent stimulus to her writing, both in the short and the long term. As I have already noted, her separation from Heneage in 1690 seems to have prompted her to embark on the first known collection of her poetry; and Jacobite nostalgia, variously expressed, is one of the recurrent preoccupations of the Northamptonshire manuscript: present, for instance, in the elegy on Lord Dundee, parabolic poems such as 'The Change' and 'The Tree', the exilic 'Psalm the 137th Paraphras'd', and an opening sequence of consolatory poems which seek to re-understand political loss as divinely sanctioned affliction.[38]

[36] See also Cameron, 'Anne, Countess of Winchilsea', vol. 1, p. 88 and McGovern, *Anne Finch*, p. 98.

[37] Heneage Finch's letter to Thomas Brett (see footnote 5, above), while denying that his wife had authorised the use of her name in the published volume, nonetheless concedes that 'she owns itt, to our Freinds & all the Town knew her to be the Author of it' (Bodleian MS Eng. th. c. 25, fol. 99r).

[38] These consolatory poems include 'Some reflections in a Dialogue between Teresa and Ardelia on the 2nd & 3rd verses of the 73rd psalm' (pp. 18–25), 'Gold is try'd in the fire and acceptable men in the time of Adversity' (pp. 30–33) and 'On Affliction' (pp. 33–34). Each of these poems, though included in the Folger manuscript, is omitted from *Miscellany Poems*.

But Finch's Jacobitism and the geographical and cultural dislocation that it precipitated had still more far-reaching effects on her writing than are apparent in the suggestive but somewhat reactive poems of the Northamptonshire manuscript: effects which were almost without exception beneficial to her practice as a poet. Few critics today would see either Finch's songs or her Tasso translations – those of her 1680s works most clearly influenced by her court circumstances – as among her most interesting poems, and it is striking that almost all of her more considered and inventive responses to city and courtly literature and writers occur in texts probably composed several years after she had left Westminster Palace. The Wellesley manuscript includes reflective allusions to Cowley, Rochester and Dryden as well as Sheffield.[39] 'Ardelia's answer to Ephelia', her satire on the norms of city life, seems to be a poem of the early to mid-1690s; it is not included in the Northamptonshire manuscript and the copy in the Folger manuscript shows signs of ongoing revision.[40]

It is also worth dwelling on the fact that 'Ardelia's answer to Ephelia' *is* a satire. Unequivocal as Finch's Jacobitism seems to have been, her poetry does not look back to her pre-revolutionary experience in a wholly unqualified or uncritical manner. (The mere suggestion, in poems such as 'Gold is try'd in the fire', that the defeat of the Jacobite cause may have been divinely sanctioned – a just punishment for pride – is enough to suggest otherwise.) It would also be unduly simplistic to see Finch's Jacobitism as ever forming the exclusive or invariable preoccupation of her writing. Even the Northamptonshire manuscript, compiled in the immediate traumatic aftermath of the Revolution, includes poems not noticeably political in import, including 'A Pastoral Between Menalcus and Damon' and several of her songs. And while it might plausibly be argued that the inclusion of Finch's songs in the Northamptonshire manuscript does, in fact, form an expression of Jacobite nostalgia (much as Herrick's *Hesperides* lyrics, published in 1648, constitute a declaration of his royalism), no such argument can be made about another poem included in NRO, 'To My Sister Ogle'. Dated 31 December 1688, 'To My Sister Ogle' makes no reference to the violent events of the preceding

[39] On Cowley, see 'To His Excellency the Lord Cartret at Stockholm', 51–54 (Wellesley MS, p. 67, McGovern and Hinnant, p. 24); Rochester, 'An Apology for my fearfull temper', 84–85 (Wellesley MS, p. 100, McGovern and Hinnant, p. 73); Dryden, 'Under the picture of Mr John Dryden' and 'A Suplication for the joys of Heaven', 45–50 (Wellesley MS, pp. 103, 109, McGovern and Hinnant, 80, 90).

[40] On the revisions, see Folger MS, pp. 8 (additions in the margin) and 11 (cancellation and substitution); Reynolds, p. 420.

two months and reads like a standard, non-topical retirement poem (with a piously other-worldly conclusion).[41] Even at the close of 1688, when the fate of James and Mary was most in question, Finch was not a single-subject writer. Similarly, even the Wellesley manuscript, which includes many of Finch's most overtly Jacobite poems, also includes numerous friendship, humorous and religious poems in which political allusions, if they are present at all, are well concealed.

Finch's committed but complex engagement with Jacobitism will be reconsidered later in this chapter. For present purposes, the point to be noted is simply that, notwithstanding the many material and cultural disadvantages it brought her, Finch's political stance should nonetheless be counted among the enabling factors which helped to make her writing possible. Finch's Jacobitism did not consist of received attitudes which, absorbed from outside sources, prescribed and delimited the views expressed in her writing; it was very much her own (and perhaps Heneage's) creation. As such, it became crucial in enabling Finch to comment on contemporary politics, social attitudes and literary assumptions, as well as underpinning many of her poems of retirement, melancholy and religious consolation. From her Jacobitism, Finch derived not just one but many of her most productive poetic subjects. It helped to give her not only a rationale for writing but also a tenable claim to insight and authority. As much as familial support and cultural literacy, it was key to constituting her agency as a poet.

THE EARLY MANUSCRIPTS

Given so many factors, paradoxical and otherwise, in her favour, Finch seems to have been remarkably well placed and equipped to excel as a poet. But this is, of course, the judgement of hindsight. Finch's own writing, unsurprisingly, treats the question of her poetic agency with rather more circumspection – though an ostentatiously performed circumspection which itself deserves to be subject to critical scrutiny. It is well known that Finch, like so many of the women writers considered in this book, expressed strong reservations about allowing her poems to be print-published, especially under her own name. *Miscellany Poems* appeared

[41] NRO, pp. 38–40. The Kirby household in Northamptonshire, where Finch was staying in late 1688, received news of the Revolution in November 1688 (Cameron, 'Anne, Countess of Winchilsea', vol. 1, p. 60), so there can be no question that she simply did not know about the violent events she fails to mention.

relatively late in her life, and was initially anonymous. Yet it is also well known that, from the early 1690s onwards, poems by Finch began to appear in print: in miscellanies such as Tate's *Miscellanea Sacra* (1696) and Gildon's *A New Collection of Poems* (1701); inserted within texts by other writers, including Thomas Wright's *The Female Virtuoso's* (1693) and – somewhat incongruously – Delarivier Manley's *The New Atalantis* (1709) and *Court Intrigues* (1711); and even in a few cases as separates: the elegy for James II in 1701 and 'The Spleen' (with John Pomfret's 'A Prospect of Death') in 1709.[42] Though critics have been rather over-hasty in assuming that Finch herself authorised the publication of these poems, there is in fact no good reason to doubt that she did. While Finch's poetry evidently did circulate in manuscript before publication – the prefatory material to the Folger manuscript indicates as much – this circulation seems to have been relatively limited and appears not to have passed beyond her and Heneage's control. Although she expresses fears – especially in the Folger manuscript – that her poems and plays may be printed without her consent, she shies away from claiming that this has already happened. Her confession, in the Folger preface, that 'I have writt, and expos'd my uncorrect Rimes, and immediately repented; and yett have writt again, and again suffer'd them to be seen, tho' att the expence of more uneasy reflections' is not quite an explicit admission of responsibility for allowing some of her poems to be print-published, but that is probably its implication.[43]

If we examine Finch's own statements about her writing, it is striking that even the earliest of these comments seems preoccupied with the possibility of her work reaching a wider readership. This is the case even in what seems to have been the most private – and is certainly the first – of Finch's known poetry collections, the Northamptonshire manuscript. Although this manuscript seems to have been compiled solely for the benefit of Anne and Heneage themselves, the issue of a more public readership is in evidence from the very beginning. In the first line of the first poem, 'The Introduction', the poet's conditional syntax hints at, even as she disclaims, a yearning for her writings to reach a 'publick view'. What holds her back, significantly, is not so much her own sense of discretion or female modesty as fear of the censure her work would suffer in the wider world:

[42] See *IELM*, esp. pp. 536 and 543–69
[43] Folger MS, fol. 7r, Reynolds, p. 7. On Finch's involvement with miscellany publication in the 1690s and early 1700s, see further Gavin, 'Critics and Criticism', pp. 644–49.

> Did I my lines intend for Publick view,
> How many Censures, wou'd their Faults pursue.
> Some wou'd, because such words they doe affect,
> Cry their insipid, empty, uncorrect,
> And many have attained, dull, and untaught,
> The name of witt, only by finding fault.
> True judges, might condemn theire want of witt,
> And all might say, they're by a woman writ.
> 'The Introduction', 1–8[44]

When Finch speculates about *why* readers might find fault with her work, she carefully ascribes their censoriousness to failings on their part, not hers. The 'Some' who might condemn her work as 'insipid, empty, uncorrect' would do so only because they have built their own reputations on ungenerous dispraise of others, not because Finch's poetry really deserves such condemnation. All that 'True judges' would find to criticise in her writing is 'want of witt', an admission which may in the circumstances be a form of inverted self-praise, dissociating Finch from over-sophisticated, masculine court wits such as Rochester. It is also probably true that Finch's earliest poetry, as gathered in the Northamptonshire manuscript, is not especially witty; such self-regarding cleverness would have been out of place among the consolatory poems which set the tone for this collection. The sharp wit of which Finch was always capable would be exercised more fully and openly later in her career, in poems such as 'Fancomb Barn' and 'To Mr Pope'.

Fear of censure, as I have noted, is a preoccupation which Finch may have inherited from her father. In Finch's case, however, the censure which she envisages being levelled at her work is frequently linked with her status as a woman poet. Whereas, in 'The Introduction', other criticisms of her poems are ascribed only to subcategories of her potential readers, criticism on grounds of sex is attributable to 'all'. A woman poet, Finch remarks, is viewed as 'an intruder on the rights of men' (10), a 'presumptious Creature' (11) who does not realise that 'Good breeding, fashion, dancing, dressing, play' (14) and 'the dull manage of a servile house' (19) are the activities and interests appropriate to her sex. Far from shrinking from the gender debate, Finch seems to revel in summarising the misogynistic case in starkly explicit terms. Her own response, equally bold, is to invoke the Bible in defence of women's poetic talents. She cites the women who joined in the 'hymn divine' (32) on the day when the Ark of the Covenant was returned to Israel, as well as

[44] NRO MS, p. 1; compare Folger MS, p. 1, Reynolds, p. 4.

the women who sang in praise of the young David (35–36), and the judge and prophetess Deborah (45–46). All these women, on Finch's account, received 'Some share of witt, and poetry' from a supremely authoritative source, 'the diffusive hand of Heaven' (24, 23). With such precedents on her side of the argument, Finch confidently attributes the lesser roles and opportunities available to women in her own day to education rather than Nature (52).

In the course of 'The Introduction' Finch seems to convince herself, at least, that women's poetry is divinely authorised. Yet, as she moves from her biblical exempla towards a conclusion, her sense of poetic self-confidence seems to falter. The ambitious female poet who *might* dare to defy convention is constructed in the third person; the first-person pronoun re-emerges only once it is clear that the poet's 'hopes to thrive' in a more public world are still set to be thwarted:

> And if some one, wou'd soare above the rest,
> With warmer fancy, and ambition prest,
> So strong, th'opposing faction still appears,
> The hopes to thrive, can ner'e out weigh the fears.
> Be caution'd then my Muse
> 'The Introduction', 55–59[45]

Though Finch may have won the argument for women's poetry, at least to her own satisfaction, this is not enough. Fear of censure from 'th'opposing faction' still holds her back. But although Finch ends 'The Introduction' by counselling her Muse to rest content in 'dark ... shades' (64) and not to seek the 'Groves of Lawrel' (63) for which she was never intended, such self-restraint did not keep her in check for long. Finch's two subsequent collections, the Folger manuscript and *Miscellany Poems*, both show her pushing ever further at the boundaries of publicity, while still harking anxiously back to the risk of critical censure.

In contrast with the relatively private Northamptonshire manuscript, the Folger manuscript seems obviously intended for a wider readership. This is apparent from the very elaborate arrangement of the volume, which consists of two distinct parts: the first compiled *c*. 1691–96, the second *c*. 1696–1701.[46] (The terminal item in the manuscript, Finch's elegy on James II, cannot have been added prior to James's death in September 1701; the absence of references to William III's death in February 1702 suggests that the manuscript was most likely completed before

[45] NRO MS, pp. 4–5; Reynolds, p. 6.
[46] On the dating and structure of the Folger manuscript, see further *IELM*, pp. 537–38.

this – for Jacobites – happy event.)[47] The first part of the manuscript begins with a formal title page, and continues with the commendatory poems by Shippen and Randolph, Finch's prose preface, and another iteration (only lightly revised from NRO) of 'The Introduction'. Later in this section, Finch's two plays, *The Triumphs of Love and Innocence* and *Aristomenes* are each provided with their own title pages (pp. 67 and 131), while there is also a prefatory 'Advertisment' to the two plays (p. 69) and a poetic prologue to *Aristomenes* addressed to Charles Finch (p. 133). Following the plays, the second part of the manuscript also has its own title page: 'Aditional Poems cheifly Upon Subjects Devine and Morall' (p. 195). In her prose preface, Finch explains that she intends to derive all her poetry henceforth from 'Devinity, or from moral and serious occasions; which made me place them [i.e. her religious and moral poems] last, as capable of addition'.[48] While probably disingenuous about Finch's plans for her own writing, this statement nonetheless witnesses to the care with which she and Heneage constructed the Folger manuscript, as well as to her own perceived need to justify herself to a wider readership: people who, unlike herself and Heneage, would not already know about her creative intentions. Nearly two decades before the publication of *Miscellany Poems*, Finch's self-understanding as a poet already included a clear sense of herself as a writer with readers.

The paratexts to the Folger manuscript send out the familiar mixed signals about Finch's attitudes to publicity. Though the title page modestly attributes 'Miscellany Poems With Two Plays' only to 'Ardelia', there is no real attempt to conceal Finch's identity, which is openly acknowledged in the titles of the two commendatory poems.[49] The paradox of Finch's self-presentation is most apparent in the epigraph on the title page:

> I never list presume to Parnass hill,
> But piping low, in shade of lowly grove,
> I play to please my self, albeit ill –

Though the epigraph speaks of the poet's modesty and desire for privacy, these overt claims are implicitly counterbalanced by the (acknowledged)

[47] Since the Folger copy of the James elegy represents a later, revised state of the poem (in comparison with the version print-published in 1701), and runs to 177 lines, this proposed timetable may allow an impossibly short period for the composition, revision and transcription of the elegy. The alternative possibility is that the elegy – much corrected and still perhaps unfinished in the Folger copy – was transcribed later, as a deliberately non-proleptic conclusion on Jacobitism up to the death of James.

[48] Folger MS, fol. 9v, Reynolds, p. 12.

[49] 'To the most Ingenious Mrs Finch On her incomperable Poems' (fol. 5v, Shippen) and 'An Epistle, From Mrs Randolph To Mrs Finch; upon her presenting her with some of her Poems' (fol. 6r–v).

origins of the extract in Spenser's *Shepheardes Calender* ('June' eclogue, 70–72). Not only is it all too obviously incongruous to express modesty by citing one of the most distinguished canonical poets in English, but the extract from 'June' which Finch – or Heneage, with Finch's blessing – quotes is taken from a speech in which Colin Clout, Spenser's own persona, voices his sense of poetic mission. Modesty such as this is highly aspirational.

This attempt to write Finch into the high canon of English poetry is continued in both the commendatory poems included in the Folger manuscript. In the rather slighter poem by William Shippen, evidently inspired by 'The Spleen' and 'An Epistle from Alexander to Hephaestion', these literary connections consist of graceful, if formulaic, comparisons of Finch to Pindar and David. Mrs Randolph, however, makes it the central argument of her poem to claim that Finch is the true successor to Abraham Cowley – here portrayed as the greatest poet of the preceding generation, 'the Prince of all the tunefull Race' (5).[50] The distinguishing greatness of Finch's verse, according to Randolph, is that it combines Cowley's artistic strength with a poetic sweetness inherited from her great female predecessor Katherine Philips (43). On Randolph's account, Finch not only belongs within the literary canon, but is properly located at its very centre. Indeed, it is her unique ability to stand as heir to both Cowley and Philips – both masculine and feminine traditions in English poetry – that entitles her to succeed to 'Poetique Monarchy' (39), a royalist metaphor which must have appealed to Finch.

Randolph's lavish praise of Finch has the obvious advantage of articulating claims to greatness that a modest poet could never have made for herself. But it is salutary that even amid these eulogies, Randolph is still obliged to acknowledge one objection that might be raised to Finch's 'Title to the Bays' (34) – namely, her sex. Though Randolph forthrightly rejects the validity of this objection, citing the 'noble Precedent' of Philips who 'cancell'd great Appollo's Salique Law' (35, 36), it is lesson enough that her poem still needs to engage with sex-based arguments, while all others can be ignored with apparent impunity. Randolph may have less fear of censure on Finch's behalf than the latter has on her own, but when the issue of censure does arise it is, inevitably, in the context of sexual difference.

[50] Folger MS, fol. 6r. The text of Mrs Randolph's poem, not included by Reynolds, is reproduced by Ellen Moody ('An Epistle, from Mrs Randolph, To Mrs Finch' http://jimandellen.org/finch/randolph.html).

Finch's own prose preface, which immediately follows the Randolph poem in the Folger manuscript, is still more conflicted and contradictory in its treatment of publicity and censure. The preface does not have a named addressee, but implies a reader who knows enough about Finch's personal history to be able to make sense of her autobiographical references. This reader is not only expected to know about Finch's service at court and her retirement to Eastwell – facts potentially in the public domain – but also to be able to decode the Jacobite implications of her claim to have written her plays in order to 'giv[e] some interruption to those melancholy thoughts, which posesst me, not only for my own, but much more for the misfortunes of those, to whom I owe all imaginable duty, and gratitude'.[51] The readership which Finch overtly anticipates at this stage of her writing career is a readership of 'freinds and acquaintance' who, far from condemning this limited circulation of her poetry, are held responsible for it: she attributes the compilation of the Folger manuscript to 'the partiality of some of my freinds', who have even 'solicited' her 'to a more daring manefestation [i.e. a printed volume], which I shall ever resist'.[52] But this immediate environment of supportive, politically like-minded friends – another enabling context for Finch's writing – is implicitly contrasted with an outer world which is fully expected to greet her poetry with scorn and derision. Though Finch, like Randolph, does not actually use the word 'censure' in her preface, fear of censure is clearly her concern here, as in 'The Introduction'. Perhaps unexpectedly, when she cites an example of how public circulation of her poetry might in the past have exposed her to ridicule, the location she specifies is the Jacobites' lost political ideal, the Stuart court:

itt is still a great satisfaction to me, that I was not so far abandon'd by my prudence, as out of a mistaken vanity, to lett any attempts of mine in Poetry, shew them selves whilst I liv'd in such a publick place as the Court, where every one wou'd have made their remarks upon a Versifying Maid of Honour; and far the greater number with prejudice, if not contempt.[53]

As I have stressed, the Folger manuscript pervasively implies a Jacobite readership. This is evident not only in Finch's allusions, in the prose preface and the 'Epilogue' to *Aristomenes*, to the role of her writing as political consolation, but also in the inclusion of such manifestly partisan poems as the elegy on James II, so prominently located as the concluding

[51] Folger MS, fol. 9v; Reynolds, p. 12. [52] Folger MS, fol. 7v, 7r; Reynolds, p. 7.
[53] Folger MS, fol. 7v; Reynolds, pp. 7–8.

item in the Folger manuscript. (Much of this overtly Jacobite material, including the prose preface, the 'Epilogue' and the elegy, was later omitted from *Miscellany Poems*.)[54] Such readers could presumably be trusted not to take this somewhat unflattering reconstruction of court life too seriously – just as they could be relied on, later in the manuscript, to interpret Ardelia's plea to her husband (in 'An Invitation to Dafnis') to abandon his study of anti-Williamite battle tactics as a light-hearted and very temporary diversion from duty.[55] Yet Finch's imagined version of what might have been if she had chosen to circulate her writing at court provides the clearest indication in her extant writing of how court circumstances – so stimulating as a literary and intellectual source for her writing – might at a day-to-day level have been a less than encouraging environment for a woman writer. Finch recollects that her fear of 'prejudice, if not contempt' had discouraged her writing to such an extent that if she had stayed much longer at court she might even have been moved to give up writing poetry altogether. Ironically, the implication of this claim – not, of course, spelled out – is that the much-loathed Revolution saved Finch's poetic career. Exile from the potentially censorious court led to retirement to Eastwell where, Finch says, two factors – the beauty of her surroundings and the support of Charles Finch – encouraged her not only to continue her writing but to do so more freely than before.

Finch's self-presentation and self-analysis in the Folger preface are riddled with contradictions. The convention that a female poet should portray herself as discreet and self-effacing – circulating, and even producing, her writing only at the behest of others – sits awkwardly alongside Finch's unapologetic self-dedication to poetry ('Again I engage my self in the service of the Muses') and her unequivocal refusal to 'deny my self the pleasure of writing'.[56] In the 'Advertisment' to her two verse dramas and the prologue to *Aristomenes*, later in the manuscript, she revisits many of the same issues, no less contradictorily than in the prose preface.[57] Plays raise more varied issues of publicity than do many other kinds of

[54] Other overtly Jacobite poems omitted from *Miscellany Poems* include the elegy on Lord Dundee and 'The Jester and the Little Fishes' (*inter alia*, a satire on the Darien adventure). 'The Jester and the Little Fishes' is a rare example of a fable included in Folger but omitted from *Miscellany Poems*; the only other such example, 'The Goute and Spider', was probably omitted because of its personal references to Heneage Finch. See Ann Messenger, 'Publishing Without Perishing: Lady Winchilsea's Miscellany Poems of 1713', *Restoration: Studies in English Literary Culture, 1660–1700* 5.1 (1981), 27–37 (p. 32), and Wright, 'The Birds and the Poet'.

[55] Folger MS, p. 42; Reynolds, p. 29. Perhaps Finch felt less able to trust the readers of *Miscellany Poems*, which omits 'An Invitation'.

[56] Folger MS, fol. 7v; Reynolds, pp. 8, 7. [57] Folger MS, p. 69; Reynolds, p. 271.

literary texts, since they are vulnerable not only to unauthorised textual circulation but also to unauthorised performance. Finch is professedly hostile to the public performance of her plays and represents the 'Advertisment' as an attempt to prevent such a calamity ever occurring. A familiar anxiety is rearticulated as she recollects seeing other dramas, of similar quality to her own, being 'expos'd, censured and condemn'd' when performed on stage.[58] Exposure, censure and condemnation seem, for Finch, to follow one another in an inevitable and terrifying sequence – though in the prologue to *Aristomenes*, she is careful to explain that the just censure of a true critic such as Charles II or Charles Finch is a very different matter from the ignorant prejudice of the multitude. Thus while private recitation of *Aristomenes* at Eastwell, as the prologue attests, was fully acceptable, public performance was at all costs to be avoided.

Finch's 'Advertisment' is premised on an assumption that any shrewd author should have known not to apply: namely, that she could plausibly expect to prevent unwanted reproduction of her writings simply by asking readers to respect her wishes. Since Finch admits that copies of her plays, presumably lacking even the inadequate protection of the 'Advertisment', have already been produced, she can scarcely have believed that including the 'Advertisment' in the Folger manuscript would successfully protect her work from further reproduction, whether on stage or page. Perhaps Finch was naïve and did suppose that making a plea to her readers' better natures would secure the desired effect. Perhaps she knew better but tried anyway; her observation that her work would be accessible only to relatives and friends may have been intended as a discreet warning that should any of them breach her trust, she would know whom to blame. Or perhaps Finch here, as (apparently) elsewhere, was being disingenuous, and secretly craved the public exposure she could not openly be seen to desire. Marta Straznicky finds it suggestive that the manuscript texts of Finch's plays, unlike other closet dramas by seventeenth-century women, are thoroughly imagined for staged performance, with particular attention in the stage directions to the visual and physical presentation of dramatic action.[59] Whatever Finch's own wishes – now, of course, irrecoverable – it is at least certain that if any of her readers *had* wanted to reproduce her plays, they would have had the advantage of starting from a clear, performable

[58] Significantly, this formative experience of playgoing, which so deterred Finch's dramatic ambitions, probably took place at court. See Marta Straznicky, *Privacy, Playreading, and Women's Closet Drama, 1500–1700* (Cambridge University Press, 2004), p. 93.

[59] Straznicky, *Privacy*, pp. 93–95.

text. Ironically, however, Finch's readers seem to have been scrupulously respectful of her wishes: there is no record that either play was ever acted, and the only known contemporary copy of either, apart from the Folger manuscript, is the version of *Aristomenes* included in *Miscellany Poems*.[60]

In the prose preface to the Folger manuscript, as we have seen, Finch claims that some of her friends have urged her to print her poems. Explaining why she will 'ever resist' such urgings, Finch cites as justification for her reticence an excerpt from one of her own early poems. The passage she quotes is a speech attributed to the god Apollo, which she describes in the preface as his 'wise, and limitted answer to me':

> I grant thee no pretence to Bays,
> Nor in bold print, do thou appear;
> Nor shalt thou reatch Orinda's prayse,
> Tho' all thy aim, be fixt on Her.[61]

Brief though it is, this excerpt – quoted here in full – is instructive. Finch's description of Apollo's words as his 'answer to me' suggests that, in the complete version of the poem, she herself had raised the issue of print-publication. Although Apollo's strictures on Finch's poetry rank her firmly below the heights achieved by Katherine Philips (Orinda), his verdict needs to be read against the construction of Finch as heir to Philips in Mrs Randolph's introductory commendation, transcribed just a few pages earlier. A well-informed reader, reaching the prose preface immediately after Randolph's commendatory poem, would have known to interpret Apollo's 'answer' strategically rather than literally, both as a standard example of the modesty topos, and as a statement of literary affiliation, linking Finch with the virtuous tradition of female poetry associated with Philips, as opposed to the libertine tradition associated with Aphra Behn.

More instructive still, however, is the fact that the poem from which these lines are supposedly extracted is otherwise completely unknown. It is not included in either the Northamptonshire manuscript, the best record of Finch's early poetry, or the Folger manuscript itself.[62] Described by Finch as 'an invocation of Apollo', its closest equivalent among Finch's

[60] Straznicky, *Privacy*, p. 96. The version of *Aristomenes* in *Miscellany Poems* lacks all the paratextual material which surrounds the play in manuscript, thus appearing without explanation or apology.
[61] Folger MS, fol. 7r; Reynolds, p. 7.
[62] If this poem ever existed in the complete form implied by the preface, it represents further evidence that even the compendious Folger manuscript offers a selective compilation of Finch's early poetry.

surviving works is her 'Sessions' poem, 'The Circuit of Appollo', tran-scribed later in the Folger manuscript (and extant only there).[63] In 'The Circuit', however, compared with the 'invocation', the positions of god and poet are reversed. While the Ardelia of 'The Circuit' insists that she writes only for her own amusement and disclaims any interest in 'Fame, which so little does last, / That e're we can taste itt, the pleasure is past' (48–49), Apollo's judgement on her prospects is much more encouraging:

> But Appollo reply'd, tho' so carelesse she seem'd,
> Yett the Bays, if her share, wou'd be higly esteem'd.
> 'The Circuit of Appollo', 50–51[64]

'The Circuit of Appollo' – as its metre, anapaestic tetrameter, implies – is a comic poem, perhaps not to be taken too seriously; and receiving the bays in the 1690s would not necessarily have implied print-publication. Yet the fact that Finch and Heneage chose to include 'The Circuit', with its more positive construction of Finch's poetry, rather than the full text of the flatly discouraging 'invocation of Apollo', in the Folger manuscript seems sig-nificant. It is also suggestive that the poet implicitly held up as a role model for the four Kentish female poets in 'The Circuit', rather surprisingly, is Aphra Behn. The acknowledged rationale for this choice (carefully speci-fied in a footnote) is Behn's origins in 'Wye, a little market Town ... in Kent', but the fact that Behn was an openly print-publishing poet is unlikely to have been forgotten.[65] Notably, though Finch chastely dissoci-ates herself from Behn's libertinism – making her Apollo regret that Behn wrote 'a little too loosly' (14) – she expresses no reservations about the latter's writing either for the stage or the press. As a result, the version of Behn which the Kentish poets, including Ardelia, are authorised to emu-late excludes her licentiousness but implicitly includes her willingness to publish her own poetry. Deep in the Folger manuscript, Finch can risk expressing the admiration for Behn that she seems to have shied away from in the more conspicuous introductory paratexts, while the insistently comic tone of the poem acts as a shield against potential censure, licensing her to toy with ideas she could not – yet – be seen to take seriously. To an attentive reader of 'The Circuit', Finch's later decision to entrust her poetry to print should have been no surprise.

[63] The titular word 'Circuit', in the Folger manuscript (p. 43), is a correction, but not for 'invocation'. The original reading, though difficult to reconstruct, is probably 'Visitation'.
[64] Folger MS, p. 45; Reynolds, p. 94. [65] Folger MS, p. 43; Reynolds, p. 427.

MISCELLANY POEMS

When a collection of Finch's poems was eventually published, in 1713, it was initially anonymous.[66] The three issues which explicitly attribute the volume to the Countess of Winchilsea are likely to have been belated attempts on the part of the publisher to stir up interest in a slow-selling volume.[67] Many of the more personal poems extant in the Northamptonshire and Folger manuscripts were omitted from *Miscellany Poems*, including several of those addressed to Heneage and other members of Finch's family. However, the title of one poem to Heneage which does survive in the printed collection, 'To Mr F. now Earl of W.' – changed from 'To Daphnis' in the Folger manuscript – would have been easy to decode, and thus would have readily disclosed the author's identity; the climax of the poem is the Muses' horror that Ardelia wants their help in order to praise her husband. Other details – such as the many references to the Thynne family, close relatives of Heneage Finch, and the intimate knowledge of Kent evinced by poems such as 'Fancomb Barn' – also argue against the hypothesis that Finch made any serious attempt to conceal her identity as author. Nor, as already noted, is there any consistent attempt to conceal the poet's Jacobite loyalties. Though the omission of explicitly partisan poems such as the elegies on James II and Lord Dundee tempers the visibility of Finch's Jacobitism, her allegiances are nonetheless clear in poems such as 'The Petition for an Absolute Retreat', with its reference to 'the sad Ardelia' being 'Blasted by a Storm of Fate, / Felt, thro' all the British State' (160–61), and 'A Pindarick Poem Upon the Hurricane', with its claim that the Bishop's mansion at Wells might not have been destroyed if its erstwhile occupant, the non-juring Bishop Ken, had still been in place (96–108).[68] *Miscellany Poems* thus adopts a compromise position in the construction of its author; personal references are muted but not expunged. There is, furthermore, no attempt to conceal the author's sex: even those issues which do not attribute *Miscellany Poems* to Finch all ascribe the volume to 'a lady'.

Miscellany Poems represents a more complex reworking of Finch's previous collections than her previous revising volume, the Folger manuscript. Although the reordering and redistribution of texts from the

[66] McGovern provides the best discussion, to date, of the likely reasons for Finch's change of heart about print-publication (*Anne Finch*, p. 100).

[67] Cameron, 'Anne, Countess of Winchilsea', vol. 1, pp. 160–62. I am also grateful to Maureen Bell for her advice on this point.

[68] *Miscellany Poems*, p. 42; Reynolds, p. 73; *Miscellany Poems*, p. 236; Reynolds, pp. 255–56.

Northamptonshire manuscript in the Folger MS is itself complex, in one key respect it is simple: all but two of the completed poems in the Northamptonshire collection are also included in Folger.[69] The contents of *Miscellany Poems*, by contrast, overlap much less fully with the contents of the Folger manuscript. Of the eighty-six poems in *Miscellany Poems*, only forty-six are inherited from the Folger manuscript, while one – 'A Pindarick Poem Upon the Hurricane' – exists in draft form in the Northamptonshire manuscript but is not in Folger.[70] One play – *The Triumphs of Love and Innocence* – and sixty-four poems included in Folger are omitted from *Miscellany Poems*. Of the thirty-nine new poems in the printed collection, twenty-seven are fables, apparently Finch's preferred genre at this stage of her career.

One aspect of *Miscellany Poems* which differs completely from the preceding manuscript collections is its preliminary matter. All the elaborate prefatory material which Finch had begun in the Northamptonshire manuscript and developed in the Folger manuscript – 'The Introduction', the prose preface, the commendatory poems by Shippen and Randolph – is abandoned in the printed volume. Instead the discursive paratexts to *Miscellany Poems* consist of a letter from 'The Bookseller to the Reader' and one of Finch's new poems, 'Mercury and the Elephant', subtitled 'A Prefatory Fable'. The bookseller's letter, a mere sixty-seven words long, is mainly concerned to identify the author of *Miscellany Poems* with the author of 'The Spleen', though it also insinuates parenthetically that the author, far from instigating the print-publication of the volume, has agreed to it only after prolonged entreaties: '(now that Permission is at last obtained for the Printing this Collection)'.[71] Finch's feminine modesty is thus assured at the outset.

'Mercury and the Elephant' is one of the most curious poems in Finch's oeuvre. Written in the genre most favoured in *Miscellany Poems*, it differs from many of Finch's other fables in that it does not follow a standard literary source such as La Fontaine or L'Estrange. Critics still disagree on

[69] One exception, 'On my Selfe' (NRO, pp. 34–35, Reynolds, pp. 14–15), may have been excluded because of its somewhat self-satisfied overtones; see Wright, 'The Birds and the Poet'. On the second exception, see below.

[70] 'A Pindarick Poem' is an anomalous example which helps to date the Finches' work on the Folger manuscript. Heneage's much-corrected draft of the 'Pindarick' is copied at the end of NRO, outside the main sequence of transcription, and is dated 9 February 1703/4; the hurricane to which it alludes occurred in November 1703. Transcription of the poem into NRO must thus have postdated Heneage's completion of the Folger manuscript in 1701–2. See my 'Manuscript, Print and Politics in Anne Finch's "Upon the Hurricane"', *Studies in Philology* (in press).

[71] *Miscellany Poems*, sig. A2r.

how to interpret the fabular narrative, which ends with an enigmatic rejoinder from Mercury to the Elephant's plea for divine judgement on his behalf.[72] What is clearly significant, however, is the reason for the Elephant's distress and thus his appeal to the gods. As he explains to Mercury, he has been unjustly accused of using unfair means to win a contest with a boar, and while he claims to 'defy the Talk of Men, / Or Voice of Brutes in ev'ry Den' (21–22), he wants to be reassured that the gods, at least, believe in his innocence.[73] The Elephant's predicament is, in effect, a fabular reworking of Finch's long-standing preoccupation with censure and misjudgement, but with two innovative twists. One is that Finch reverses the usual gender positions, with the Elephant, the alleged object of slander, gendered masculine, while the slander he has suffered is attributed to the feminine 'Fame'.[74] The other is that Finch further problematises the issue of judgement by stressing at the outset that Mercury himself is an untrustworthy figure, 'Whose Errands are more Fleet than Good' (2).[75] With the unreliable, impatient Mercury as the sole visible representative of the gods, the Elephant's prospects of gaining an authoritative judgement on his conduct never look good. In the end, the only response he elicits from Mercury is the frustratingly non-committal 'Then have you Fought!' (26).[76]

Finch's answer to the crisis of authority adumbrated by the Elephant's story is robust self-reliance. In the epimyth to 'Mercury and the Elephant', she first clarifies the implications of the fable for herself and her writing. The points at issue, as she explains, are literary reputation and gender:

> Solicitous thus shou'd I be
> For what's said of my Verse and Me;
> Or shou'd my Friends Excuses frame,
> And beg the Criticks not to blame
> (Since from a Female Hand it came)
> Defects in Judgment, or in Wit;
> They'd but reply – Then has she Writ!
> 'Mercury and the Elephant', 27–33[77]

In her manuscript collections, still holding back from print-publication, Finch professed to fear potential critics. In *Miscellany Poems*, criticism of

[72] See, for instance, Charles Hinnant, *The Poetry of Anne Finch: An Essay in Interpretation* (Newark, DE: University of Delaware Press, 1994), pp. 70–73; Jayne Elizabeth Lewis, *The English Fable: Aesop and Literary Culture, 1651–1740* (Cambridge University Press, 1996), pp. 144–46; Backscheider, *Eighteenth-Century Women Poets*, pp. 58–59; and Gavin, 'Critics and Criticism', pp. 650–51.

[73] *Miscellany Poems*, p. 2; Reynolds, p. 3. [74] Compare Hinnant, *Poetry*, p. 71.

[75] *Miscellany Poems*, p. 1; Reynolds, p. 3. [76] *Miscellany Poems*, p. 2; Reynolds, p. 3.

[77] *Miscellany Poems*, pp. 2–3; Reynolds, pp. 3–4.

her work is still evidently a matter of concern: why else would she have chosen to make it the focus of the prefatory 'Mercury and the Elephant'? But the 'Criticks' she imagines seem indifferent rather than actively hostile, though the implied equation with Mercury is hardly to their credit. Even the gender issue is this time raised by the poet's friends rather than her enemies, in order not to condemn her for her weaknesses of judgement or wit but to explain them away. Finch's response, however, is not to try to mollify either friends or critics but to declare indifference to anyone's opinion but her own:

> Our Vanity we more betray,
> In asking what the World will say,
> Than if, in trivial Things like these,
> We wait on the Event with ease;
> Nor make long Prefaces, to show
> What Men are not concern'd to know:
> For still untouch'd how we succeed,
> 'Tis for themselves, not us, they Read;
> Whilst that proceeding to requite,
> We own (who in the Muse delight)
> 'Tis for our Selves, not them, we Write...
> And only to the Press repair,
> To fix our scatter'd Papers there;
> Tho' whilst our Labours are preserv'd,
> The Printers may, indeed, be starv'd.
> 'Mercury and the Elephant', 34–44, 47–50[78]

Finch envisages a set of relationships – or anti-relationships – in which writers, readers and printers all have mutually exclusive interests. Readers read and writers write solely for themselves; poets may benefit from the power of the press to 'fix' their 'scatter'd Papers', but the unwanted volumes that result will reduce their printers to starvation. Finch's comments, as ever, should not be taken wholly at face value; a writer who had overseen two manuscript collections of her writings would have known better than to think that 'scatter'd Papers' could be preserved only by print. The concept of authorial self-sufficiency ("Tis for our Selves, not them, we Write') she articulates so forcefully is also problematic. Whether set against the anxieties expressed in her own previous writings or the importunacy of the Elephant, Finch's professed indifference to critical opinion sounds aspirational rather than descriptive. But if it is aspirational, it is an aspiration which belongs within a world very different from those

[78] *Miscellany Poems*, pp. 3–4; Reynolds, p. 4.

constructed by Finch's earlier manuscript collections. Whereas both the Northamptonshire and the Folger manuscripts locate Finch within a supportive environment where friends and family – above all, Heneage – co-operate to facilitate and appreciate her writing, the world presupposed by 'Mercury and the Elephant' is atomised and alienated, its relationships ranging from the indifferent to the exploitative. There is no Heneage to mediate between the poet and her publisher, and attempts by her friends to intercede on her behalf seem fruitless. In this world of rumour and suspicion, where even the gods cannot be trusted, the poet can prosper only by taking advantage of her printer and writing strictly for her own satisfaction.

The uncertain, suspicious world imagined by Finch in 'Mercury and the Elephant' has a political subtext: it is very much an aristocratic Jacobite's view of the world ushered in by the Revolution of 1688, which had seen both the erosion of traditional relationships and loyalties and the rise of modern commercial capitalism. The anxieties outlined in 'Mercury and the Elephant' are revisited in one of the other fables new to *Miscellany Poems*, 'A Tale of the Miser and the Poet', which more explicitly connects the decline of poetry and its associated virtues with the consolidation of a money-centred national ethos. Mammon, Finch's 'Miser', is discovered digging bags of gold out of an overgrown pit which the naïve Poet initially mistakes for Homer's underworld. He explains that he had hidden the gold during the reign of Charles II, when wit and learning were in fashion, but now that the country's norms have changed and money is properly appreciated he is digging it up again. In support of his claim that the Poet's 'Time is ended, / And Poetry no more befriended' (29–30), he instances the lack of reward received by Prior, Vanbrugh, Nicholas Rowe, John Philips, Philomela (Elizabeth Singer) and Ardelia herself, and even cites the opinion of another poet, Samuel Butler, that the modern world sees 'no Worth in any thing / But so much Money as 'twill bring' (78–79).[79] This displacement of older norms culminates in Mammon's claim that 'Money … only can relieve you / When Fame and Friendship will deceive you' (84–85).[80] The poem ends with the Poet, convinced by Mammon's arguments if not by his values, vowing to bury his own wit in place of the unearthed gold, in the hope that some later age will learn to appreciate poetry again. The application of the moral to Whig capitalism is made

[79] *Miscellany Poems*, pp. 146–49; Reynolds, p. 193. The quotation from Butler (unnamed in the poem) is from *Hudibras*, the second part, canto 1, 465–66.

[80] *Miscellany Poems*, p. 149; Reynolds, pp. 192–93.

clear only in the Poet's bleak concluding line: 'let the Bank out-swell Parnassus' (103).[81] The Bank of England, founded in 1697 to finance the Williamite war effort, was loathed by Jacobites both on this account and as the epitome of Whiggish, money-centred values. Finch's nostalgic Jacobitism is capacious enough to cherish such Whig-identified writers as Vanbrugh, Singer and Philips, but her construction of Whig attitudes, here and elsewhere in *Miscellany Poems*, is uncompromisingly hostile.[82]

Finch's *Miscellany Poems* depicts a polarised world. Jayne Elizabeth Lewis observes that those of Finch's fables which are based on La Fontaine typically heighten the element of confrontation and violence in their originals; they thus refuse any conclusion premised on reconciliation or justice.[83] The confrontations staged in Finch's fables vary from the comic or petty, as in 'The Shepherd Piping to the Fishes', where the fish stubbornly resist all efforts on the Shepherd's part to catch them, to the tragic, as in 'The Battle Between the Rats and the Weazles', which ends with the aristocratic rat officers being fatally trapped by their 'lofty Plumage' (10) while the 'undress'd Vulgar' (16) rats escape.[84] The epimyths are conservative, and, where a contemporary application can be glimpsed, the effect is often to suggest that the current political dispensation indulges the worst aspects of human nature. Thus 'Democritus and his Neighbours' begins 'In Vulgar Minds what Errors do arise!' (1), describes how the foolish neighbours misinterpret Democritus's scholarly habits as evidence of madness, and ends by deploying such ignorance as a counterargument to those (by implication, Whigs) who 'to promote some Int'rest, wou'd define / The Peoples Voice to be the Voice Divine' (72–73).[85] For Finch, the ignorance and folly of vulgar minds set them firmly apart from 'the Learn'd and Wise' (4), and is apparently ineradicable. Significantly, Hippocrates, called in to diagnose Democritus's condition, pities him as 'a Man of Sense, judg'd by a Croud of Fools' (70), but makes no attempt to persuade the neighbours of their error.

Many of Finch's fables, including 'Democritus and his Neighbours', turn on issues of judgement. Democritus is misjudged by his foolish neighbours but correctly understood by the wise Hippocrates, despite the superficial eccentricity of his habits. Mammon, in 'The Tale of the Miser and the Poet', stands for a whole society in which poetic and moral

[81] *Miscellany Poems*, p. 150; Reynolds, p. 194.
[82] On this point see also Backscheider, *Eighteenth-Century Women Poets*, pp. 46–47.
[83] Lewis, *The English Fable*, p. 138. [84] *Miscellany Poems*, p. 284; Reynolds, p. 207.
[85] *Miscellany Poems*, pp. 285, 288; Reynolds, pp. 208, 210.

values are systematically misjudged and inverted. This concern with judgement in the fables is often expressed in relation to those familiar preoccupations of Finch's poetry: censure, slander and reputation. The topsy-turvy judgements of Mammon's world are epitomised by the low repute now enjoyed by poets of all complexions: Whig and Tory, male and female. 'The King and the Shepherd' centres on the persistent attempts by 'Whisp'rers' (48) and 'Sycophants' (56) to poison the King's mind against a virtuous Shepherd he has raised up to govern the country.[86] There are tragic consequences in 'The Owl Describing her Young Ones' as the Owl inadvertently condemns her own chicks to death by misjudging her description of them to the Eagle. Finch's unsentimental epimyth construes the Eagle's attack on the owlets as a form of censure, and likens their fate to the desperate consequences suffered by over-praised books:

> Faces or Books, beyond their Worth extoll'd,
> Are censur'd most, and thus to pieces pull'd.
> 'The Owl Describing her Young Ones', 76–77[87]

The topic of literary judgement is also addressed in Finch's metafable, 'The Critic and the Writer of Fables'. Here, however, Finch is concerned not only with the role of critics in the reception of literary texts but also with their self-appointed role in determining literary production. The titular Critic denounces in turn each of the genres the writer proposes to practise – fables ('childish', 13), epic translations or imitations ('Bombast', 28) and love poetry ('insipid', 41) – reserving his approbation only for the inherently censorious genre of satire.[88] Whereas the Writer holds to the traditional view that poetry should 'Teach' and 'Divert' (8) (as well as to the affective view that it dispels the poet's cares), the Critic and his fellows are prepared only to praise poetry which is malicious and can be slanderously misapplied:

> We'll praise the Weapon, as we like the Stroke,
> And warmly sympathizing with the Spite
> Apply to Thousands, what of One you write.
> 'The Critic and the Writer of Fables', 48–50[89]

[86] *Miscellany Poems*, p. 169; Reynolds, p. 163. [87] *Miscellany Poems*, p. 108; Reynolds, p. 181.

[88] *Miscellany Poems*, pp. 163–65; Reynolds, pp. 153–55. The fable-writer's description of epic-based poetry (26) quotes Dryden's translation of the *Aeneid* (*The Works of John Dryden*, vol. 5, ed. by William Frost and Vinton A. Dearing (Berkeley, CA: University of California Press, 1987), p. 392, 2.436).

[89] *Miscellany Poems*, p. 165, Reynolds, p. 155.

The 'harmless Fable-writer' (52) is left protesting at the impoverished view of poetry implied by these self-serving critical standards. Her own steadfast adherence to more liberal poetic ambitions – like the Poet's refusal to connive in Mammon's values – is in self-conscious opposition to the prevailing norms of a misjudging age.

The fables in *Miscellany Poems* construct a world where judgement is unreliable, reputation is fragile, and authority is either weak or untrustworthy. Set against this, however, are the several poems – fewer, but an unignorable presence in the volume – in which Finch alludes gracefully to the virtues or achievements of her friends or relatives. These include not only poems such as 'On the Marriage of Edward and Elizabeth Herbert' or 'On the Birth-day of Lady Catherine Tufton', where the personal application is made clear in the title, but also poems such as 'The Petition for an Absolute Retreat' and 'A Nocturnal Reverie', where a few lines of personal reference are embedded within a longer, less obviously localised text. In contrast with the genuinely intimate poems in the Northamptonshire and Folger manuscripts (such as those to Heneage or to Finch's sister Dorothy), those in the printed volume are more properly identifiable as public private poems. With one exception ('To Mr F. now Earl of W.'), they concern people and places one step beyond Finch's immediate family, and their principal function in the volume is apparently to articulate compliments and assert a community of friendship. (The omission of 'Upon my Lord Winchilsea's Converting the Mount', extant in Folger and openly critical of Heneage's father, is thus doubly significant.)[90] As such, they stand in an ironic relationship with the atomised, commercially driven environment imagined in 'Mercury and the Elephant'. Much as, in the Folger manuscript, 'The Circuit of Apollo' admits to a debt to Aphra Behn that the introductory paratexts to the collection had eschewed, these personal references in the main body of *Miscellany Poems* speak of a supportive community unacknowledged in Finch's prefatory fable – or in the fables elsewhere in the volume.

Finch's depiction of a supportive community in *Miscellany Poems* serves several purposes. First, although *literary* community is not foregrounded in *Miscellany Poems* as it had been in either the Northamptonshire or the Folger manuscripts, it is nonetheless presupposed in many of these poems. Finch acts as poetic celebrant to the Herberts and Catherine Tufton; she

[90] On the critique of Heneage's father in 'Upon my Lord Winchilsea's Converting the Mount', see Nicolle Jordan, '"Where Power Is Absolute": Royalist Politics and the Improved Landscape in a Poem by Anne Finch, Countess of Winchilsea', *Eighteenth Century*, 46.3 (2005), 255–75.

elegises James Thynne; she responds with playful respect 'To Edward Jenkinson, Esq; a very young Gentleman, who writ a Poem on Peace'. While there is less emphasis than in the manuscripts on Finch's community as an appreciative readership for her poetry, its role in occasioning and stimulating her writing is still apparent.

But a second, more important purpose is social. Finch's variously helpful and admirable friends are clearly marked as members of the nobility or aristocracy: they are earls and countesses, Herberts and Thynnes, denizens of famous country houses such as Longleat. In a country shaped (for the worse, in Finch's view) by Whiggish pandering to the ignorant lower classes, it is the Jacobite upper classes alone who uphold traditional loyalties and values and who display the fine moral and aesthetic judgement that Finch finds lacking in the wider world.[91] 'A Description of One of the Pieces of Tapistry at Long-Leat', for instance, praises Henry Thynne as the one person truly capable of analysing Raphael's depiction of a Biblical scene. The idealisation of James Thynne as a model of young manhood is perhaps no more than is appropriate to the genre of elegy, but the qualities for which she praises him – piety, bravery, generosity, attention to duty and faithfulness to his friends – testify eloquently to the values that Finch herself wanted to advocate. Female virtue is variously represented by James Thynne's collateral ancestor, Lady Pakington, who is praised for both writing and concealing her authorship of the famous devotional handbook *The Whole Duty of Man*, and by the Countess of Salisbury, whose 'perfect Charms, and perfect Virtue' enable her to outshine those 'trivial Beauties' who look their best only at certain times of day.[92]

But friendship and female virtue play their most dramatic role in *Miscellany Poems* through the figure of Arminda in 'The Petition for an Absolute Retreat'. The 'Petition' is notable for including one of the few allusions in *Miscellany Poems* to Heneage Finch, who is described as 'A Partner suited to my Mind' (106) and whose company Finch judges essential to her happiness in her retired ideal.[93] But it is Arminda (identified in Finch's headnote to the poem as the Countess of Thanet) who revives and comforts Ardelia when she is 'Blasted' (160) by the shock of the

[91] Compare Susan Staves, *A Literary History of Women's Writing in Britain, 1660–1789* (Cambridge University Press, 2006), p. 139.

[92] *Miscellany Poems*, p.158; Reynolds, p. 57 ('On the death of the Honourable Mr James Thynne', 41); *Miscellany Poems*, pp. 292, 291; Reynolds, p. 269 ('A Nocturnal Reverie', 20, 18). *The Whole Duty of Man*, published anonymously, is now more generally attributed to Richard Allestree.

[93] *Miscellany Poems*, p. 39; Reynolds, p. 72.

Williamite Revolution – a shock so great that it penetrates even the retired ideal celebrated in the 'Petition'. Finch describes Arminda as a friend sent by heaven, and specifies her 'wise Discourse' (168) and 'Wit' (174) as the means by which she effects her rescue of Ardelia.[94] The idealised and uniquely powerful friendship between Arminda and Ardelia combines love, wisdom, language and judgement, and is premised both on divine authority and Jacobite fidelity. For Finch, women's friendship is at its most potent when it is inspired by heaven and rests on shared political convictions.

Retirement poetry – the genre to which 'The Petition for an Absolute Retreat' belongs – does not loom as large in *Miscellany Poems* as it does in Katherine Philips's *Poems*, or even in Finch's manuscript collections. Where it does appear, however, it is significant. 'The Petition for an Absolute Retreat' is a comparatively rare example of a retirement poem which survives from the Folger manuscript (relatively unaltered) into the printed volume. The longest poem in Finch's surviving oeuvre, it is, as the title indicates, a plea. The 'sweet, but absolute Retreat' (3) which the speaker describes at such loving length is located firmly in the realms of the ideal; it is a gift which 'indulgent Fate' (1) has not yet been persuaded to bestow. Even the linguistic construction of the 'absolute Retreat' in the course of the poem is repeatedly interrupted by recollections of the turbulent outside world: most dramatically through the intrusion of the Williamite revolution (159–81), but also through a series of allusions to distressed, violent or morally suspect characters: the biblical David (182–91) and the Romans Crassus (206–37) and Sertorius (238–57). The peroration to the poem is unable to forget 'th'Ambitious ... the giddy Fool ... the Epicure' (286, 287, 288).[95]

For Finch, physical retirement and the stoical self-reliance that it facilitates are a vexed but important ideal. Quite how important they are to *Miscellany Poems* is indicated by the way in which Finch chooses to end the collection. The final poem in the volume is 'A Nocturnal Reverie', another retirement lyric and one of the thirty-nine new poems in *Miscellany Poems*. 'A Nocturnal Reverie' is a technical tour de force, its fifty lines a single, carefully worked sentence describing a rural walk 'In such a Night'. The main verb clause is deferred until line 47, and is then another plea: 'In such a Night let Me abroad remain'.[96] The dreamy, night-time

[94] *Miscellany Poems*, pp. 42–43; Reynolds, pp. 73–74.
[95] *Miscellany Poems*, pp. 33–49; Reynolds, pp. 68–77.
[96] *Miscellany Poems*, p. 293; Reynolds, p. 270.

idyll constructed by 'A Nocturnal Reverie' is thus temporally ambiguous: even after the deferred verb is at last reached, it is never entirely clear whether the speaker's night-time ramblings are to be thought of as 'real' or wholly imagined. (This contrasts with the 'Cares ... Toils... Clamours' and even 'Pleasures' of the final couplet, each located in an all too certainly anticipated future.) Yet however tenuous the rural ideal may be, it is clearly important to Finch to reassert it. The factual status of the speaker's walk may be unclear, but its power to inspire and calm the uneasy soul is certain:

> But silent Musings urge the Mind to seek
> Something, too high for Syllables to speak;
> Till the free Soul to a compos'dness charm'd,
> Finding the Elements of Rage disarm'd,
> O'er all below a solemn Quiet grown,
> Joys in th'inferiour World, and thinks it like her Own:
> 'A Nocturnal Reverie', 41–46[97]

'A Nocturnal Reverie' holds out the beguiling prospect that even the troubled poet of *Miscellany Poems* may be able, 'In such a Night', to find peace. But *Miscellany Poems* does not end with the ambivalent comfort of 'A Nocturnal Reverie' but rather with Finch's one published play, *Aristomenes*. Locating dramatic texts at the end of a collection seems to have been established practice for Finch: *The Triumphs of Love and Innocence* and *Aristomenes* had been transcribed at the end of the original draft of the Folger manuscript, probably in imitation of Katherine Philips's 1667 *Poems*. Less easy to explain, however, is why Finch chose to include only *Aristomenes* and not *Triumphs* in her printed collection. *Triumphs* has sometimes been seen as a less accomplished work than *Aristomenes* – Cameron, still more damning, dismissed both plays as 'fairly poor, especially the first' – but recent criticism has tended to take a more favourable view.[98] McGovern praises *Triumphs* for the authenticity of its court scenes and the characterisation of the female roles, while Straznicky describes the play as 'packed with incident and written in a suitably elegant, heroic verse' and also commends its dramatic qualities ('the pace is unrelenting, the structure is tight, and there is an overall coherence of moral sentiment').[99] But why, if not on grounds of quality, should Finch have wanted to omit *Triumphs* from *Miscellany Poems*, while including *Aristomenes*? The answer,

[97] *Miscellany Poems*, p. 293; Reynolds, pp. 269–70.
[98] Cameron, 'Anne, Countess of Winchilsea', vol. 2, Chapter 13, n. 31.
[99] McGovern, *Anne Finch*, p. 54; Straznicky, *Privacy*, p. 92.

as so often with Finch, is likely to be a matter of genre. Both *Triumphs* and *Aristomenes* are dramas of love and political conflict, where the affections of men and women play out against, and sometimes interact with, momentous issues of national sovereignty. But *Triumphs* is a tragicomedy, *Aristomenes* a tragedy. *Triumphs*, as the title suggests, ends happily, with the restoration of all rightful rulers and marriages between the youthful lovers. *Aristomenes*, however, ends bleakly, with the eponymous hero restored to his lost throne but heartbroken at the death of his son and heir. Though the restoration of Aristomenes may represent a rare moment of wish-fulfilment for the Jacobite Finch, her emphasis in the final lines of the play is far from triumphalist. Instead, the bereaved Aristomenes, dissuaded with difficulty from committing suicide, recommits himself to duty by vowing 'Fortitude in Ills, and brave Submission' (V.i.399).[100] While the play thus offers a glimpse of the political ideal – the restoration of the just ruler – it also provides a model for how to cope with troubled times, political disappointment and personal grief. For Finch, no better conclusion to *Miscellany Poems* could have been imagined.

THE WELLESLEY MANUSCRIPT, JACOBITISM AND THE JUDGEMENT OF GOD

Miscellany Poems marks a definitive break in Finch's poetic career. Before this point, the compilation of revised collections of Finch's poetry had always involved a painstaking process of selecting and reworking old materials, as well as a judicious recombination of old and new. A clear if intricate paper trail links the Northamptonshire and the Folger collections and both earlier manuscripts with the printed *Miscellany Poems*. After the publication of *Miscellany Poems*, however, this pattern changes; the process of reworking ceases. Even the eight poems by Finch scattered through Pope's 1717 *Poems on Several Occasions* comprise entirely new material, not to be found in any pre-existing print or manuscript source.[101] Similarly the fifty-three poems transcribed in the Wellesley manuscript, as already noted, include no items which had previously been collected in manuscript or print, with the single exception of 'To Mr Pope'.[102]

[100] *Miscellany Poems*, p. 389, Reynolds, p. 409.

[101] The non-duplication of pre-existing material is curiously emphasised by the fact that 'The Fall of Caesar' (*POSO*, p. 228) has the same subject, metre and number of lines as her 'Caesar and Brutus', included in both NRO and Folger, but has been completely rewritten.

[102] On the partial exception of 'On Absence', see above, footnote 31. One poem ('To the Right Honourable the Lord Viscount Hatton') has been copied twice.

It is tempting to suppose that Finch, like so many book historians after her, associated fixity with print, and saw the published *Miscellany Poems* as having produced the definitive version of her early to mid-career poems. But this assumption could apply only if it were certain that Finch herself was directly responsible for the choice of materials in the Wellesley manuscript. In fact, the only – somewhat dubious – evidence for Finch's direct involvement with the Wellesley MS is a note on the outer back cover, 'for transcribing my poems' – possibly but not certainly in the poet's own hand.[103] While it is possible that Finch had a role in planning the compilation of the Wellesley manuscript before her death, it seems more likely that Heneage – whose role as editor and scribe in the manuscript is indisputable – made the decision not to duplicate materials from other collections. However, if this 'repository' explanation for the existence of the Wellesley manuscript is correct, the logical corollary is to see Finch herself as having an indirect role in determining the contents of this posthumous collection. Several of the poems in the Wellesley manuscript – including 'Upon an impropable undertaking', 'A Letter to the Honourable Lady Worseley' and 'An Apology for my fearfull temper' – clearly predate 1713, and must thus have been deliberately excluded from *Miscellany Poems*. A number of the undatable poems in the volume may also represent pre-1713 work. Finch's decisions about what she wanted to include and not include in the public-facing *Miscellany Poems* would thus have contributed towards the effect created by the posthumous Wellesley manuscript. Wellesley itself should be understood not simply as a record of Finch's poetic activity in the last seven years of her life but as the principal manuscript witness to her writing after the completion of the Folger manuscript, complementing *Miscellany Poems* and *Poems on Several Occasions*.

Previous accounts of the Wellesley manuscript have tended to emphasise its Jacobitism – which is sometimes, in turn, suggested as the reason why the poems were not published.[104] In fact, as I have stressed, all of Finch's collections – print and manuscript alike – are Jacobite, albeit to varying degrees. One question, however, which is rarely asked of Finch is what kind of Jacobite she was.[105] Finch's political sentiments seem to have

[103] *IELM*, p. 539.

[104] Most influentially, McGovern's and Hinnant's introduction to their edition of the manuscript (pp. xviii–xxiii).

[105] The few exceptions include Hinnant, *Poetry*, p. 256, and Claire Pickard, 'Literary Jacobitism: the Writing of Jane Barker, Mary Caesar and Anne Finch' (unpublished doctoral thesis, University of Oxford, 2006).

been remarkably consistent throughout the thirty-two years that elapsed between the deposition of James II in 1688 and her own death in 1720. From first to last, Finch's Jacobitism is personal, nostalgic, pessimistic and non-revolutionary. Premised on the poet's emotional attachment and fidelity to James and Mary of Modena, it thrives on reproaching her fellow-countrymen for ingratitude and disloyalty, but is conspicuously loath to entertain any possibility of political redress or redemption. In only a few of her poems does she so much as contemplate the restoration of the House of Stuart, and even in these few instances she is consistently and notably reluctant to look to James and Mary's son – the putative James III – as a plausible future king of England. One might, for instance, have expected Finch's elegies on either James or Mary to end by hailing the young James as a potential Jacobite saviour: a means through which the true Stuart line might yet be returned to power. But 'On the Death of the Queen' makes no attempt to envisage a political resolution of Mary of Modena's misfortunes, while in 'Upon the Death of King James the Second', Finch confines herself to the loyal but vague hope that in some unspecified future Britain may achieve 'lasting Peace' through the rule of 'Rightfull Kings' (159).[106] 'Rightfull' – the revised reading of the Folger manuscript – is, as Carol Barash points out, a more overtly Jacobite statement than the 'Happier' of the printed elegy (and the original reading in Folger); but this is, nonetheless, a Jacobitism which shies away from imagining the means through which the wrongs of the past might be redressed.[107] Even *Aristomenes*, Finch's most fully realised piece of Jacobite wish-fulfilment, imagines political rehabilitation through the restoration of the father, not the son, and refuses straightforward triumphalism by following the restoration of Aristomenes with the murder of his son Aristor.

The closest Finch ever comes to envisaging the accession of James III is in the conclusion to her poem 'Upon an impropable undertaking'. A Wellesley poem, 'Upon an impropable undertaking' was presumably written soon after the death of William III, to which it unmistakably refers.[108] The poem describes how, after 'A tree the fairest in the wood' (1) is torn up by a tempest, the 'tenants of the Land' (9) attempt to supply the gap by planting another tree in its place. For a while, all seems to be well,

[106] Folger MS, p. 304, Reynolds, p. 91. [107] Barash, *English Women's Poetry*, pp. 266–67.
[108] Wellesley MS, pp. 81–82, McGovern and Hinnant, pp. 45–46. Though McGovern and Hinnant (understandably) correct 'impropable' to 'improbable', it is likely that the pun on the unpropped tree is intentional.

but over time – 'which all discovery brings / Distinguishing 'twixt knaves and Kings' (21–22) – the second tree withers, dries and is flung into the air. From the Northamptonshire manuscript onwards, a noble tree is one of Finch's favourite symbols for the Stuart monarchy: most obviously in 'The Tree' (NRO, Folger, *Miscellany Poems*), but also in 'The Petition for an Absolute Retreat' (Folger, *Miscellany Poems*). In 'Upon an impropable undertaking' the first tree, an oak, clearly represents the deposed James II, while its impostrous replacement – tended by the tenants to their own disadvantage; maintained only by 'cost and art / Since nature in it had no part' (29–30) – is evidently the usurping William. At the end of the poem, a sympathetic onlooker – a Jacobite counterpart to the 'friend' whose wise advice resolves so many of George Herbert's poems – admonishes the tenants for ever supposing that such a rootless, branchless 'Timber' (39) could substitute for the 'stable reign' (40) they had lost. Yet the onlooker's speech concludes on what appears at first to be a note of mild optimism:

> But yet if you'd successfull be
> A Scyon from the home-bred tree
> May grow in time to fill the place
> And Royal Oaks be of his race.
> 'Upon an impropable undertaking', 41–44

This 'Scyon', though unnamed, is most probably the young James Stuart: just thirteen years old at the time of William's death, but with the potential to grow into a true royal oak, the rightful successor to his father. Yet the moderate optimism of these lines is overtly speculative – '*May* grow in time' (my emphasis) – and is swiftly countered by the 'Application' which follows:

> Your project seems as wild as this
> Then 'twere not strange if it shou'd miss
> But if you wou'd that fate prevent
> With solid maxims be content.
> 'Upon an impropable undertaking', 46–49

Though these lines are cryptic, the obvious possibility is that the 'project' of line 46 alludes to Jacobite plans to restore James to his father's throne by military force. Whatever the exact allusion, Finch evidently has no time for such 'wild' proposals, which in her view are all too likely to fail. Instead, her attitude is strictly quietist. Rather than pursuing such madcap plans, her addressee should take comfort in 'solid maxims' – philosophical reflection and detachment. Finch's nostalgic Jacobitism, though often sharply worded and undoubtedly sincere, admits no place

for violent action.[109] It is a Jacobitism which, while underpinning Finch's creative agency, allows no place for political agency.

There is no need to invoke Finch's Jacobitism to explain why she – or Heneage, after her death – did not choose to publish the poems of the Wellesley manuscript. In contrast with the Northamptonshire and Folger manuscripts, where Finch's fascination with and vexed attraction towards the possibility of print-publication are all too apparent, the subject of print and public readership is barely addressed in the poems of the Wellesley manuscript. Since the volume includes no prefatory material – the first poem, 'On Lady Cartret', lacks any introductory function – there are no obvious clues to what, if anything, Finch herself planned to do with these otherwise uncollected poems from the final two decades of her life. Even at this late stage, print-publication was by no means an inevitable course of action for her, and at least some of the contents of the Wellesley manuscript seem much more suited to manuscript than to print. Of the fifty-three poems by Finch in the Wellesley manuscript, twenty-three are addressed to or take as subjects close friends or family, such as Catherine Fleming, the Countess of Hertford, Alexander Pope and the Lord Viscount Hatton. The exchange of social compliments (in the case of Hertford and Hatton) or even of poems (in the case of Fleming and Pope) would have been adequately satisfied through manuscript circulation, with no need for print.

Much about Finch's engagement with the world of print-publication remains unclear. We still do not know why, after more than two decades of ostentatious self-denial, she chose to publish *Miscellany Poems* in 1713. However, it is evident from her subsequent willingness to countenance the publication of so many of her poems in *Poems on Several Occasions* – under her own name, and with her contribution to the volume highlighted on the title page – that she did not simply turn away from print-publication in the last few years of her life. It may be that Finch did hope to arrange a second printed collection of her poetry, but was unable to find a publisher. As Cameron points out, the several variant title pages in the surviving copies of *Miscellany Poems* provide compelling if circumstantial evidence that the volume sold badly (an ironic fulfilment of Finch's own prediction in 'Mercury and the Elephant') and had to be passed from bookseller to bookseller in an attempt to stimulate sales.[110] Alternatively, it

[109] Even in 'An Invitation to Dafnis', Ardelia distracts her husband not from *real* battles against William of Orange, but merely from studying the battle-plans of others.

[110] Cameron, 'Anne, Countess of Winchilsea', vol. 1, pp. 161–62.

may be that Finch simply did not produce enough new poems between 1713 and 1720 to warrant a second printed collection. The contents of the Wellesley manuscript – even eked out by the eight additional poems from *Poems on Several Occasions* – would have made for a very slim volume, even if all of them had been deemed suitable for publication. We cannot, therefore, assume that either Finch or Heneage *decided* not to publish the Wellesley poems; there are too many other, equally plausible, possibilities.

In creating the Wellesley manuscript as a repository for his wife's otherwise uncollected poems, Heneage was also, of course, creating a memorial for her. By preserving poems such as 'A Ballad to Mrs Catherine Fleming', 'After drawing a twelf cake at the Honourable Mrs Thynne's' and 'The white mouses petition to Lamira', Heneage ensured that his wife would be remembered not only for her poetic skills in many genres, but also for her friendships, her social connections and her wit. The inclusion in the volume of 'Upon an improbable undertaking', as well as the elegies on Mary of Modena and Colonel Bagot (formerly a Groom of the Bedchamber to James II) and the fable 'Moderation or the Wolves and the sheep', memorialises her Jacobite sympathies. The many devotional poems in the collection – several on liturgical subjects – also witness both to the strength of Finch's personal faith and also to her steadfast adherence to Anglican forms of worship. Her affectionate poem to Heneage's chaplain, Hilkiah Bedford, indirectly testifies to their shared allegiance to the non-juring cause.

Religious poetry, always important within Finch's creative life, is especially prominent at both the beginning and the end of her poetic career. The Wellesley manuscript ends, as the Northamptonshire manuscript had begun, with a series of Finch's religious poems. Fifteen out of the last twenty, and all of the last nine, of the poems in the Wellesley manuscript are on religious subjects.[111] Strongly individualistic, these poems focus on the speaker's own experience of God's mercy, her thankfulness to the Almighty, and her anticipation of the Christian afterlife. In contrast to the retirement lyrics in *Miscellany Poems*, which locate happiness, however problematically, in withdrawal from the world, the religious poems in the Wellesley manuscript include meditations on how to live well *within* the human world, as well as contemplative poems which yearn for the joy and

[111] This is to count as one item both the uncorrected and the corrected copies of her (non-religious) poem to Viscount Hatton (Wellesley MS, pp. 105–07 and 115–17; McGovern and Hinnant, pp. 86–88 and 99–102).

peace of heaven – albeit in terms which remain acutely conscious of the sin and imperfection of human life.[112] Thus Finch's meditation on Matthew 25:40 ('for as much as ye did it unto the least of these my Brethren ye did it unto me') illustrates the responsibilities of the rich towards the poor, while 'A Suplication for the joys of Heaven' looks forward to the 'perfections' which await the speaker's soul in the 'Superior World', once freed from the 'weakness' and 'degrading crime' of earthly life (38, 1, 34).[113] Finch's vision of the afterlife even admits a role for her own 'low Poetick tendency', which she foresees being so 'rais'd' by heavenly glory that her celestial 'numbers' will outshine even Dryden's 'St Cecilia' – apparently her ideal of the most sublime earthly poetry ('A Suplication', 43–50). While Wellesley lacks the prefatory statements of ambition to be found in Finch's earlier manuscripts, this translocation of Finch's creative aspirations to the heavenly kingdom is possibly the boldest claim she ever makes for her own poetry – however hedged around with modest acknowledgements of the divine power which alone can raise her to such heights of eloquence. Even towards the end of her poetic career, Finch's competitive instincts were apparently undiminished.

But 'A Suplication' and the other religious poems in the concluding section of the Wellesley manuscript do not straightforwardly represent the end of Finch's poetic career. The five dated items in this grouping – 'A Suplication', 'On these Words Thou hast hedg'd in my way with thorns', 'An Ode Written upon Christmasse Eve', 'Written after a violent and dagerous fitt of sicknesse' and 'A Prayer for Salvation' – are ascribed, respectively, to 6 February 1717/18, 22 March 1715, 24 December 1714, 'the Year 1715' and 23 September 1716.[114] Even the latest of these poems, 'A Suplication', chronologically precedes at least three other, more secular poems in the manuscript: 'To His Excellency the Lord Cartret at Stockholm' (13 January 1719/20), 'On the Death of the Queen' (which must postdate Mary of Modena's death in April/May 1718) and 'An Epistle to Mrs Catherine Fleming at Coleshill' (18 October 1718).[115] Given the many undatable religious poems in the Wellesley manuscript, the evidence of the relatively few dated items must be treated with caution; however, insofar as these poems can be linked with any specific period of

[112] This distinction between Finch's meditative and contemplative poems follows McGovern and Hinnant, and is ultimately based on Louis Martz's taxonomy of seventeenth-century religious poetry in *The Poetry of Meditation* (New Haven, CT: Yale University Press, 1962). See McGovern and Hinnant, pp. xxv–xxxi.

[113] Wellesley MS, pp. 125–27, 108; McGovern and Hinnant, pp. 114–17, 90, 89.

[114] Wellesley MS, pp. 108–09, 127–33, 134–38, 139–40, 141–42; McGovern and Hinnant, pp. 89–91, 118–24, 126–30, 131–33, 135–36.

[115] Wellesley MS, pp. 66–67, 68–71, 79–81; McGovern and Hinnant, pp. 23–24, 25–29, 42–44.

Finch's life, it is not with the very end but rather with the two years following her serious illness in 1715 (to which a poem transcribed earlier in the manuscript, 'An Hymn of Thanksgiving', also refers).[116] The positioning of these poems at the end of the manuscript cannot, in other words, be taken at face value as witness to the religious preoccupations of Finch's final years. The devotional conclusion thus constructed for her writing career is, instead, the product of posthumous editing.

As a grouping, the religious poems which bring the Wellesley manuscript to a close are more of a cluster than a sequence. Collectively, they testify to a poetic versatility which encompasses the meditative and the contemplative, the worldly and the other-worldly, the sombre and the ironic, and the personal and the public, as well as a range of metres and genres from trimeter and pentameter couplets to regular and irregular stanzaic forms, prayers, paraphrases and dramatic dialogues. What they do not do, however, is offer any kind of narrative, either of Finch's own, or of a model, spiritual progression towards death. For the most part, there seems to be no ordering principle – whether chronological or devotional – underlying the exact arrangement of these concluding poems. The one exception is the very last poem in the manuscript, 'A Contemplation'.[117]

As a conclusion to Finch's forty-year poetic career, 'A Contemplation' could hardly have been bettered. The poem begins – rarely, for the Wellesley manuscript – with a reference to 'Ambition', which, the speaker suggests, cannot be 'a fault / If plac'd above the Sky' (3–4). Subsequent stanzas of the poem continue to revisit many of Finch's familiar preoccupations, looking forward, in each case, to the resolution in heaven of the sorrows and injustices which have troubled her on earth. In heaven, she anticipates, there will be no usurpation or theft (15–16), no sorrow, tears, sighs, decay or sickness (17–24) and no hypocrisy (53–56). The martyrdom of Charles I will be revered as it deserves – audaciously, Finch conflates Charles's crown with that of the crucified Christ (45–46) – while the injuries suffered by Finch's own family and friends will also be redressed. Heneage – the 'Lord to whom my life is joyn'd' (49) – will 'full retribution find' (51), while one of her women friends, 'Coventry of Tufton's line', will receive due recognition for her virtue, charity and generous support for overseas evangelism (65–80). Finch's satirical instincts also make a brief but telling reappearance in the penultimate stanza, as she illustrates the human

[116] 'An Hymn of Thanksgiving after a dangerous fit of sickness in the year 1715' (Wellesley MS, pp. 76–78; McGovern and Hinnant, pp. 37–39).
[117] Wellesley MS, pp. 143–46; McGovern and Hinnant, pp. 138–41.

tendency to misuse money by citing the destruction of 'Woolsey's Pallace' and the expensively unfinished work on Marlborough's Blenheim (91–92).[118]

So effective is 'A Contemplation' in recalling and addressing Finch's recurring poetic concerns – ambition, injustice, family, friendship, royalist and Jacobite politics, human vices and virtues – that there is scope to wonder whether this was in fact deliberate, on Finch's part as well as her editor's. Conceivably, though against the pattern of the Wellesley poems, 'A Contemplation' may have been drafted by Finch in order to fulfil a planned role – in this case, recapitulation and summation – in a final collection of her poetry. Though this is possible, the disproportionate attention paid by the poem to Lady Coventry – praise of whom occupies twenty of its ninety-six lines – makes it more likely that the key motivation behind 'A Contemplation' was complimentary rather than summative.[119] That it serves so effectively as a concluding statement on Finch's poetic career is due not only to its deft recapitulation of so many of her personal and political anxieties, but also to the mode of resolution that the poem so eagerly anticipates. Although 'A Contemplation' includes visions of Christ as both the Lamb of God and the Son of Man (27, 44), the poem as a whole lays less emphasis on the presence of God than on the just dispensation that the divine presence will secure. Finch, so often exercised about the false judgements and undeserved censures suffered by the worthy while on earth, seems to see the redress of such wrongs as the chief joy that heaven will afford. In Finch's heaven, at long last, the corrupt judgement of men will be superseded by the absolute and indisputable judgement of God.

The Wellesley manuscript, the final collection of Anne Finch's poems, ends in irony. As we have seen, Finch's poetry – from her earliest compilation, the Northamptonshire manuscript, onwards – is persistently but problematically preoccupied with issues of agency. In the early manuscripts and *Miscellany Poems*, Finch's strong sense of herself as a creative agent and her evident pleasure in writing are repeatedly threatened by worries about readership and reception. A general anxiety about critical censure is compounded by fear of the particular opprobrium she may suffer as a female poet, as well as by her deep mistrust of the literary and political values of a post-Revolutionary age. In political terms, the two poetic collections completed during her lifetime both end elegiacally: the Folger manuscript with the death of James II,

[118] 'Woolsey's Pallace' may denote either Hampton Court, extensively remodelled during Finch's lifetime, or Whitehall, formerly Wolsey's York Place, destroyed by fire in 1698.

[119] If McGovern and Hinnant are correct to identify 'Coventry of Tufton's line' with Lady Margaret Tufton (pp. 193–94), then the poem presumably predates Tufton's death in 1710.

Miscellany Poems with the murder of Aristor. By contrast, the Wellesley manuscript ends with hope. As the final stanza of 'A Contemplation' insists, the heavenly resolution it anticipates for Finch's personal, political and even literary wrongs is no mere abstract consolation; the promise of other-worldly comforts also offers strength and support in the present world:

> Whilst to this Heav'n my Soul Aspires
> All Suff'rings here are light
> He travells pleas'd who but desires
> A Sweet Repose at Night
>> 'A Contemplation', 93–96

Yet the sense of hope with which the Wellesley manuscript – and thus Finch's entire poetic oeuvre – is brought to a close is multiply paradoxical. The political redemption it anticipates, though royalist, is not Jacobite; it is Charles I, not his son James, whose crown Finch conflates with Christ's. Furthermore, the vindication of the Stuart monarchy anticipated in 'A Contemplation' is deferred until the afterlife and is then achieved through divine, not human, agency. The most, it seems, any Stuart can do to vindicate his cause is to die a martyr's death. If any living person is responsible for the redemption of the Stuarts in 'A Contemplation' it is the poet herself, and it is fully consistent with the well-established patterns of Finch's poetry that the redemption she anticipates is not political Restoration but heavenly restitution. More unexpectedly, Finch is also the only person whom the poem depicts as finding happiness before as well as after death: a happiness secured by her own visionary creativity. It is Finch's own poetic construction of the 'Sweet Repose' of heaven which, she believes, will empower her to 'travel ... pleas'd' through the inescapable 'Suff'rings' of earthly life. Where war and politics have failed, poetry can succeed.

But there is one final irony in the hopeful conclusion to the Wellesley manuscript. The only one of Finch's four poetic compilations to end on an optimistic note is also the only one which envisages no public readership for her poetry and whose conclusion she did not live to oversee. It is difficult to imagine Finch – intellectually restless, politically suspicious, unstoppably creative – being quieted for long by the soothing promises of 'A Contemplation'. The beautiful but somewhat improbable culmination of her writing career in 'Sweet Repose' is not her own doing, but stems rather from the husbandly piety of Heneage Finch. In the privacy of the Wellesley manuscript, Heneage constructs a redemptive conclusion not only for the Stuarts but also for his wife. The personal and political consolation thus created is due not to Anne Finch's agency but rather to her absence.

CHAPTER 5

Publishing Marinda: *Robert Molesworth,*
Mary Monck and Caroline of Ansbach

In 1716 the firm of Jacob Tonson, the most distinguished literary booksellers in early eighteenth-century London, published a book entitled *Marinda: Poems and Translations upon Several Occasions.* An octavo volume, *Marinda* – as its subtitle implies – is a miscellaneous collection. Prefaced with a dedicatory epistle addressed to Caroline of Ansbach, the first Hanoverian Princess of Wales, the main section of the volume includes songs, madrigals, pastorals, epigrams and a few political poems. It also includes translations from Italian, French and Spanish (many in parallel text), as well as one poem translated into Latin. The final item, demarcated by its own title page, is a lengthy prospect poem, 'Moccoli'. Marinda, the titular poet, is the implied author of most of the poems and translations in the collection, while the remainder are attributed to unnamed members of her poetic coterie. The dedicatory epistle is subscribed by Robert Molesworth, an Irish politician and writer and, by his own admission, a close relative of the eponymous Marinda. His epistle also discloses that *Marinda* is a posthumous publication, the work of 'a Young Gentlewoman lately Dead'.[1] The identity of Marinda herself is not revealed, either in the prefatory paratexts or at any other point in the collection.

In 1720, Giles Jacob identified 'Marinda' as Mary Monck, second daughter of Robert Molesworth and his wife Letitia.[2] This identification was subsequently endorsed by George Ballard in his *Memoirs of Several Ladies of Great Britain*.[3] Although no conclusive external evidence for the link between Monck and 'Marinda' has yet been found, it is almost certainly correct. Monck, who died in 1715, is the only female member of her family who could plausibly have been described in 1716 as 'lately

[1] *Marinda*, sig. b7v.
[2] Giles Jacob, *An Historical Account of the Lives and Writings of our most Considerable English Poets* (1720), pp. 106–108, 327.
[3] George Ballard, *Memoirs of Several Ladies of Great Britain* (1752), pp. 418–22.

Dead'. She is also known to have been fluent in Italian, the most common source-language for the numerous translations in *Marinda*.[4] Although Robert Molesworth does not clarify his relationship with Marinda in the dedicatory epistle, he includes her poetry in the category of 'every thing which belongs to me or my Family' and writes of the poet herself that 'I loved her more *because she deserv'd* it, than *because she was mine*'.[5] The title of one of the *Marinda* poems, 'An Elegie on a Favourite Dog. To her Father', also implies that the poet was Robert Molesworth's daughter; a monument to Molesworth's white greyhound, who died in 1714, still survives near his former estate in Yorkshire.[6]

Compared with the other poets studied in *Producing Women's Poetry*, Mary Monck is little known, and the critical bibliography on her writings is thin. Monck's own contributions to *Marinda* have always been over-shadowed by Molesworth's dedicatory letter, which physically dominates the volume and has inevitably conditioned critical responses to his daughter's work. Molesworth's conspicuous – for some readers, over-conspicuous – role in *Marinda* may have discouraged some scholars of women's writing from engaging with Monck's texts, while the generic choices represented in *Marinda* may also have deterred some scholars of eighteenth-century poetry from taking her work seriously. Translation, the most significant single category within Monck's writings, is still often disregarded or undervalued by literary scholars, and is sometimes viewed with particular suspicion by feminist scholars, given the derivative, non-original connotations often ascribed to the mode as practised by women.[7] Furthermore, both the authors translated by Monck (predominantly Italian poets of the sixteenth century and earlier) and the original genres she favoured seem oddly old-fashioned by late seventeenth- or early eighteenth-century standards. In comparison with Anne Finch – so responsive to contemporary poetry, so self-conscious a presence within her own writings, so aware of her own status as a female poet – Monck may initially seem outdated or insubstantial. In none of the poems included in *Marinda* does she – or the figure of Marinda – either comment

[4] Isobel Grundy, *Lady Mary Wortley Montagu: Comet of the Enlightenment* (Oxford University Press, 1999), p. 24.

[5] *Marinda*, sigs a2r–v, b8r. Molesworth's use of italics in the epistle is apparently deliberate and idiosyncratic (it differs from Tonson's usual house style), and so will be reproduced in all quotations from the 'Dedication'.

[6] *Marinda*, pp. 66–71; Phillip Molesworth, 'Molesworth Newsletter', personal information.

[7] On scholarly discomfort with women's translation, see Jonathan Goldberg, *Desiring Women Writing: English Renaissance Examples* (Stanford University Press, 1997), pp. 75–90, and Danielle Clarke, *The Politics of Early Modern Women's Writing* (Harlow: Longman, 2001), pp. 13–14.

on her own writings or emerge as a fully characterised or biographically situated persona. Indeed, it may be this apparent lack of authorial substance which, more than anything, accounts for the relative neglect of *Marinda* in recent scholarship. The biographical factors which have stimulated – and in some cases substituted for – critical work on other early modern women writers may have had precisely the opposite effect in the case of Monck, who remains an elusive figure both inside and outside *Marinda*. She is rarely mentioned in her family's extant correspondence, and her own few surviving letters are concerned largely with family issues and make no reference to her poetry.[8] Though some manuscript circulation of her poetry is known, it is limited in scope, and was apparently confined to just a few members of her extended friendship circle.[9] *Marinda* itself represents the principal – if not quite the only – evidence both for Monck's own writing practices and for the contemporary reception of her work.

Marinda, however, is a much more interesting volume – and Monck a much more estimable poet and translator – than this history of comparative neglect might suggest. Among my reasons for including a chapter-length discussion of *Marinda* in *Producing Women's Poetry* is the conviction that Monck's skilled, idiosyncratic and allusive poetry deserves a wider readership and more detailed scholarly scrutiny than it has so far received. A more specific reason, however, is that the very factors which may have discouraged previous research on Monck and *Marinda* paradoxically make both the poet and her publication highly germane to the concerns of *Producing Women's Poetry*. Issues of textuality, agency and genre are central to evaluating not only the contents of *Marinda*, but also the literary and political project represented by the volume. Addressing these issues is essential to answering the key question which any reader of *Marinda* must confront: namely, why Robert Molesworth wanted to publish his daughter's poems after her death.

[8] The Molesworths' correspondence is calendared in Historical Manuscripts Commission, *Report on Manuscripts in Various Collections*, vol. VIII (London: His Majesty's Stationery Office, 1913) (henceforward *HMC Var. Coll.*), vol. VIII. *HMC Var. Coll.* includes just one letter by Monck herself (pp. 264–65), as well as one addressed to her (pp. 252–54); the latter, however, provides important context for 'Moccoli'.

[9] Copies transcribed by Lady Mary Wortley Montagu (a friend of Monck's friend Mary Banks) and Montagu's cousin Philippa Mundy are extant (Grundy, *Lady Mary Wortley Montagu*, p. 24, footnote 35). A search of the Folger first-line index of English poetry (http://firstlines.folger.edu/) in June 2012 turned up twenty copies of poems attributed to Monck. Of these, the majority (eighteen, reproducing either 'An Epitaph on a Gallant Lady' or 'Thou who dost all my worldly thoughts employ') probably derive from Ballard's *Memoirs*, the remaining two from *Marinda* itself.

Posthumous publication is, of course, by no means a rare phenom-
enon either in the history of women's writing or in early modern book
history more generally. Using the death – real or imagined – of the
woman writer to justify print-publication of her works was a well-
established practice in the late sixteenth and seventeenth centuries,
though by 1716 it might already have seemed somewhat old-fashioned
(and thus in keeping with the general tenor of *Marinda*). However,
Marinda is anomalous within the history of women's posthumous
publication in certain important respects. Not only is it a comparatively
late instance of the phenomenon – appearing at a time when print-
publication, even by aristocratic and noble women, was becoming much
more acceptable – but there is also no attempt within the paratexts of
Marinda to claim that publication had been provoked by external
factors such as the threat of piracy. Nor – again in contrast with her
older contemporary, Anne Finch – had Monck's poetry previously
achieved visibility through inclusion in literary miscellanies. The closest
precedent for *Marinda* is not to be found in early eighteenth-century
collections such as Finch's *Miscellany Poems* (1713) or Mary Chudleigh's
Poems on Several Occasions (1703), but rather in an earlier volume, Anne
Killigrew's *Poems* (1686). Like *Marinda*, Killigrew's *Poems* was published
posthumously, at the aegis of the poet's father, and without any attempt
to justify publication as a response to piracy or readerly demand. The
two volumes are also alike in that each is introduced by, and best known
for, a preface by an authoritative man: Molesworth's dedicatory letter
to Caroline of Ansbach, John Dryden's ode in memory of Anne
Killigrew.[10] Where *Marinda* and Killigrew's *Poems* critically differ, how-
ever, is in their representation of the deceased female author. Dryden's
ode on Anne Killigrew, as has often been noted, is over-idealised and
riddled with gender stereotypes, not least in its suggestion that Kill-
igrew's extraordinary talents may have been due to 'traduction' from her
father.[11] It is, however, on the literal level at least, unquestionably
concerned with Anne Killigrew: her virtues, her painting, her poetry.
By contrast, Molesworth scarcely mentions either Mary Monck or her
writings until the final pages of his dedication, and then only in broad

[10] Margaret Ezell, 'The Posthumous Publication of Women's Manuscripts and the History of
Authorship', in Justice and Tinker, eds., *Women's Writing*, pp. 121–36 (pp. 130–33).
[11] See *The Poems of John Dryden*, vol. III, ed. by Paul Hammond and David Hopkins (London:
Longman, 2000), pp. 7 (23). On scholarly disquiet with Dryden's praise of Anne Killigrew, see
David Wheeler, 'Beyond Art: Reading Dryden's Anne Killigrew in its Political Moment', *South
Central Review*, 15.2 (1998), 1–15.

and non-specific terms. The chief subject of Molesworth's preface is neither the author nor the contents of *Marinda* but rather its dedicatee, the Princess of Wales.

Among Molesworth's few comments on Monck's writings in the dedication to *Marinda* is the claim that 'we found most of them [her poems] in her Scrittore after her Death, written with her own Hand, little expecting, and as little desiring the Publick shou'd have any Opportunity either of Applauding or Condemning them'.[12] Though the discovery of women's manuscripts after their deaths is a cliché of the period, it does seem genuinely to have occurred in some instances: Mary Evelyn and Octavia Walsh, as well as Monck, are cases in point.[13] While Robert Molesworth's claims about his daughter and her writings in the preface to *Marinda* should be treated with caution, there is no good reason to suppose that Monck herself had any role in preparing her poems and translations for publication. The speed with which the printed *Marinda* followed Monck's death in 1715 tends rather to confirm that the publication of her literary remains was a posthumous project, planned and executed by Monck's father, probably in conjunction with his two eldest sons. But attributing the publication of *Marinda* so firmly to Molesworth raises again the key issues of why and how this project was undertaken. What did Robert Molesworth hope to achieve by publishing *Marinda*? What were his motives for dedicating *Marinda* to Caroline of Ansbach, and why is so much of his prefatory letter devoted to her, not to Monck? How did his editorial practices – his selection, organisation and contextualisation of his daughter's poems and translations – work to his own advantage, both as a political agent and as a father?

As these questions imply, understanding the composition and significance of *Marinda* necessarily involves close attention to Robert Molesworth's role in producing the volume. Yet Molesworth, though a well-documented public figure, has received relatively little scholarly notice, and even the best existing discussions of his life and writings take little account of *Marinda*. Similarly, the few published studies of *Marinda* itself have typically focused on Monck's own poetry, and have been less concerned to assess the collection's significance within her father's career. However, an exclusive focus on Monck's own writings, though important and understandable in the critical recovery of her poems, is problematic for any historically or textually inflected reading

[12] *Marinda*, sig. b8v. A 'Scrittore' is a writing-desk (see *OED*, 'escritoire', *n.*).
[13] British Library Additional MSS 78440 (Evelyn), RP 343 (Walsh).

of her work. Molesworth's role in shaping *Marinda* exceeds even such formative editorial interventions as John Woodbridge's work on *The Tenth Muse* or the reconstruction of Katherine Philips's writings in *Poems* (1664 and 1667). Recognising Robert Molesworth's significance within *Marinda*, as well as *Marinda*'s relevance to his polemical and familial interests, is essential to any appreciation of why the volume was published. Paradoxically, it is also essential to any historically and textually informed reading of Monck's poems and translations.

Over the next two sections, I reconstruct some of the principal biographical and bibliographical contexts for *Marinda*. I outline what is known of Mary Monck's own life, and also discuss the careers and cultural interests of her father, Robert, and her brothers, John and Richard. In subsequent sections I analyse the three principal components within *Marinda*: Molesworth's dedicatory letter to Caroline of Ansbach, Monck's 'Poems and Translations Upon Several Occasions', and the concluding poem, 'Moccoli'. As we will see, assessing the arguments, interrelationships and textual agencies in all three elements is crucial to understanding the production of *Marinda*. It is also key to the literary and political significance of the *Marinda* thus produced.

MARY MONCK AND THE MOLESWORTHS

Mary Monck was one of seventeen children born to Robert Molesworth and his wife Letitia, nine of whom survived to adulthood.[14] Since the Molesworths were married in 1676, Mary, their second daughter, was probably born in the early 1680s. Little is known of her youth and education, though it is likely that she spent time at the Molesworth family properties on both sides of the Irish Sea. She is also known to have travelled abroad, visiting both Germany and Denmark with a family party in 1692.[15] By at least 1701, she was married to George Monck who, like Robert Molesworth, was a graduate of Trinity College, Dublin. The Moncks had three children, one of whom may have been the original for the guileless 'new-born Infant' honoured in 'To Marinda. A Puerperium'.[16]

[14] Biographical information on Monck is drawn from Ezell, 'Monck, Mary', *ODNB* and (especially) Elizabeth Anne Taylor [Betsey Taylor-Fitzsimon], 'Writing Women, Honour and Ireland, 1640–1715' (unpublished doctoral thesis, University College Dublin, 1999), except where specified.

[15] Ian Campbell Ross and Anne Markey, eds., *Vertue Rewarded; Or, The Irish Princess* (Dublin: Four Courts Press, 2010), p. 158.

[16] Taylor-Fitzsimon, personal communication; *Marinda*, pp. 114–15.

In 1703, George Monck embarked on a career in public life, representing Philipstown, a seat controlled by Robert Molesworth, in the Irish parliament. However, in 1712 he seems to have suffered some sort of illness or breakdown; Molesworth, writing to his wife in July 1712, explains that George is irregularly conscious of his condition and describes him as 'quarrelsome and withal dangerous'.[17] The senior Molesworths took charge of his treatment ('bleeding, physicking, and dieting'); and while the exact nature of George's 'disorder, or feigned disorder' is unclear, it is evident that both Moncks were still financially and emotionally dependent on the Molesworth parents, even at this comparatively late stage in their lives.[18] Letters by and concerning Mary Monck among the family correspondence indicate that she spent much of her time from 1712 onwards at the Molesworth estate at Edlington, Yorkshire, possibly without her husband. The cause, place and exact time of her death are all unknown. George Ballard represents her as dying at Bath (and writing a stoically affectionate poem to her husband on her deathbed); however, a letter from her father to the Duchess of Marlborough suggests instead that she may have died at his house in Chelsea.[19] The latter possibility accords better with Molesworth's claim that 'we' found her poems 'in her Scrittore after her Death'; it is also consistent with the complete absence of George Monck from the published *Marinda*.

Better known than his daughter – though still somewhat neglected in recent scholarship – is Monck's father, Robert Molesworth.[20] Born in 1656, Molesworth was an Irish-born gentleman of English stock who, after graduating from Trinity, studied briefly at Lincoln's Inn in London. A Protestant (though of a firmly anti-clerical outlook), Molesworth supported William of Orange in the Revolution of 1688 and was subsequently rewarded with the position of English envoy extraordinary to the Danish court in Copenhagen. However, Molesworth proved to be a somewhat undiplomatic diplomat who gave offence at the Danish court and was recalled to London in 1692. Two years later he published a book – *An Account of Denmark, as it was in the year 1692* – which gave still greater offence to his erstwhile hosts in Copenhagen. The main section of the *Account* consists of an unremittingly hostile description of contemporary Denmark, focusing on what Molesworth saw as the tyrannical structure of

[17] *HMC Var. Coll.*, pp. 258–59. [18] *HMC Var. Coll.*, pp. 259, 264.
[19] Ballard, *Memoirs*, p. 421; Taylor, 'Writing Women', p. 743.
[20] Biographical information on Molesworth follows D. W. Hayton, 'Robert, first Viscount Molesworth', *ODNB*, except where specified.

its monarchical government. Molesworth traced this structure back to the Danish Revolution of 1660, when the old, 'gothic' constitution, in which power was balanced between the elective king, the nobles and the commons, had been overthrown and replaced by an absolute hereditary monarchy. The *Account* mercilessly describes the role of the Lutheran clergy in supporting the coup of 1660, and explains in extensive detail how the Danish people – both nobles and commons – have suffered as a result of their catastrophic loss of liberty. The volume also includes a polemical preface, in which Molesworth clarifies the implications of the Danish experience for other nations, especially England. His overriding message is that the English, having gained a greater degree of liberty as a result of the Williamite Revolution, should be on their guard against any attempts to erode these achievements. Denmark's experience should be seen as a dreadful warning of what could all too easily happen closer to home: most obviously (though the *Account* does not quite spell this out) if the Stuarts were to be restored to the throne of England.

An Account of Denmark – with its frank, Tacitean analysis not only of the 1660 revolution but also of contemporary machinations at the Danish court – destroyed what was left of Molesworth's diplomatic career. It left him with an ineradicable reputation as a maverick who could not be trusted to maintain a proper level of diplomatic discretion. It was also unfortunate that the 1690s was an especially inopportune time for an English envoy to be rude about Denmark, with the heir to the throne, Princess Anne, married to Prince George of Denmark (son of the Danish king whose Machiavellian manoeuvrings Molesworth had so ruthlessly exposed in the *Account*), and with King William dependent on the support of Danish mercenaries to pursue his wars against the French. Unsurprisingly, Molesworth was largely excluded from royal favour during the rest of William's reign and throughout Queen Anne's, though he was appointed to the Irish privy council in the later 1690s and spent various periods as an MP in both the English and Irish parliaments. He returned to publishing in 1711 with a translation of François Hotman's classic of Calvinist resistance theory, the *Franco-Gallia*. His preface to the second edition of the *Franco-Gallia* (1721) was separately republished later in the century (1775) under the title *The Principles of a Real Whig*. His final publication, *Some Considerations for the Promoting of Agriculture, and Employing the Poor* (1723), was published in Dublin and addressed to the Irish House of Commons. He died in 1725.

Molesworth has never been the subject of a scholarly monograph in English, and a recent complete edition of his works (prepared by Justin

Champion) is the first English-language republication of any of his major political writings since the eighteenth century.[21] However, the relatively few twentieth- and twenty-first-century publications which discuss him and his works – usually very briefly – collectively sketch out the impressive range of his political, literary and familial interests. They include studies of Molesworth as a diplomat, as a 'Commonwealthsman' (a supporter of republican or limited monarchical government), as a reader, as a patron of architecture and garden design, as a political thinker and man of influence, as a father, and as an intellectual influence on philosophers such as Hutcheson and Shaftesbury.[22] Within his own lifetime – largely as a result of *An Account of Denmark* – Molesworth's public reputation seems to have been chiefly as a champion of liberty. Writers as different as the Tory Jonathan Swift and the deist John Toland both cited his defence of liberty when dedicating books to him (the fifth *Drapier's Letter* and the *History of the Druids*, respectively).[23] He also had a reputation as a sceptic about both monarchical power and the role of the church in public life. (In 1713 an injudiciously anti-clerical remark about the Irish episcopate – 'they that have turned the world upside down have come hither also' – lost him his seat on the Irish privy council.)[24] Recent scholarship (notably the work of Justin Champion) has stressed his links with radical and heterodox thinkers and agitators, especially Toland. This intellectual background needs to be borne in mind when assessing Molesworth's involvement in the publication of *Marinda*.

[21] Robert Molesworth, *An Account of Denmark: with Francogallia & Some Considerations for the Promoting of Agriculture and Employing the Poor*, ed. Justin Champion (Indianapolis, IN: Liberty Fund, 2011).

[22] D. B. Horn, *British Diplomatic Representatives, 1689–1789* (London: Royal Historical Society, 1932); Paul Ries, 'Robert Molesworth's *Account of Denmark*: A Study in the Art of Political Publishing and Bookselling in England and on the Continent before 1700', *Scandinavica*, 7 (1968), 108–25; Justin Champion, 'Enlightened Erudition and the Politics of Reading in John Toland's Circle', *The Historical Journal*, 49.1 (2006), 111–41; Edward McParland, *Public Architecture in Ireland, 1680–1760* (New Haven, CT: Yale University Press, 2001); Finola O'Kane, 'Design and Rule: Women in the Irish Countryside, 1715–1831', *Eighteenth-Century Ireland* 19 (2004), 56–74; Caroline Robbins, *The Eighteenth-Century Commonwealthman* (Cambridge, MA: Harvard University Press, 1959); M. A. Stewart, 'John Smith and the Molesworth Circle', *Eighteenth-Century Ireland*, 2 (1987), 89–102; Robert Allen, 'Steele and the Molesworth Family', *The Review of English Studies*, 12.48 (1936), 449–54; Michael Brown, *Francis Hutcheson in Dublin, 1719–1730* (Dublin: Four Courts Press, 2002); and Robert Voitle, *The Third Earl of Shaftesbury, 1671–1713* (Baton Rouge, LA: Louisiana State University Press, 1984); see also Ethel Seaton, *Literary Relations of England and Scandinavia in the Seventeenth Century* (Oxford: Clarendon Press, 1935); Justin Champion, *Republican Learning: John Toland and the Crisis of Christian Culture, 1696–1722* (Manchester University Press, 2003); and Gillian Wright, 'The Molesworths and Arcadia: Italian Poetry and Whig Constructions of Liberty, 1702–1728', *Forum of Modern Language Studies*, 39.2 (2003), 122–35.

[23] Jonathan Swift, *A Letter to the Right Honourable the Lord Viscount Molesworth* (1724), p. 9; John Toland, *A Collection of Several Pieces*, vol. 1 (1726), p. 4.

[24] Brown, *Francis Hutcheson*, p. 30.

Robert Molesworth, however, was by no means the only intellectually distinguished man in his family. Nor was he the only Molesworth to play a part in the published *Marinda*. The two eldest Molesworth sons, John and Richard, are both mentioned in the final poem in the collection, 'Moccoli'. Richard, the second son, was a career soldier who served under Marlborough, and claimed to have saved the latter's life at the Battle of Ramillies in 1706; he later published a well-regarded treatise on standing armies.[25] He is the addressee of 'Moccoli', which is inscribed to 'Colonel Richard Molesworth' at 'the Camp at Pratz del Rey in Catalonia. Anno 1711'.[26] A more understated but equally important presence in 'Moccoli' is Richard's brother John, the oldest of the Molesworth children. An accomplished linguist, John was a diplomat who served terms as English envoy to the Medici court in Tuscany (1711–14) and the Savoy court in Turin (1721–24). Though he published nothing himself, he was closely connected with literary and artistic circles in England, Ireland and Italy. During his two diplomatic postings he cultivated links with contemporary Italian poets, scholars and architects: he is known to have facilitated poetic translations in both England and Italy, and to have worked with his father to commission Italianate designs for their Irish estates.[27] Although John Molesworth remains discreetly unnamed in 'Moccoli', he is clearly the 'M – ' whose character and household are praised in the closing lines of the poem; the eponymous 'Moccoli' is glossed in a footnote as 'A Villa near Florence, where her Majesty's envoy liv'd'.[28] His influence can also be detected in the idiosyncratic array of Italian poets translated in *Marinda*, which, in addition to classic writers of earlier eras such as Petrarch, Tasso and Giovanni della Casa, includes two contemporary and near-contemporary Florentine poets, Antonio Maria Salvini and Vincenzo da Filicaia – neither otherwise well-known in English. The role of John Molesworth in connecting Mary Monck with the most modish debates in early eighteenth-century Italian literature will be discussed later in this chapter.

The full extent of the male Molesworths' editorial involvement in the published *Marinda* is impossible to determine. No authorial manuscripts

[25] Richard Molesworth, *A Short Course of Standing Rules, for the Government and Conduct of an Army* (1744); H. M. Chichester, 'Molesworth, Richard, third Viscount Molesworth', *ODNB*.

[26] *Marinda*, p. [141].

[27] On John Molesworth's involvement with Italian poets and scholars, see Wright, 'The Molesworths and Arcadia', pp. 124–26; on his (and his father's) patronage of Italian artists and architects see McParland, *Public Architecture*, pp. 6, 9–11, 182–84, and Elisabeth Kieven, 'An Italian Architect in London: The Case of Alessandro Galilei (1691–1737)', *Architectural History*, 51 (2008), 1–31.

[28] *Marinda* pp. 154–55, 143.

of Monck's poems and translations are known to survive, and the texts included in *Marinda* are smooth and orderly copies, with none of the anomalies and discontinuities that make the editorial reconstruction of Anne Bradstreet's poems in *The Tenth Muse* so visible. Where editorial agency can be detected, however, is in the paratexts of the volume, and in the selection and organisation of its contents. Such aspects of *Marinda* – almost certainly the work of Robert Molesworth, with assistance from his son John – offer important insights into what Molesworth hoped to achieve in publishing his daughter's poetry. Among the most significant are the title page, the choice of the title itself, and the canon of poetry included in the volume.

CONSTRUCTING *MARINDA* AND 'MARINDA'

Compared with the densely crowded title page of Anne Bradstreet's *The Tenth Muse*, the title page of *Marinda* seems relatively sparse (see Figure 4). The principal items of information included in this initial leaf are the title and subtitle of the volume, an epigraph (from Horace) and the Tonsons' publication imprint. The author herself is not directly mentioned.

By the early eighteenth century, Jacob Tonson was well known as the publisher of Dryden, Milton and Shakespeare; he had also been responsible for the *Pastorals*, the earliest publication by the young Alexander Pope. Despite his professional relationships with Dryden and Pope, his political affiliations were firmly Whiggish, and he was a member of the famous Whig society, the Kit-Cat Club. No member of the Molesworth family or their immediate circle (whose books to date had focused on political, religious and philosophical topics) had previously published with Tonson, who worked mainly with literary texts. His involvement with *Marinda* may be explained in part by his political sympathies with Robert Molesworth, in part by his own long-standing association with literary translation, which dated back to 1680. Through the Tonson imprint, *Marinda* – despite its anonymity and its somewhat outmoded contents – would have been visibly associated with some of the most highly regarded literary publications in early eighteenth-century London. It would also have carried implicitly Whig connotations.

The remaining elements within the *Marinda* title page also make culturally significant claims. The Latin epigraph – '*Tentavit quoque rem si digne vertere posset*' – is one of three quotations in *Marinda* from Horace, an author much favoured by classicising eighteenth-century writers such as Robert Molesworth. The epigraph, which derives from

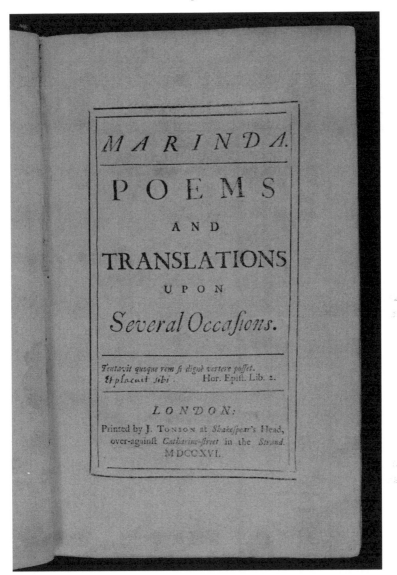

4. *Marinda*, title leaf, with Horatian annotation. The Fales Library & Special Collections, New York University.

Horace's epistle to Augustus, literally means 'He [or she] also tried to imitate worthily'.[29] Modestly, it stops short of quoting the following half-line – '*Et placuit sibi*': 'And he [she] succeeded' – but an educated readership would have known how to complete the clause.[30] The primary allusion, both in Horace and in *Marinda*, is to literary imitation between languages: Horace's reference is to Roman dramatists' reinvention of Greek tragedy in Latin, *Marinda*'s to Monck's numerous translations. The principal effect of this Horatian epigraph – probably chosen by Robert Molesworth – is to reinforce the subtitle's emphasis on the role of translation within *Marinda* (albeit translation of modern European vernacular languages, rather than the Greek or Latin which the epigraph might have led a reader to expect). It also draws attention to translation as an activity as well as a product, stressing the objectives and skill of the 'worthy' translator. Furthermore, it anticipates the significance of *Marinda*'s royal readership, locating the collection within the tradition of literary advice to princes. As Horace once advised his literary patron, Augustus, so Mary Monck – or Robert Molesworth – will advise *Marinda*'s addressee, Caroline of Ansbach.

As a title, '*Marinda*' is both more ambiguous and culturally allusive than it may at first appear. As with '*The Tenth Muse*', its gendered connotations provide a strong indication of female authorship while allowing the author herself to remain (overtly or initially) anonymous. A key difference, however, is that whereas *The Tenth Muse*, as far as anyone knows, includes poems *only* by Anne Bradstreet herself (prefatory materials excepted), *Marinda* also includes numerous poems ascribed not to the titular author but to her unnamed 'Friends', as well as an Italian sonnet addressed to Marinda by Antonio Maria Salvini.[31] The title *Marinda* thus attributes a misleading impression of authorial unity to a collection which is by no means exclusively the eponymous poet's own work. Like so much else in the construction of *Marinda*, the ambiguity of its title can almost certainly be attributed to Robert Molesworth and is undoubtedly deliberate. As we shall see, both the mildly disingenuous foregrounding of 'Marinda' in the title and the role of the titular Marinda within her literary community play a key role within the political construction of the volume.

[29] Compare Horace, *Satires, Epistles and Ars Poetica*, trans. by H. Rushton Fairclough (Cambridge, MA: Harvard University Press, 1970), pp. 410–11 (Epistle 2.1.164).

[30] At least one contemporary owner of *Marinda* did thus complete the quotation: see Figure 4.

[31] *Marinda*, pp. 24, 26.

Though 'Marinda' may sound like a traditional pastoral name, it is actually quite rare. It occurs only infrequently in English pastoral poetry of the early modern period, and scarcely at all in Italian.[32] The closest analogue for Monck's coterie use of the name occurs in a novel published in London in 1693, *Vertue Rewarded; or The Irish Princess*. Set in Ireland in the late 1680s, *Vertue Rewarded* tells the story of a foreign prince, serving in the Williamite army, who falls in love with an Irish gentlewoman while stationed in Clonmel. The gentlewoman, Marinda, is too poor and humble for the Prince to think of marrying her; but she is virtuous, and so although she loves the Prince, she steadfastly rejects his advances. However, as the title none too subtly hints, Marinda's virtue ultimately triumphs over the Prince's attempts to corrupt her; they are married, and Marinda becomes the Irish princess promised in the subtitle.

Vertue Rewarded is anonymous, and the identity of its author has never been discovered. Its most recent editors, Ian Campbell Ross and Anne Markey, note the likely connection with the Molesworths, and speculate both that the chaste and honourable Irish princess may have been named as a compliment to the young Mary Molesworth and that the author of *Vertue Rewarded* may have been her father, Robert.[33] These are attractive but problematic possibilities. While the politics of *Vertue Rewarded* – pro-Williamite, anti-authoritarian – are similar to Molesworth's, and the detailed knowledge of the anti-Jacobite wars it evinces is plausibly his, the language of courtship employed in its dedicatory letter from the author to Marinda would read rather uncomfortably if the two, biographically, were father and daughter. *That* there is a link between the heroine of *Vertue Rewarded* and the use of the name 'Marinda' by Mary Monck seems certain – the coincidence is otherwise too great – but quite what the link was is more difficult to determine. It is possible either that the name of *Vertue Rewarded*'s heroine is drawn from a poetic sobriquet already used by Mary Molesworth or that her use of the name was inspired by the book. The former seems more probable (because less derivative on the part of the self-consciously independent Molesworths), but without evidence either way, this can be no more than conjecture. What is certain, however, is that in choosing *Marinda* as the title for his daughter's (and her friends') literary works, Robert Molesworth was sending out powerful signals. Most

[32] The few English instances include a minor character in William Browne's *Britannia's Pastorals*, Book 1, song 3 (1613).
[33] Ross and Markey, eds., *Vertue Rewarded*, pp. 156–59.

obviously, the title would have associated *Marinda* with pro-Williamite –
still more pertinently, in 1716, anti-Jacobite – political allegiances. It also
recalls a Marinda whose personal chastity acts as a restraint on male sexual-
ity, and whose Irishness is firmly located within an international context.

Beyond the title page, Robert Molesworth's editorial agency in *Marinda*
can most obviously be seen in the tripartite division of the volume and in
the choice of Caroline of Ansbach as his dedicatee. All three sections, as well
as the significance of the dedication, will be discussed later in this chapter;
for now, the key point is that *Marinda*'s three-part structure highlights the
Molesworth family both at the beginning (through Robert's prefatory letter)
and at the end (through the praise of John and Richard in 'Moccoli').
However, a more foundational issue raised by the structure and contents of
Marinda is the canon of Monck's poetry that it includes. How can we know
whether all the poems in *Marinda* which are *not* explicitly attributed to
'A Friend' were really written by Mary Monck? How fully does the corpus
of her poems included in *Marinda* represent Monck's poetic output? Did
she write other poems which were not discovered in her 'Scrittore' after her
death? Or did her family suppress poems which, for reasons of their own,
they did not want to include in the *Marinda* project?

Since no authorial manuscripts of any of the *Marinda* poems are extant,
answers to some of these questions can only be conjectural. As we will see,
there are indeed some grounds for questioning whether all the poems and
translations implicitly attributed to the titular poet in *Marinda* are in fact
hers. On the issue of omission or suppression of unwanted contents, the lack
of authorial *Marinda* manuscripts, though regrettable, is only half the story.
Post-publication, two poems not included in *Marinda* have subsequently
been attributed to Mary Monck: 'Thou who dost all my earthly thoughts
employ' and 'To Her Brother in Italy'. First ascribed to Monck in Ballard's
Memoirs (1752), 'Thou who dost' was anthologised in several eighteenth-
century collections, and is still the poem for which Monck is best known.[34]
Apparently autobiographical, it is a consolation poem, addressed to the
speaker's husband and anticipating her own approaching death:

> Thou, who dost all my worldly thoughts employ,
> Thou pleasing source of all my earthly joy:
> Thou tend'rest husband, and thou best of friends,

[34] On the inclusion of 'Thou who dost' in both eighteenth-century and modern anthologies, see
Matthew Steggle, 'The Text and Attribution of "Thou who dost all my earthly thoughts employ":
A New Moulsworth Poem?', *Early Modern Literary Studies*, 6.3 (2001) http://extra.shu.ac.uk/emls/
06-3/stegmoul.htm.

To thee this first this last adieu I send.
At length the conqu'ror death asserts his right,
And will for ever vail me from thy sight.
He woos me to him with a chearful grace;
And not one terror clouds his meagre face.
He promises a lasting rest from pain;
And shews that all life's fleeting joys are vain.
Th'eternal Scenes of Heaven he sets in view,
And tells me that no other joys are true.
But love, fond love, would yet resist his power;
Would fain a while defer the parting hour:
He brings thy mourning image to my eyes,
And would obstruct my journey to the skies.
But say, thou dearest, thou unwearied friend;
Say, shouldst thou grieve to see my sorrows end?
Thou knowst a painful pilgrimage I've past;
And shouldst thou grieve that rest is come at last?
Rather rejoice to see me shake off life,
And die as I have liv'd, thy faithful wife.

 Ballard, *Memoirs*, pp. 421–22

Described by Paula Backscheider as 'brief, beautiful love poetry', 'Thou who dost' has long been admired both for its emotional balance and concision and for its skilful use of the couplet form.[35] However, as Matthew Steggle points out, textual evidence provides very little support for Ballard's attribution of the poem to Monck (a point on which Ballard himself is less than categorical).[36] Steggle, who doubts Monck's authorship of the poem, justifies his scepticism with reference not only to the weak textual evidence but also to biographical plausibility and stylistic consistency. As he notes, the steadfast marital devotion which characterises 'Thou who dost' – evident, for instance, in the speaker's address to her husband as 'Thou pleasing source of all my earthly joy' and 'thou dearest, thou unwearied friend' (2, 17) – sits uneasily alongside the biographical evidence for the Moncks' troubled marriage (and their continuing reliance on the Molesworth parents for practical support).[37] Steggle also argues that the tone of 'Thou who dost' – sombre, stoical, world-denying – is inconsistent with the predominantly light-hearted preoccupations of Monck's attested poems in *Marinda*, and is thus less likely to be her work. This latter

[35] Backscheider, *Eighteenth-Century Women Poets*, p. 65.

[36] 'The following verses were wrote by her (as I am inform'd) on her death-bed at Bath, to her husband in London' (Ballard, *Memoirs*, p. 421); Steggle, 'Text and Attribution', section 6.

[37] Steggle, 'Text and Attribution', section 6.

argument, however, holds good only if we assume that *Marinda* is a fully representative collection of Monck's poems and translations. If, on the other hand, *Marinda* is a selected edition of Monck's work, then other possible reasons for the omission of 'Thou who dost' come into play. 'Thou who dost' might have risked drawing the reader's attention towards Monck's husband and marriage, rather than her birth family; its rejection of 'life's fleeting joys' in favour of 'Th'eternal Scenes of Heaven' (10, 11) might also have jarred with the predominantly this-worldly concerns of the published *Marinda* volume. Meanwhile the religiously inflected stoicism of the poem is closely consistent with Molesworth's claim, in the preface to *Marinda*, that his daughter had died 'not only like a *Christian* but a *Roman* Lady'.[38] Thus, while the attribution of 'Thou who dost' to Monck is undoubtedly shaky on textual grounds, the biographical and stylistic evidence is capable of other interpretations. The possibility that Robert Molesworth omitted 'Thou who dost' from the published *Marinda* because it did not suit his purposes cannot be excluded.

'To Her Brother in Italy', the second poem belatedly attributed to Monck, is more problematic. It is recorded only in a letter to *The European Magazine* in 1800 by one 'C.D.' – probably the magazine's reclusive editor, Isaac Reed – who claimed to have found the text inscribed in a copy of *Marinda* 'which formerly belonged to Dr. Farmer'.[39] Though metrically similar to 'Thou who dost', in subject and tone it is very different:

TO HER BROTHER IN ITALY, UPON HIS
SENDING AND DEDICATING TO HER
HIS TRANSLATION OF TASSO'S AMINTAS.
What can the lost Marinda (doom'd to mourn
In silence her unhappy fate) return
To her lov'd Brother? whose harmonious Muse
Suspends her sorrows and her joy renews?
'Tis not alas! the fond desire of praise,
Or flourishing in his immortal lays,
That can her weary drooping spirits raise:
Nor yet the flatt'ring thoughts that her renown
Shall live when all the beauties of the town,
After a short and glaring blaze must die,
And in the common herd forgotten lie
(So much the inferior merit rais'd by thee

[38] *Marinda*, sig. b8r.
[39] 'C.D.' [Isaac Reed], 'To the Editor', *The European Magazine*, 38 (1800), 423–24. On the identity of 'C.D.', see Arthur Sherbo, 'Isaac Reed and the *European Magazine*', *Studies in Bibliography*, 37 (1984), 211–27.

Outlasts the objects of our gallantry);
Whilst future times shall hear Marinda's name
With Sylvia's echo from the mouth of fame,
And the same deathless page preserve entire
Her brother's kindness, and Aminta's fire.
These gay ideas may they happy please,
And fill their minds who live in mirth and ease,
But are too weak supports t afford relief
T'inveterate troubles and substantial grief.
That which alone buoys up her sinking mind
Thro' all the storms of fate, is still to find
Her friends are faithful, and her brothers kind.
These weighty blessings o'er her woes prevail,
The trembling balance bend and turn the scale.
These soothing thoughts still chide her swelling sighs,
Forbid the rowling flood of tears to rise,
And gently whisper – Can Miranda [sic] grieve,
Or blame her fate, whilst two such Brothers live.

In contrast with 'Thou who dost', the internal evidence in 'To Her Brother in Italy' clearly supports the attribution to Monck. Not only does the speaker refer to herself by Monck's coterie name, but the biographical information supplied in the title (and corroborated by the rest of the poem) is consistent with the known facts about the Molesworth family – facts, moreover, which would not have been otherwise apparent from the *Marinda* volume. The 'Brother in Italy' to whom the poem is addressed is presumably John, the only one of the Molesworth men to have lived in Italy during Monck's lifetime; but although John's residence outside Florence is mentioned in 'Moccoli', his relationship with Marinda is not. John is not otherwise known to have written poetry or translations, but his close involvement with Italian literature from the early 1710s onwards makes his responsibility for a 'translation of Tasso's Amintas' very plausible. 'To Her Brother in Italy' is almost certainly a genuine Monck poem which, assuming a copy had been passed to the addressee, would have been readily available for inclusion in *Marinda*. The obvious question is why it should have been omitted.

In some respects, 'To Her Brother in Italy' would have been a very apposite inclusion in *Marinda*. Its emphasis on translation is consistent with the interests of the published collection, as is its conception of poetry and translation as social activities furthered within productive coterie relationships. The construction of John and Richard Molesworth – 'two such Brothers' – as providing indispensable support for their sister would

also have tallied with the insistence on their exemplary qualities in 'Moccoli'. On the other hand, if the stoical sorrow of 'Thou who dost' might have seemed out of place within the generally positive tone of *Marinda*, the near-despair evinced in 'To Her Brother in Italy' would have been still worse. The 'lost Marinda' is afflicted by 'inveterate troubles and substantial grief' (21), which only her friends and brothers – not even her brother's poetry – can do anything to ease. While Marinda's grief may of course be merely literary convention, the extremity of her distress – and, in particular, the failure of poetry as a source of solace – strongly suggests an autobiographical explanation. The most likely interpretation is that the 'unhappy fate' lamented in 'To Her Brother in Italy' relates in some way to Mary Molesworth's troubled marriage to George Monck. Had the poem been included among her published poetry, it would undoubtedly have invited biographical speculation of a kind that the rest of the volume largely eschews; as I have noted, although *Marinda* offers stylised depictions of Robert, John and Richard Molesworth, it remains curiously reticent about Mary Monck. One reason for Robert Molesworth's omission of 'To Her Brother in Italy' from *Marinda* may thus have been the desire to protect his daughter's privacy.

It may seem counter-intuitive to ascribe concerns for privacy to a father who, to quote Betsey Taylor-Fitzsimon, 'exposed the poems of his dead daughter to the outside world'.[40] Yet while Molesworth did expose Monck's poems through the publication of *Marinda*, it is arguable that he exposed Monck herself as little as possible. As I have stressed, Monck is barely mentioned in her father's dedicatory letter; and the 'Marinda' constructed in the central section of the volume, through her own and her friends' poems and translations, is an idealised figure almost completely devoid of distinguishing biographical attributes. Ironically, to understand the significance of Marinda in *Marinda*, we need to look first at another idealised but much more conspicuous figure: Molesworth's dedicatee, Caroline of Ansbach.

DEDICATING *MARINDA*: THE COMMONWEALTHSMAN AND THE PRINCESS

The publication of *An Account of Denmark* in 1694 had made Robert Molesworth's reputation as a defender of liberty and as a critic of absolute monarchy. This reputation was consolidated in 1711 with the publication

[40] Taylor, 'Writing Women', p. 747.

of his *Franco-Gallia* translation, which vindicated the rights of subjects to resist tyrannical rulers. Given such a record, Molesworth's dedication of *Marinda* to Caroline of Ansbach, the new Princess of Wales, may have come as rather a shock to some contemporary readers. Neither of Molesworth's previous publications had had a named dedicatee; instead, each carried a preface addressed to the general reader (explicitly in the *Franco-Gallia*, implicitly in *An Account of Denmark*), with the avowed aim of spelling out the possible implications of other countries' political experience for the English nation. The prefatory dedication to *Marinda*, however, is startlingly different. Molesworth's habitual suspicion of the claims of royalty is apparently in abeyance as he lavishes praise on the princess. Observing that the practice of writing dedications has recently fallen into disuse through lack of worthy dedicatees, he protests:

> I have not the least Apprehension, that I shall run any Risque of this sort; the Danger is on the other Hand, that I should tarnish the Lustre of your Glories, (*most Excellent Princess*) by my Unskilful handling ... I own, 'tis possible so to manage even *Truth*, as to make it *Flattery* by the manner of telling; but *Real Worth*, like yours, (*most Excellent* Princess) will easily distinguish itself to the World, and will as easily discern *Flattery* from *Praise*; And as it hates and contemns a false and fulsome Train of Compliments, so it covets and has a just Esteem of a well-deserv'd *Commendation*; which it looks upon as the *best Present* that can be given to Greatness.
>
> *Marinda*, sigs A3r, A3v–A4r

Later he declares that 'It would be difficult to tell where to begin, when one foresees it will be as hard to tell where to leave off' in setting out the princess's many virtues.[41] Caroline is elsewhere lauded for her piety, her skill in argument, her tact, her proficiency in the English language, and her excellence in every 'Action and Relation of ... Life; as ... a *Subject*, a *Daughter*, a *Patriot*, a *Wife*, a *Mother*, a *Friend* and a *Princess*: which last comprehends all the Degrees of Good-breeding suitable to your Quality'.[42] Amid such all-encompassing praise, the suspicion of the institution of monarchy for which Molesworth had become famous seems very far away.

Yet Molesworth also deliberately recalls the reputation of his earlier publications as he anticipates the objection that he has 'Publish'd a little Book [*Marinda*] barely for the sake of a Dedication, as 'twas once afore that I had done so for the sake of a Preface'.[43] The reference here is almost certainly to *The Account of Denmark*, whose main section – the *Account*

[41] *Marinda*, sigs A7r–v. [42] *Marinda*, sig. A8v. [43] *Marinda*, sigs b6r–v.

itself – had been seen by some as a mere pretext for the anglocentric concerns of its polemical preface.[44] In conspicuously reminding readers of his infamous *Account*, Molesworth seems to invite comparisons between the disconcerting royal encomium of the *Marinda* 'Dedication' and the overt radicalism of his earlier writings. On closer examination, the old and the new works are not so different after all.

The accession of the first Hanoverian king, George I, in August 1714, offered fresh opportunities for Robert Molesworth and his family. Molesworth quickly regained his seat on the Irish privy council, and was appointed a commissioner for trade and plantations. Yet preferment for his sons – a key aim at this stage of his life – proved harder to secure. In October 1715, Molesworth wrote to his wife:

I wish Mr. Molyneux would inform the Prince that our family are no boasters, but performers, and hope to make our court more effectually this way than by attending twice a day in the Ante-chamber ... I hope this manner of distinction, which my sons choose to appear in, will in time convince the [un]grateful ministry what wrong they continue to do us all in undervaluing us, especially poor Jack Molesworth, who has more worth in him than is in half the persons employed put together, yet has been and is monstrously ill-used. I have no patience when I think of it and see the zeal we all have, and the abilities some of us have, to serve the King, neglected and all our merits and losses esteemed as a trifle.

HMC Var. Coll, pp. 268–69[45]

The 'Mr. Molyneux' alluded to by Molesworth was Samuel Molyneux, another graduate of Trinity College, Dublin, and secretary to the Prince of Wales.[46] Molesworth's long-standing connections with the Molyneux family offered a potentially valuable means of access to the prince, whom, together with his wife, Molesworth had evidently identified as potential patrons; later in the same letter, he suggests that his son Richard's military unit 'deserve[s] to be distinguished by the title of the Princess's Regiment

[44] Robbins, *The Eighteenth-Century Commonwealthman*, p. 99; compare Jørgen Sevaldsen, 'Diplomatic Eyes on the North: Writings by British Ambassadors on Danish Society', in *Britain and the Baltic: Studies in Commercial, Political and Cultural Relations, 1500–2000*, ed. by Patrick Salmon and Tony Barrow (University of Sunderland Press, 2000), pp. 321–36 (p. 325). The preface to the 1711 *Franco-Gallia*, although similarly forthright, is a mere 5½ pages in length, and never achieved the fame either of the preface to the *Account* or of the much longer preface included in the second *Franco-Gallia* edition.

[45] Molesworth's reference to his eldest son's being 'monstrously ill-used' may allude to John's difficulties in obtaining his salary and expenses as envoy to Florence – a subject repeatedly raised in the latter's last few diplomatic despatches. See PRO SP/98/23, despatches for 21 November 1713 and 3 April 1714.

[46] A. M. Clerke, 'Molyneux, Samuel', *ODNB*.

or Prince Frederick's Regiment'.[47] Molesworth also had a still closer connection with Caroline herself through his eldest daughter, Charlotte Tichborne, who had been appointed one of the princess's Women of the Bedchamber in February 1715.[48] Family advancement and personal affiliations thus do much to explain not only Molesworth's unexpected dedication of *Marinda* to a member of the royal family but also his uncharacteristically effusive language towards his addressee. Flattering his daughter's employer was a key move in a long-running campaign to further John's and Richard's careers in the service of the state.[49]

But Molesworth had ideological as well as familial reasons for praising Caroline in such public and extensive detail. Given his hostility to absolute monarchy, he was a natural supporter both of the Act of Settlement and of the new Hanoverian dynasty that it had established. His political ally John Toland had already embarked on a publishing campaign with the double aim of both underwriting the Hanoverians' claim to the throne and appealing for their patronage.[50] (Toland's record both of cultivating relationships with influential women and of editing the works of the dead to his own political advantage are also important, if partial, precedents for Molesworth's involvement in *Marinda*.)[51] Molesworth's support for the Hanoverians and hostility to the Stuarts and monarchical absolutism are everywhere presupposed in the 'Dedication', though they are only occasionally made explicit.[52] In this context, Molesworth's praise of Caroline provides an implicit justification of the Hanoverian succession. Caroline's exemplary behaviour as Princess of Wales, as outlined in *Marinda*, helps to vindicate her family's right to the British throne. Molesworth's description of her virtues is thus more than just

[47] *HMC Var. Coll.*, p. 269. Frederick was the Prince and Princess of Wales's eldest son. On links between Samuel Molyneux's father, William, and the Molesworth circle, see John Locke, *The Correspondence of John Locke*, ed. E. S. de Beer, vol. 6 (Oxford: Clarendon Press, 1981), p. 192, and James O'Hara, 'Molyneux, William', *ODNB*.

[48] Institute of Historical Research, 'Household of Princess Caroline 1714–27' http://history.ac.uk/publications/office/caroline.

[49] Molesworth's concern about his sons' careers, and his conviction that their abilities were undervalued, are a recurring theme in his letters: see, for instance, *HMC Var. Coll.*, pp. 224, 231, 233–34, 236, 239.

[50] Champion, *Republican Learning*, pp. 141–63.

[51] On Toland and women – including Caroline's grandmother-in-law, Sophia of Hanover, and her guardian, Sophie Charlotte of Prussia – see Champion, *Republican Learning*, pp. 52–54. On Toland's ideologically motivated editions of dead men's works, see Edmund Ludlow, *A Voyce from the Watch Tower*, ed. by A. B. Worden, Camden Society, fourth series, vol. 21 (London: Royal Historical Society, 1978), pp. 17–39, and Champion, *Republican Learning*, pp. 98–112.

[52] See, for instance, Molesworth's caustic comment that English flatterers of their late king (presumably James II) are even more servile than their French equivalents, who have at least stopped praising Louis XIV so fulsomely now that he is dead (*Marinda*, sigs A4v–A5v).

personal flattery; it is an ideologically valuable construction of his addressee and her family as worthy successors to the disfavoured Stuarts.

For Molesworth, however, Caroline was more than just an accessible member of a politically acceptable dynastic regime. By 1716, just two years after her arrival in London, she had already established herself as one of the most visible, popular and culturally engaged members of the new royal family. Unlike her father-in-law, who notoriously never learnt to speak his new subjects' language, she had begun studying English while still in Hanover, and had also cultivated relationships with important political and intellectual figures in England.[53] The well-known story that she had rejected a proposal of marriage from the Archduke Charles of Vienna (subsequently the Holy Roman Emperor), rather than agree to convert to Catholicism, gave her a politically useful (if not wholly accurate) reputation for having renounced an empire for the sake of Protestantism.[54] Yet despite this impeccably Protestant record, Caroline was also interested in religious controversy and disputation, and was willing to countenance – some thought, to encourage – more heterodox religious thinkers, such as deists and Arians. The wide range of her intellectual interests is signalled by the extensive book collection which she amassed during her years in England, and which later laid the foundation for George III's Royal Library.[55] In addition to English and her native German, she was fluent in French and also studied Italian.[56] Surviving catalogues of her personal library (albeit from much later in her life) show that she collected poetry in several languages, including English, French, Italian and German.[57] Caroline's idiosyncratic combination of religious and literary interests thus

[53] R. L. Arkell, *Caroline of Ansbach* (Oxford University Press, 1939), p. 34; Taylor, 'Caroline', *ODNB*.

[54] Stephen Taylor, 'Queen Caroline and the Church of England', in *Hanoverian Britain and Empire*, ed. by Stephen Taylor, Richard Connors and Clyve Jones (Woodbridge: Boydell, 1998), pp. 82–101 (p. 85); Andrew Hanham, 'Caroline of Brandenburg-Ansbach and the "Anglicisation" of the House of Hanover', in Clarissa Orr, ed., *Queenship in Europe, 1660–1815: The Role of the Consort* (Cambridge University Press, 2004), pp. 276–99 (p. 281).

[55] On Caroline's book collection, see Emma Jay, 'Caroline, Queen Consort of George II, and British Literary Culture' (unpublished doctoral thesis, University of Oxford, 2004) and 'Queen Caroline's Library and Its European Contexts', *Book History*, 9 (2006), 31–55. Caroline's literary, cultural and ecclesiastical interests are also discussed in Peggy Daub, 'Queen Caroline of England's Music Library', in *Music Publishing and Collecting: Essays in Honor of Donald W. Krummel*, ed. David Hunter (Urbana, IL: University of Illinois at Urbana-Champaign, 1994), pp. 131–65; Christine Gerrard, 'Queens-in-Waiting: Caroline of Anspach and Augusta of Saxe-Gotha as Princesses of Wales', in *Queenship in Britain, 1660–1837: Royal Patronage, Court Culture and Dynastic Politics*, ed. by Clarissa Campbell Orr (Manchester University Press, 2002), pp. 143–61; Hanham, 'Caroline of Brandenburg-Ansbach'; and Taylor, 'Queen Caroline'.

[56] Arkell, *Caroline*, p. 250; George Dorris, *Paolo Rolli and the Italian Circle in London 1715–1744* (The Hague: Mouton, 1967), pp. 144–45.

[57] Jay, 'Queen Caroline's Library', p. 42.

made her the ideal reader and dedicatee for Robert Molesworth's *Marinda*. Interested in the main subject matter of the volume – poetry and translation – she was also a potentially sympathetic audience for the political and cultural agenda that Molesworth wanted to promote.

Perhaps most importantly of all, Caroline was an appropriate dedicatee for Molesworth's *Marinda* because she was a woman. Molesworth's previous publications, focused on issues of politics and governance, had in consequence been largely concerned with men and had made little reference to women. The educational reforms he had advocated in *An Account of Denmark*, offered in good humanist style as a means of preparing the young for participation in government (and described by Caroline Robbins as 'one of the important stimulants to new educational ideas in the period'), were thus, by implication, applicable only to men.[58] Yet Molesworth's few references to the female sex in the *Account* and the preface to the *Franco-Gallia* show that, while scarcely a radical on the subject of gender, he was willing to recognise and recommend the abilities of special women.[59] In *An Account of Denmark*, for instance, the present Queen of Denmark, Charlotta Amelia, is almost the only person exempted from Molesworth's denunciation of all things Danish, praised as 'a Princess that deserves to be mentioned with all honour'.[60] In his preface to the *Franco-Gallia*, the only point on which he takes issue with his author, François Hotman, is the latter's endorsement of the Salic law.[61] Few though they are, Molesworth's references to women in the pre-*Marinda* publications indicate a strong awareness of their capacity for political agency, both for good and for ill. While he praises Charlotta Amelia for her active defence of 'the little French Protestant Church (lately founded in Copenhagen by her Bounty, and subsisting through her Protection)', he denounces her mother-in-law, the former queen, as 'a Woman of Intrigue and high Spirit' who 'wrought strongly in it [the Danish Revolution] by all manner of ways'.[62] In the preface to the *Franco-Gallia*, condemning the Salic law, he

[58] Robbins, *The Eighteenth-Century Commonwealthman*, p. 100; the other 'stimulants' alongside which she ranks the *Account* are Milton's *Of Education* and Locke's *Letters on Education*.

[59] As Hannah Smith points out, praise of 'Illustrious Ladies' held strongly Whiggish associations in the late seventeenth century. See Smith, 'English "Feminist" Writings and Judith Drake's *An Essay in Defence of the Female Sex* (1696)', *The Historical Journal*, 44.3 (2001), 727–47 (p. 736).

[60] *Account of Denmark*, p. 151. Charlotta Amelia, as Molesworth does not fail to point out, was actually German by birth.

[61] *Franco-Gallia*, p. iv.

[62] *Account of Denmark*, pp. 152, 56. Charlotta Amelia's protection of the French Calvinist Church seems to have been valued by Molesworth both because it undermined the authority of the Lutheran clergy and because of the Calvinist tradition of opposition to tyranny.

declares that 'I am sure our Island in particular has never been able to boast of so much Felicity as under the Dominion of Queens'.[63] The final sentence of this preface even makes a rare favourable reference to Queen Anne, confidently predicting that 'the Destruction of the present Grand Oppressor of Europe [Louis XIV] seems reserved by Heaven to Reward the Piety and Virtue of our Excellent Queen.'[64]

Molesworth's interest in special women is still in evidence in the dedication to *Marinda*, most obviously in his treatment of Caroline of Ansbach; he also singles out '*Queen* MARY, that incomparable Consort of the late King WILLIAM *of Glorious Memory*' who '(like your Royal Highness [Caroline]) understood how to joyn *Majesty* with *Affability*, how to make *Magnificence* consistent with *Oecomony*, the strictest *Virtue* with the most *Obliging Freedom*; the *Highest Wisdom* with the *least Pretences* to it'.[65] What is new in the preface to *Marinda*, however, is not just its much more extensive attention to such special women – Molesworth's praise of Caroline, as I have stressed, occupies most of the document – but also his explicit construction of these outstanding figures in exemplary terms. Queen Mary, for instance, is described as an 'Illustrious Example', whose life had offered 'good Lessons' – alas, too soon forgotten by 'a People running full-drive into Corruption, and a course of *ill-understood Luxury*'.[66] But while Mary is apparently represented as an example to the 'People' as a whole, irrespective of sex, Molesworth's depiction of Caroline constructs her specifically, and repeatedly, as a model to other women. He introduces his first extended account of the Princess's virtues by assuring his readers that 'I do not know such a perfect Model to propose for Imitation, as your Royal Highness, especially to the Ladies'.[67] Later, justifying the extensive attention he has paid to Caroline in his dedication, he explains that 'my principal Drift in this Attempt at your Picture ... was to propose your Exact *Model* as near as I cou'd to the Fair Ladies of our Nation for their Imitation'.[68] While Molesworth claims that Caroline's good example has already begun to inspire 'Noble Emulation' among those ladies who have already met her, his aim in describing the princess's virtues so fully in his preface is avowedly to make these moral benefits more widely available to the reading public.[69] It also, of course, has the further advantage of allowing Molesworth to create his own (implicit) model of virtuous womanhood: a model to which Caroline's new female compatriots are expected to aspire.

[63] *Franco-Gallia*, pp. iv–v. [64] *Franco-Gallia*, p. vi. [65] *Marinda*, sigs b2v–b3r.
[66] *Marinda*, sigs b2v–b3r. [67] *Marinda*, sig. A7r. [68] *Marinda*, sigs b6v–b7r.
[69] *Marinda*, sig. a8v; see also sigs a8r, b1v, b2v and b5r.

So what are the characteristics of Molesworth's ideal woman? Perhaps unexpectedly, when he begins to single out Caroline's exemplary qualities, he awards 'the first Place' to 'your Royal Highness's Regard for the Protestant Religion in General, and the Church of *England* in Particular'.[70] Surprising as this may seem, given Molesworth's long-standing hostility to institutional religion, it soon becomes clear that this privileging of religion is no more inconsistent with past practice than his copious praise of Caroline herself, and indeed stems from similar motives. The version of religion which Molesworth advocates in the preface is predominantly secular, with an emphasis on human-centred virtues and a distinct absence of other-worldly aspirations. Caroline's religious practice is glossed as 'Your remarkable *Piety* without *Bigottry*' and 'your just Notions of it [religion], and extensive Charity, (which is the best Effect of it)'.[71] Later he expresses the hope that when women have learnt from Caroline's example '*Religion* will not be *Treason* or *Contention*, but the *Practice of a Good Life*' and that '*Charity* will be esteemed at least a *part of Christianity*'.[72] While Molesworth's habitual anti-clericalism briefly surfaces in the concurrent hope that '*Atheism* will not take its surest footing on the Behaviour of some *Clergymen*', he nonetheless acknowledges 'The Good and Pious of this Order (whereof, Heaven be prais'd, there are many among us)'.[73] Perhaps Molesworth realised that denouncing (or even ignoring) religion was not the best way to recommend his ideas to a princess whose personal piety, however unconventional, was foundational to her public identity. Instead, his preface constructs a version of religion to suit his own priorities: tolerant, charitable, and disconnected from political activism; his reference to '*Treason* or *Contention*' presumably alludes to Catholics and non-jurors, whose religious practice Molesworth was apparently willing to tolerate, providing it did nothing to foster revolutionary intrigue. His praise of Caroline's 'just Notions' not only flatters the princess's own religious ideas, of which she was known to be deeply protective, but also implicitly admits a role for female judgement in determining issues of conscience.

Molesworth's preface, while consistent in its praise of Caroline, is by no means uniformly complimentary about women in general. Like other male commentators on women – the prefatory writers to both *The Tenth Muse* and Philips's *Poems* are obvious comparisons – he also makes use of exceptionalist arguments, depicting his subject as a shining counter-example to the unsatisfactory habits common amongst other members of her sex. Chief among the unsatisfactory habits identified in the preface are

[70] *Marinda*, sig. A7v. [71] *Marinda*, sig. A7v. [72] *Marinda*, sig. b5v. [73] *Marinda*, sig. b5v.

deficiencies in women's personal demeanour and conduct of familial relationships. Molesworth accuses modern women of having abandoned 'the Natural Sweetness and Modesty which so well became their Sex', in favour of 'a Careless, Indecent Masculine Air'.[74] They have lost 'the Ancient good Housewifry of their homebred Grandmothers', without acquiring any of the 'Politeness with the Address of Foreigners' in compensation.[75] As a result of their 'Modish Neglect of their Husbands, Children and Families', moral instruction of children is in decline and marriage itself is threatened; such is the poor reputation of modern women that matrimony 'is now grown almost too dangerous a State for Young Sober Gentlemen to venture upon'.[76] Needless to say, Molesworth is confident that this woeful situation can be rectified if women look to the 'Illustrious Example' of Caroline — an ideally responsible wife and mother — and start to model their own conduct on hers.[77]

It would be easy to dismiss Molesworth's attitude to women in the preface to *Marinda* as reactionary and misogynistic. Yet severe as he is on the moral inadequacies of women, he does not utterly neglect the role of men — who, he argues, need to learn that 'Matching with Women of Scandalous Characters will Entitle them and their Families to nothing but Infamy and Disgrace'.[78] More importantly, as several allusions in the preface make clear, Molesworth's critique of female misconduct — in particular, female unchastity — is premised on political as well as moral concerns. An early reference to '*Slavery and Licentiousness* (these two commonly going together)' (sig. a1r) is amplified in a later assurance to Caroline that:

Your known Respect for, and Complyance with *The Good Old English Customs* will never carry you one Step towards the bearing with *bad* new *ones*, as soon as you are convinced that they are *New*; Introduc'd by our *Libertine Princes* within the compass of this last Age, and Encouraged on purpose to *Debauch the Morals*, in order to *trample* on the *Liberties* of their People.

Marinda, sig. b2r–v

Molesworth's distinctive expression, '*The Good Old English Customs*', is a deliberate echo of 'the Good Old Cause', the term used by Commonwealthsmen to refer to the parliamentary side in the English Civil Wars and interregnum.[79] By replacing 'Cause' with 'Customs', Molesworth hints at an identification between traditional sexual morality and

[74] *Marinda*, sig. a7r. [75] *Marinda*, sig. a6v. [76] *Marinda*, sigs a7v and b1r.
[77] *Marinda*, sig. a8v. [78] *Marinda*, sig. b1r. [79] *OED*, 'cause' (*n* I.11.a).

opposition to the excesses of the Stuarts which he unpacks more fully at the end of the sentence. He claims that the notorious sexual licentiousness of the post-Restoration Stuart courts was really a cunning political ploy: a bread-and-circuses tactic which used the pleasures of sex to distract the people from noticing their monarchs' encroachment on their liberties. As a result, albeit through a rather counterintuitive chain of logic, Molesworth sees women's chastity as an important political tool. Unlikely as it may seem, women's sexual propriety has a role in safeguarding English liberty.

Molesworth's emphasis on the domestic and social virtues in his portrait of Caroline is of little surprise. Writers on female conduct had traditionally laid great emphasis on women's domestic responsibilities, and it was a commonplace of the early eighteenth-century cult of sociability that women, as the more naturally sociable sex, had an important role in helping to civilise their less polished male contemporaries.[80] What is more unusual, however, is that Molesworth's construction of his exemplary woman does not stop there. Politically, for instance, the exemplary woman is credited with the ability not only to further good government through her sexual propriety, but also to make sound political judgements on her own account. Although Molesworth, in the more reactionary sections of his preface, sometimes seems to suggest that women should not 'turn their Heads to Politicks', it is clear from other references that this stricture applies only to the wrong sort of politics; he laments that 'among great Numbers of them, a malicious, inveterate, and unreasonable Disaffection to the Government is notorious'.[81] In his initial compliments to Caroline he praises her for the 'true Value you have for *Liberty*, which ... is so remarkable, that one wou'd wonder where your Royal Highness (who has been Bred up in a part of *Europe*, but slenderly furnish'd with just Notions of that great Blessing) cou'd have acquired it'.[82] While Caroline has gained opportunities to appreciate liberty through 'your frequent and intimate Conversation with that incomparable Princess, *the late Electress* SOPHIA' (a nice recollection of the Hanoverians' link with the throne of Great Britain, as well as an instance of female emulation in action) and 'your indefatigable Reading the best Books in all the modern Languages', responsibility for benefiting from these advantages is attributed firmly to the princess herself: ''tis your own good Sense and good Nature which makes the Application'.[83] A still

[80] Lawrence Klein, 'Politeness and the Interpretation of the British Eighteenth Century', *The Historical Journal*, 45.4 (2002), 869–89 (p. 881).
[81] *Marinda*, sig. a6r–v. [82] *Marinda*, sig. a1r. [83] *Marinda*, sig. a1v.

more telling attribution of good political judgement to Caroline occurs, ironically, in Molesworth's praise of her 'exact and *unenforced Obedience,* where due'.[84] Misogynistic as this privileging of a woman's obedience may seem, Molesworth's rider – 'where due' – introduces a politically significant qualification. This is neither the absolute obedience so often enjoined on early modern women, nor the passive obedience advocated by the Tories in the 1680s, which Whigs like Robert Molesworth saw as a form of capitulation to incipient Stuart tyranny. The obedience valorised by Molesworth, unlike the Tories', is not blindly submissive, but is limited, voluntary, and subject to reasoned judgement. The properly obedient woman, as imagined by Molesworth, is a Whig.

The final point to be noted in Molesworth's praise of Caroline is the importance he attaches to reading and linguistic skills. While intellectual considerations such as these are not among the more prominent elements in the preface, their importance is frequently presupposed; Molesworth's reference to Caroline's 'indefatigable Reading the best Books in all the modern Languages' is a case in point. Where Molesworth is most keen to stress Caroline's intellectual judgement, however, is in constructing her as an appreciative and perceptive reader of *Marinda* itself. His first reference to the *Marinda* poems – 'these Verses, (which I will not call Trifles, because you have approv'd of them,)' – premises the value and quality of Monck's poetry on Caroline's authoritative judgement. His emphasis on Caroline's critical skills serves both to enhance his idealised portrait of the princess herself and also to highlight the merits of the *Marinda*-poet's poems and translations:

as your Royal Highness has an Admirable Taste in all Things, is a Judge of the Beauties of the several Languages, and truth of the Translation, the Spirit and Numbers of the Poetry, the Delicacy of the Turns, and Justness of the Thought and Expression; and in short, what our Language is capable of, which (if I am not mistaken) may be found in some of these Poems.

Marinda, sig. a2v

These few lines of aesthetic recommendation represent the first of just two references in Molesworth's preface to the poems he is purportedly introducing, and the only one which focuses, however allusively, on the poetry itself. In his second reference, deferred until the penultimate paragraph, the poems instead become a pretext, via the modesty topos, for a belated tribute to their unnamed author:

[84] *Marinda*, sig. b4v.

As to these Poems which give me the Opportunity of Addressing myself to your Royal Highness, it becomes me to say but little of them. Most of them are the Product of the leisure Hours of a Young Gentlewoman lately Dead, who in a Remote Country Retirement, without any Assistance but that of a good Library, and without omitting the daily Care due to a large Family, not only perfectly acquired the several Languages here made use of, but the good Morals and Principles contain'd in those Books, so as to put them in Practice, as well during her Life and languishing Sickness, as at the Hour of her Death; in short, she dyed not only like a *Christian* but a *Roman* Lady, and so became at once the Object of the *Grief* and *Comfort* of her Relations ... I cannot do a greater Honour to her Memory, than by Consecrating her Labours, or rather her Diversions to your Royal Highness[.]

> *Marinda*, sigs b7v–b8v

Two points are immediately striking in Robert Molesworth's brief memorialisation of Mary Monck. One is how little it actually tells us about Monck herself. No biographically specific information is offered, and much of what *is* said – that she was caring, bookish, linguistically able, and morally admirable – merely draws attention to qualities which no reader of the *Marinda* poems would be likely to overlook. The other is the congruence between Molesworth's extended portrait of the Princess of Wales and this condensed and carefully anonymised account of his daughter.[85] The unnamed gentlewoman's love of reading and facility in 'the several Languages here made use of' are exactly parallel to virtues already attributed to Caroline, as are her 'good Morals and Principles' and her dutiful attention to her 'large Family'. The one respect in which she clearly diverges from Caroline is in her 'languishing sickness' and virtuous death (in which '*Roman*' stoicism seems to take priority over '*Christian*' consolation). In this instance, the gentlewoman-poet offers an exemplary model for the princess.

Having featured so prominently in the preface to *Marinda*, Caroline of Ansbach does not appear in any other part of the volume. Instead, in the centrepiece of the volume, 'Poems and Translations Upon Several Occasions', the figure of Marinda herself becomes the central exemplar of female virtue. It is Marinda's own poems, as well as those addressed to her by members of her coterie, which have to make good on Molesworth's aspirations for womanhood in the letter to Caroline. Unsurprisingly, they are perfectly calibrated to do so.

[85] The equivalence between Caroline and Marinda in Molesworth's preface is noted by Taylor-Fitzsimon (Taylor, 'Writing Women', pp. 749–52).

'POEMS AND TRANSLATIONS UPON SEVERAL OCCASIONS'

'Poems and Translations Upon Several Occasions' is both the sectional and the running title for the central portion of *Marinda*. Of the sixty-two English-language poems included in this section, ten are original poems attributed (implicitly or explicitly) to a 'Friend' – not necessarily always the same person.[86] A 'Friend' is also responsible for one of the English-language translations, from a 'sonetto' by 'Abbate Salvini'.[87] The remainder of the English-language texts – twenty-seven translations and twenty-four original poems – are unattributed, and are thus assigned by default to Marinda herself.[88] Most of the English translations are accompanied by their source text in the original language, while one of Marinda's own poems, 'An Elegie on a Favourite Dog', has been supplied with a translation into Latin – unattributed but perhaps also the work of a 'Friend'.

As already noted, the translations in *Marinda* are an unusual selection. Of the twenty-seven translations implicitly attributed to Marinda herself, twenty-two are based on Italian originals, one on French and four on Spanish. Of the Italian poets included in the volume, the majority – Tasso, Guarini, Della Casa, Marino and Petrarch – would have been equally available to a translator working 100 years earlier. The remaining two – Filicaia and Salvini – represent much more recent material (Filicaia had died only in 1707, while Salvini lived until 1729), and the latter is in fact represented as participating in Marinda's poetic coterie: the 'sonetto' translated by Marinda's 'Friend' is a response to her translation of Guarini's *Maschrata delle Virtù contr' Amore*. This awareness of, and involvement with, contemporary Italian poetry might seem surprising in a poet who is not known to have visited Italy – all the more so given that, by the eighteenth century, Italian had long since been replaced by French as the most prestigious vernacular for literary translation. The answer, however, lies with John Molesworth, who had become acquainted with the Florentine Salvini during his three years as envoy to Tuscany.[89] Salvini was a leading member of the Accademia dell'Arcadia, a literary academy

[86] These figures are approximate, since in a few cases the 'translation' or 'original' status of Marinda's poems is unclear. One poem, Quevado's *Retrato de Lisi en Marmol*, is provided with two translations into English: one serious, one humorous (pp. 60–62).
[87] *Marinda*, pp. 24–27.
[88] A few of these poems and translations are explicitly ascribed to Marinda in answer poems elsewhere in the volume: thus 'Answer to the foregoing Eclogue' (pp. 19–21) clarifies the attribution of the 'Eclogue' itself to Marinda, while 'To Marinda leading up the Masque of the Virtues' (pp. 62–63) compliments her on one of her translations from Guarini's *Pastor Fido* (pp. 23, 25).
[89] On John Molesworth's links with Salvini, see Wright, 'The Molesworths and Arcadia', pp. 124–25.

which took inspiration from, and aimed to revive interest in, earlier periods of Italian literary history. The range of Italian poets translated by Monck in *Marinda* reflects the narrative of Italian literary history favoured by the Arcadians, encompassing an approved selection of 'pure' poets from earlier eras, as well as two of their own number (Filicaia and Salvini). The test case here is Giovanni della Casa, whose poetry had previously attracted little interest from English-language translators, but had been freshly edited by a team of Arcadians including Salvini in 1707.[90]

The opening poem in 'Poems and Translations Upon Several Occasions' offers a good illustration of the preoccupations, aesthetic qualities and interpretative difficulties represented by the *Marinda* translations. 'Runaway Love. From Tasso' is a rendering of the epilogue from the pastoral drama *Aminta*. The poem is voiced by Venus, who has descended from 'the Immortal Seats above' (p. 3) and now appeals for her audience's help in finding her lost son, Cupid.[91] The latter has fled his mother's presence after wounding her with his 'Golden Arrow' (p. 3), and Venus – assuring her hearers that she wants only 'To give him Pardon for my Wound' (p. 5) – offers a detailed description of her son's deceptive behaviour so that he can be more easily identified and returned to her. This Venus, unlike the voluptuous, sexually transgressive goddess familiar from so much classically inspired literature, is a wise, knowledgeable and responsible figure, who is both a good mother to her wayward son and a trustworthy counsellor to the human audience she addresses. Though she fails to persuade her listeners to yield up the wily Cupid, she remains committed to her self-imposed task, ending her speech with the resolve to search a 'little farther' for 'the Wanderer', before returning to heaven (p. 13).

'Runaway Love' forms a significant opening to 'Poems and Translations Upon Several Occasions'. Following so closely on Molesworth's letter to Caroline, it creates a similar figure of virtuous, responsible womanhood: here contrasted not only with the boyish Cupid, to whom blame for all the sufferings and delusions of love is assigned, but also with the ladies in Venus's audience, whom she describes as beautiful but disdainful (pp. 5, 7). As a rendering of Tasso's original, it is close but not slavish, converting the irregular canzone metre of the *Aminta* epilogue into accomplished tetrameter couplets (with the occasional triplet), and ascribing to

[90] Gillian Wright, 'Giovanni della Casa in Two English Verse Collections', *Translation and Literature*, 11.1 (2002), 45–63 (p. 50).
[91] Since no line numbers are provided in the 1716 *Marinda*, quotations are identified (parenthetically) by page number alone.

Venus a witty and elegant poetic register. The key question, however, is whether it is really the work of Mary Monck. As we have seen, the endorsement of 'To Her Brother in Italy' – 'Upon his sending and dedicating to her his translation of Tasso's Amintas' – credits one of Monck's brothers, probably John, with a translation of the *Aminta*, presumably including the epilogue. It is possible that both John and Mary may have translated this section of the play, perhaps as some kind of familial competition, though no hint of any rival translation is mentioned in 'To Her Brother in Italy'. It is also possible, however, that 'Runaway Love', though implicitly attributed to Marinda in 'Poems and Translations Upon Several Occasions', in fact derives from John Molesworth's translation of the entire *Aminta* (which is otherwise not known to survive). This would in turn provide a further reason why 'To Her Brother in Italy', with its telltale endorsement, was not included in *Marinda*.

'Runaway Love' is by no means the only text of questionable authorship included in *Marinda*. Several of the poems and translations seem to presuppose a worldly-wise point of view which is easier to read as male than female. Thus, for instance, 'To Sylvia reading St. Bernard's Life' posits that a Bernard who had seen Sylvia would have gone to Hell rather than becoming a saint, while 'Upon Orpheus and Eurydice', a translation from Quevedo, argues cynically that Orpheus's success in regaining his wife was more 'Plague' than 'Gain' and that losing her a second time was 'Luck in its Extremity' (pp. 118, 137, 139). Translations of love poems such as Della Casa's canzone '*Come fuggir per selva ombrosa*' and Petrarch's sonnet '*Stiamo Amore à veder la gloria nostra*' presuppose a male speaker and a female love-object (pp. 30–41, 72–75). Needless to say, the fact that a poem has a male speaker does not prove that its author is a man; literary ventriloquism on Monck's part is also plausible. A more problematic case, however, is provided by one of the original poems in the volume, 'On Sight of the Present Empress'. The famously beautiful Elisabeth of Brunswick-Wolfenbüttel was in Catalonia when her husband, the Archduke Charles, succeeded his brother as Holy Roman Emperor in 1711, and remained there until 1714, when she rejoined her husband in Vienna.[92] Given that Monck is not known to have travelled in continental Europe during this period, she is unlikely to be the author of 'On Sight of the Present Empress', which is premised on the poet-speaker's direct

[92] Charles W. Ingrao and Andrew L. Thomas, 'Piety and Power: The Empresses-Consort of the High Baroque', in Clarissa Orr, ed., *Queenship in Europe, 1660–1815: The Role of the Consort* (Cambridge University Press, 2004), pp. 107–30 (pp. 116–17, 122, 123, 126).

experience of Elisabeth's beauty.[93] More plausible authors are John Molesworth, who could have visited Austria while travelling back from Florence in 1714 (though no such visit is on record) or, still more likely, Richard Molesworth, who was stationed in Catalonia with his regiment in 1711.[94] While including 'On Sight of the Present Empress' in a volume dedicated to Caroline of Ansbach (the Archduke Charles's first choice of bride) seems inescapably tactless, Richard's authorship may make a little more sense both of the inclusion itself and of the poem's final couplet, 'Well may'st Thou Charles th'Iberian Throne resign, / All that is worth contending for is Thine' (p. 121).[95] Charles's decision in 1713 to relinquish the throne of Spain helped bring the War of the Spanish Succession to what many Whigs saw as a humiliating conclusion that made too many concessions to Louis XIV. Given Robert Molesworth's long-standing hostility to French absolutism (restated in the preface to *Marinda*) and the fact that Richard had risked his life defending Catalonia on Charles's behalf, a poem which reads superficially as a conventional tribute to female beauty and conjugal devotion may carry a surprisingly venomous sting in its tail. In preferring his wife's beauty over loyalty to his allies, Charles has proved himself a romantic hero but has failed in the moral and political duty privileged throughout *Marinda* and Molesworth's other publications. Molesworth's inclusion of 'On Sight of the Present Empress' in a volume dedicated to Caroline of Ansbach may even offer a subtle vindication of the latter's wisdom in rejecting such an unreliable and injudicious suitor.

The strategic deployment of Tasso's Venus and the tribute to the Empress Elisabeth's beauty (the latter rendered no less credible by the implied critique of her husband) are just two instances of an interest in exemplary women which – extending and diversifying Robert Molesworth's emphases in the preface – is apparent throughout 'Poems and

[93] The logic of the poem would have been just as valid had it been entitled 'On a Picture of the Empress', a plausible title in this period; compare Anne Finch's near-contemporary 'picture' poems in the Wellesley manuscript.

[94] Richard's critical interest in and possible authorship of poetry is attested by the Molesworth correspondence; see *HMC Var. Coll.*, pp. 282, 398–99. Lady Mary Wortley Montagu, another member of Monck's extended circle, had an audience with the Empress in September 1716 – too late, however, for any poetic response on her part to have been included in *Marinda*. See her *Letters of the Right Honourable Lady Mary Wortley Montagu, Written During her Travels*, vol. 1 (1763), pp. 42–46.

[95] Caroline's rejection of Charles 'for the sake of Protestantism' was well known in England at the time of the Hanoverian succession, so it is difficult to believe that Robert Molesworth, when editing *Marinda* in 1716, did not know about it. The parallels between Caroline and Elisabeth were all the closer given that the two were cousins and that Elisabeth, unlike Caroline, had agreed to conversion as the price of marriage (Ingrao and Thomas, 'Piety and Power', p. 111).

Translations Upon Several Occasions'. Also, as in the preface, this interest is expressed through both positive and negative means. On the positive side, the most obvious and consistent strand in *Marinda*'s depiction of women is its strongly favourable portrayal of Marinda herself. Praise of Marinda is a key feature in many of the poems by 'a Friend' included in the volume, and indeed seems likely to be the principal reason for their inclusion. In the course of 'Poems and Translations', Marinda is acclaimed for numerous qualities, but most repeatedly for her beauty, her virtue, and her abilities as a poet, translator and critical reader. An answer poem to 'On Sight of the Present Empress', entitled 'To a Friend of Marinda's that did not enough admire the Empress', claims that 'Marinda's Form' has so overwhelmed the 'Friend' that even the Empress's charms can make no impression on him (p. 121). 'On Marinda's Toilette' compares her to an angel who has thoughtfully adopted human shape in order to avoid dazzling the 'weak Sight' of humans with her beauty (p. 112). The issues of beauty, virtue and poetic skills are conflated in two complimentary poems: 'Sonetto of Abbate Salvini's sent from Italy on occasion of the foregoing Translation' and 'To Marinda leading up the Masque of the Virtues' (pp. 24–27, 62–63). Both poems respond to Marinda's 'Masque of the Virtues against Love', a translation of Guarini's rima *Maschrata delle Virtù contr' Amore* (pp. 23, 25).[96] Salvini's sonnet declares that if Virtue could appear amongst men, she would choose to reside in Marinda's 'beauteous Form' (p. 25), while 'To Marinda leading up the Masque of the Virtues' depicts the 'Fair' Marinda's translation as forcing 'Ungovern'd Appetite, and bold Desires' into retreat (pp. 62–63). The following poem, 'An Epigram on the same Subject', raises the stakes still higher, imagining Marinda as the living embodiment of Plato's ideal of virtue (p. 63).

The 'Sonetto of Abbate Salvini's' and 'To Marinda leading up the Masque of the Virtues' are only the most conspicuous instances in 'Poems and Translations' of praise for Marinda's literary talents. The 'Sonetto', endorsed as 'Done into English by a Friend', is in fact the only translation in the volume credited to a poet other than Marinda, presumably for reasons of decorum; it would scarcely have been appropriate for Marinda herself to translate this tribute to her own beauty and virtue. Otherwise, however, the absence of specific attributions from the other translated texts in *Marinda* creates an implicit association between the category of translation (with all its associated linguistic and literary skills) and the eponymous poet herself. Elsewhere, Marinda is repeatedly hailed as the most talented

[96] On the translation source-texts in *Marinda*, see Wright, 'Giovanni della Casa', pp. 47–48.

and critically astute member of her poetic community, and thus as an example to others. Perhaps unexpectedly, the would-be poets to whom she is held up as a literary model and guide are invariably male. 'Answer to the foregoing Eclogue' ends with an 'inchanted Swain' breaking his pipe and lyre, frustrated at his own inability to emulate Marinda's achievements (p. 21). In 'Wrote the last Day of the Year. To Marinda', the Muse urges the Shepherd to retire from writing poetry, safe in the comfort that 'Marinda lik'd your Song' (p. 120). The speaker of 'An Epistle to Marinda', a witty and well-informed critique of contemporary poetry and criticism, confidently advises an aspiring poet on how to distinguish 'A false Applause ... from a true' (p. 84), but concludes by deferring to the more trustworthy leadership of Marinda herself:

> Marinda, let your steady Judgment guide
> Your Poet thro' those Dangers, steer him wide
> Of all these Shelves, let your unerring Taste
> Secure him from the Malice of the rest.
> *Marinda*, p. 85

Marinda's uniquely virtuous status is also enhanced by implicit contrast with other female figures in the volume. The figure of Cloe, for instance, appears in numerous poems and translations in *Marinda*, including 'A Tale sent by a Friend', the first 'Canzone' from Della Casa, 'On a Lady's Statue in Marble' (from Quevedo), and 'Epigram I. To Cloe' (pp. 14–15, 31–41, 61, and 118). (In the case of both the Della Casa and the Quevedo translations, the name 'Cloe' is an addition to the English, with no equivalent in the original language.) On her first appearances in the volume, Cloe is fickle and self-regarding: her refusal in 'A Tale sent by a Friend' and its companion 'Eclogue' to choose between Aegon and Strephon leads to 'Strife' (p. 16) between the two rivals, while in the Della Casa canzone she is characterised as 'wayward', 'giddy' and 'wild' (pp. 33, 41). In later poems, contrastingly, she is portrayed both as sexually forbidding and also as excessively available: in 'On a Lady's Statue' she is as hard and pitiless as the sculptor's marble, while in the epigram 'To Cloe' she is taunted for blaming her 'Child-bed Pains' on Hymen, even though 'Before she Wedd, she'd much the same'.

Many other named women are also criticised for their sexually inappropriate behaviour. The Sylvia who reads St Bernard's life is accused of 'cruel Scorn' (p. 118), while her near-namesake Silvia is urged to learn from the short lifespan of the rose and relinquish her 'disdainful' ways (p. 94). An epitaph on the 'Gallant Lady', Rosalinde, declares suggestively that 'All Mankind was pleas'd with her, / And She with all Mankind' (p. 125). The foolish Mistress

Betty in 'On a Romantick Lady' has spent too much time reading romances and thus has a hopelessly unrealistic perception both of herself and of her possible suitors (p. 124). While 'Poems and Translations Upon Several Occasions' does also include a few positive representations of women – including Diana in 'A Pastoral Dialogue from the Spanish' (pp. 50–61), as well as Gloriana and Elisabeth in 'On the Sight of the Present Empress' (pp. 120–21) – the overwhelming effect of most of these female images is to emphasise the particular virtues of Marinda herself. The force of contrast between Marinda and other women is at its most evident in the immediately consecutive poems 'A Tale' and 'To Marinda' (pp. 110–111). In 'A Tale', Cloe apparently makes no demur as a 'Band of Cupids' clusters over her face and one falls into her breast (p. 110). In 'To Marinda', however, Cupid's appeal to be granted 'Lodging in Marinda's Breast' is politely but firmly declined, and Marinda instead bids Disdain to carry him back to Venus. Unlike Cloe, Marinda is too wise to succumb to Cupid's flattery. Her model response to his youthful entreaties also defines a legitimate role for disdain – apparently an acceptable quality when thus judiciously governed – as well as presupposing a mother's responsibility to discipline and control her mischievous child.[97]

'Poems and Translations Upon Several Occasions' also includes one unexpected instance of exemplary womanhood, namely the late monarch, Queen Anne. Molesworth's preface to *Marinda* had conspicuously failed to include Anne in its tributes to outstanding royal women; indeed, given that the preface explicitly praises 'the late King WILLIAM *of Glorious Memory*' as well as his wife Mary, the period of 'Corruption, and … *ill-understood Luxury*' which Molesworth describes as following Queen Mary's death is implicitly identified with her sister's reign. But Molesworth had earlier, as we have seen, applauded Anne's commitment to the cause of liberty in his preface to the *Franco-Gallia* in 1711, a time when England was still involved on the anti-French side in the War of the Spanish Succession. In *Marinda*, still more pointedly, 'An Ode on the Queen's Birth-day' not only celebrates Anne's protection of liberty but portrays it as a necessary condition for divine protection of her own rule:

> Be Anna Heaven's peculiar Care;
> Ye Angels be her Guardians here,

[97] 'To Marinda' is one of two poems (along with 'To Marinda. A Puerperium', pp. 114–15) which read as creative responses to 'Runaway Love', and slightly redefine its values. 'To Marinda. A Puerperium' is also comparatively rare for its period in complimenting a poet on her motherhood of a living child. It is noticeable that, despite *Marinda*'s emphasis on sexual propriety, no reference is made to the child's father.

> And watch around her Head, whilst she
> Is Guardian of our Europe's Liberty.
> > *Marinda*, p. 92

Stanza II of the 'Ode' cites a specific example to illustrate its claims for Anne's political merits:

> To Her th'Oppress'd for Refuge fly,
> To Heaven and Her in vain th'Oppress'd can never cry...
> Long while had Vict'ry, that Bird of Prey,
> > Stoop'd to the Tyrant's Lure;
> Anna has chain'd her to the juster Side,
> Taught her the Rights of Nations to secure.
> > *Marinda*, pp. 92–93

The flight of the oppressed to Queen Anne's kingdom is probably an allusion to the so-called 'poor Palatines': Protestant refugees from the Palatinate in Germany who had begun to arrive in England in 1708–9, fleeing religious persecution and the incursions of the French.[98] The queen took a leading role in both offering and organising support for the poor Palatines – thus, rarely, siding with the Whigs rather than her usual allies, the Tories. Since the main phase of refugee arrivals (some 10,000 people) occurred in the summer of 1709, the poem was probably composed for Anne's birthday in February 1709/10; its reference to the queen's reign as a time when 'the juster Side' rather than 'the Tyrant' enjoys victory also associates it with the years prior to the Peace of Utrecht in 1713, the period of the Duke of Marlborough's military successes against Louis XIV. The 'Ode' thus takes advantage of the moment to create an 'Anna' selectively fashioned in the Molesworths' preferred image and to attempt to recruit her permanently to the cause of liberty. Its inclusion in *Marinda*, six years later, encourages the new Hanoverian dynasty to live up to the standards set by 'Anna' at her best.[99]

Without manuscript evidence, the question of how many of *Marinda*'s 'Poems and Translations Upon Several Occasions' were really written by Mary Monck remains uncertain. It seems likely, however, that most of the collection is indeed her own work, supplemented in just a few instances by contributions from her brothers and perhaps other close members of her immediate circle. While it is possible that John Molesworth may have been the translator of 'Runaway Love', Monck's competence in Italian is attested

[98] This episode is discussed by H. T. Dickinson in 'The Poor Palatines and the Parties', *English Historical Review*, 82 (1967), 464–85.

[99] The religious language and imagery employed in the 'Ode' – culminating in a direct reference to Exodus 10:23 – provides a further instance of the Molesworths' willingness to use Christianity, selectively, to enhance the appeal of their arguments to pious women readers.

by both external and internal evidence: externally through the evidence of Mary Banks's correspondence, internally through the testimony of Molesworth's preface and the praise accorded to Marinda's translation of the '*Maschrata delle Virtù contr' Amore*' in both English and Italian.[100] Mary's responsibility for the remaining translations in *Marinda* is thus likely, if not certain. But while the historical facts about *Marinda*'s authorship may never be fully known, the role of Marinda in the reader's experience of the volume is both clear and crucial. The texts attributed in 'Poems and Translations Upon Several Occasions' to Molesworth's 'Young Gentlewoman lately Dead' collectively produce a 'Marinda' who is not only a renowned beauty, a paragon of virtue, a good mother and a shrewd political commentator, but also a skilled translator and an impressively versatile poet. While her facility with epigrams, madrigals, sonnets and canzoni amply demonstrates her mastery of older poetic forms, a poem such as 'Ode on the Queen's Birth-day' similarly testifies to her command of a more up-to-date literary genre, the pindaric ode. However, this skill in appropriating contemporary genres, rewriting them in the service of the Molesworthian project, is at its most evident not in any of the texts in 'Poems and Translations Upon Several Occasions' but in the final, longest, and most ambitious poem in *Marinda*, the prospect poem 'Moccoli'.

'MOCCOLI'

'Moccoli' is unusual within *Marinda* in several respects. Although, bibliographically, it is continuous with the 'Poems and Translations' section of the volume, textually it is treated almost as a book within a book, separated from 'Poems and Translations' by its own title page. Following the title, 'Moccoli. A Poem', the endorsement 'Address'd to Colonel Richard Molesworth At the Camp at Pratz del Rey in Catalonia. Anno 1711' further sets it apart as the only poem in *Marinda* to refer directly to the Molesworth family (p. [141]). It is also provided with its own Horatian epigraph: '*Saevam / Militiam Puer, et Cantabrica bella tulisti*'.[101] This epigraph – 'Nay e'en your tender Age / Endur'd the Wars, and fierce Cantabrian rage', in Creech's translation – draws attention to Richard's extensive military experience, despite his comparative youth (he was 31 in 1711).[102] It thus introduces the topic, central to 'Moccoli', of service to one's country.

[100] On the Banks correspondence, see Grundy, *Lady Mary Wortley Montagu*, p. 24.
[101] Horace, *Satires*, p. 372 (Epistles 1.18.54–55).
[102] Creech, trans., *The Odes, Satyrs, and Epistles of Horace. Done into English* (1684), p. 518.

'Moccoli' is a prospect poem on the model of John Denham's *Cooper's Hill* (to which it explicitly refers in the concluding section). Like many prospect poems, including both *Cooper's Hill* and Pope's near-contemporary *Windsor Forest*, it is written in heroic couplets, grouped into verse-paragraphs. The speaker of the poem is apparently the Muse herself, who salutes Richard Molesworth in the opening section (p. 143) and retires, 'wearied', from her poetic 'Flight' in the final paragraph (p. 155). This, however, is a Muse with an avowed and intimate connection to the Molesworths: she addresses Richard as 'Our dear Soldier' (p. 143), and later speaks of his brother John's 'winning Air' as stealing into 'our Hearts' (p. 155). Thus, while the subject matter of 'Moccoli' is firmly focused on masculine activities – war, diplomacy – the narrative itself is overtly mediated by a female voice. By implication, this is the voice of Marinda.

'Moccoli' is set in two locations: Richard Molesworth's military camp in 'th'Iberian Fields' (p. 143) and the Tuscan hills around Moccoli, John Molesworth's country house near Florence. The opening section, addressed directly to Richard, loses no time in expanding on the martial achievements already signalled by the titular endorsement and epigraph. Richard is depicted as reaping the 'Noble Harvest' yielded by 'Honour', and is addressed as 'Future Hope of War' and 'Thou early Champion of true Liberty' (p. 143). This deft association between Richard and the most highly valued term in the Molesworths' political lexicon is quickly followed by a confident prediction of future achievements on his part, 'When at the Head of Armies Thou shalt show, / What thou hast learnt under Great Marlborough' (p. 143). Within the first page of 'Moccoli', the Muse has made her case for Richard to receive the military preferment which, on the record she describes, is clearly his due. The remaining sections of the poem are presented as a 'Song' which Richard can listen to, in his 'inmost Tent', during a well-earned retirement from the 'Noise and Throng' of battle (p. 144).

In the second verse-paragraph, the scene shifts to Tuscany, and to 'a Hill, that with a high Disdain / Surveys the lesser Swellings in the Plain' (p. 144). A footnote glossing the 'Hill' as that '[o]n which the Envoy's Villa or Country House stands' reworks the substance of an earlier note (p. 143), which had defined Moccoli as 'A Villa near Florence, where Her Majesty's Envoy liv'd'. Presumably Robert Molesworth – who, with John, is likely to have compiled these footnotes – wanted to take no chances that readers would fail to decode the less explicit allusions to his family in the Tuscan

section of the poem.[103] Meanwhile, the landscape surrounding Moccoli is invested with political significance, the speaker lamenting that the Arno, 'once the Tuscan Muses Theam', now flows 'ingloriously ... unenvy'd and unsung' (p. 144). The distinction between Moccoli – celebrated in the current poem – and its now 'unsung' Italian surroundings is also signalled by the 'high Disdain' with which the Envoy's hill regards its less exalted neighbours (the adjective 'high' both clarifying the legitimacy of this disdain and echoing the disparity between Moccoli and its neighbours). It is this contrast between the sorry state of contemporary Italy and the virtuous Britain represented by the Molesworth brothers that is the chief subject of the Tuscan sections of 'Moccoli'.[104]

Over the next five verse-paragraphs, the 'prospect' device is used to survey four neighbouring locations: Flora (Florence), Fiesole, Vallombrosa, and L'Arpeggi, the 'smiling Rural Seat' lately inhabited by Francesco de' Medici (pp. 145–54). In the first three instances, the emphasis in Marinda's narrative is on the political, religious or cultural poverty of the current landscape, often in contrast with its more admirable past. Florence itself provides an especially stark example of a culture in sad decline from its former greatness:

> Fair Flora, but alas! how chang'd we see
> The once fam'd Seat of Wealth and Liberty!
> To her th'Oppress'd fled for a safe Retreat,
> After successless Struggles with the Great ...
> No Thriving Crowds now in her Streets are found,
> But meager Want and Silence stalk the Round[.]
>
> *Marinda*, pp. 145–46

A reader who recollects the 'Ode on the Queen's Birth-day' will be aware that Florence's former role as refuge for the oppressed has now been assumed by Britain. Such a reader will also be unsurprised to find Marinda attributing Florence's loss of material and moral prosperity categorically to its loss of liberty. Explaining that those 'Treasures which by Industry procur'd, / By Liberty can only be secur'd', she imagines the current city as haunted by

> Ghosts of those murder'd Patriots who dy'd
> In Liberty's brave Cause, and Groan to see

[103] John's involvement is suggested by footnotes such as the gloss to 'lesser Swellings' – 'In the Valley there are many other little Hills every one of which has its Villa with Cypress Trees about it, and a Podere or Farm under it' – which look like eyewitness testimony.

[104] The cultural imperialism implicit in 'Moccoli' is discussed by Taylor-Fitzsimon (Taylor, 'Writing Women', esp. p. 601).

> Their base degenerate Off-spring bend the Knee
> To a Plebeian Stock[.]
>
> *Marinda*, p. 146

But Florence's discreditable history in fact long precedes its subjection to its 'Plebeian' rulers (the House of Medici). The sight of nearby Fiesole evokes recollections of how, centuries earlier, this 'Mother City' had been treacherously attacked and conquered by her 'Fairest Daughter', Flora (pp. 147–48). Tellingly, however, while Marinda holds Flora, with her 'Lust of Rule' (p. 147), primarily responsible for the clash with Fiesole, she does not wholly exonerate the latter. Her description of pre-conquest Fiesole, who

> proud, and secure
> Under the Shadow of past Greatness sat,
> Careless, and fearless, and provok'd her Fate
>
> *Marinda*, p. 147

offers a subtle, quasi-Tacitean analysis of the victim's complicity in her own downfall. It may also quietly hint that contemporary Florence, similarly dependent on 'past Greatness', is similarly vulnerable to external aggression.

It is in the Vallombrosa section of 'Moccoli' that the contrast between Britain and Italy, implicit in much of the poem, becomes most apparent. Sighting Vallombrosa, Marinda's first reaction is to recall, and defer to, its most famous English-language celebrant, Milton:[105]

> But how dare I rehearse
> Those awful Beauties sung in Milton's Verse?
> Thrice happy Vale! by his Immortal Wit
> You'll flourish, when your aged Trees submit
> To Avarice, or Fate
>
> *Marinda*, p. 150

But Marinda's homage to Milton is immediately thrown into sharp relief by her scornful description of the monks who currently inhabit Vallombrosa. A heavy mid-line caesura, breaking up her iambic pentameter, emphasises the discrepancy between Milton's immortalising poetry and the religious torpor of the monks:

> – A numerous Fry,
> The Lumber of the World, are here thrown by,
> Who're yet thought good enough their God to please,
> And here devoutly dull in reverend Ease

[105] Monck may be the first poet to comment on Milton's citation of Vallombrosa. See Edward Chaney, *The Evolution of the Grand Tour: Anglo-Italian Cultural Relations since the Renaissance* (London: Frank Cass, 1998), pp. 284–85.

Doze away Life, and in a Mystick Round
Of senseless Rites their Days and Nights confound.
Strange Charms this Place enchant with Holy Art,
They enter Fools, live Drones, and Saints depart[.]

Marinda, pp. 150–51

Marinda's condemnation of monastic life not only demonstrates her skill with poetic form – 'They enter Fools, live Drones, and Saints depart' has a mocking concision worthy of Pope – but also testifies to her typically Molesworthian hostility to organised religion in general and Catholicism in particular. While Marinda's attitude to religious faith, as opposed to religious structures, remains ambiguous in this passage, her use of Milton to denigrate Italian Catholicism implicitly elevates both English-language poetry and the sceptical traditions of English Protestantism. Given the late seventeenth-century appropriation of Milton as a Whig author, it also consolidates the party-political affiliations of *Marinda*.[106]

The final prospect surveyed by the Muse offers a more subtle vindication of the superiority of Moccoli over even its most impressive local rival. A lengthy verse paragraph (pp. 151–54) describes the country house L'Arpeggi, as it was lately inhabited by 'a most gen'rous Prince' and his 'Beauteous Bride' Leonora (pp. 151, 153). Monck describes the union of the Prince and Leonora as a love match, for which the former had given up a cardinal's hat and a chance of the papacy, and emphasises the happiness of their life together. L'Arpeggi itself is described as a place of 'Delight', in which the pleasures of 'Art' and 'wild Nature's Luxury' are perfectly combined (p. 153). Yet the scenes of hunting and fishing enjoyed by the Prince and Leonora, though reminiscent of both *Cooper's Hill* and Jonson's 'To Penshurst', carry a more threatening edge. The Hare is 'fearful', while 'The Feldfare struggles with the viscous Chain', and the 'Finny Race' pursued with 'Hooks, and Folding-Nets', clearly have no intention of leaping into their captors' clutches (p. 152).[107] Negative associations are also implied by the identification of the Prince as Francesco de' Medici (p. 151), a member of the 'Plebeian Stock' already condemned in the 'Flora' section of the poem. Most negative of all, however, is the abrupt conclusion of this section with the Prince's death and 'Leonora's Tears'. In the light of the Prince's death, the pleasures he shared with Leonora are bittersweet, as much past history as is Flora's role as haven for

[106] On the Whig interpretation of Milton, see Nicholas von Maltzahn, 'The Whig Milton, 1667–1700', in *Milton and Republicanism*, ed. by David Armitage, Armand Himy and Quentin Skinner (Cambridge University Press, 1995), pp. 229–53.

[107] Compare *Ben Jonson: The Oxford Authors*, ed. by Ian Donaldson (Oxford University Press, 1985), pp. 283 (31–38).

the oppressed. Pleasing as the prospect of 'L'Arpeggi' may be, it is a site of mourning, and offers no hope for the future.[108]

When hope does at last emerge, after so many scenes of Italian decline and disappointment, it is of course at Moccoli. The prospect device enhances the sense of inevitability as, in the penultimate section of the poem, the Muse returns to 'M – 's Hill, from whence we first did start' (p. 154). The would-be discreet initial 'M – ' scarcely conceals the identity of John Molesworth, whose character, abilities and household are summed up in eight of Monck's most value-laden couplets:

> Retiring here, He oft his Mind unbends,
> Enjoys himself, whilst he enjoys his Friends:
> Pure and unmix'd Delight! O blest Retreat!
> True Pleasures which with Thee wou'd be compleat.
> Let M – 's Name exalt these humble Lines,
> In whom an Universal Genius shines;
> Each, what he most affects, in Him may chuse,
> An easie Humour, or an easier Muse,
> A winning Air, that steals into our Hearts,
> The nicest Knowledge in those taking Arts
> That charm the Mind, a Conversation free
> At once from Emptyness, and Pedantry:
> Some may his steddy Gen'rous Soul revere,
> Not to be brib'd by Hope, or aw'd by Fear;
> Others his Skill in Men and Courts commend,
> Applaud the Minister; we'll love the Friend.
>
> *Marinda*, pp. 154–55

The John Molesworth described in these lines is a perfect embodiment of the personal, domestic and social virtues. The unambiguous happiness afforded by his household – 'Pure and unmix'd Delight!' – stands in stark contrast to the gloom of Florence and Fiesole, and even the flawed and temporary joys of Francesco de' Medici's L'Arpeggi, while the retirement it offers is more truly 'blest' than the sleepy monasticism of Vallombrosa. The combination of charm, good conversation and 'steddy' generosity credited to 'M – ' at once produces a model of sociable masculinity and constructs John, its exemplar, as both an eminently well-qualified 'Minister' and a lovable 'Friend'. Monck's reference to 'Thee' – Richard Molesworth – as the one missing element in the otherwise 'compleat' pleasures of his brother's house at Moccoli is both an

[108] As Taylor-Fitzsimon points out, Monck's tale of the Prince and Leonora – historically, a somewhat unsavoury marriage of convenience – might have carried satirical undertones for readers familiar with contemporary Florence. See Taylor, 'Writing Women', pp. 584–85.

affectionate compliment to her long-unmentioned addressee and a useful means of bringing the complementary talents of both brothers to the reader's attention. Just as Richard has proved himself a good servant to his country through his labours on the battlefield, John has similarly proved himself through his 'Skill in Men and Courts'.[109] The diplomatic abilities of one brother are the ideal counterpart to the military prowess of the other. A British state which knew its own best interests, the poem implies, would make still further use of these two outstanding young men.

Following this tribute to John Molesworth, 'Moccoli' draws quickly to a close. Monck's 'wearied Muse', humbly disclaiming her ability to match 'Denham's tow'ring heighth', vows to 'adore' his *Cooper's Hill* from her own more modest 'Rising-ground' (p. 155). If the royalist Denham seems an unlikely role model for a Molesworth, it is worth recalling that the conclusion to *Cooper's Hill* celebrates the great historic rapprochement of Magna Carta, through which the titles of 'Tyrant and slave' were commuted to 'King and Subject', the Crown laid down '[a]ll marks of arbitrary power', and liberty was guaranteed.[110] It thus affords an ideal precedent (in Molesworthian terms) for the Hanoverian monarchy. Meanwhile, 'Moccoli' – and *Marinda* – ends with one final literary allusion: another excerpt from Horace, this time lightly adapted to refer directly to Monck's addressee, Richard Molesworth:

> Vos Molefortem militiâ simul
> Fessas cohortes abdidit oppidis
> Finire quaerentem labores
> Pierio recreatis Antro.
> *Marinda*, pp. 156

Creech's translation of the equivalent lines reads:

> When [Molesworth], great as all our Hopes,
> In Towns hath hid his weary Troops,
> You cheer his Soul, you soften Cares,
> And ease the harsh fatigue of Wars[.][111]

[109] Some corroboration of Monck's praise of her brother can be found in Charles de Saint-Maure's description of John Molesworth, during his later posting to Turin, as 'the Delight of this whole Court'. See Charles de Saint-Maure, *A New Journey Through Greece, Ægypt, Palestine, Italy, Swisserland, Alsatia, and the Netherlands* (1725), pp. 137–38, and Michael Wynne, 'Some British Diplomats, some Grand Tourists and some students from Great Britain and Ireland in Turin in the eighteenth century', *Studi Piemontesi*, 25.1 (1996), 145–59 (p. 148).

[110] John Denham, *Expans'd Hieroglyphicks: A Critical Edition of Sir John Denham's Coopers Hill* (Berkeley, CA: University of California Press, 1969), p. 160.

[111] Creech, trans., *Odes*, p. 90; compare Horace, *Odes and Epodes*, trans. by Niall Rudd (Cambridge, MA: Harvard University Press, 2004), p. 154 (Ode 3.4, 37–40). Molesworth's 'Molefortem' adapts Horace's original 'Caesarum'.

The 'you' ('vos') of these lines is not Richard, but the Muses – and by extension 'Moccoli' itself, here imagined as providing solace for Richard at his encampment in Spain. The addition of this epigraph – again, presumably, the work of Robert Molesworth – ensures that *Marinda* ends with another specific allusion to the Molesworths, reminding the reader not only of Richard's military service but also of his more sociable qualities, through his appreciation of poetry. It also offers a final half-hidden compliment to Mary Monck, whose inspired poetic labours alone can offer her soldier-brother such comfort.

PUBLISHING *MARINDA*

Why did Robert Molesworth publish – and edit – his daughter's poems and translations? The simplest answer is probably that she was dead, and he could. Mary Monck, dead, was manipulable in a way that her surviving siblings were not – especially given her husband's apparent lack of involvement with her writings. It is noticeable that despite the known literary activities of so many of the Molesworth children, very few of their works underwent the transition from manuscript into print. Apart from *Marinda*, the only literary work by any of the Molesworths to be print-published was *The Roman Empresses*, a translation by Bysse, the seventh son, published as late as 1752. Perhaps the Molesworths feared that dabbling in poetry or even translation would look too frivolous in men such as John and Richard Molesworth, who aspired to serious careers in public life. Such concerns would not have attached to Mary Monck, though Robert Molesworth's assurance that she produced her poetry 'without omitting the daily Care due to a large Family' does hint at comparable – albeit gendered – anxieties. Even while introducing Monck's achievements as a poet and translator, Molesworth is careful to insist that they did not lead her to scant her duty.

In retrospect, the discovery of Mary Monck's poems and translations – 'in her Scrittore after her Death' – offered Robert Molesworth an ideal opportunity. Publishing a selection of his daughter's literary works – padded out with original-language texts and the contributions of her 'Friends' – gave him the occasion to do two politically useful things: to write publicly about women and to recommend his family to the new Hanoverian monarchy. Within *Marinda*, the femininity of the poet herself not only underpins Molesworth's address to Caroline of Ansbach but also helps to substantiate the politicised and moralised ideal of womanhood first outlined in the letter to the princess. It also, more subtly but no less

powerfully, hints at the still greater achievements that a man from this accomplished family could be expected to attain. If a mere woman from the Molesworth family could be as wise, linguistically adept and politically insightful as Marinda – a reader might think – how much more able and fit for public service should her menfolk be?

Marinda was entered in the Stationers' Register on 13 June 1716.[112] Robert Molesworth was created first Viscount Molesworth of Swords in the Irish peerage just a few weeks later, on 16 July. John Molesworth did not receive preferment until 1720, when he was appointed British envoy to Turin, while Richard Molesworth continued to serve with his regiment (which never did attain the title of the 'Princess's' or 'Prince Frederick's' Regiment) until 1718, when it was disbanded; his military career did not resume until 1724.[113] Perhaps *Marinda* played a part in obtaining Robert Molesworth's viscountcy; the coincidence of timing is suggestive, but Molesworth's value as a potential ally in the Irish House of Lords may have been rather more relevant. The benefits he had hoped would accrue to his two eldest sons seem not to have materialised. Caroline of Ansbach's copy of *Marinda* survives in the British Library's collections, but the few annotations it preserves bear no resemblance to the princess's handwriting.[114] Caroline herself may never have read it.

[112] Robin Myers, ed., *Records of the Worshipful Company of Stationers*, 115 microfilm reels (Cambridge: Chadwyck Healey, 1985), part 1, reel 6, p. 236.

[113] H. M. Chichester, 'Molesworth, Richard', *ODNB*.

[114] Caroline's copy of *Marinda* is now BL 79 d. 1. See Jay, 'Queen Caroline's Library', p. 54.

Conclusion: producing women's poetry

Among the poets addressed in *Producing Women's Poetry*, Mary Monck is in many ways the exception to the rule. Despite their many differences, Anne Southwell, Anne Bradstreet, Katherine Philips and Anne Finch each display a self-consciousness as poetic agents and an interest in the production and material organisation of their own writings that is difficult to detect in Monck's contributions to *Marinda*. Similarly, whereas Southwell, Bradstreet, Philips and Finch can each be shown to have sustained their commitment to poetry throughout their adult lives, the chronology of Monck's work on her poems and translations is, with a few significant exceptions, all but impossible to trace. The appropriation of Monck's poetry by her father, Robert Molesworth, is so complete as to have almost entirely suppressed the evidence for his daughter's own textual agency or self-understanding as a writer. Even the generic range of her work as witnessed by *Marinda* cannot be taken at face value as reflecting her own interests and priorities, but is rather a posthumous construct, the result as much of Molesworth's exclusions as Monck's inclusions. That this full-scale suppression of Monck's agency and reconstruction of her canon should have occurred as late as 1716 is a salutary reminder of how problematic the production of women's poetry continued to be, even at the outset of the eighteenth century.

To assess how the production of women's poetry changed in the long seventeenth century, we must look beyond the canon of poets so far addressed in *Producing Women's Poetry* and consider the most ambitious and inventive female-authored collection of the early part of the period, Aemilia Lanyer's *Salve Deus Rex Judaeorum* (1611). *Salve Deus*, innovative in so many ways, is especially remarkable for its confidence in manipulating genre, appropriating social and cultural authority, and engaging with English poetic traditions. Its elaborate prefatory section reworks the conventions of patronage poetry in explicitly gendered terms, constructing Lanyer's all-female addressees as 'a community of good women' whose

exemplary femininity enables them to appreciate both the sufferings of Christ and Lanyer's own poetic skills.[1] The remaining sections of the volume are also generically innovative: the central 'Salve Deus' not only presumes to retell the story of Christ's passion, but also creatively reinterprets texts from across the Bible to vindicate women and denounce men, while 'The Description of Cooke-ham' is the first known English country house poem, predating the publication of Ben Jonson's 'To Penshurst' by five years. As well as detailed knowledge of the Bible, Lanyer's collection shows both a sound understanding of classical history and mythology and evidence of critical engagement with earlier English poets such as Daniel and Drayton. In 'The Authors Dreame to the ... Countesse Dowager of Pembrooke' she also provides one of the earliest witnesses to a self-conscious women's literary tradition in English, praising Pembroke's (as yet unpublished) psalm paraphrases and acclaiming the poet herself as 'farre before' her brother, Philip Sidney, for 'virtue, wisedome, learning, dignity'.[2] Though critics now query the 'feminism' attributed to Lanyer in earlier scholarship, there can be no doubt that *Salve Deus Rex Judaeorum* represents one of the most sophisticated and audacious poetic collections by a seventeenth-century Englishwoman. Its reputation as a foundational text within English women's literary history is thoroughly deserved.

Yet from another angle, *Salve Deus* looks rather different: less an adroit appropriation of early seventeenth-century literary forms than a courageous but flawed cultural intervention by a poet whose understanding of her readership and command of her materials were too often imperfect. Her dedicatory verses are socially misordered, giving too much prominence to the ageing Countess of Pembroke at the expense of the influential Countess of Bedford.[3] The importance attributed to the Countess of Cumberland within the 'Salve Deus' poem itself is not only a potential affront to each of Lanyer's other dedicatees, including Queen Anne, but on occasions verges on the blasphemous: she twice apologises to the Countess for writing about Christ instead of her.[4] There is also a curious mismatch between the addressees named within Lanyer's volume and the recipients of the two surviving presentation copies: while the former are all female,

[1] Barbara Lewalski, 'Of God and Good Women: The Poems of Aemilia Lanyer', in *Silent But for the Word: Tudor Women as Patrons, Translators, and Writers of Religious Works*, ed. by Margaret Hannay (Kent State University Press, 1985), pp. 203–24 (p. 224).

[2] *The Poems of Aemilia Lanyer*, ed. by Susanne Woods (Oxford University Press, 1993), p. 28 (151, 152).

[3] Leeds Barroll, 'Looking for Patrons', in *Aemilia Lanyer: Gender, Genre, and the Canon*, ed. by Marshall Grossman (Lexington, KY: University Press of Kentucky, 1998), pp. 29–48 (pp. 39–40).

[4] Lanyer, *Poems*, pp. 57 (145–47), 62 (265–67).

the latter are both men, and neither Henry, Prince of Wales, nor Thomas Jones, Archbishop of Dublin, seems like an ideal reader for the anti-patriarchal rhetoric of *Salve Deus*. Overall, it is hard to avoid the conclusion that – in social terms at least – Lanyer misjudged her prefatory materials, addressing them to a readership which, with the possible exception of Cumberland and her daughter, she did not fully understand and to which she had no realistic means of access. Anomalies in the construction of the volume (the rhetorically excessive attention paid to the Countess of Cumberland, the inconsistent cross-referencing between 'Salve Deus' and 'The Description of Cooke-ham') also witness to the less than complete success with which Lanyer's numerous texts – some, perhaps, independently conceived and composed – were combined into a single collection.[5] Though none of these misjudgements or anomalies seriously detracts from Lanyer's achievement in *Salve Deus*, they witness to the difficulties – social, educational, literary – to which even the most determined, skilled and well-read women poets of the period were likely to be subject. They may also explain why *Salve Deus* seems to have failed in one of its author's key aims: that of gaining the patronage of some of the most powerful women in England. Ironically, manuscript – more readily adjustable for multiple readers – would probably have served her purposes better than print.[6]

As *Producing Women's Poetry*, like much recent scholarship, has emphasised, early modern women's poetry does not represent a single, unbroken narrative of progress. If we respect our materials, we cannot tell a simple story in which women poets gradually gain better access to print, engage with more challenging topics and genres, and establish themselves as professional literary writers. Though elements within this narrative are, of course, correct, it fails to do justice to the complexity of women's literary experience in the long seventeenth century. As *Salve Deus* demonstrates, even a poet who gained access to print might not succeed in achieving her own aims, still less in influencing subsequent generations of women writers. Yet the evident audacity of 'Salve Deus' should also unsettle any narrative which constructs the history of women's poetry in terms of increased generic challenge or writerly confidence; for a seventeenth-century Englishwoman, little could be more challenging or require more self-confidence than Lanyer's project of rewriting nearly 1600 years of biblical interpretation. Furthermore, Lanyer's apparent failure to

[5] On Lanyer's cross-referencing, compare the (misleading) 'Salve Deus', 17–24 (Lanyer, *Poems*, pp. 51–52) with the more accurate version in 'The Description', 5–6 (Lanyer, *Poems*, p. 130).
[6] Longfellow, *Women and Religious Writing*, pp. 66–67.

gain financially from her one venture into print-publication should not obscure the fact that, for a poet of her period, earning money through literary patronage was a valid possibility – and in the case of *Salve Deus* might well have succeeded had its manipulation of print conventions been more shrewd or more carefully targeted. Indeed, Aemilia Lanyer, preparing *Salve Deus* in the early 1610s, may have had better prospects of earning at least a temporary living from poetry than did Aphra Behn, whose attempt to coax £25 out of Jacob Tonson for her 1684 *Poems Upon Several Occasions* make painful reading and may not have been successful.[7] If we recall the poets discussed in *Producing Women's Poetry* – Southwell, with her exclusive concentration on manuscript; Bradstreet, Philips, Finch and Monck, with their complicated and often inadvertent relationships with print-publication – the limitations of the 'progress' account of seventeenth-century women's poetry become all the more apparent.

A more modest, but more defensible, version of the 'progress' narrative is to see the seventeenth and early eighteenth centuries as a time of expanding possibilities for English women poets. How complicated – and often counter-intuitive – some of these possibilities might be can be glimpsed if we again look beyond the case studies examined in *Producing Women's Poetry* and compare the work of two other mid-century women writers, Margaret Cavendish and Lucy Hutchinson. Cavendish, though dismissed by Virginia Woolf as 'untutored', is now recognised as an intellectually adventurous writer whose poetry shows the influence both of Lucretian philosophy and of English poets such as Milton and Herrick.[8] She is also one of the most strongly print-identified of all seventeenth-century women writers, and was closely involved with both the publication and dissemination of her numerous literary works (scarcely any of which survive in manuscript form).[9] Her one single-volume collection of poetry, *Poems and Fancies*, though not the first of her works to be written, was the first to reach print; on Cavendish's own account, she thought her philosophical mistakes might be treated more kindly by readers if expressed in verse rather than in prose.[10] Her defence of her own emergence as a

[7] On Lanyer and the Cumberland women, see Longfellow, *Women and Religious Writing*, p. 65. For Behn's letter to Tonson, see M. L. Stapleton, *Admired and Understood: The Poetry of Aphra Behn* (Newark, DE: University of Delaware Press, 2004), pp. 47–48, and below.

[8] Emma Rees, *Margaret Cavendish: Gender, Genre, Exile* (Manchester University Press, 2003), pp. 54–79; Hero Chalmers, '"Flattering Division": Margaret Cavendish's Poetics of Variety', in *Authorial Conquests: Essays on Genre in the Writings of Margaret Cavendish*, ed. by Line Cottegnies and Nancy Weitz (London: Associated University Presses, 2003), pp. 123–44.

[9] Whitaker, *Mad Madge*, pp. 312–14. [10] Margaret Cavendish, *Poems and Fancies* (1653), sig. A6r.

print author shows an awareness – rare among mid-seventeenth-century English women – of a distinctively female literary tradition: she compares the censure she is likely to elicit from male readers to that previously suffered by 'the Lady that wrote the Romancy' (Mary Wroth).[11] She also assumes sole responsibility for the publication of her collection, insisting that 'I have not asked leave of any Freind thereto'.[12] Remarkably, even in her first venture into the print-publishing world, Cavendish shows a keen awareness of the potential of her medium. The paratexts to the volume include a frontispiece portrait of the poet herself, draped in classical robes, as well as prefatory letters mediating her works for different readerships (including 'ladies' and 'natural philosophers') and a self-deprecating final poem in which she attributes all her best literary qualities to her husband. She even concludes the volume by alerting her readers to the imminent publication of her next work, the *Philosophical Fancies*.[13] Within the main body of the volume, the apparently random organisation of the 'poems and fancies' is in fact structured by a royalist-inflected dialogic engagement with Lucretius's *De Rerum Natura*, culminating in a reaffirmation of monarchical authority.[14] As a collection, Cavendish's *Poems and Fancies* represented both an expansion of the intellectual territory available to women poets and a confident manipulation of the resources of print. In both respects, it offered an obvious potential role model for subsequent women writers.

Yet there is little evidence that later seventeenth-century women poets did take inspiration from Margaret Cavendish. This lack of influence can easily be explained by factors such as Cavendish's rank and reputation for eccentricity; the former shielded her from many of the social pressures which continued to inhibit other women, while the latter made her an example to be avoided, not followed. (Similarly, few other women could have hoped to enjoy such enthusiastic support as Cavendish received from her husband, William, for her later ventures into print.) But it would also be a mistake to assume that all women poets of this period had the kind of literary aspirations best satisfied by Cavendish-style print-publication. One who clearly did not was Cavendish's contemporary (and political opposite) Lucy Hutchinson. Hutchinson – a prolific poet, translator and memoirist – was an almost exclusively manuscript-based writer, only one of whose works (the first five cantos of her biblical paraphrase, *Order and Disorder*) was published during her lifetime. Typically, Hutchinson's

[11] Cavendish, *Poems and Fancies*, sig. A3v.
[12] Cavendish, *Poems and Fancies*, sig. A4v.
[13] Cavendish, *Poems and Fancies*, p. 214.
[14] Rees, *Margaret Cavendish*, pp. 59–70.

comments on her own writing stress its role as practical help for her family or herself: her *Life* of her husband is presented as moral and biographical advice for their young children, while she claims to have translated Lucretius's *De Rerum Natura* merely in order to understand 'things I heard so much discourse of at second hand' – and to have embarked on *Order and Disorder* to cleanse her brain from the adverse effects of reading Lucretius.[15] Her reasons for composing her elegies and epitaphs on her husband are unstated, but presumably included attempts at self-consolation, as well as – as in the *Life* – describing his virtues for the benefit of their children. Evidently, print-publication was not necessary for any of these ends to be achieved.

But the comparison between the circulation practices of the flamboyant Margaret Cavendish and the self-effacing Lucy Hutchinson is more complex than this straightforward contrast suggests. Although Hutchinson seems to have written mainly for her own or her family's benefit, she was also willing to countenance the wider transmission of her work in certain circumstances. Her satirical poem 'To Mr Waller upon his Panegyrique to the Lord Protector' survives among the papers of the Clarendon family, while her Lucretius translation is extant in a presentation manuscript dedicated to the Earl of Anglesey.[16] Moreover, differences between the published and manuscript versions of *Order and Disorder*, cantos 1–5, also suggest Hutchinson's own direct involvement in revising her text for publication. Why she chose to publish is unclear; her own explanation – that she 'sent forth' her biblical poem to pre-empt the possible publication of her Lucretius translation – may be correct, but feels like a thin justification for such a radical departure from her usual habits. David Norbrook speculatively links the 1679 publication of *Order and Disorder* with the involvement of Hutchinson's circle in the Exclusion Crisis; however, it is questionable whether Hutchinson, a firm republican, would have troubled to intervene in events which posed no threat to the future of the monarchy.[17] Another possibility is that Hutchinson's poem, which ends by advocating 'constant fortitude' and recourse to the 'true rest' found only in God, was intended to model an appropriate puritan response to religious persecution (past and prospective) by the Stuarts.[18]

[15] *Lucy Hutchinson's Translation of Lucretius, De Rerum Natura*, ed. by Hugh de Quehen (Ann Arbor, MI: University of Michigan Press, 1996), p. 23.

[16] David Norbook, 'Lucy Hutchinson versus Edmund Waller: An Unpublished Reply to Waller's *A Panegyrick to my Lord Protector*', *The Seventeenth Century* 11.1 (1996), 61–86 (pp. 61–62); Hutchinson, *Lucretius*, pp. 23–27.

[17] Lucy Hutchinson, *Order and Disorder*, ed. by David Norbrook (Oxford: Blackwell, 2001), p. xx.

[18] Hutchinson, *Order and Disorder* (1679), pp. 77, 78.

Whatever the reason, one factor which clearly played no part in Hutchinson's decision to print-publish her work – unlike Cavendish's – was any desire for self-promotion. The printed edition of *Order and Disorder* was anonymous, and was not attributed to Hutchinson until the 1990s.[19]

By the late 1660s and early 1670s, when Hutchinson was writing her elegies on her late husband, the literary possibilities open to women had undergone a decisive change. As described in Chapter Three, the publication of Katherine Philips's posthumous *Poems* in 1667 was key to redefining cultural assumptions and establishing literary writing – even in print – as an acceptable activity, especially for royalist women. Hutchinson's republicanism may have been one reason why she, in general, eschewed print-publication, though considerations of subject and genre are likely to have been still more compelling: the elegies would have been too personal, *De Rerum Natura* too theologically dangerous, to commit to print. Another, though more nebulous, factor may have been her attitude to poetry, which seems to have differed from her female contemporaries' in several important respects. Hutchinson's personal dedication to poetry cannot be doubted: it is inherent in her use of verse for such lengthy projects as her Lucretius translation and *Order and Disorder*, as well as in her employment of scribes to produce fair copies of her works. However, compared with Philips in particular, Hutchinson seems to have had less interest in poetic experimentation for its own sake than in using verse form as a means to an – often didactic – end. (In this, ironically, she is closer to Cavendish, given the latter's openly functional attitude to poetry in *Poems and Fancies*) The intellectual ambition of her major literary projects – unequalled by any other woman in this period – masks an approach to poetry which is oddly but consistently reactive: 'To Mr Waller', the Lucretius translation and *Order and Disorder* are all, in their different ways, answer poems, while even the elegies were produced in response to a specific event, the death of John Hutchinson. Though she was clearly well read in sixteenth- and seventeenth-century English poetry, engaging with literary tradition appears to have ranked relatively low among her concerns, and her use of varying metres is comparatively slight. She also seems to have had little interest in collecting her own poetical works, each of which now survives in a separate manuscript.[20] Of all her poems, only

[19] David Norbrook, 'Lucy Hutchinson and *Order and Disorder*: The Manuscript Evidence', *English Manuscript Studies* 9 (2000), 257–91.
[20] The separate survival of Hutchinson's poems may also be due in part to their genre: the Lucretius translation and *Order and Disorder* are both freestanding (and very lengthy) texts,

the elegies are presented as a collection, albeit rather contradictorily, their orderly form (progressing from meditative elegies through epitaphs to songs) contrasting with a narrative structure which repeatedly resists consolatory resolution, its end no less grief-stricken than its beginning. For the most part, given her attitudes, genres and subjects, Hutchinson had no need of either the material resources or the public readership afforded by print; her distinctive combination of familial, theological and political priorities was much more adequately served by manuscript. By comparison, *Order and Disorder* is the exception that proves the rule; while her reasons for undertaking this one foray into print-publication may still be unclear, the desire to communicate her theological views beyond her immediate circles was presumably among them. When it suited her interests, Lucy Hutchinson would use print-publication as readily as Margaret Cavendish, though for very different reasons.

Only in the mid-1680s, when Cavendish, Hutchinson and Philips were all dead, did professionalisation become an active issue for women poets, and even then rather problematically. Aphra Behn's only collection of her own poetry, *Poems Upon Several Occasions*, was published in 1684, over a decade after she had begun writing for the London stage. By 1684, many of Behn's plays had already been printed, and several of her poems had also been published in miscellanies, as broadsides, or as commendatory verses for other writers.[21] Her apparent delay in issuing her collected poems was due not – as with so many of her female predecessors – to modesty, but to commercial imperatives; she seems to have focused her efforts on poetry only after the demand for new plays had begun to decline in the early 1680s. Ironically, despite her obvious divergence from the more demure traditions of women's poetry, even Behn found it expedient to invoke the authorising precedent of Katherine Philips, albeit in a somewhat incongruous context; pleading with Tonson that her erotic translation, 'A Voyage to the Island of Love', deserved an extra £5, she also suggested that – as the longest item in her volume – it should be located last, on the model of Philips's dramatic translations in the Herringman *Poems*.[22] Tempting though it may be to read this comparison with Philips as self-conscious identification with a female literary tradition, the fuller context suggests otherwise: Behn cites the treatment of Cowley's 'Davideis' alongside that

while the most appropriate context for 'To Mr Waller' is not alongside her other compositions but in dialogue with Waller's own 'Panegyrick'.

[21] See ESTC and *The Works of Aphra Behn*, vol. 1, ed. by Janet Todd (Columbus, OH: Ohio State University Press, 1992), pp. 373–84.

[22] Stapleton, *Admired and Understood*, pp. 47–48.

of Philips's *Pompée* and *Horace*, with no implication that the latter is a more appropriate precedent than the former. What does clearly emerge from Behn's argument, however, is her strong – if possibly optimistic – sense of the monetary value of her own writing, as well as her concern for the appropriate organisation of her collection. Her bibliographical arguments seem to have carried weight with Tonson, who did place 'A Voyage' at the end of *Poems Upon Several Occasions*. We do not know if he paid Aphra Behn her extra £5.

As a poet, Behn shows a commitment to print matched only (amongst her female predecessors) by Margaret Cavendish. Her keen understanding of the opportunities afforded by print-publication is shown not only by her negotiations with Tonson, but also by her canny use of materials within *Poems* itself. The volume is dedicated to the Earl of Salisbury, a youthful Tory who had recently succeeded a Whig father and whose patronage offered lucrative possibilities for the ultra-royalist Behn. Her preface praises the earl's loyalty, applauds his resistance to the politically corrupting effects of his education, and flatters him as 'Great ... Noble and ... Brave'.[23] Nine commendatory poems by male writers, possibly commissioned by Behn herself, salute her poetic abilities in specifically gendered terms; she is hailed as the 'wonder of thy Sex' and 'Britannia of our Land', and is compared to both Sappho and Katherine Philips.[24] Her own 'poems upon several occasions' encompass a diverse range of genres, including excerpts from her own plays ('Love Arm'd', 'The Surprize'), translations from French ('The Golden Age', 'A Voyage to the Island of Love'), imitations of classical literature ('In Imitation of Horace', 'A Paraphrase On Ovid's Epistle of Oenone to Paris'), and numerous songs and epistles. Her collection also includes both sexually explicit poems, such as 'On a Juniper-Tree' and 'The Disappointment', and overtly partisan political verses, such as 'The Cabal at Nickey Nackeys' and 'Silvio's Complaint'. Literary roles assumed by Behn's speakers construct her variously as an urbane theatre professional ('A Letter to a Brother of the Pen in Tribulation'), a poetic disciple of the late Earl of Rochester ('To Mrs. W. On her Excellent Verses'), and a Latinless woman indebted to the labours of more educated men ('To Mr. Creech ... on his Excellent Translation of Lucretius'). She also deliberately courts a reputation for religious heterodoxy in her allusion to Lucretius's 'Reason' as conquering 'poor Feeble Faith's dull Oracles'; the equivalent line as it appears in the

[23] Aphra Behn, *Poems Upon Several Occasions* (1684), sigs A3r, A2r.
[24] Stapleton, *Admired and Understood*, p. 20; Behn, *Poems*, sigs A8v, b8v, A7r, b5v–b6v, b8v.

preliminaries to Creech's translation refers to 'strong … Faiths resistless Oracles'.[25] Yet despite the eclectic and apparently random array of genres and topics within *Poems*, the volume is subtly structured through a complex series of thematic and verbal connections, with the concluding item, 'A Voyage', recapitulating, expanding and interrogating many of the ideas first raised in the opening poem, 'The Golden Age'.[26] If, as seems likely, this structure was planned by Behn herself, it provides still further evidence of her professional skill, bibliographical acumen and attention to detail.

As even Virginia Woolf acknowledged, Aphra Behn left a difficult legacy for later women writers. Both her sexual frankness and her professionalism made her a problematic role model for gentlewomen and aristocratic poets who cherished their reputation for chastity and respectability and were less willing than she to connive – openly at least – with the commercial book trade. The writers who most obviously followed her example were dramatists such as Mary Pix and Susannah Centlivre, and prose-writers such as Delarivier Manley and Eliza Haywood: women whose choice of genre automatically risked compromising their reputation for propriety and sexual virtue. Within poetry, however, the famously racy flavour of Behn's *Poems Upon Several Occasions* can easily disguise the many other respects in which her collection resembles, rather than diverging from, the work of earlier seventeenth-century female writers. Behn's poems on love and politics, as well as her songs, retirement lyrics, translations and imitations, and complimentary poems to literary friends and potential patrons, all have precedents among previous women poets, including Philips, Lanyer and even Lucy Hutchinson. Even the striking secularity of Behn's *Poems* – probably deliberate, given the omission of her 'Paraphrase on the Lords Prayer' – has a precedent in Cavendish's *Poems and Fancies*.[27] It is generic affinity, as well as the unquestionable skill and wit of her verses, that explains the impeccably proper Anne Finch's citation of Behn – albeit a sanitised, partially desexualised version of Behn – as a poetic ideal in 'The Circuit of Appollo'. It is telling, however, that 'The Circuit', discreetly obscured even within Finch's Folger manuscript, was omitted from her one published collection, the *Miscellany Poems*, in 1713. For Finch, even so limited a self-identification with the still-controversial Aphra Behn was unacceptable in print.

[25] Compare Behn, *Works*, pp. 26 (56–58), 29 and 383.
[26] Stapleton, *Admired and Understood*, pp. 48–64.
[27] The 'Paraphrase' was first printed in Behn's edited *Miscellany* in 1685; it is possible but unlikely that its composition postdates the compilation of *Poems*.

Read against the key issues addressed in *Producing Women's Poetry* –
textuality, agency and genre – Behn's *Poems Upon Several Occasions*
emerges less as a rupture than as an only mildly anomalous intervention
within women's literary history. Even Behn's full-scale commitment to
print and her unconcealed involvement with the publication process are
anticipated by Margaret Cavendish, and indeed – as also with Cavendish –
seem to have exerted relatively little influence on later writers. In the years
after 1684, women poets such as Jane Barker, rather than following Behn
into print-publication, continued to work in the ambiguous middle
ground between manuscript and print, their practice more reminiscent
of earlier writers such as Katherine Philips and even Anne Bradstreet than
of Aphra Behn.[28] Such collections of women's poetry as did appear in
print were still more often due to the agency of male editors or publishers
than to the female poets themselves: Barker's *Poetical Recreations* (1688)
and Elizabeth Singer's *Poems on Several Occasions* (1696), as well as Anne
Killigrew's *Poems* (1686) and Mary Monck's *Marinda*, are cases in point.[29]
Even posthumous collections of women's poetry, though sometimes com-
mitted to print, were still frequently retained in manuscript, where they
were often produced with great care and devotion to detail. Osborn MS
b. 408, a compilation of poetry by Anne Wharton, shows attention both to
internal planning and to the construction of the poet's image: the poems
are organised by subject, beginning with Wharton's biblical paraphrases
and concluding with her versions of Virgil and Ovid, while Edmund
Waller's complimentary poem 'Of Devine Poesy' is also included immedi-
ately after Wharton's paraphrase of Isaiah 53, to which it directly refers.[30]
Still more elaborate is a memorial manuscript of Octavia Walsh's poetry
and devotional prose, prepared by her nephew, William Bromley, after
her death in 1706; as well as corrected copies of her poems, organised
and divided by subject, it includes a portrait of the author, a biographical
headnote, and a meticulous title page.[31] The reason why Wharton and
Walsh remained in manuscript while Killigrew and Monck made the
further transition into print seems to have been less a matter of the kind

[28] On Barker, see King, *Jane Barker*, and Eicke, 'Jane Barker's Jacobite Writings'. Barker's apparent
willingness to print-publish her prose fiction forms an interesting contrast with her attitude to
poetry.
[29] On Singer, see Sarah Prescott, *Women, Authorship and Literary Culture, 1690–1740* (Basingstoke:
Palgrave, 2003), pp. 169–70.
[30] The manuscript is undated (and incomplete), but the absence of the poet's hand as well as the many
small uncorrected errors in transcription suggest that it probably postdates Wharton's death in 1685.
[31] British Library RP 343; for Walsh's authorial copies of her own poems, see Bodleian Library MS
Eng. poet. e. 31. The current whereabouts of Bromley's original manuscript is unknown.

or quality of their poetry than of the habits and interests of their respective families. Killigrew and Monck both belonged to families with a history of print-publication, and both had male relatives who could expect to benefit from publishing their works. The same did not apply to Wharton and Walsh, whose families' desire for textual memorialisation was apparently satisfied by manuscript alone.[32]

Even by the 1710s, the decade of Finch's *Miscellany Poems* and Monck's *Marinda*, it was by no means inevitable that any woman poet who took her writing seriously would want to collect it for print-publication. Lady Mary Wortley Montagu, whose town eclogues also date from this period, is an obvious instance to the contrary.[33] More apposite is Margaret Ezell's comment – originally applied to post-Restoration England but still more relevant to the early eighteenth century – that 'women poets' manuscripts had more ways of moving into print than ever before': ways which might, but still need not, include the agency of the poet herself.[34] If any woman poet of this period does mark a clear transition towards a more print-based model of female poetic authorship, it is not the overtly radical Aphra Behn, still less the relatively conservative Anne Finch or the scarcely knowable Mary Monck. All these women, varied and often innovative as they were, are still largely comprehensible in terms of norms and expectations familiar from the mid-seventeenth century, the time of Margaret Cavendish and Katherine Philips. To see how a woman, formed amid these earlier norms, might nonetheless learn to thrive in the very different world of early eighteenth-century print, we must look elsewhere – to the Devonshire poet, Mary Chudleigh.

Born in 1656, Chudleigh remained an exclusively manuscript-based writer until her mid-forties. Though her early literary activities are difficult to chart (no manuscripts of her writings are known to survive), by at least 1697 her work had reached the attention of such influential men of letters as John Dryden, William Walsh and Jacob Tonson.[35] However, her initial transition into print seems not to have been directly assisted by her literary friends (she was not published by Tonson), and her first publication, far

[32] Walsh's brother, William, did publish a few poems during his lifetime, but is characterised by his biographer as having 'a gentlemanly negligence about publication' (James Sambrook, 'Walsh, William', *ODNB*).

[33] On Montagu's eclogues – all retained in manuscript by the author; three surreptitiously printed by Curll in 1716 – see Grundy, *Lady Mary Wortley Montagu*, pp. 103–12.

[34] Margaret Ezell, 'From Manuscript to Print', in Sarah Prescott and David E. Shuttleton, eds., *Women and Poetry 1660–1750* (Basingstoke: Palgrave, 2003), pp. 140–60 (p. 158).

[35] Mary Chudleigh, *The Poems and Prose of Mary, Lady Chudleigh*, ed. by Margaret Ezell (Oxford University Press, 1993), p. xvii.

from representing a considered collection of her life's work to date, consists of a single topical poem introduced by two polemical prefaces. *The Ladies Defence* (1701), an 845-line poetic dialogue, is a direct response to John Sprint's *The Bride-Woman's Counseller*, a misogynistic sermon published in 1699. Dedicated to 'All Ingenious Ladies', *The Ladies Defence* was technically anonymous, but the initials appended to the 'Epistle Dedicatory' ('M——y C——') would have been easy to decode, especially since Chudleigh also admits in her 'Preface to the Reader' to a direct connection with Sprint.[36] Though very properly deploying the modesty topos (she apologises for her 'mean Performance' in refuting Sprint's arguments), Chudleigh clearly relished her opportunity not only to defend women but also to outline her views on the importance of women's reading and moral self-education. In the 'Defence' itself, she unashamedly gives all the best lines to her one female character, Melissa, while in her 'Epistle Dedicatory' she advises her lady readers to school themselves into a 'happy disposition of Mind' through reading stoic philosophers such as Seneca and Epictetus and classical poets such as Homer and Virgil.[37] She also praises some (unnamed) 'modern Ladies' as 'renown'd for Knowledge, and for Sense, / For sparkling Wit, and charming Eloquence'.[38] Mary Chudleigh's ideal woman, like Robert Molesworth's, is fully adept in the social graces, but is more openly and deliberately cerebral and well-read.

What sets Chudleigh apart from her female contemporaries – more even than the 'protofeminism' of her poetry – is the shape and self-confidence of her subsequent publishing career.[39] *The Ladies Defence* was followed in 1703 by a second publication, *Poems on Several Occasions* – this time explicitly attributed to 'the Lady Chudleigh'. A third collection, *Essays upon Several Subjects in Prose and Verse*, also published under Chudleigh's own name, appeared in 1710. Not only did both *Poems* and *Essays* (like the *Defence*) include a polemical preface, advocating women's intellectual engagement with philosophy and literature, each is dedicated to an important and carefully chosen patron: *Poems* to Queen Anne, whose young son is commemorated in an elaborate elegy; *Essays* to the Electress Sophia of Hanover, who was known for her interest in philosophy and ethics. As with the *Defence*, there is no obvious sign that publication of either *Poems* or *Essays* was assisted by a helpful male friend; there are no

[36] Mary Chudleigh, *The Ladies Defence* (1701), sig. a1v. [37] Chudleigh, *The Ladies Defence*, sig. a11r–v.
[38] Chudleigh, *The Ladies Defence*, p. 19. The unnamed ladies probably include Mary Astell, the addressee of one of Chudleigh's verse epistles in *Poems on Several Occasions* (1703).
[39] On Chudleigh's 'protofeminism', see Rebecca Mills, 'Mary, Lady Chudleigh (1656–1710): Poet, Protofeminist and Patron', in Prescott and Shuttleton, eds., *Women and Poetry*, pp. 50–59.

commendatory materials by other writers, and the only voice to be heard in the preliminaries to the volumes is that of the author herself. Both Chudleigh's proprietorial attitude to her own writings and her sensitivity to print textuality are further evinced in the preface to her *Essays*, where she sharply criticises Bernard Lintott, publisher of her 1703 *Poems*, for reprinting *The Ladies Defence* not only without her permission but also without the introductory materials necessary to put her arguments in context; in consequence, she complains, Lintott 'has left the Reader wholly in the Dark, and expos'd me to Censure'.[40] Her decision to entrust *Essays* to a rival consortium of publishers was not only an obvious snub to the offending Lintott but also an attempt to regain control over her own publications. Having learnt to exploit the textual possibilities of print, Chudleigh would not readily let them go.

Mary Chudleigh's late flowering as a print-published author marks an important transitional moment in the history of English women's poetry. Her three printed collections show that, by the early eighteenth-century century, it was possible for a woman to print-publish original and even controversial poetry, within her own lifetime, respectably, and without scandal. Half a century after the death of Katherine Philips, they also confirmed that the success of Philips's *Poems* was not a unique achievement and that the best poetry by women was capable of attaining both a solid and a prolonged public readership. Lintott, undaunted, would produce two further editions of Chudleigh's poems, still including the *Defence* but omitting its preliminaries, albeit not until after the poet's death; a final edition, by another publisher, was to follow in 1750.[41] Publishers, if not yet the poets themselves, were apparently profiting from women's poetry.

In the century following *Salve Deus Rex Judaeorum*, English women's poetry expanded and prospered. Its story in this period is not one of radical transformation, still less of the emergence of the woman poet as an autonomous professional writer. Even Mary Chudleigh, probably the most successful female poet of the early eighteenth century, remained a gentlewoman amateur, whose longest poem, 'The Song of the Three Children', belongs to the same genre – biblical paraphrase – favoured by both Lanyer and Southwell, nearly 100 years earlier.[42] As late as the 1710s and 20s,

[40] Mary Chudleigh, *Essays upon Several Subjects in Prose and Verse* (1710), sig. A5r.

[41] Chudleigh died in December 1710; Lintott's two posthumous editions followed in 1713 and 1722. It seems unlikely Chudleigh's objections would have deterred him even if she had lived.

[42] Janine Barchas aptly describes Chudleigh's involvement in print culture as 'tentative'; see her 'Before Print Culture: Mary, Lady Chudleigh, and the Assimilation of the Book', in *Eighteenth-Century Genre and Culture: Serious Reflections on Occasional Forms: Essays in Honour of J. Paul Hunter*, ed. by Dennis Todd and Cynthia Wall (Newark, DE: University of Delaware Press, 2001), pp. 15–35 (p. 18).

manuscript still retained its appeal for many women, valued by poets as diverse as Anne Finch, Elizabeth Rowe and Judith Cowper as a repository for sensitive materials or work in progress, a safe space for experimentation, or a site for privileged communication and debate.[43] Meanwhile, the interventions of a Bernard Lintott or a Robert Molesworth offer a salutary reminder that, even at the start of the eighteenth century, the print-publication of women's poetry was still more likely to signal appropriation and exploitation than independent agency or professional success. A century after Lanyer, the production of women's poetry was still often difficult and contentious, its reception a matter of controversy or oblivion. But against the odds, a public tradition of women's poetry was now firmly in place, and more people than ever – publishers and readers as well as poets and their families – had an interest in seeing it flourish. Its expansion and prosperity were set to continue.

[43] On Rowe and Cowper, see Kathryn King, 'Elizabeth Singer Rowe's Tactical Use of Print and Manuscript', in Justice and Tinker, eds., *Women's Writing*, pp. 158–81, and Valerie Rumbold, 'The Poetic Career of Judith Cowper: An Exemplary Failure?', in *Pope, Swift, and Women Writers*, ed. by Donald C. Mell (Newark, DE: University of Delaware Press, 1996), pp. 48–66.

Select bibliography

MANUSCRIPTS

British and Irish repositories

Bodleian Library, Oxford. MSS Eng. poet. e. 31 (Octavia Walsh), Eng. th. c. 25 (Heneage Finch)

British Library, London. Additional MSS 10037 (Jane Seager), 21621 (Jane Barker), 41161 (Ann Fanshawe), 78440 and 78441 (Mary Evelyn), Lansdowne MS 740 (Anne Southwell), RP 343 (Octavia Walsh)

Cardiff Central Library. MS 2.1073 (Katherine Philips)

Lichfield Cathedral Library. MS 2 (William Kingsmill)

Magdalen College, Oxford. MS 343 (Jane Barker)

National Archives, London. PRO SP/98/23 (John Molesworth)

National Library of Wales. MSS 775B, 776B (Katherine Philips, 'Tutin MS', 'Rosania MS')

Northamptonshire Record Office. MS Finch Hatton 283 (Anne Finch)

Worcester College, Oxford. MSS 6.13 (Katherine Philips, 'Clarke MS')

North American repositories

Folger Shakespeare Library, Washington. MSS N.b.3 (Anne Finch), V.a.104 (Mary Wroth), V.a.166 (Elizabeth Lucy/Martha Eyre), V.b.198 (Anne Southwell), V.b.231 (Katherine Philips)

Harvard College Library. Houghton MS Am 1007.1 (Anne Bradstreet)

Huntington Library, San Marino. MS HM 600 (Mary Wroth)

Newberry Library, Chicago. Case MS fY 1565.W 95 (Mary Wroth)

University of Texas at Austin. Pre-1700 MS 151 (Katherine Philips, 'Dering MS')

Wellesley College, Massachusetts. Wellesley College MS (Anne Finch)

Yale University Library. Osborn MS b.408 (Anne Wharton)

EARLY PRINTED TEXTS

Ballard, George, *Memoirs of Several Ladies of Great Britain* (1752)
Behn, Aphra, *Poems Upon Several Occasions* (1684)
Bradstreet, Anne, *Several Poems* (1678)
 The Tenth Muse Lately Sprung up in America (1650)
Cavendish, Margaret, *Poems and Fancies* (1653)
Chudleigh, Mary, *Essays upon Several Subjects in Prose and Verse* (1710)
 Poems On Several Occasions (1703)
 The Ladies Defence (1701)
Creech, Thomas, trans., *The Odes, Satyrs, and Epistles of Horace. Done into English*
 (1684)
Daniel, Samuel, *The Civil Wars* (1609)
Finch, Anne, *Miscellany Poems On Several Occasions* (1713)
Finch, Francis, *Friendship* [1654]
Firmin, Giles, *A Serious Question Stated* (1651)
Hutchinson, Lucy, *Order and Disorder* (1679)
Jacob, Giles, *An Historical Account of the Lives and Writings of our most
 Considerable English Poets* (1720)
Lanyer, Aemilia, *Salve Deus Rex Judaeorum* (1611)
Lock, Anne, trans., *Of the Markes of the Children of God* (1590)
Makin, Bathsua, *An essay to revive the antient education of gentlewomen in religion,
 manners, arts and tongues* (1673)
Molesworth, Robert, *An Account of Denmark, as It was in the Year 1692* (1694)
 trans., *Franco-Gallia: Or, An Account of the Ancient Free State of France, and
 Most Other Parts of Europe, before the Loss of their Liberties* (1711), second
 edition (1721)
 Some Considerations for the Promoting of Agriculture, and Employing the Poor
 (Dublin, 1723)
 The Principles of A Real Whig (1775)
Montagu, Lady Mary Wortley, *Letters of the Right Honourable Lady Mary Wortley
 Montagu*, vol. 1 (1763)
Monck, Mary, *Marinda: Poems and Translations upon Several Occasions* (1716)
Ogilby, John, *The Fables of Aesop Paraphras'd in Verse* (1651)
Overbury, Sir Thomas, *A Wife Now the Widdow of Sir Thomas Overbury*, second
 edition (1614)
Philips, Katherine, *Letters from Orinda to Poliarchus* (1705)
 Poems. By the Incomparable K. P. (1664)
 *Poems By the most deservedly Admired Mrs Katherine Philips, The matchless
 Orinda* (1667)
 *Poems By the most deservedly Admired Mrs Katherine Philips, The matchless
 Orinda* (1669)
Poems, by Several Persons (1663)
Pope, Alexander, ed., *Poems on Several Occasions* (1717)
Raleigh, Sir Walter, *The History of the World* (1614)

Sainte-Maure, Charles de, *A New Journey Through Greece, Ægypt, Palestine, Italy, Swisserland, Alsatia, and the Netherlands* (1725)

Swift, Jonathan, *A Letter to the Right Honourable the Lord Viscount Molesworth* (1724)

Toland, John, *A Collection of Several Pieces*, vol. 1 (1726)

Vertue Rewarded; Or, The Irish Princess (1693)

Ward, Nathaniel, *The Simple Cobler of Aggawam* (1647)

Wheatley, Phillis, *Poems on Various Subjects, Religious and Moral* (1773)

Whitney, Isabella, *A Sweet Nosgay, or Pleasant Posye* (1573)

 The Copy of a Letter (1567)

Wroth, Mary, *The Countesse of Mountgomeries Urania* (1621)

MODERN EDITIONS AND ANTHOLOGIES

Behn, Aphra, *The Works of Aphra Behn*, vol. 1, ed. by Janet Todd (Columbus, OH: Ohio State University Press, 1992)

Bradstreet, Anne, *The Complete Works of Anne Bradstreet*, ed. by Joseph R. McElrath Jr. and Allan P. Robb (Boston, MA: Twayne, 1981)

 The Works of Anne Bradstreet, ed. by Jeannine Hensley (Cambridge, MA: The Belknap Press of Harvard University Press, 1967)

 The Works of Anne Bradstreet in Prose and Verse, ed. by John Harvard Ellis (Charlestown, MA: A. E. Cutter, 1867)

Brown, Sylvia, *Women's Writing in Stuart England: The Mothers' Legacies of Dorothy Leigh, Elizabeth Joscelin, and Elizabeth Richardson* (Stroud: Sutton, 1999)

Butler, Samuel, *Hudibras*, ed. by John Wilders (Oxford: Clarendon Press, 1967)

'C.D.' [Isaac Reed], 'To the Editor', *The European Magazine*, 38 (1800), 423–24

Cartwright, William, *The Plays and Poems of William Cartwright*, ed. by G. Blakemore Evans (Madison, WI: University of Wisconsin Press, 1951)

Chudleigh, Mary, *The Poems and Prose of Mary, Lady Chudleigh*, ed. by Margaret Ezell (Oxford University Press, 1993)

Denham, John, *Expans'd Hieroglyphicks: A Critical Edition of Sir John Denham's Coopers Hill* (Berkeley, CA: University of California Press, 1969)

Dryden, John, *The Poems of John Dryden*, vol. 3, ed. by Paul Hammond and David Hopkins (London: Longman, 2000)

 The Works of John Dryden, vol. 5, ed. by William Frost and Vinton A. Dearing (Berkeley, CA: University of California Press, 1987)

Finch, Anne, *The Anne Finch Wellesley Manuscript Poems*, ed. by Barbara McGovern and Charles H. Hinnant (Athens, GA: University of Georgia Press, 1998)

 The Poems of Anne Countess of Winchilsea, ed. by Myra Reynolds (University of Chicago Press, 1903)

Herodotus, *Herodotus*, trans. by A. D. Godley, vol. 2 (Cambridge, MA: Harvard University Press, 1982)

Historical Manuscripts Commission, *Report on Manuscripts in Various Collections*, vol. VIII (London: His Majesty's Stationery Office, 1913)

Horace, *Odes and Epodes*, trans. by Niall Rudd (Cambridge, MA: Harvard University Press, 2004)

Satires, Epistles, and Ars Poetica, trans. by H. Rushton Fairclough (Cambridge, MA: Harvard University Press, 1970)

Hutchinson, Lucy, *Lucy Hutchinson's Translation of Lucretius, De Rerum Natura*, ed. by Hugh de Quehen (Ann Arbor, MI: University of Michigan Press, 1996)

Order and Disorder, ed. by David Norbrook (Oxford: Blackwell, 2001)

Jantz, Harold, *The First Century of New England Verse* (Worcester, MA: Proceedings of the American Antiquarian Society, 1944)

Jonson, Ben, *Ben Jonson: The Oxford Authors*, ed. by Ian Donaldson (Oxford University Press, 1985)

Lanyer, Aemilia, *The Poems of Aemilia Lanyer*, ed. by Susanne Woods (Oxford University Press, 1993)

Locke, John, *The Correspondence of John Locke*, ed. by E. S. de Beer, vol. 6 (Oxford: Clarendon Press, 1981)

Ludlow, Edmund, *A Voyce from the Watch Tower*, ed. by A. B. Worden, Camden Society fourth series, vol. 21 (London: Royal Historical Society, 1978)

Molesworth, Robert, *An Account of Denmark: with Francogallia & Some Considerations for the Promoting of Agriculture and Employing the Poor*, ed. by Justin Champion (Indianapolis, IN: Liberty Fund, 2011)

Myers, Robin, ed., *Records of the Worshipful Company of Stationers*, 115 microform reels (Cambridge: Chadwyck Healey, 1985)

Paton, W. R., trans., *The Greek Anthology*, vol. 3 (London: Heinemann, 1916)

Philips, Katherine, *Orinda: The Literary Manuscripts of Katherine Philips (1632–1664)*, 4 microform reels (Marlborough: Adam Matthews, 1995)

The Collected Works of Katherine Philips: The Matchless Orinda, vols 1–2, ed. by Patrick Thomas (Stump Cross Books, 1990–92)

Raleigh, Walter, *The Poems of Sir Walter Ralegh: A Historical Edition*, ed. by Michael Rudick (Tempe, AZ: Medieval and Renaissance Text and Studies, 1999)

Ross, Ian Campbell and Anne Markey, eds., *Vertue Rewarded; Or, The Irish Princess* (Dublin: Four Courts Press, 2010)

Southwell, Anne, *The Southwell-Sibthorpe Commonplace Book: Folger MS V.b.198*, ed. by Jean Klene (Tempe, AZ: Medieval and Renaissance Texts and Studies, 1997)

Stevenson, Jane and Peter Davidson, eds., *Early Modern Women Poets, 1520–1700* (Oxford University Press, 2001)

Stuart, Arbella, *The Letters of Lady Arbella Stuart*, ed. by Sara Jayne Steen (Oxford University Press, 1995)

Woolf, Virginia, *A Room of One's Own and Three Guineas*, ed. by Hermione Lee (London: Vintage, 1996)

The Diary of Virginia Woolf, vol. II: 1920–1924, ed. by Anne Olivier Bell and Andrew McNeillie (London: Hogarth Press, 1978)

Wroth, Mary, *Mary Wroth's Poetry: An Electronic Edition*, ed. by Paul Salzman http://wroth.latrobe.edu.au

The Early Modern Englishwoman: A Facsimile Library of Essential Works, Part I: Printed Writings 1500–1640, vol. 10, ed. by Josephine A. Roberts (Aldershot: Scolar Press, 1996)

The Poems of Lady Mary Wroth, ed. by Josephine A. Roberts (Baton Rouge, LA: Louisiana State University Press, 1983)

SECONDARY TEXTS

Allen, Robert, 'Steele and the Molesworth Family', *The Review of English Studies*, 12.48 (1936), 449–54

Arkell, R. L., *Caroline of Ansbach: George the Second's Queen* (Oxford University Press, 1939)

Backscheider, Paula, *Eighteenth-Century Women Poets and their Poetry: Inventing Agency, Inventing Genre* (Baltimore, MD: Johns Hopkins University Press, 2005)

Barash, Carol, *English Women's Poetry, 1649–1714: Politics, Community, and Linguistic Authority* (Oxford University Press, 1996)

Barchas, Janine, 'Before Print Culture: Mary, Lady Chudleigh, and the Assimilation of the Book', in *Eighteenth-Century Genre and Culture: Serious Reflections on Occasional Forms: Essays in Honour of J. Paul Hunter*, ed. by Dennis Todd and Cynthia Wall (Newark, DE: University of Delaware Press, 2001), pp. 15–35

Barroll, Leeds, 'Looking for Patrons', in *Aemilia Lanyer: Gender, Genre, and the Canon*, ed. by Marshall Grossman (Lexington, KY: University Press of Kentucky, 1998), pp. 29–48

Beal, Peter, *In Praise of Scribes* (Oxford University Press, 1998)

 ed., *Index of English Literary Manuscripts*, vols I (1450–1625) and II (1625–1700) (London: Mansell, 1980–93)

 'Notions in Garrison: The Seventeenth-Century Commonplace Book', in *New Ways of Looking at Old Texts: Papers of the Renaissance English Text Society, 1985–1991*, ed. by W. Speed Hill (Binghamton, NY: Renaissance English Text Society, 1993), pp. 131–47

Bell, Maureen, 'Hannah Allen and the Development of a Puritan Publishing Business, 1646–51', *Publishing History*, 26 (1989), 5–66

 'Seditious Sisterhood: Women Publishers of Opposition Literature at the Restoration', in *Voicing Women: Gender and Sexuality in Early Modern Writing*, ed. by Kate Chedgzoy, Melanie Hansen and Suzanne Trill (Keele University Press, 1996), pp. 185–95

Bevan, Jonquil, 'Isaac Walton and his Publisher', *The Library*, 32.4 (1977), 344–59

Bland, Mark, *A Guide to Early Printed Books and Manuscripts* (Oxford: Wiley-Blackwell, 2010)

Brady, Andrea, 'The Platonic Poems of Katherine Philips', *The Seventeenth Century*, 25.2 (2010), 300–22

'"Without welt, gard, or embroidery": A Funeral Elegy for Cicely Ridgeway, Countess of Londonderry (1628)', *Huntington Library Quarterly*, 72.3 (2009), 373–95

Brown, Michael, *Francis Hutcheson in Dublin, 1719–1730* (Dublin: Four Courts Press, 2002)

Brown, Sarah Annes, 'Women Translators', in *The Oxford History of Literary Translation in English*, vol. 3 (1660–1790), ed. by Stuart Gillespie and David Hopkins (Oxford University Press, 2005), pp. 111–20

Burke, Victoria E., 'Medium and Meaning in the Manuscripts of Anne, Lady Southwell', in *Women's Writing and the Circulation of Ideas: Manuscript Publication in England, 1550–1800*, ed. by George L. Justice and Nathan Tinker (Cambridge University Press, 2002), pp. 94–120

'"The art of Numbering well": Late Seventeenth-Century Arithmetic Manuscripts Compiled by Quaker Girls', in *Material Readings of Early Modern Culture: Texts and Social Practices, 1580–1730*, ed. by James Daybell and Peter Hinds (Basingstoke: Palgrave, 2010), pp. 246–65

Burke, Victoria E. and Jonathan Gibson, eds., *Early Modern Women's Manuscript Writing* (Aldershot: Ashgate, 2004)

Caldwell, Patricia, 'Why Our First Poet Was a Woman: Bradstreet and the Birth of an American Poetic Voice', *Prospects*, 13 (1988), 1–35

Cavanaugh, Jean Carmel, 'Lady Southwell's Defense of Poetry', *English Literary Renaissance*, 14.3 (1984), n.p.n.

'The Library of Lady Southwell and Captain Sibthorpe', *Studies in Bibliography*, 20 (1967), 243–54

Chalmers, Hero, '"Flattering Division": Margaret Cavendish's Poetics of Variety', in *Authorial Conquests: Essays on Genre in the Writings of Margaret Cavendish*, ed. by Line Cottegnies and Nancy Weitz (London: Associated University Presses, 2003), pp. 123–44

Royalist Women Writers, 1650–1689 (Oxford University Press, 2004)

Champion, Justin, 'Enlightened Erudition and the Politics of Reading in John Toland's Circle', *The Historical Journal*, 49.1 (2006), 111–41

Republican Learning: John Toland and the Crisis of Christian Culture, 1696–1722 (Manchester University Press, 2003)

Chaney, Edward, *The Evolution of the Grand Tour: Anglo-Italian Cultural Relations since the Renaissance* (London: Frank Cass, 1998)

Chedgzoy, Kate, *Women's Writing in the British Atlantic World: Memory, Place and History, 1550–1700* (Cambridge University Press, 2007)

Chernaik, Warren, 'Philips, Katherine (1632–1664)', *ODNB* (2004)

Chichester, H. M., 'Molesworth, Richard, third Viscount Molesworth (1680–1758)', rev. by Jonathan Spain, *ODNB* (2007)

Clarke, Danielle, *The Politics of Early Modern Women's Writing* (Harlow: Longman, 2001)

Clarke, Elizabeth, 'Anne Southwell and the Pamphlet Debate: The Politics of Gender, Class, and Manuscript', in *Debating Gender in Early Modern*

England, 1500–1700, ed. by Cristina Malcolmson and Mihoko Suzuki (Basingstoke: Palgrave, 2002), pp. 37–53

Clerke, A. M., 'Molyneux, Samuel (1689–1728)', rev. by Anita McConnell, *ODNB* (2004)

Considine, John, 'The Invention of the Literary Circle of Sir Thomas Overbury', in *Literary Circles and Cultural Communities in Renaissance England*, ed. by Claude J. Summers and Ted-Larry Pebworth (Columbia, MO: University of Missouri Press, 2000), pp. 59–74

Coolahan, Marie-Louise, '"We live by chance, and slip into Events": Occasionality and the Manuscript Verse of Katherine Philips', *Eighteenth-Century Ireland*, 18 (2003), 9–23

 Women, Writing, and Language in Early Modern Ireland (Oxford University Press, 2010)

Crawford, Patricia, 'Women's Published Writings, 1600–1700', in *Women in English Society, 1500–1800*, ed. by Mary Prior (London: Methuen, 1985), pp. 211–82

Cust, Richard, *The Forced Loan and English Politics, 1626–1628* (Oxford: Clarendon Press, 1987)

Daub, Peggy, 'Queen Caroline of England's Music Library', in *Music Publishing and Collecting: Essays in Honor of Donald W. Krummel*, ed. by David Hunter (Urbana, IL: University of Illinois at Urbana-Champaign, 1994), pp. 131–65

Derounian-Stodola, Kathryn Zabelle, '"The Excellency of the Inferior Sex": The Commendatory Writings on Anne Bradstreet', *Studies in Puritan American Spirituality*, 1 (1990), 129–47

DeZur, Kathryn, '"Vaine Books" and Early Modern Women Readers', in *Reading and Literacy in the Middle Ages and Renaissance*, ed. by Ian Moulton (Turnhout, Belgium: Brepols, 2004), pp. 105–25

Dickinson, H. T., 'The Poor Palatines and the Parties', *English Historical Review*, 82 (1967), 464–85

Dorris, George E., *Paolo Rolli and the Italian Circle in London 1715–1744* (The Hague: Mouton, 1967)

Eames, John, 'Sir William Kingsmill (1613–1661) and His Poetry', *English Studies*, 67.2 (1986), 126–56

Eberwein, Jane Donahue, 'Civil War and Bradstreet's "Monarchies"', *Early American Literature*, 26.2 (1991), 119–44

 '"No rhet'ric we expect": Argumentation in Bradstreet's "The Prologue"', *Early American Literature*, 16.1 (1981), 19–26

Eicke, Leigh A., 'Jane Barker's Jacobite Writings', in *Women's Writing and the Circulation of Ideas: Manuscript Publication in England, 1550–1800*, ed. by George L. Justice and Nathan Tinker (Cambridge University Press, 2002), pp. 137–57

Engberg, Kathrynn Seidler, *The Right to Write: The Literary Politics of Anne Bradstreet and Phillis Wheatley* (Lanham, MD: University Press of America, 2010)

Evans, Robert C., 'Paradox in Poetry and Politics: Katherine Philips in the Interregnum', in *The English Civil Wars in the Literary Imagination*, ed. by

Claude Summers and Ted-Larry Pebworth (Columbia, MO: University of Missouri Press, 1999), pp. 174–85

Ezell, Margaret, 'From Manuscript to Print', in *Women and Poetry 1660–1750*, ed. by Sarah Prescott and David E. Shuttleton (Basingstoke: Palgrave, 2003), pp. 140–60

'Monck, Mary (1677?–1715)', *ODNB* (2004)

Social Authorship and the Advent of Print (Baltimore, MD: Johns Hopkins University Press, 1999)

'The Posthumous Publication of Women's Manuscripts and the History of Authorship', in *Women's Writing and the Circulation of Ideas: Manuscript Publication in England, 1550–1800*, ed. by George L. Justice and Nathan Tinker (Cambridge University Press, 2002), pp. 121–36

Writing Women's Literary History (Baltimore, MD: Johns Hopkins University Press, 1993)

Faith, Melanie, 'Correcting the Date of the "conceited *Newes*"', *Notes and Queries*, 53.4 (2006), 505–8

Fink, Zera, *The Classical Republicans* (Evanston, IL: Northwestern University Press, 1945)

Fitzmaurice, James, 'Cavendish, Margaret, duchess of Newcastle upon Tyne (1623?–1673)', *ODNB* (2004)

Freeman, Arthur, 'The Historical Thought of Samuel Daniel: A Study in Renaissance Ambivalence', *Journal of the History of Ideas*, 32.2 (1971), 185–202

Fritze, Ronald H., 'Kingsmill family (*per. c.*1480–1698)', *ODNB* (2004)

Gallagher, Catherine, 'Embracing the Absolute: The Politics of the Female Subject in Seventeenth-Century England', *Genders*, 1 (1988), 24–39

Gavin, Michael, 'Critics and Criticism in the Poetry of Anne Finch', *English Literary History*, 78.3 (2011), 633–55

Gentles, Ian J., 'Skippon, Philip, appointed Lord Skippon under the protectorate (*d.* 1660)', *ODNB* (2004)

Gerrard, Christine, 'Queens-in-Waiting: Caroline of Anspach and Augusta of Saxe-Gotha as Princesses of Wales', in *Queenship in Britain, 1660–1837: Royal Patronage, Court Culture and Dynastic Politics*, ed. by Clarissa Campbell Orr (Manchester University Press, 2002), pp. 143–61

Gibson, Jonathan, 'Synchrony and Process: Editing Manuscript Miscellanies', *Studies in English Literature, 1500–1900*, 52.1 (2012), 85–100

Gillespie, Stuart, 'Dillon, Wentworth, fourth earl of Roscommon (1637–1685)', *ODNB* (2004)

Gim, Lisa, 'Representing the "Phoenix Queen": Elizabeth I in Writings by Anna Maria van Schurman and Anne Bradstreet', in *Resurrecting Elizabeth I in Seventeenth-Century England*, ed. by Elizabeth Hageman and Katherine Conway (Madison, NJ: Fairleigh Dickinson University Press, 2007), pp. 168–84

Goldberg, Jonathan, *Desiring Women Writing: English Renaissance Examples* (Stanford University Press, 1997)

Gray, Catharine, 'Katherine Philips and the Post-Courtly Coterie', *English Literary Renaissance*, 32.3 (2002), 426–51

Women Writers and Public Debate in Seventeenth-Century Britain (Basingstoke: Palgrave, 2007)

Greer, Germaine, *Slip-Shod Sibyls: Recognition, Rejection and the Woman Poet* (London: Penguin, 1996)

Grundy, Isobel, *Lady Mary Wortley Montagu: Comet of the Enlightenment* (Oxford University Press, 1999)

Hageman, Elizabeth, 'Katherine Philips, *Poems*', in *A Companion to Early Modern Women's Writing*, ed. by Anita Pacheco (Oxford: Blackwell, 2002), pp. 189–202

'Making a Good Impression: Early Texts of Poems and Letters by Katherine Philips, the "Matchless Orinda"', *South Central Review*, 11.2 (1994), 39–65

'Treacherous Accidents and the Abominable Printing of Katherine Philips's 1664 *Poems*', in *New Ways of Looking at Old Texts*, vol. III, ed. by W. Speed Hill (Tempe, AZ: Arizona Center for Medieval and Renaissance Studies in conjunction with Renaissance English Text Society, 2004), pp. 85–95

Hageman, Elizabeth, and Andrea Sununu, '"More Copies of it abroad than I could have imagin'd": Further Manuscript Texts of Katherine Philips, The Matchless Orinda', *English Manuscript Studies 1100–1700*, 5 (1995), 127–169

'New Manuscript Texts of Katherine Philips, The "Matchless Orinda"', *English Manuscript Studies 1100–1700*, 4 (1993), 174–219

Hammond, Paul, *The Making of Restoration Poetry* (Woodbridge: Boydell and Brewer, 2006)

Hanham, Andrew, 'Caroline of Brandenburg-Ansbach and the "Anglicisation" of the House of Hanover', in *Queenship in Europe, 1660–1815: The Role of the Consort*, ed. by Clarissa Campbell Orr (Cambridge University Press, 2004), pp. 276–99

Hannay, Margaret, *Mary Sidney, Lady Wroth* (Farnham: Ashgate, 2010)

Harvey, Tamara, '"My goods are true": Tenth Muses in the New World Market', in *Feminist Interventions in Early American Studies*, ed. by Mary C. Carruth (Tuscaloosa, AL: Alabama University Press, 2006), pp. 13–26

Hayton, D. W., 'Robert, first Viscount Molesworth (1656–1725), *ODNB* (2008)

Heller, Jennifer, *The Mother's Legacy in Early Modern England* (Farnham: Ashgate, 2011)

Hinnant, Charles H., *The Poetry of Anne Finch: An Essay in Interpretation* (Newark, DE: University of Delaware Press, 1994)

Hobbs, Mary, *Early Seventeenth-Century Verse Miscellany Manuscripts* (Aldershot: Scolar Press, 1992)

Hobby, Elaine, '"Oh Oxford Thou Art Full of Filth": The Prophetical Writings of Hester Biddle, 1629(?)–1696', in *Feminist Criticism: Theory and Practice*, ed. by Susan Sellers, Linda Hutcheon and Paul Perron (University of Toronto Press, 1991), pp. 157–69

Horn, D. B., *British Diplomatic Representatives, 1689–1789* (London: Royal Historical Society, 1932)

Hutton, Ronald, 'Vaughan, Richard, second earl of Carbery (1600?–1686)', *ODNB* (2004)

Ingrao, Charles W., and Andrew L. Thomas, 'Piety and Power: The Empresses-Consort of the High Baroque', in *Queenship in Europe, 1660–1815: The Role of the Consort*, ed. by Clarissa Campbell Orr (Cambridge University Press, 2004), pp. 107–30

Institute of Historical Research, 'Household of Princess Caroline 1714–27', http://history.ac.uk/publications/office/caroline

Jay, Emma, 'Queen Caroline's Library and Its European Contexts', *Book History*, 9 (2006), 31–55

Johns, Adrian, *The Nature of the Book: Print and Knowledge in the Making* (University of Chicago Press, 1998)

Jordan, Nicolle, '"Where Power Is Absolute": Royalist Politics and the Improved Landscape in a Poem by Anne Finch, Countess of Winchilsea', *Eighteenth Century*, 46.3 (2005), 255–75

Justice, George L. and Nathan Tinker, eds., *Women's Writing and the Circulation of Ideas: Manuscript Publication in England, 1550–1800* (Cambridge University Press, 2002)

Keeble, N. H., 'Bradstreet, Anne (1612/13–1672)', *ODNB* (2004)

Kerrigan, John, *Archipelagic English: Literature, History, and Politics 1603–1707* (Oxford University Press, 2008)

Kieven, Elisabeth, 'An Italian Architect in London: The Case of Alessandro Galilei (1691–1737)', *Architectural History*, 51 (2008), 1–31

King, Kathryn, 'Elizabeth Singer Rowe's Tactical Use of Print and Manuscript', in *Women's Writing and the Circulation of Ideas: Manuscript Publication in England, 1550–1800*, ed. by George L. Justice and Nathan Tinker (Cambridge University Press, 2002), pp. 158–81

 Jane Barker, Exile: A Literary Career, 1675–1725 (Oxford: Clarendon Press, 2000)

Klein, Lawrence, 'Politeness and the Interpretation of the British Eighteenth Century', *The Historical Journal*, 45.4 (2002), 869–89

Klene, Jean, '"Monument of an Endless affection": Folger MS V.b.198 and Lady Anne Southwell', *English Manuscript Studies 1100–1700*, 9 (2000), 165–86

 'Southwell, Anne, Lady Southwell (*bap*. 1574, *d*. 1636)', *ODNB* (2004)

Larminie, Vivienne, 'King, Anne (*b*. in or before 1621, *d*. 1684x1701)', *ODNB* (2008)

Levy, F. J., *Tudor Historical Thought* (San Marino, CA: Huntington Library, 1967)

Lewalski, Barbara, 'Of God and Good Women: The Poems of Aemilia Lanyer', in *Silent But for the Word: Tudor Women as Patrons, Translators, and Writers of Religious Works*, ed. by Margaret Hannay (Kent State University Press, 1985), pp. 203–24

Lewis, Jayne Elizabeth, *The English Fable: Aesop and Literary Culture, 1651–1740* (Cambridge University Press, 1996)

Lim, Paul C.-H., 'Woodbridge, Benjamin (1622–1684)', *ODNB* (2004)

Lindsay, Alexander, *Index of English Literary Manuscripts*, vol. III (*1700–1800*), part 4 (London: Mansell, 1997)

Llewellyn, Mark, 'Katherine Philips: Friendship, Poetry and Neo-Platonic Thought in Seventeenth Century England', *Philological Quarterly*, 81.4 (2002), 441–68

Longfellow, Erica, *Women and Religious Writing in Early Modern England* (Cambridge University Press, 2004)

Loscocco, Paula, 'Inventing the English Sappho: Katherine Philips's Donnean Poetry', *Journal of English and Germanic Philology*, 102.1 (2003), 59–87

Love, Harold, *Scribal Publication in Seventeenth-Century England* (Oxford: Clarendon Press, 1993)

Major, Philip, '"A credible omen of a more glorious event": Sir Charles Cotterell's *Cassandra*', *The Review of English Studies*, 60.245 (2009), 406–30

Maltzahn, Nicholas von, 'The Whig Milton, 1667–1700', in *Milton and Republicanism*, ed. by Quentin Skinner, Armand Himy and David Armitage (Cambridge University Press, 1995), pp. 229–53

Marotti, Arthur, *Manuscript, Print, and the English Renaissance Lyric* (Ithaca, NY: Cornell University Press, 1995)

Marshall, Alan, 'Blood, Thomas (1617/18–1680)', *ODNB* (2008)

Martin, Wendy, *An American Triptych: Anne Bradstreet, Emily Dickinson, Adrienne Rich* (Chapel Hill, NC: University of North Carolina Press, 1984)

Martz, Louis. L., *The Poetry of Meditation: A Study in English Religious Literature of the Seventeenth Century* (New Haven, CT: Yale University Press, 1962)

McDowell, Paula, *The Women of Grub Street: Press, Politics, and Gender in the London Literary Marketplace, 1678–1730* (Oxford: Clarendon Press, 1998)

McGovern, Barbara, *Anne Finch and Her Poetry: A Critical Biography* (Athens, GA: University of Georgia Press, 1992)

McKitterick, David, *Print, Manuscript, and the Search for Order, 1450–1830* (Cambridge University Press, 2003)

McParland, Edward, *Public Architecture in Ireland, 1680–1760* (New Haven, CT: Yale University Press, 2001)

Merrim, Stephanie, *Early Modern Women's Writing and Sor Juana Inús de la Cruz* (Liverpool University Press, 1999)

Messenger, Ann, 'Publishing Without Perishing: Lady Winchilsea's *Miscellany Poems* of 1713', *Restoration: Studies in English Literary Culture, 1660–1700*, 5.1 (1981), 27–37

Mills, Rebecca M., 'Mary, Lady Chudleigh (1656–1710): Poet, Protofeminist and Patron', in *Women and Poetry 1660–1750*, ed. by Sarah Prescott and David E. Shuttleton (Basingstoke: Palgrave, 2003), pp. 50–59

Moody, Ellen, 'A Review of *The Anne Finch Wellesley Manuscript Poems*' http://jimandellen.org/finch/review.mcgovern.html

'An Epistle, from Mrs Randolph, To Mrs Finch' www.jimandellen.org/finch/randolph.html

'Orinda, Lucasia, Rosania *et aliae*: Towards a New Edition of the Works of Katherine Philips', *Philological Quarterly*, 66.3 (1987), 325–54

Niemeyer, Carl, 'A Roscommon Canon', *Studies in Philology*, 36.4 (1939), 622–36

Norbrook, David, 'Lucy Hutchinson and *Order and Disorder*: The Manuscript Evidence', *English Manuscript Studies 1100–1700*, 9 (2000), 257–91

'Lucy Hutchinson versus Edmund Waller: An Unpublished Reply to Waller's *A Panegyrick to my Lord Protector*', *The Seventeenth Century* 11.1 (1996), 61–86

O'Kane, Finola, 'Design and Rule: Women in the Irish Countryside, 1715–1831', *Eighteenth-Century Ireland*, 19 (2004), 56–74

O'Hara, James G., 'Molyneux, William (1656–1698)', *ODNB* (2008)

Orr, Clarissa Campbell, ed., *Queenship in Europe, 1660–1815: The Role of the Consort* (Cambridge University Press, 2004)

Patterson, Annabel M., *Fables of Power: Aesopian Writing and Political History* (Durham, NC: Duke University Press, 1991)

Pender, Patricia, 'Disciplining the Imperial Mother: Anne Bradstreet's *A Dialogue Between Old England and New*', in *Women Writing, 1550–1750*, ed. by Paul Salzman and Jo Wallwork (Bundoora, Australia: Meridian, 2001), pp. 115–31

Perdita Project catalogue http://warwick.ac.uk/english/perdita/html

Prescott, Sarah, '"That private shade, wherein my Muse was bred": Katherine Philips and the Poetic Spaces of Welsh Retirement', *Philological Quarterly*, 88.4 (2009), 345–64

Women, Authorship and Literary Culture, 1690–1740 (Basingstoke: Palgrave, 2003)

Prescott, Sarah and David E. Shuttleton, eds., *Women and Poetry 1660–1750* (Basingstoke: Palgrave, 2003)

Rees, Emma, *Margaret Cavendish: Gender, Genre, Exile* (Manchester University Press, 2003)

Rees, Joan, *Samuel Daniel: A Critical and Biographical Study* (Liverpool University Press, 1964)

Ries, Paul, 'Robert Molesworth's *Account of Denmark*: A Study in the Art of Political Publishing and Bookselling in England and on the Continent before 1700', *Scandinavica*, 7 (1968), 108–25

Robbins, Caroline, *The Eighteenth-Century Commonwealthman* (Cambridge, MA: Harvard University Press, 1959)

Roberts, Sasha, 'Feminist Criticism and the New Formalism: Early Modern Women and Literary Engagement', in *The Impact of Feminism in English Renaissance Studies*, ed. by Dympna Callaghan (Basingstoke: Palgrave, 2007), pp. 67–92

Rosenmeier, Rosamond, *Anne Bradstreet Revisited* (Boston, MA: Twayne, 1991)

Røstvig, Maren-Sofie, *The Happy Man: Studies in the Metamorphoses of a Classical Ideal*, vol. I, 1600–1700, second edition (Oslo: Norwegian Universities Press, 1962)

Round, Phillip H., *By Nature and by Custom Cursed: Transatlantic Civil Discourse and New England Cultural Production, 1620–1660* (Hanover, MA: Tufts University published by University Press of New England, 1999)

Rumbold, Valerie, 'The Poetic Career of Judith Cowper: An Exemplary Failure?', in *Pope, Swift, and Women Writers*, ed. by Donald C. Mell (Newark, DE: University of Delaware Press, 1996), pp. 48–66

Salzman, Paul, *Reading Early Modern Women's Writing* (Oxford University Press, 2006)

Sambrook, James, 'Walsh, William (*bap.* 1662, *d.* 1708)', *ODNB* (2005)

Schleiner, Louise, *Tudor and Stuart Women Writers* (Bloomington, IN: Indiana University Press, 1994)

Schweitzer, Ivy, *The Work of Self-Representation: Lyric Poetry in Colonial New England* (Chapel Hill, NC: University of North Carolina Press, 1991)

Schwoerer, Lois, *Lady Rachel Russell: 'One of the Best of Women'* (Baltimore, MD: Johns Hopkins University Press, 1988)

Scott-Baumann, Elizabeth, *Forms of Engagement: Women, Poetry and Culture 1640–1680* (in press)

Seaton, Ethel, *Literary Relations of England and Scandinavia in the Seventeenth Century* (Oxford: Clarendon Press, 1935)

Seaward, Paul, 'Dering, Sir Edward, second baronet (1625–1684)', *ODNB* (2008)

Sevaldsen, Jørgen, 'Diplomatic Eyes on the North: Writings by British Ambassadors on Danish Society', in *Britain and the Baltic: Studies in Commercial, Political and Cultural Relations, 1500–2000*, ed. by Patrick Salmon and Tony Barrow (University of Sunderland Press, 2000), pp. 321–36

Sherbo, Arthur, 'Isaac Reed and the *European Magazine*', *Studies in Bibliography*, 37 (1984), 211–27

Shifflett, Andrew, '"Subdu'd by You": States of Friendship and Friends of the State in Katherine Philips's Poetry", in *Write or be Written: Early Modern Women Poets and Cultural Constraints*, ed. by Ursula Appelt and Barbara Smith (Aldershot: Ashgate, 2001), pp. 177–95

Smith, Hannah, 'English "Feminist" Writings and Judith Drake's *An Essay in Defence of the Female Sex* (1696)', *The Historical Journal*, 44.3 (2001), 727–47

Smyth, Adam, *'Profit and Delight': Printed Miscellanies in England, 1640–1682* (Detroit, MI: Wayne State University Press, 2004)

Souers, Philip Webster, *The Matchless Orinda* (Cambridge, MA: Harvard University Press, 1931)

Stanford, Ann, *Anne Bradstreet: The Worldly Puritan* (New York: B. Franklin, 1974)

Stapleton, M. L., *Admired and Understood: The Poetry of Aphra Behn* (Newark, DE: University of Delaware Press, 2004)

Staves, Susan, *A Literary History of Women's Writing in Britain, 1660–1789* (Cambridge University Press, 2006)

Steggle, Matthew, 'The Text and Attribution of "Thou who dost all my earthly thoughts employ": A New Moulsworth Poem?', *Early Modern Literary Studies*, 6.3 (2001) http://extra.shu.ac.uk/emls/06-3/stegmoul.htm

Stewart, M. A., 'John Smith and the Molesworth Circle', *Eighteenth-Century Ireland*, 2 (1987), 89–102

Straznicky, Marta, *Privacy, Playreading, and Women's Closet Drama, 1500–1700* (Cambridge University Press, 2004)

Suzuki, Mihoko, 'What's Political in Seventeenth-Century Women's Political Writing?', *Literature Compass*, 6.4 (2009), 927–41

Sweet, Timothy, 'Gender, Genre, and Subjectivity in Anne Bradstreet's Early Elegies', *Early American Literature*, 23.2 (1988), 152–74

Taylor, Stephen, 'Caroline (1683–1737)', *ODNB* (2004)

'Queen Caroline and the Church of England', in *Hanoverian Britain and Empire*, ed. by Stephen Taylor, Richard Connors and Clyve Jones (Woodbridge: Boydell, 1998), pp. 82–101

Thorne, Alison, 'Women's Petitionary Letters and Early Seventeenth-Century Treason Trials', *Women's Writing*, 13.1 (2006), 23–43

Tinker, Nathan P., 'John Grismond: Printer of the Unauthorized Edition of Katherine Philips's *Poems* (1664)', *English Language Notes*, 34.1 (1996), 30–35

Voitle, Robert, *The Third Earl of Shaftesbury, 1671–1713* (Baton Rouge, LA: Louisiana State University Press, 1984)

Wall, Wendy, 'Isabella Whitney and the Female Legacy', *English Literary History*, 58.1 (1991), 35–62

The Imprint of Gender: Authorship and Publication in the English Renaissance (Ithaca, NY: Cornell University Press, 1993)

Wheeler, David, 'Beyond Art: Reading Dryden's Anne Killigrew in its Political Moment', *South Central Review*, 15.2 (1998), 1–15

Whitaker, Katie, *Mad Madge: Margaret Cavendish, Duchess of Newcastle, Royalist, Writer and Romantic* (London: Chatto and Windus, 2002)

White, Elizabeth Wade, *Anne Bradstreet: The Tenth Muse* (New York: Oxford University Press, 1971)

Winn, James, '"A Versifying Maid of Honour": Anne Finch and the Libretto for *Venus and Adonis*', *The Review of English Studies*, 59.238 (2008), 67–85

Wiseman, Susan, *Conspiracy and Virtue: Women, Writing and Politics in Seventeenth-Century England* (Oxford University Press, 2006)

Wolfe, Heather, 'Reading Bells and Loose Papers: Reading and Writing Practices of the English Benedictine Nuns of Cambrai and Paris', in *Early Modern Women's Manuscript Writing*, ed. by Victoria E. Burke and Jonathan Gibson (Aldershot: Ashgate, 2004), pp. 135–56

Woudhuysen, H. R., *Sir Philip Sidney and the Circulation of Manuscripts, 1558–1640* (Oxford: Clarendon Press, 1996)

Wright, Gillian, 'Giovanni della Casa in Two English Verse Collections', *Translation and Literature*, 11.1 (2002), 45–63

'Manuscript, Print and Politics in Anne Finch's "Upon the Hurricane"', *Studies in Philology* (in press)

'Textuality, Privacy and Politics: Katherine Philips's *Poems* in Manuscript and Print', in *Material Readings of Early Modern Culture: Texts and Social Practices, 1580–1730*, ed. by James Daybell and Peter Hinds (Basingstoke: Palgrave, 2010), pp. 163–82

'The Birds and the Poet: Fable, Self-Representation and the Early Editing of Anne Finch's Poetry', *The Review of English Studies* (in press)

'The Molesworths and Arcadia: Italian Poetry and Whig Constructions of Liberty, 1702–1728', *Forum of Modern Language Studies*, 39.2 (2003), 122–35

'Women Reading Epictetus', *Women's Writing*, 14.2 (2007), 321–37

Wynne, Michael, 'Some British Diplomats, some Grand Tourists and some students from Great Britain and Ireland in Turin in the Eighteenth Century', *Studi Piemontesi*, 25.1 (1996), 145–59

UNPUBLISHED DOCTORAL THESES

Cameron, W. J., 'Anne, Countess of Winchilsea: Materials for the Future Biographer' (unpublished doctoral thesis, Victoria University of Wellington, New Zealand, 1951)

Eames, John, 'The Poems of Sir William Kingsmill: A Critical Edition' (unpublished doctoral thesis, University of Birmingham, 1981)

Jay, Emma, 'Caroline, Queen Consort of George II, and British Literary Culture' (unpublished doctoral thesis, University of Oxford, 2004)

Pickard, Claire, 'Literary Jacobitism: the Writing of Jane Barker, Mary Caesar and Anne Finch' (unpublished doctoral thesis, University of Oxford, 2006)

Ross, Sarah, 'Women and Religious Verse in English Manuscript Culture, c. 1600–1668' (unpublished doctoral thesis, University of Oxford, 2000)

Taylor, Elizabeth Anne [Betsey Taylor-Fitzsimon], 'Writing Women, Honour and Ireland, 1640–1715' (unpublished doctoral thesis, University College Dublin, 1999)

Index

28949005R00158

Printed in Great Britain
by Amazon